Game Usability

Game Usability

Advice from the Experts for Advancing the Player Experience

Katherine Isbister
Noah Schaffer

CRC Press
Taylor & Francis Group
Boca Raton London New York

CRC Press is an imprint of the
Taylor & Francis Group, an **informa** business

CRC Press
Taylor & Francis Group
6000 Broken Sound Parkway NW, Suite 300
Boca Raton, FL 33487-2742

© 2008 by Taylor & Francis Group, LLC
CRC Press is an imprint of Taylor & Francis Group, an informa business

No claim to original U.S. Government works
Printed in the United States of America on acid-free paper
International Standard Book Number-13: 978-0-1237-4447-0 (Softcover)

Library of Congress Cataloging-in-Publication Data

Catalog record is available from the Library of Congress

**Visit the Taylor & Francis Web site at
http://www.taylorandfrancis.com**

**and the CRC Press Web site at
http://www.crcpress.com**

TABLE OF CONTENTS

Part III. Focus on Special Contexts and Types of Players 141

Part IV. Advanced Tactics 185

Part V. Putting it all Together and Where Things are Going 345

Randy Pagulayan
Microsoft Game Studios

Dennis Wixon
Microsoft Surface

Games User Research at the Crossroads

Gaming and user research on gaming have finally come of age, and for many of us it's been a fast and furious ten years of industry growth and progress in research and practice. Just taking a quick look at the scope and depth of this book provides clear evidence of the health and progress of the field. With 23 chapters by distinguished authors from industry, academia, and consultancy, this volume represents a watershed in research on gaming and clearly provides an excellent overview of where we are. At this time, we feel games user research is at a crossroads. With our combined experience, we've seen and been part of an evolution in applied research that feeds into some of our thoughts on where gaming research can go. However, rather than predicting trends, we'd like to give our perspective on the pitfalls and promise of user research on games in hopes that the next ten years can be as fruitful as the past decade.

One size fits all – it's all story, it's all mechanics

One of the pitfalls of thinking about game design and research is the seduction of a dogmatic approach. The arguments for dogmatic approaches are often passionate and persuasive containing compelling examples. Typical example of a dogma is "the story is the most or only critical element of game design". After all, the argument goes, shooting alone is not compelling unless the story is good. Alternatively one could argue that mechanics are the only critical element of game design. What's the story line for Guitar Hero or Hexic?

Like most dogmas these assertions contain a kernel of truth that has been over-extended. Making a great game depends on many elements (mechanics, story, visuals, sound, characterization, etc.) and the relative importance of these elements varies from game to game and genre to genre. In addition the elements are complementary and not mutually exclusive. It's time to think of games holistically. When we think of movies, novels, paintings, and great meals, we already know that all the elements combine for great experience. Let's apply a lesson from Gestalt psychology to games, "The whole is different than the sum of the parts." There is a "Pragnanz*" in game design where it all comes together; this is just like when we look at a set of dots but perceive the closure of a circle. The underlying principle

is that it's not the dots but their relationship that matters. The important corollary for game design is that a single failed part (something out of place) can disrupt an otherwise great experience. We can start to think of game design in terms of what's blocking the fun. In other words, what design element was out of place that prevented closure on the intended experience? Let's move away from useless dogma and take the road to more productive thinking.

Games are art

A common discussion within the games industry revolves around the question of games being art...or not. Many industry luminaries will gladly propose that games are indeed a form of art, and of course, those who aren't in the games industry will claim the opposite. The debate over whether games are art will no doubt continue over the long-term. So what does that mean for us, as we push forward the discipline? We don't think our role is in helping to decide which side is right. In fact, we suggest not wasting time engaging in that debate. Instead, we should approach games research in a way that is more meaningful and useful to the creators and consumers of the medium. We should focus more on what the consequences are for a given perspective. It's not so much whether games are art or not. The more relevant question (in our opinion), is "What kind of art?" We must make a distinction between fine art and commercial art. In many cases, games lean toward commercial art. In this case, the research focus becomes clearer and debates should revolve around the clarity of the communication of the message from the artist to the consumer. We often refer to this as "realizing the design intent." Of course, the pitfall here is a damaging belief that games research can end up *dumbing down* one's creative vision, which we know is untrue. Just be ready to educate.

The gulf between research and practice

It seems that games and entertainment are on the verge of becoming the next hot research topic, which puts us at risk for a lot of the same mistakes made when new areas of application surface. For example, the web became very prevalent in the HCI and research fields, and web "research" began to permeate everything from conference presentations, to new books, to becoming the focus of doctoral dissertations. Not all of that particular body of research was ineffective, but there definitely were more conclusions and results that were presented as novel but were already known from existing research on basic human factors or perception. At our current crossroads, we need to continue to understand the basics and fundamentals of research while using those skills to look ahead. Game designers and the games industry at large can be extremely critical; thus, researching the right questions becomes imperative as opposed to rehashing existing psychological constructs for research, and calling it a game. We must maintain the rigor and skill sets of good research (applied or basic research),

but we also must be honest with ourselves in terms of what truly is important to games. Otherwise, we end up with researchers and practitioners performing research that ultimately serves no one but ourselves (which isn't very good).

Relying on people successful in other fields – spread of expertise

An admittedly touchy, and controversial, subject is what background is most useful for a commentator who aspires to contribute to our emerging discourse on game theory and research. The most insightful and useful commentaries will come from folks who combine deep knowledge of games with deep knowledge of some other fields. For example, those who know both games and film can provide a fresh perspective on the age old question of the relationship of games to film. Conversely one of our pitfalls is something philosophers call "the spread of expertise." The spread of expertise occurs when a noted authority from one field extends his/her thinking to a new field without really coming to grips with the history and culture of that field. The result will, all too often, be an unreflective dabbling in the field that is counterproductive. For example, some noted authors have advocated the wholesale importation of reinforcers into productivity applications. It's hard to image anything more annoying than a message "You won !! Your order will be shipped to you tomorrow!!!" or "Great work!!! You have now achieved the level of Master Jedi for this database!!!" While such feedback could be amusing the first time, we predict its charm would wear off quickly and it would soon be annoying. We also imagine that after a long struggle to complete a task with a productivity application, the congratulatory message would provoke the response "No kidding you made it hard enough." That's hardly the intended effect. The gaming research field can benefit greatly from new and fresh perspectives, provided those offering them have done their due diligence in studying games and their unique challenge and culture.

Promise

After a promising start in the early 90's, research to determine which usability method was the most effective in the real world abruptly stopped. This setback has been partly attributed to an unfortunate article by Gray and Stalzman (1998). In it they argued that evaluating user research methods in business required a classical experimental approach. While this article may have provoked some interesting discussion, it served to stifle a promising area of research on the relative effectiveness of methods. Fortunately, research on methods in games has proceeded in a real world context and has taken a case-study approach as opposed to a formal experimental approach. Several authors have described the contribution of a research design collaboration to the commercial success of games. This is a trend to be supported

and encouraged. Perhaps games research can reinvigorate efforts to evaluate methods for productivity applications in the context of real world products and tools. Given the sterility of formal experimental methods for real world applications, it would be a welcome change.

A new behavioral/environmental emphasis

Along with a focus on evaluating methods in the context of the real world, we also feel strongly that the next evolution in games research will be taking these methods, tactics, and techniques (many of which are listed in this book) and focusing less on cognitive states and emotional taxonomies, and more on opportunities for player behaviors. Games can become complete worlds for our users, so now more than ever we need to understand the interactions between the player and the environment, understand the player's behavior within a virtual world, and understand the player's ability to detect the infinite possibilities created for them. To borrow from James Gibson, a shift in emphasis from "inside the head" to "what the head is in" lends itself quite well for research that is actionable and accessible to both the researcher and the game designer.

So there it is, games user research has taken leaps and bounds over the past 10 years, as evidenced by the content of this book. As the editors point out, the book represents a snapshot of where we are today, which is quite remarkable given the state of games user research just 10 years ago. We encourage the readers to use this resource as a great starting point for strengthening the discipline while taking us into the future. But most importantly, if you were to only take one thing from reading this forward, take this thought...Life is short, have fun.*

Keep it tilt,
-Randy Pagulayan & Dennis Wixon
April, 2008

* Editors' note: Pragnanz is a term from Gestalt theory in Psychology, meaning a sort of ordered and balanced image that the mind pulls together when perceiving and making sense of the world.

WHAT IS USABILITY AND WHY SHOULD I CARE?

CHAPTER ONE

Introduction

Katherine Isbister and Noah Schaffer

1.1 Why Usability Now?

More and more game developers (and educators in the field of game development) are talking about user research and usability. There have been articles in industry venues such as *Gamasutra*, and workshops on usability at the annual Game Developers Conference. You may be wondering what exactly the excitement is about, and what it has to do with your daily challenges as a game developer.

There are many reasons for the increasing interest in user research for games that led us to feel the time was right for an edited volume about what's state-of-the-art in this emerging field:

- *Developers and publishers are trying to reach out to broader audiences.* User research becomes more crucial to development teams when the target audience is someone other than people who closely resemble the developers themselves.
- *Game development teams have grown.* User research can help to keep larger teams "on track" in their efforts—it's harder to manage by intuition when one person can't have all the many facets of the design in their head.
- *Proliferation of platforms.* Designing for new input modes and modified platforms, or for many platforms at once, creates usability problems that user research can help to anticipate and lessen.

For these and other reasons, more and more game developers are turning to tactics that emerged from the study of productivity software, to help fine-tune their efforts.

1.2 What Exactly Is Usability? How Is It Different from Playability and Fun?

In the realm of productivity tools, such as word processors and banking websites, *usability* has come to mean the extent to which the software is intuitive and effective for a

3

person trying to accomplish the tasks at hand. Making software usable means paying attention to human limits in memory, perception, and attention; it also means anticipating likely errors that can be made and being ready for them, and working with the expectations and abilities of those who will use the software. Traditional usability testing, then, has been testing with people in the target user group to see whether the software meets expectations in these practical concerns about task. In more recent years, productivity software designers have also become interested in a broader sense in the overall *user experience*—what it is like to interact with the software, including how engaging the experience is, regardless of the end goals. This leads to testing techniques that are concerned with qualities such as engagement, flow, and fun—qualities that bring user research closer to the primary concerns of game developers.

Game developers have evolved two main tactics for collecting play feedback and reincorporating it into design: *playtesting* and *QA* (quality assurance). In playtests, the focus is on whether the game is fun to play, but also where players may be getting stuck or frustrated (similar to usability test concerns). Playtests are conducted when there's a playable version of the game, but as early as possible in the process, to help correct any issues before full production. QA is testing done fairly late in the development process, focused mostly on catching bugs in the game software, but also aiding in tuning play, for example adjusting the difficulty level of the game.

In this book, you'll see that each author has a slightly different way of using these terms. We see this as an indication that the field is still evolving—the differences reflect the origins of each author's knowledge and practice. If you keep in mind the broad definitions above, you should be able to follow along regardless of these variations.

1.3 What to Expect from This Book

As of yet, no "one size fits all" easy approach exists to incorporate user research into game development. Rather, there are a range of tactics and tools that may be appropriate depending upon the project and the resources at hand. As developers adapt and apply more and more of what's known from traditional usability and user research to games, the repertoire of tactics continues to grow.

This book is not a definitive primer on how to do game usability. Instead, it is a collection of techniques and perspectives—a snapshot of what's available today, and of where things may be going. We've gathered insights from game industry practitioners, ranging from straightforward advice from a small studio about why you should do usability (see Chapter 3), to discussion of elaborate instrumentation techniques from a company on the cutting edge of incorporating user research into their development process (Microsoft—see Chapter 15). There are developers from around the United States, as well as from Europe and Asia. We've also included input from researchers, many of whom serve as active consultants to game developers (for example, Lazzaro, Chapter 20; Mandryk, Chapter 14), and all of whom take very seriously the unique challenges of measuring player engagement and

satisfaction with games. Whatever your resource level and interest level, we believe you'll find something of use in these pages, including:

- Advice for how (and why) to fire up your company about usability and user research (see Chapter 2),
- Bread-and-butter techniques that have broad relevance (see Part II),
- Special contexts, such as casual games, and types of players, such as players in other cultural markets, for example Japan (see Part III),
- Advanced tactics to try out, such as biometrics and instrumentation (see Part IV),
- A use matrix that helps you decide what techniques may be appropriate to the project and phase you are in (see Part V),
- Interesting perspectives on how gaming has influenced the broader world of design and user research (two interviews in Part V).

1.4 Tips for Using this Book

If you are a student, or someone new to the area of usability:
We suggest that you begin with Parts I, II, and V, then pursue Parts III and IV depending upon how your interests evolve once you have a broad feel for this area.

If you are someone with an existing basic knowledge of usability, interested in new techniques.
You may want to skip to Part IV of the book, to learn about methods in the vanguard of user research for games.

If you are a manager or developer interested in promoting usability in your organization.
Part I has tips for how to inspire your company and how to successfully implement usability practices in your team. Part V has some inspirational advice and commentary about how games are at the cutting edge of user experience, as well as a matrix for what techniques may be useful when.

1.5 Acknowledgments

We'd like to thank Regina Bernhaupt for the wonderful International Conference on Advances in Computer Entertainment Technology (ACE) 2007 workshop on methods for evaluating games, at which quite a few of the book's authors were gathered. Regina has been a valuable advocate for bringing user experience in games to the conversation in traditional user research circles. We'd also like to thank the staff at Morgan Kaufmann for their help in shaping this book, and in bringing it to press. Thanks also to Jason Della Rocca, for his excellent editorial comments along the way.

CHAPTER TWO

Organizational Challenges for User Research in the Videogame Industry: Overview and Advice

Mie Nørgaard is a Ph.D. fellow in human computer interaction (HCI) at the University of Copenhagen. Her research interests include collaborative and organizational aspects of user research and experienced-focused HCI. With her background in archaeology, she is also curious about modern technological artefacts and their potential for supporting everyday life.

Janus Rau Sørensen holds an M.A. in Information Studies and Ethnography & Social Anthropology. He works as a User Research Manager for the Danish game developer IO Interactive, where he has done research on games such as Hitman and Kane & Lynch.

2.1 Overview

In this chapter, we take a look at organizational challenges for third-party developers who are interested in implementing and conducting HCI-related user research, such as usability testing, in a game development setting. We discuss the challenges related to justifying the return on investment of user research, formalizing work procedures involving user research, and the building of cross-professional relationships amongst key stakeholders to user research. Furthermore, we also discuss the challenges related to the fact that many games developers are owned or closely affiliated with a publisher. Through the lenses of a questionnaire survey including members from the game industry, we specifically look at the relationship between third-party developers and the publisher's marketing department, and investigate how and to which extent these two parties collaborate on user research issues. During the chapter we also present concrete advice on how to tackle the various challenges mentioned.

2.2 Introduction

There are many potential rewards for the videogame developer who wants to implement methods to evaluate usability or user experience in the game development process, but there are also a multitude of challenges. Not only are games complicated pieces of software, the nature of their use is also very different from the use of traditional task-oriented software, which is what most usability evaluation methods are designed for, and this poses a challenge for user researchers in the game industry. Well-known usability measures, such as efficiency, effectiveness, and satisfaction (such as identified by ISO 9241–11) can only partially give a picture of how well a game performs. In fact, one may wonder what "efficiency" in relation to videogames actually means, or whether the term makes sense in this context at all (Barr et al., 2007; Pagulayan et al., 2004; Jørgensen, 2004; Philips, 2006; Bernhaupt et al., 2007). But adapting methods or designing new ones are not the only challenges for user research in the game industry. In this chapter, we discuss organizational challenges for user research, such as justifying return on investment, formalizing work procedures, and the building of cross-professional relationships. We further identify a challenge that in some aspects is unique for the game industry; it is a challenge that is connected to the developer-publisher relation and springs from the fact that many game developer studios are either formally owned by or are affiliated with a publisher. In this structural setup, the publisher handles, for example, marketing and distribution, whereas the developer handles the actual development of the game.

Introducing user research in the form of usability or user experience evaluation at the developer site can potentially create a conflict between the publisher and the developer, because both parties—sometimes simultaneously—conduct user studies. Practically speaking, the user research workers at the developer site will do research

with, for instance, a usability focus, whereas the publisher mainly focuses its user research on marketing issues. At the very least, such a situation will require intense coordination between the publisher and the developer site, because they need to agree on, for example, who the users are, and what the consequences of particular results should be; i.e. if and how to use the results in the development and/or marketing of the game.

This challenge of coordinating marketing and development user research efforts is also present in the software industry, but because of the videogame industry's close historical and structural ties with the toy and entertainment industry, the marketing-development relation and power balance in games development are different from those in the software industry. This poses unique challenges to implementing user research methods in videogame R&D.

In the course of this chapter, we will use the term "UR champion" to describe the person who incorporates—or wishes to incorporate—user research in the development process at the developer site. In terms of job roles in the game industry, such a person may belong to level design, QA, management, etc. The goal of the chapter is to discuss the organizational challenges such a person may encounter and to provide tips for how to work around them.

We wish to emphasize that the results and advice presented in the following should not be understood as devious tactics to gain world domination for UR champions at the expense of developers, for instance. Neither should it be understood as an attempt to point out either developers or publishers as antagonists—both can be quite positive towards user research. On the contrary, it is the authors' firm belief that user research should help and enable game developers, as well as publishers and marketing, to develop, market, and sell better games. Accordingly, the challenges and advice presented in the following are aimed at how to manage the organizational aspects of implementing and maintaining a new methodology to the benefit of all parties.

2.3 Three Well-Known Challenges

In Nørgaard & Rau (2007), we described and discussed four common challenges in incorporating usability and user experience evaluation in the development of commercial videogames: (1) justifying return on investment, (2) developing game-specific evaluation methods, (3) formalizing work procedures, and (4) building cross-professional relationships. This discussion was based on our experience from working with user research at a large Danish game developer under Eidos Interactive. However, we find that the challenges are of such a general nature that they will be relevant in other organizational settings as well. The challenge concerning the methods for involving users in the development of a game is discussed elsewhere in this volume. Accordingly, this chapter elaborates on the remaining three interconnected challenges—justifying return on investment, formalizing work procedures, and the building of cross-professional relationships—all of which concern

intra-organizational aspects of major importance to how successful user research can be introduced in a company developing games.

Finally, we describe a challenge concerning the relationship between developer and publisher, which in some aspects is unique for the game industry, and thus has not been described elsewhere.

2.3.1 *Return on Investment*

Just as in any other industry, the production and design methods that survive are the ones which add the most to a company's profit. Consequently, a key challenge in convincing management or developers to include user research in the game development process relies on the UR champion's ability to adequately describe the return on investment. Return on investment is not a new theme and has already been discussed in detail in relation to traditional software development (Karat, 1997; Nielsen & Gilutz, 2003). UR champions everywhere may experience difficulty persuading the company's management and/or development team to allocate time and money to evaluate an upcoming product's usability. In the game industry, skeptics may argue that many games have done well without much usability evaluation or user research studies, and they will, in fact, be right. So why do user research, one may ask. To answer this, we need to consider that traditionally, game designers have developed games for users who—experience and preference-wise—were much like themselves. And with such a well-known group of users, the need for intensive user studies was fairly low. Today, however, players are much more heterogeneous (Bateman & Boon, 2005), and user studies are crucial for the success of a game. As a result, UR champions need to persuade game designers that user studies can provide new insights about the users, which can be utilized to improve the design and better target the game to the intended users. UR champions need to produce a set of convincing arguments about both short- and long-term benefits of their work if they are to succeed in convincing management and colleagues to spend time and money on, for instance, usability and user experience work. Pointing to examples from the game industry which document user research being used successfully in game development is a good first step: If the competitors use a method that seems to give them an edge in the marketplace, this is in itself a good reason to consider implementing similar methods.

But more than this, the UR champion will also need to point to the reasons *why* a specific method will have a positive impact on game development. An important factor in being able to make any successful pitch is to make the pitch fit the listener's professional and personal profile—just like a good game must fit the targeted user. This should be kept in mind when attempting to convince different people or whole departments of the generous returns of user research investments. This means that a UR champion needs to identify the key stakeholders (in other words, the key people who are going to pay for it or whose work will be affected by it), understand what specific returns they are interested in, explain to them what kinds

of return they can expect, and relate this to the size of the investment they have to make.

Developers, in particular, may worry that user research will lead to letting the users (or the UR champion) design the games instead of the developers. On the contrary, user research should support and enable the developers' vision for the game rather than take away responsibility and competence, and this should be communicated clearly to the developers. Furthermore, as project schedules are often very tight on time, a reasonable worry on behalf of the developers is that user research will add more hours and stress to an already heavy workload. Therefore, the UR champion needs to present arguments that user research—although naturally requiring some investment of time—enables the developer to identify necessary design changes much earlier than without user research, and thus saves time in the end. Such an argument fits developers as well as management.

Another persuasive argument is hidden in including developers in the preparation, execution, and analysis of user test sessions. This will demystify user research and help developers understand what user research methods are, what kind of results they can provide, and which questions they might help answer. Because of time constraints, it may not be easy to convince developers to take part in user research. This makes it all the more important to emphasize that the developers' knowledge about the game can be invaluable for the analysis of the research data, which calls for the developers' active participation. Furthermore, from a psychological point of view, developers are more likely to act on evaluation results when they have contributed to creating them (Benton, Kelley, & Liebling, 1972; Schindler, 1998) which makes the involvement of developers in user research even more important.

Whereas developers primarily will focus on the production side of the game, management will additionally be interested in how user research can help the company in the marketplace. The UR champion could, therefore, seek to document current industry trends—such as a diversifying market with new types of users, escalating production costs etc.—and use these as an argument for user research. A well-supported argument that states that user research can align the game better to the market, as well as cut costs, is an efficient argument that states: We cannot afford *not* to implement user research if we are to remain competitive.

As a last persuasive factor, it is important that results start rolling in fast after the first user tests, and that these results are both easily communicated, relatively uncontroversial, and easily translated into action points. For instance: A lengthy ethnography-inspired field-work study—although potentially yielding interesting and insightful results—is difficult to validate, hard to understand for non-ethnographers, may require deep (and thus complicated) intervention in the game design, and prolongs the time between investment and return. So, introducing user research through thorough ethnographic studies will make it harder for developers and management to accept user research as adding tangible value to development. Instead, much can be gained by some amount of strategic planning. Initially, the UR champion could focus on methodologies, such as basic usability testing, which focus on objective data collection criteria and/or relatively isolated parts of

the game. As these methods gain momentum, the UR champion could then start expanding the user research toolkit in order to gradually expose colleagues to other user research methods and train colleagues to think in terms of user experience.

Skeptics may object that it is not the job of the user researcher to pick and choose strategically from the pool of results or tools, and that UR champions have an obligation to present whatever results they uncover, despite any practical or political complications. While this is certainly valid from a purely academic stand-point, we do advice practitioners to at least consider the option of a more pragmatic approach After all, firing all your artillery and using all your ammunition at level 1 may not be the best strategy to secure success for user studies in the long run.

Key takeaways:

- Collect real-world examples of successful user research practices in the game industry and share them.

- Tailor return-on-investment arguments to fit key stakeholders' individual and professional needs and goals.

- Be realistic and choose battles wisely: Start off by implementing user research methods with focus on data and objectivity, as well as a high and reliable success rate. This will enable you to build return-on-investment credibility fast and open doors to introducing new user research methods.

2.3.2 Formalized Work Procedures

A methodology cannot truly prove itself unless it is clearly connected to the relevant development processes it intends to support, which is why a key challenge for UR champions is to create, maintain, and further develop formalized work procedures for user research.

Another critical part of game development—QA testing and other established QA processes—has for a long time been an integrated part of the production process. By now, QA has a relatively well-defined place in the development structure and process, the idealized work-cycle being: QA receives the latest build from the developers, the build is tested in different ways against a set of requirements, and discrepancies are entered into a bug/defect database application. Following this, the developer resolves the bug in the code, commits the code, and makes a new build for the QA department to test. Accordingly, it is relatively clearly defined who has which responsibilities at what stage of the workflow. This means that the bug does not end up in limbo. Similarly, it is also relatively well-defined when in the development process that QA testing should start, when it should finish, and what it should focus on at which stages in production. UR champions need to ensure similar formalized work procedures for user research.

Of course, bugs are different from usability problems, and creating the ideal work-cycle that supports user research during the development of a game may sound easy—but it isn't necessarily because it must involve the entire development team.

Thus, after having identified what parts of the game to research—probably central game play features and/or key segments of the game—the UR champion needs to embed the user research efforts into the development of these parts of the game. We use the term "embed" as opposed to "add" because it is important that user research doesn't become an add-on method, applied when milestones have already been met. In an agile/scrum type of development environment, this means, for example, including user research-criteria for when features are done, and similarly in a waterfall production, including user research in the milestone definitions (Cusumano & Selby, 1997; Schwaber & Beedle, 2001).

One general and practical problem for the UR champion is getting access to playable builds that can be used for user testing. Since it is difficult to pre-order playable builds for a certain date, planning user tests can be quite a hassle. The problem increases if stakeholders understand user research as a less important activity that is merely added to the development. It is crucial to the quality of the user research that the delivery of builds for user studies is an integrated part of the development schedule. UR champions who struggle with work procedures that impede user research by not including it in the development schedule should make it clear to management that the point is not to add more deadlines to the project, but to create work procedures that support user research so time can be saved in the long run. Otherwise user research will remain an add-on that can be cancelled at convenience. The UR champion could argue that if the company wishes to work seriously with user research, work procedures should reflect that a feature is not done until it is user tested. Accordingly, testable builds need to be available for user research during the development process.

When establishing user research as an integrated part of a development processes, user research practitioners face the challenge of determining to whom the user research feedback should be directed, and who is responsible for carrying out which usability recommendations. This is important if results are to actually be used and redesigns implemented. Game development is often organized in a way in which different developers are responsible for different parts of the game, for example animation, character graphics, or AI code. Unfortunately, some user research results simply fall between areas of competence because they involve several functional components of the game. And if convincing a developer to deal with user research issues in his own domain is difficult, convincing him to deal with issues outside of his domain is practically impossible. Thus, one important challenge for a UR champion is to get a clear image of who is responsible for what, and to make sure that any usability issues that *do* fall between areas of competence are somehow still discussed and handled instead of put on hold or ignored. Also, to catch any unsettled issues in danger of being forgotten the UR champion should be prepared to do an extensive amount of follow-up work.

The issue described above is complicated by the nature of the feedback that user research yields: In contrast to traditional bugs, which primarily focus on clear-cut functional defects in the code or the character models, results from user research are less clear-cut. For example, most results from user research can rarely be considered

13

showstoppers that will leave the game entirely unplayable. Instead, they describe issues that, if resolved, will improve on more intangible aspects of the game such as the overall player experience. That being the case, unless formalized work procedures are in place before results start coming in from user research, there is a great risk of the issues being lost in translation or down-prioritized because they are considered less important than bugs. Ultimately, this may very well mean that usability or user experience issues will end up not being resolved.

Related to this, specifications and best practices on how the UR champion shares his or her results with colleagues are needed to improve user research's impact on the product. Current literature confirms that the means by which results from usability evaluations are presented and communicated to developers are highly determinant for how they are received (Nørgaard & Høegh, 2008; Nørgaard & Hornbæk, 2008). This will vary from organization to organization, and from team to team, so there will be an element of trial and error and gut feeling connected to this. One way of helping such processes along is to agree on who is responsible for and has the mandate to make decisions about usability priorities, who can instigate user research, to whom the results are handed over, and how these results are handled. It is not the authors' opinion that user research results should automatically warrant a fix as would the discovery of a bug; developers may have good reasons for rejecting a proposed redesign. Nevertheless, there should be a clear work-flow for the handling of user research results and recommendations for redesign. To make this easier, we recommend implementing one method and workflow at a time.

Key takeaways:

- Identify key development components and milestones that user research should connect to.

- Build standardized procedures for user research: Make it an integral part of the development process, not just an add-on that can be dismissed when time is tight.

- Use best practices and gut feeling for which format should be used to share the results. Remember that user research should be supporting the developers' goals and the overall company strategy.

- Start slowly, integrating in tiers or one method at a time.

2.3.3 *Nursing Cross-professional Relations*

Successfully implementing user research methods does not only rely on work procedures that support user research, it also relies on the UR champion's ability to form sound cross-professional alliances and relationships.

In order to boost their impact on colleagues who regard user research with suspicion or reluctance, UR champions may benefit from forming alliances with those stakeholders who take an interest in user research. Through alliances (or tight cross-professional relations, as we diplomatically call them) with powerful colleagues, a UR champion may improve the impact of his or her work tremendously. Thus,

the successful UR champion has an eye for strategic planning, lobbyism, and for spotting influential colleagues.

However, the relations with influential managers are not the only ones that UR champions need to nurse. Because user research ultimately will impact most of the development processes, the UR champion needs to develop fruitful relations with a whole range of professionals. For example, because game developers' visions for a game are rarely entirely documented, and because UR champions depend on knowing these visions to understand which challenges in a game are intended and which are actual problems, close cooperation with game developers is important.

Having said that, getting the relevance of user research acknowledged by game developers may be fairly difficult. So, apart from justifying the return on investment, UR champions should also pay close attention to the professional and personal relationships that exist between themselves and other stakeholders in an organization.

When seeking to nurse cross-professional relations, UR champions should pay attention to the fact that different professionals have different aims and job roles, and make an effort to build tight relationships with stakeholders bearing that in mind. Personal relationships are—obviously—also very important because good personal relations help bridge conflicting interests and generally facilitate ongoing informal communication, the latter being very helpful from a proactive point of view.

To a critical eye, teaming up with influential colleagues and making alliances might seem a little too Machiavellian. However, the point is not to trick people or to force an opinion upon someone, the point is to build and nurse good relations with colleagues in order to aid the development of successful games.

Key takeaways:

- Think strategically: Do lobby work and strive to make alliances with influential colleagues. Remember, an influential colleague is not always the one with the fancier job title.

- Talk with the game developers and listen to their thoughts and ideas. This may sound trivial, but to succeed with user research you need to understand their visions for the game and you will not if you solely correspond per email.

- Nurse professional and personal relationships continually—not only when you need favors or support. An informal chat once in awhile will help get attention and goodwill when push comes to shove.

Based on our own research and experiences, we have presented some key organizational challenges for UR champions working to introduce user research in the game industry. These challenges are not unlike the challenges that any software company will encounter in the process of maturing its view on usability and the processes for conducting user research. Further discussions of such themes can be found in Helander et al.'s Handbook of Human Computer Interaction (Helander, Landauer, & Prabhu, 1997).

In the following, we will discuss one organizational challenge that, in some aspects and to the best of our knowledge, is unique for the role of user research in the development of videogames. Accordingly, it is not mentioned in traditional literature on user experience or usability work. This challenge is partly linked to the fact that games development has not sprung from the organizational context of traditional software development, but from the publishing and toy industry. Thus, companies that produce games may organizationally resemble a publishing company more than a producer of traditional task-oriented software, and should be understood in that context, even though basic production issues, such as ensuring usability and a good user experience, on the surface are nearly identical to issues in the software industry.

2.4 The Publisher and The Developer

2.4.1 *Background*

To understand how and why companies that develop videogames are structurally different from the ones that produce ordinary software, we will briefly look at how game developers ended up being related to the publishing industry. Most readers will be familiar with many of the points in the following, but we believe that this brief history lesson is important for understanding the organizational context of game development.

The dawn of the commercial videogame occurred in the early 1970s; up until then, games were basically programmed by engineers to entertain engineers (Bateman & Boon, 2005; Juul, 2005). But with the emergence of successful coin-up games, such as Atari's PONG (Kline, Dyer-Witheford, & De Peuter, 2003), intended for public spaces, such as bars and cafeterias, videogames showed up on the entertainment industry's radar. Soon, toy and media companies joined the game business contributing knowledge and experience in production, publishing, and distribution.

When Atari's VCS-console was released in 1977 it was a big hit, but by 1985 video console game sales had dropped from $3 billion in the United States alone to $100 million worldwide (Miller, 2005). The reasons for this collapse may be manifold. One reason, which is interesting from an organizational perspective, is that the industry was put together in such a way that developers could create games for whatever console they desired, relatively independent of any publisher. And the ability to make an easy surplus made many types of companies—even breakfast cereal producers such as Quaker Oats—enter the business of developing games. Unfortunately, this gold-digger mentality flooded the market with poorly designed games, and sales dropped accordingly.

To mend the negative sales statistics, console producers introduced rigorous screening procedures, for example, proof of concept and technical requirements, to help them decide which games should be published on their particular gaming console (Kline, Dyer-Witheford, & De Peuter, 2003). This made it virtually impossible

for independent developers to get into the console game market without a powerful publisher to get them through the screening process.

From an organizational perspective, this may be considered a cornerstone in the relationship between publishers and developers: To get a game onto the market, developers now had to go through a publisher (at least when it comes to AAA console games). In this respect, the videogame industry is actually closer to the music industry than the software industry. From the nineties and on the bond between developer and publisher tightened, and today many development studios are owned by a publishing company that manages the distribution and marketing of a videogame.

In terms of games evaluation, such an organizational set-up often entails that the publisher will handle the user-centered evaluation (via marketing methodologies) and the developer most of the technical evaluation (quality assurance) through functional tests or bug-testing (Kline, Dyer-Witheford, & De Peuter, 2003). Such a distribution of responsibilities seemingly leaves many critical decisions about user research in the hands of the publisher's marketing department. This is not a bad thing per se, but what happens when someone decides to evaluate usability or user experience at the developer site?

Based on the assumption that no one likes to give away power or influence we expected that such actions might not be welcomed by the publisher's marketing department and that some rivalry might occur between publisher and developer on that account. At the very least, we assumed there would be an increased need for coordinating the user research efforts at the developer studio and the publisher respectively.

To investigate this and to better understand the reality and challenges for user research at the developer site we conducted an informal survey in the videogame industry.

2.4.2 Stories from the Field

We invited people from the game industry to answer an online questionnaire focusing on issues such as: How is user research carried out in the particular company, what is its focus, and what is the relationship between the people conducting user research from the developer site and from the publisher's marketing department. The invitation was emailed to eighty recipients from our professional network or randomly selected from the games developer database on www.gamesdevmap. com. An invitation was also posted on the bulletin board on the International Games Developer Association's Web site. Participants were promised anonymity, because we knew our request that they share sensitive information about their user research challenges might put participants in an awkward position if they were to be identified.

Eleven questionnaires were returned. While this may not be an impressive number in and of itself, we had an equal amount of responses that expressed

TABLE **2.1** A description of the companies and the participants.

ID	Type	Full-time employees	Location of HQ	Job title	Experience
A	Developer	17	North America	General Manager	7 years
B	Developer	25	Middle East	CEO	10 years
C	Developer	80	Europe	QA Manager	4 years
D	Developer	7	North America	Development studio head	25 years
E	Publisher	150	Europe	Senior QA lead	8 years
F	Developer/ Publisher	500+	North America	User research engineer	3 years
G	Developer	n/a	Europe	CEO	10 years
H	Developer	30	Europe	Project lead/ Producer	9 years
I	Developer	150+	Europe	Development Director	4 years
J	Developer/ Publisher	500+	Europe	Producer	4 years
K	Developer/ Publisher	500+	North America	User Researcher	3 years

great interest in the topic and regretted not to have time to participate. Since user researchers and other professionals in the game industry hold myriads of job titles we dare not comment on our sample size or the quality of the answers. However, we find that the answers cover both large corporations with many well-known titles in the past and smaller ones with less experience. Furthermore, informal "off the record" conversations with people from the industry confirm the findings.

Participants were offered to comment on our findings and discussion in order to increase the relevance and validity of these. Only one participant provided comments and ideas for improvements.

On average, the participants had worked 7.9 years with user research or related work in the game industry. Ten of eleven participants had a background in university studies like history, physics, engineering, computer science, cinema, or psychology—though some had never finished their degree. One had other education.

Seven of the participants were third-party developer studios, that is, a game developer that works under contract with a publisher for each game. Four participants were publishers/developers or mainly publishers. Table 2.1 shows a description of the companies and participants. The average age of the companies/game departments was eleven years, the youngest having existed for five and the eldest for twenty-two years.

TABLE **2.2** The distribution of practical 'user research tasks.'

Who conducts user research.	ID
Developers site	BK
Mostly developer, but some at the publisher site	CGI
Shared equally between developer and publisher	DEHJ
Mostly publisher, but some at the developer site	F
Publisher site	A

TABLE **2.3** The distribution of user research initiative.

Who takes the initiative to user research	ID
Developer	BCGJK
Publisher	EA
Both	FHI
No answer	D

The responses suggested that user research procedures in the game industry are quite diverse, but that publisher and developer in most cases share the work between them (see Table 2.2 and Table 2.3 for details).

We also asked which findings or issues the participants look for in the user research they had knowledge of. Table 2.4 shows which focus areas were described by participants. UI, game play, and concept are the focus areas of most user research. It is interesting to see that developer B, which has very limited cooperation with their publisher, and thus has all responsibilities for user research, also deploys methods with traditional marketing foci, such as market analysis.

Table 2.5 shows the multitude of methods UR champions use to answer their research questions. What is apparent about the answers is that most participants had difficulty describing the methods they use. We expect that "usability test" describes some sort of practice related to the think-aloud protocol, whereas "playtest" may mean observing or otherwise monitoring users play. Thus, "conducting playtests" may be the same as "observing play sessions." If this is true, observing users play the game is the most commonly used method deployed and, in fact, the only method used by some of the participants. The lack of clarity in terms of describing the methods used to conduct user research may be because participants were not familiar with research terminology or simply because of a lack of generally agreed-upon naming conventions. However, we are more prone to explain it with user

TABLE **2.4** The focus areas for producers' user studies.

Focus area	ID
Acceptance of concept	BDEFGHIJ
Problems with game play	AFGHIJK
Do users understand UI?	ADGK
How game is perceived in different markets	EIJ
Market and competitor analysis	BIJ
Fun	CDK
Quantitative measures (e.g. number of times died/preferred weapon/playtime)	CK
How well does game correspond with the brand and its values	E
Estimation of sales numbers	B

TABLE **2.5** The methods used to conduct user research.

Method	ID
Filmed or observed play sessions	EFGHIJK
"Playtest" (e.g. with the participation of friends)	ACDIJK
Interviews with target users	CEHIJK
Focus groups	CIJ
"Surveys"	FK
Usability tests	FK
Questionnaires	CK
Data logging	CK
Rudimentary testing with users through web site	B

research practice being improvised and hardly ever formalized or put into system. Notable exceptions are C and K. They specifically mentioned the aim to triangulate methods and combine qualitative and quantitative methods in order to obtain both objective and subjective data. As discussed earlier, we urge UR champions to formalize their procedures, describe the methods they use, and which questions these particular methods can help them answer. Such work will yield the most reliable results and thus boost the credibility of the user research. Without this formalization work, the results of the user research are more vulnerable to invalid "common sense" objections.

Because we wanted to investigate the relationship between publisher/marketing and developer, we asked participants if and how user research results were shared. Five participants answered that they hardly have any communication with the publisher's marketing department about user research results. One developer mentioned

being very interested in getting data from the marketing department and another that the publisher was unlikely to be interested in the developer's user research.

With regards to sharing of results, developer B mentioned how they mostly communicate early user research results to the publisher as an attempt to make them "join the adventure." Such a sharing of results thus seems mostly motivated by the wish to land a contract. Along the same lines, developer D described how both developer and publisher manipulate their user research results before sharing them with the other party. J described how user research results from the publisher are shared with the developer studio and vice versa, but also suggested that not all results were to be shared with everyone. Related to this, K described how user research results were kept from the marketing department on purpose—the rationale behind this was that marketing tended to misinterpret preliminary results and base marketing and approval decisions on them, thus effectively causing development teams to not want to work with the user researchers. Similarly, K describes how development teams only listened to marketing user research results (such as focus groups) so as to please marketing with the ultimate goal of ensuring a marketing budget for the game; not really to make any changes in the game design based on the results.

These answers may suggest that some of the communication and relationship between developer and publisher is not primed to actually facilitate better collaboration on the shared goal, that of making a good and successful game. Rather, they seem to suggest that developers do not always consider the publisher a friendly colleague but rather a partner that needs to be maneuvered to fit the developer's goals. And that the same goes for the publisher. On the other hand, it is only to be expected that developer studios and publishers see the world from different perspectives, and therefore it is no surprise that they have different goals for user research. Nevertheless, this points directly to a need to coordinate user research efforts.

Participants described how the relationship between developer and publisher isn't all roses. The lack of knowledge about what occurs on the other side of the fence impedes and slows down production and coordination. Some suggest this affects creativity and probably, in particularly unfortunate cases, ultimately sales.

One developer explained how the very nature of being a third-party developer means that the publisher has the most rights to the game. And this is suggested to cause some imbalance in the relationship. Conversely, a publisher described being helplessly dependent on the developer to implement the changes that arise from for example focus tests. This is also suggested to cause unevenness in the relationship, mainly because the timing of user research is hugely important to the relationship and that fights are bound to break out if user research results are forced into the development at too late a stage in the development process. As an example, changes that will require large investments are mentioned as an issue giving rise to severe challenges for publisher-developer cooperation.

In all fairness it should be emphasized that three participants from publishing or publishing/developer companies generally were very satisfied with their communication with the developers and the planning of user research. However,

the three companies are fairly large and experienced publishers, and this may explain why they pay attention to and enjoy success implementing effective work procedures around user research. Since the developers in the study seemed more concerned about the state of the communication and collaboration between developer and publisher, we do speculate whether developers in general feel more insecure or unsatisfied simply because they are the less powerful party of the two.

One publisher explained that user research results rarely get completely ignored, and that developers often have a good reason for putting results on hold. Such a comment shows a rare and valuable understanding for colleagues' points of view, and confirms that much is accomplished by trying to understand colleagues' motivations and goals. This supports the importance of building and nursing the cross-professional and personal relationships.

Another publisher specified how not being able to communicate directly with a third-party developer was a huge challenge. Direct, informal, and frequent communication was claimed to be crucial to the publisher, who needs to be up to date with the development process and recent game builds. "Getting to know each other" secures that colleagues are accessible, that they listen, and that they are honest in their communication, the publisher suggested, emphasizing the value of personal relationships. In this context, the building of cross-professional relationship should be seen both in an intra-organizational and trans-organizational context.

A developer explained how there seems to be a semantic gap between development and marketing: that the developer seemingly has difficulty understanding what exactly marketing does and vice versa. This was confirmed by other participants that mentioned a need for creating a better understanding for user research methods on each side. Such efforts should provide greater transparency for what research is being done in each camp and what questions it is supposed to answer. Related to this, one participant suggests that the marketing department needs a higher level of methodological rigor in their user research and an increased awareness of what methods can assess what questions: Focus groups should not be used to validate design, but instead function as a point of departure for brainstorming design ideas.

2.4.3 Reflections on the Results

Involving users successfully in systems development is never an easy feat. Numerous accounts on the difficulties of this task have been given in relation to the development of office-ware, Web applications etc. (see, for example, Gould, Boies, & Ukelson, 1997). Some of this work specifically points to how organizational issues (Iivari, 2006) and the relationship among job roles may impede the impact of usability on design (Furniss, Blandford, & Curzon, 2007; Gulliksen, Boivie, & Göransson, 2006; Nørgaard & Hornbæk, 2008).

Grudin and Markus (1997) described how contract development has often ended up creating substantial barriers between developers and users, and how the

separation between developers and users—as in cases where, for instance, a marketing department monopolizes user contact—presents a major organizational obstacle for design in contract development. Gould and Lewis discuss similar issues in their classic paper on key principles of design (Gould & Lewis, 1985). Other records describe how marketing departments are reluctant to share the opportunity to get in firsthand contact with users, or perhaps forbid other departments to do it all together (Grudin, 1991; Frøkjær, 1987).

Based on some of the anecdotes we have heard in the game industry, we wondered if the same was true for the relationship between a publisher's marketing department and a third-party game developer. While our study clearly contains examples of it, the results are not univocal: The horror story frequency in the answers was in fact very low. However, some of the results as well as informal communications we have had with participants suggested that perhaps the developer-publisher relationship is a bit more complicated than described by the answers we received. We have come across anecdotes that imply that it may be a challenge for some UR champions to get to do user research on the developer site at all. Some of the developers in this study have also described their relationship to the publisher's marketing department as being a bit tense, and it was suggested that user research results sometimes were kept away purposefully from the marketing department. Some also implied that the publisher's marketing department considers a videogame the publisher's property, and behaves jealously if attempts are made from the developer site to take control of user research. In this way, the historical structures that lie behind the publisher/developer relationship, where the publisher often decides the fate of the games, potentially makes it harder for the UR champion to implement user research at the developer site, since prior experience with user research methods such as focus groups (performed by marketing) in some cases has created mistrust against user research methods in general.

Once again, the overall challenge as we see it, is that the developer's UR champion and the publisher's marketing department both work with user research, and determine which methods should be used for what insights. However, even though they may share the goal to produce a good and successful game, their focus areas, methods, challenges, and timing are different. This should be crystal clear to anyone who does user research, but unfortunately it is not always.

The developer is often basically interested in how the game works, how fun it is, how difficult it is, and so on. The publisher's marketing department, on the other hand, is basically interested in how the game fits the target audience and the market in general, how it is presented to potential buyers, and so on. Before commencing on a new game marketing may thus choose the customer segment, conduct focus group interviews with potential users, and perform other surveys related to users. When the game is close to being finished, it will then conduct more user tests. To reach its goals the marketing department will also involve users when creating a marketing strategy or settling on a name for the game.

But, while the publisher's marketing department may investigate issues that are closely related to usability and user experience it does not conduct user research in

the way it is traditionally understood in the software development or usability consultancy industries. For example, the experience-centered evaluation methods that marketing deploys are often traditional methods for evaluating consumer goods. These include focus groups, market surveys, systematical collection of sales data, and pre-production questionnaires. Accordingly, when the publisher's marketing department assures the developer that user research is carried out, it may imply the use of traditional marketing methods before and after production rather than through the qualitative HCI-methods deployed by traditional software producers. And UR champions need to make sure that marketing will not dismiss any user research on account that they have already done it—because most likely they haven't. Equally important is the coordination of results as they roll in: If user studies at the development site unveil new and crucial knowledge about the target users, then this knowledge needs to be disseminated to the marketing department, since this knowledge could be interesting enough to have an impact on the marketing strategy. Conversely, if marketing methods deployed at the publisher site show new preference patterns from the target audience, this needs to be communicated to the developer site. Of course not all results are crucial enough to warrant design or marketing plan changes, but nevertheless formalized coordination processes need to be in place, preferably in an atmosphere of trust and not mistrust. Making this happen will in some cases require a significant amount of "marriage counseling" or even a restructuring of the relationship between publisher and developer.

Now, our study suggests that borders between responsibilities and focus areas are not always clearly separated according to whether one is a developer or a publisher. Developers sometimes do market research and publishers sometimes conduct gameplay or feature-centered user research with an HCI focus. However, we still find that a great responsibility lies with the UR champion at the developer site in making it clear that when developing a videogame, user research is not only traditional marketing research. It should also be user research as it is understood in an HCI context. Apart from a different methodology, this means conducting user research in close contact with the potential users of the game and the people developing the game. This is where we see a great opportunity for the UR champion to spearhead the linking together of developer and publisher, and to create the best possibilities for relevant user research.

Our results also suggest, what was also intuitively expected, that the successful coordination of user research efforts between developer and publisher to a large extend depends on organizational proximity, that is: The closer the organizational ties between development studio and publisher (for instance in the case of a publisher-owned development studio), the better the flow of information. This is not to say that a healthy relationship will always be present, as some of our results also show, but at least very good organizational preconditions for creating and sustaining trust and common goals are present. Conversely, the further apart a publisher and a development studio are—organizationally speaking—the bigger the challenges for coordinating user research efforts. In any event, it is the authors' clear recommendation that every effort should be made to build trust between developer and

publisher, so user research efforts can be coordinated, since failure to do so will entail a high risk of incommensurable views on the user and the game's future impact on the marketplace.

Key takeaways:

- Be aware that "user research" might not mean the same thing for marketing as it does for development.'
- Work to build trust between publisher and developer, for instance by sharing your thoughts on methods and research questions with marketing.
- HCI-related user research should be done in close contact with potential users and the people developing the game.
- The larger the distance between developer and publisher, the bigger the challenge of coordinating user research work.

2.5 Conclusion

In many ways, the challenges UR champions encounter when striving to do user research in the game industry are similar to the ones they would encounter if they were developing traditional office-ware or other task-oriented systems. Such challenges include justifying the investment made in user research, creating company work procedures that support user research, and developing professional and personal alliances with key stakeholders. However, since many third-party developers are either owned or tightly affiliated with a publisher, some organizational challenges for user research in the game industry are, in some aspects, quite unique.

Our survey amongst eleven developers/publishers from the game industry suggests that a close cooperation between a third-party developer and the publisher's marketing department is crucial, but also that UR champions need to pay attention to some of the obvious dangers of doing user research in two separated camps. One danger is that the publisher's marketing department confuses marketing related user research with HCI-related user research and—thinking it is all the same thing—miss the HCI-perspective on a game, and accordingly ignores great opportunities to link the development of a game close to potential users and to the people who develop the game. Another danger is inefficient work procedures caused by the geographical distance and perhaps also mismatching ideas about how, when, and by whom user research should be carried out. There will be variations as to how the described challenges will manifest themselves in different organizational settings, but we expect the basic mechanisms behind the challenges to be present in most game development settings.

Because the success of user research at the developer site ultimately rests on the UR champion's shoulders, we have presented some key take-aways that we believe will help anyone who is interested in conducting this work and navigate through the most common organizational challenges.

2.6 Acknowledgments

We wish to thank those who took the time to participate in our study and share their thoughts. Also, we thank the editors of this book, Erik Frøkjær and other colleagues for valuable discussions and comments.

2.7 References

Barr, P., Noble, J., & Biddle, R. (2007). Video Game Values: Human-Computer Interaction and Games. *Interacting with Computers, 19*, 180–195.

Bateman, C., & Boon, R. (2005). *21st Century Game Design*. Rockland, MA: Charles River Media.

Benton, A.A., Kelley, H.H., & Liebling, B. (1972). Effects of Extremity of Offers and Concession Rate on the Outcomes of Bargaining. *Journal of Personality and Social Psychology, 24*, 73–83.

Bernhaupt, R., Eckschlager, M., & Tscheligi, M. (2007). Methods for Evaluating Games: How to Measure Usability and User Experience in Games? *Proceedings of the international Conference on Advances in Computer Entertainment Technology (ACE'07)*, Salzburg, Austria.

Cusumano, M., & Selby, R. (1997). How Microsoft Builds Software. *Communications of the ACM, 40*(6).

Frøkjær, E. (1987). Styringsproblemer i det offentliges edb-anvendelse. *Politica, Tidsskrift for Politisk Videnskab, 19*(1), 31–56.

Furniss, D., Blandford, A., & Curzon, P. (2007). Usability Work in Professional Website Design: Insights From Practitioners' Perspectives. In E. Law, E. Hvannberg, & G. Cockton, *Maturing Usability: Quality in Software, Interaction and Value* (pp. 144–167). London: Springer.

Gould, J.D., & Lewis, C. (1985). Designing for Usability: Key Principles and What Designers Think. *Communications of the ACM, 28*(3), 300–311.

Gould, J., Boies, S., & Ukelson, J. (1997). How to Design Usable Systems. In M. Helander, T. Landauer, & P. Prasad, *Handbook of Human-Computer Interaction*. New York, NY, USA, Elsevier Science.

Grudin, J. (1991). Interactive Systems: Bridging the Gaps Between Developers and Users. *Computer, April issue*, 59–69.

Grudin, J., & Markus, M.L. (1997). Organizational Issues in Development and Implementation of Interactive Systems. In M.G. Helander, T.K. Landauer, & P.V. Prabhu, *Handbook of Human-Computer Interaction*, (*second ed.* Vol. 1, pp. 1457–1474). Amsterdam: Elsevier Science B.V.

Gulliksen, J., Boivie, I., & Göransson, B. (2006). Usability Professionals—Current Practices and Future Development. *Interacting with Computers, 18*, 568–600.

Helander, M., Landauer, T.K., & Prabhu, P.V. (1997). *Handbook of Human Computer Interaction*. New York, NY, USA, Elsevier Science.

Iivari, N. (2006). "Representing the User" in Software Development—A Cultural Analysis of Usability Work in the Product Development Context. *Interacting with Computers, 18*, 635–664.

Juul, J. (2005). *Half-Real: Video Games Between Real Rules and Fictional Worlds*. Cambridge, MA: MIT Press.

Jørgensen, A. (2004). Marrying HCI/Usability and Computer Games: A Preliminary Look. *Proceedings of NordiChi '04*, Tampere, Finland.

Karat, C. (1997). Cost-Justifying Usability Engineering in the Software Life Cycle. In M. Helander, T.K. Landauer, & P.V. Prabhu, *Handbook of Human-Computer Interaction*. New York, NY, USA, Elsevier Science.

Kline, S., Dyer-Witheford, N., & De Peuter, G. (2003). *Digital Play: The Interaction of Technology, Culture, and Marketing*. Montreal: McGill-Queen's University Press.

Miller, M.A. (2005, April 1st). History of Home Video Game Consoles. *InformIT, http://www. informit.com/articles/article.aspx?p=378141&seqNum=3&rl=1*

Nielsen, J., & Gilutz, S. (2003). *Usability Return on Investment*. Nielsen Norman Group.

Nørgaard, M., & Høegh, R.T. (2008). Evaluating Usability—Using Rhetorical Models to Improve the Persuasiveness of Usability Feedback. *Designing Interactice Systems (DIS2008)*.

Nørgaard, M., & Hornbæk, K. (2008). Exploring the Value of Usability Feedback Formats. *International Journal of Human Computer Interaction*, (in press).

Nørgaard, M., & Hornbæk, K. (2008). Working Together to Improve Usability: Challenges and Best Practices. http://www.diku.dk/publikationer/tekniske.rapporter/rapporter/08-03.pdf

Nørgaard, M., & Rau, J. (2007). User Testing in the Combat Zone. *Workshop of the International Conference on Advances in Computer Entertainment Technology (ACE'07)*, Salzburg, Austria.

Pagulayan, R.J., Steury, K., Fulton, B., & Romero, R. (2003). Designing for Fun: User-testing Case Studies. In Blythe, M., Overbeeke, K., & Monk, A., (2004), *Funology: From Usability to Enjoyment* (pp. 137–151), Dordrecht, The Nederlands, Kluwer Academic Publishers.

Philips, B. (2006). Talking About Games Experiences: A View from the Trenches. *Interactions, 13*(5), 22–23.

Schindler, R.M. (1998). Consequenses of Perceiving Oneself As Responsible for Obtaining a Discount. *Journal of Consumer Psychology, 7*, 371–392.

Schwaber, K., & Beedle, M. (2001). *Agile Software Development with Scrum*. Upper Saddle River, NJ: Prentice Hall.

Interview with Tobi Saulnier, Founder and CEO of 1st Playable Productions

Interviewer:
Katherine Isbister

Tobi Saulnier, after earning a B.S., M.S., and Ph.D. degrees in Electrical Engineering from Rensselaer Polytechnic Institute, spent five years overseeing product development at respected game developer Vicarious Visions before founding 1st Playable Productions. At VV, she delivered over sixty game titles ranging from Blues Clues GBC to Doom III Xbox, establishing a track record of being able to build and train diverse teams to deliver high-quality games on time. She led a product development team that grew over five years to ninety artists, engineers, designers, and project managers, as well as a number of established subcontractors. Tobi is active in the game industry, a frequent speaker at industry conferences, and has delivered seminars on topics ranging from kid testing, to IP rights, to the application of new software processes to improve industry quality of life through structured planning and

development processes. She is currently the treasurer of the International Game Developers Association's Board of Directors.

Tobi first learned about play testing while developing a number of well-received children's Gameboy Color games. She remembers well the first time she watched a four-year-old struggle to play what had seemed until then to be a ridiculously easy game! Subsequently, she developed the kid-testing program at Vicarious Visions as a way to get designers more and faster feedback, and intuition, on the impact of design tradeoffs on players other than themselves. This experience inspired the creation of 1st Playable Production, a game studio that specifically focuses on games for kids, and where play testing is integrated into all phases of development.

Tobi, you run a small game company (1st Playable), and some small studios say they have no time for usability. How is it that you find the time, and why?
That's an interesting question, because I have never considered the alternative. To me it is such a waste of one's time to make something your intended audience doesn't enjoy or can't use. I have learned that while you can develop some intuition for what an audience needs or wants, you don't really know until you put it in front of them. There's always a surprise awaiting you. What's more, its a great way to solve debates of opinion about what the player wants—like so many situations the best thing to do is try to use data to make decisions, whenever you can collect or find some.

What kinds of usability tactics does your company use?
We have a few approaches to usability. One is that designers do gain over time a set of guidelines and anticipation of what a player needs, for instance based on prior games, or just growing knowledge of child development and play styles. The other is that we try to do usability tests throughout the game development lifecycle, using other similar games when ours is not yet playable.

We don't do statistical usability testing, where we have a large enough sample size to determine any sort of distribution. What we do is more lead user testing where we find a range of potential responses without trying to measure the frequency of each. Although that does have limitations, there's a lot of bang for the buck.

The other tactic we use is to have preferably just one player testing the game, and the designer in an observational, not coaching role. Designers sometimes take a while to learn to not offer help or conversation, but just let the player approach it on their own, however we always remind them that they will not get shipped with the game, so they will learn the most by offering little about the game, and instead listening and watching. We always want to have the designer be there firsthand, as there are a lot of aspects that can't be transferred efficiently through notes. We do sometimes take video of the game (not the child, for privacy reasons) so we have a record for programmers or artists to review.

What sorts of interesting outcomes/lessons have you gotten from doing usability?
Usability *always* affects our design. Sometimes it just helps us fix some user interface or player information problems; other times it has caused us to entirely throw out an approach and rethink the basics. One example is a game for four-year-old girls, which started with some cool gesture-type mechanics. But once we had the game in front of players we found they just wanted to fly around and make sparkles, and a four-year-old likely wants to scribble without a specific required shape. So the game embraced that aspect and took out the gesture aspects. After all, you really can't explain to a four-year-old what they should or should not like, or even what they can or cannot do (unlike an older audience who is going to be somewhat responsive to instructions). Another example is a game design we were developing for non-gamer women over twenty-seven. It was eye-opening to see their various responses to the challenges and feedback of some other games. Situations we might think of as motivating or exciting (time pressures, game responses to failure), quickly became frustrating or upsetting.

Would you recommend doing usability to other small studios? If so, why? In what situations?
Yes! Always! The overhead of implementing of play testing program is quite small, for the value you get back for your game. Furthermore it's a great way to be an ambassador to your community, letting them learn more about this exciting media.

Are there types of usability, or times for doing usability, that you would recommend against? Why so?
There are two types of usability we avoid, for different reasons. For one, we don't have the scale or resources (or knowledge) to do statistical studies on usability, where you are trying to determine what percent of players like what aspect. Microsoft is a leader in this area, and many larger companies could probably afford this, but not a small studio. I have used this approach in other industries, and my takeaway was it's better to not do this at all than to do it wrong.

The other type is focus-group testing, which is when you bring in a group of similar people at one time, have them play the game in that group setting, and then gather their responses as a group. Focus-group testing is used fairly often by our publishers but is subject to many biases in data due to the group setting. You can get wildly different results just based on the interplay of personalities and the approach to moderation. Focus groups are good for some aspects of game development, but are more likely to steer you wrong or just provide garbage data, in game usability.

If someone wanted to get started with this, where would your recommend that they turn? (books, first steps, etc)?
There are all kinds of resources on this topic, and often roundtables or other sessions at conferences like the Game Developers Conference.

Any other thoughts about this topic?

For lead user testing there are really not a lot of rules or methods needed, other than being sure you are observing, not influencing the player you want to learn from. For kids you always want to be sure that parents are your main point of contact, that they have provided written permission, and that your testing area is visible, just so you can avoid any possible liability.

PART II

USABILITY TECHNIQUES 101

CHAPTER FOUR

Games User Research (GUR): Our Experience with and Evolution of Four Methods

George Amaya has been doing usability work since 1989. He has a Ph.D. in cognitive psychology with a minor in social psychology from Wayne State University in Detroit, Michigan. He started in usability during graduate school, working as an intern at General Motors. Upon graduation he accepted a teaching position at Seattle University and moved to the Pacific Northwest. Since then he's had the opportunity to work on many different products at a few different companies, leading to his current role as a user researcher for Microsoft Game Studios. His focus in recent years has been casual and social/party games.

John P. Davis is a user experience researcher in the entertainment experience group, where he works on products related to the Xbox and Windows gaming. He was also a user researcher in the games user research group in Microsoft Game Studios for several years. He has worked on several titles large and small, including *Jade Empire, Inside Drive,* and *Poker Smash*. John has co-instructed a successful tutorial on conducting usability research for games at the Game Developers Conference, and has been a regular contributor to the Conference

on Computer-Human Interaction (CHI). Before coming to the games user research group, John was a usability engineer in the social computing group at Microsoft Research and an assistant professor of psychology at Seattle University. John earned his B.S. in psychology from Texas A & M University and his Ph.D. in experimental social and personality psychology from the University of Washington.

Daniel V. Gunn is a user research engineer within the user research group at Microsoft Game Studios and has been an avid gamer for over twenty-seven years. Prior to joining the group, he taught college courses for over seven years including research methods in psychology, psychology of learning, physiological psychology, and statistics. His work at MGS has been on titles such as *Forza Motorsport* for the Xbox and *Forza Motorsport* 2 for the Xbox 360 as well as *Rise of Nations: Rise of Legends* and *Viva Piñata PC* for the PC. Daniel received his B.S. in psychology from Wright State University and his M.A. and Ph.D. in experimental psychology, with an emphasis in human factors, from the University of Cincinnati.

Chuck Harrison has been active in the user research community since the early 1990s and has industry experience ranging from consumer products to back office and business applications. Before joining Microsoft Game Studios, Chuck worked at several other software companies such as Siebel, BMC, Intel, and Netscape. Chuck's primary gaming research focus has been on Microsoft's digitally distributed gaming experiences, such as Xbox LIVE Arcade and Web-based games. Over the years, Chuck has presented research at several HCI and game-related conferences and has published researched focused articles and book chapters. Chuck has a B.S. in human factors from the University of Idaho, an M.A. in engineering psychology from New Mexico State University and an M.B.A. from the University of Houston.

Randy J. Pagulayan manages the user research group at Microsoft Game Studios. As one of the early members, he helped pioneer user testing methods in the entertainment space while leading user research efforts on numerous games, including *Top Spin, RalliSport Challenge, Age of Empires III,* and *Halo 2* and *3.* Randy also has co-authored several book chapters on user-centered design in games, and has been published

in several scientific journals. Most recently, he was featured in a cover story in *Wired* (September 2007) representing the work of his team. Before joining Microsoft, Randy was part of the human factors and ergonomics group at Motorola. Randy has a B.A. in psychology from the University of Maryland, and a Ph.D. in experimental psychology from the University of Cincinnati.

Bruce Phillips is a user research engineer at Microsoft Game Studios and has worked there since 2001. He received his B.A. in psychology from Carleton University and his Ph.D. from the University of Victoria. Bruce has a special interest in multiplayer games and matchmaking systems.

Dennis Wixon joined Microsoft Surface Computing in February 2008. As the user research manager, Wixon leads a team responsible for directing, planning, executing, reporting, and evangelizing the research that measures the usability, usefulness, and desirability of Microsoft Surface. He believes his work on user interaction complements traditional market research because his team focuses specifically on the user's experience with working hardware and software prototypes. According to Wixon, user research is an important aspect of understanding and measuring the user's experience with Surface.

Wixon has worked at Microsoft Corp. for more than ten years. Before working for Microsoft Surface Computing, he was the user research manager for Microsoft Game Studios, where he and his team played a pivotal role in the success of Microsoft's popular games including the *Halo* franchise.

Before Microsoft, Wixon was a usability manager at Digital Equipment Corp., where he worked on and helped develop a number of important usability methods. A member of the human factors community for many years, Wixon also was one of the five founding members of the Association for Computing Machinery (ACM) Special Interest Group on Computer-Human Interaction (SIGCHI) Boston Chapter. Wixon holds a doctorate in social psychology from Clark University, and he has written more than twenty-five articles, columns and talks on Human-Computer Interaction (HCI) methods.

4.1 Objectives in the Chapter

For twenty-five years, user research methods have been applied to software in order to make it easier and more effective for people to use, and in some cases adopt and buy it. These methods have also been advocated as part of a movement to "humanize" technology and involve workers in decisions about their workplace (Ehn, 1988). The methods used have been derived from methods used in the social sciences, psychology, anthropology, and sociology. However, they have been adapted (sometimes to a point that obscures their roots) to the unique goals, constraints, and opportunities presented by development of commercial products and in-house tools. As these methods have evolved, they have become both more widely adopted and more effective in making products usable and useful.

The application of research methods to entertainment products and games in particular is relatively more recent (last ten years) and is evolving rapidly. Games represent an important domain with its own unique challenges and opportunities. In this chapter, we will discuss the methods that we have developed at Games User Research as part of Microsoft Game Studios.

In this chapter:

- We'll discuss some of the unique challenges and opportunities when performing research on games.
- We'll review a set of case studies of the application of research on games. For each method we will discuss
 - the context
 - the research problem/question
 - the research method for approaching the problem
 - learnings for both the method, and the game design implications
 - the broader context for this method and future developments
- We'll conclude with our take on the state of user research on games and its future.

4.2 The Opportunity and Challenge of Games Research

Applying research to game design presents unique challenges and opportunities. These stem from the following factors:

1. **The purchase and use of games is discretionary.** Unlike productivity applications no one **has** to learn how to play a game in order to get work done (Pagulayan, Keeker, Fuller, Wixon, & Romero, 2007). As such, research in

gaming must focus both on what users do and how they feel about what they are doing. In contrast, productivity applications can focus primarily on usefulness (does the application support required tasks) and usability (what are the costs, ease of learning, efficiency of use, minimizing errors). For discretionary products like games, these factors are secondary and only relevant to the extent that they affect the likelihood of a rich and engaging experience. That is, the user's aesthetic/emotional experience is paramount. While such considerations apply to all consumer products (for example, cameras, cell phones, etc.), consideration of the user's experience is primary for games since their sole purpose is to provide a positive emotional experience to the player.

2. **Games are a highly competitive space**. Several truisms reinforce this conclusion. Most games (almost 80 percent) lose money. A few games (20 percent) make most of the money (80 percent). Successful games are highly profitable. For example, *Goldeneye,* the movie, cost $10 million to make and generated $200 million in gross revenue. *Goldeneye* (1997), the game, cost somewhere around $25 million to make and generated $200 million in revenue. Games can also drive additional sales ranging from specialized controllers to action figures.

3. **There are many game studios and publishers.** Unlike most other markets for software (business applications, databases, etc.) in which a few producers have established a dominant position in each market, there are many suppliers and publishers of games. While the games industry is consolidating rapidly, it lags behind most other software markets in which two or three suppliers dominate.

4. **Games are extremely complex.** Many modern games push the technology envelope in terms of graphics, artificial intelligence, and system integration. For games played over the internet, the games can demand a very high level of performance.

5. **Games are very popular.** According to Entertainment Software Association (ESA, 2007) 67 percent of American heads of households play videogames. Twenty-four percent are over fifty. Thirty-eight percent are female. Internationally, the popularity of game can also drive national network infrastructure. Some writers have attributed the development of high-speed bandwidth in Korea to the popularity of computer games such as *Starcraft.*

6. **Games are big business.** In 2006, the revenue for video and computer game sales combined was $7.4 billion (ESA, 2007). These numbers do not include hardware sales for consoles. The growth in games has been strong for the past ten years increasing from 2.6 billion (1996) to today's figure. Game sales from last year have outpaced the growth of the U.S. national economy and have eclipsed film box office sales for a number of years. In addition to new consoles, games are increasingly appearing on new platforms such as cell phones.

7. **Games have an increasingly wide range of application.** Games are being considered as a platform not only to teach specific skills but also to teach transferable skills, and impart values and attitudes.

8. **The essence of a game rests in creative design.** Games do not attempt to automate an existing task the way many productivity products and applications do. Instead, they attempt to create unique, novel, and appealing experiences for their customers and users.

9. **Gaming has a development cycle that is well-adapted to user research.** A typical development cycle can begin by creating tools to build the game. Then the game is built in bits and pieces until a "playable" build is created. Once a playable build exists, the team focuses on refining and tuning the game play. This tuning period is an ideal time to conduct user research and a window during which findings can be readily incorporated into the game play. In contrast, it is all too often the case for productivity applications that as soon as the functionality is working and the product relatively crash free, management will press to ship the product. So, in this respect, games development represents a more fertile environment for user research.

10. **Most game developers and designers are dedicated to providing a great user experience.** One of our design partners put it well when asked what convinced him to work with user research—"we needed to know you cared as much about the game as we did." By "the game" he meant that the game is great for the players. Every studio we have ever worked with has been dedicated to their vision of a great user experience. Unfortunately, all too often the designers and developers of productivity products are satisfied when the functionality is present.

11. **Gamers demand novelty.** While there are exceptions, people who use productivity applications rarely welcome innovation in UI design. They know how to do their work using a given tool and a new interface often represents both a learning cost and a productivity risk. In contrast, gamers welcome new challenges and new capabilities.

12. **There is an excellent framework for considering how user research can contribute to games.** Commercial games research does not have to live in a vacuum. The Mechanics, Dynamics, Aesthetics (MDA) framework developed by Mark LeBlanc (Hunike, Leblanc, & Zubek, 2007) postulates the experience of games is based the game mechanics—the elements of the game, the rules by which they interact and the goals of the game. As he put it, this is "what you can put in the box" after that it is out of your hands. When the user interacts with the mechanics he/she produces dynamics. These are patterns of behavior. These emerge from the interaction of user with the game and the combination of game mechanics. They are influenced by the player's history and expectations. As the user plays the game he or she will draw conclusions about the game. These conclusions can take many forms. They could be judgments about the game, such as "this game is too easy." They also represent "emotional" conclusions, like "I am having fun," "I am frightened," "I've accomplished something." This framework is a good starting point for thinking about research in games and any product that has discretionary use.

In this chapter, we will give a brief overview of some well-established test methods and some new applications of the testing process. These methods are by no means definitive or complete. Instead, it is intended to provide inspiration to researchers and practitioners to build on and improve what the games user research group at Microsoft Game Studios has done. This is also by no means a complete inventory of our work. The methods we will discuss are;

1. Researching Play in the first hour: Playtest. An early and evolved method of assessing users' reactions to initial game experience.
2. Researching Social/Party Games: Testing shoulder-to-shoulder play with an audience.
3. Researching Play in the Real World: Collecting user data from beta
4. Researching Trials and Demos

4.3 Researching Play in the First Hour: Playtest

4.3.1 Behavioral vs. Attitudinal Data

In general, usability testing and Playtest were the first two methods we originally employed at Microsoft in the games user research (GUR) group. Although there are many ways to classify these methods (Olson & Moran, 1995), it's useful to think of them at a general level in terms of the type of data they generate: behavioral and attitudinal. In usability testing, we focus on players' behavior to reveal areas of the game in which the player experience does not match with the design intent. By measuring players' behaviors, such as time to completion or frequency and nature of errors for a task, we are able to make explicit where these mismatches occur. In Playtesting, we focus on players' opinions to illuminate areas of the game in which player experience does not map onto design intent. By explicitly tapping players' opinions and attitudes, we hope to reveal more about what the subjective experience of playing the game is like for people and ensure it matches with what the designers hoped it to be. The demarcation between these two methods based on the type of data we collect is important because, as we will discuss in this section, some research questions that speak to the core of any game (for example, Is it fun?) cannot be answered by behavioral data alone.

4.3.2 The Problem

Conducting usability research on games required us to adapt the research methods used on productivity applications to account for the differences between these types of software. The most general difference between productivity applications and games is the overall design goal behind them: productivity applications are tools that help consumers be productive whereas games are "tools" that help consumers

have fun. While applying traditional usability methods to games allows us to answer many similar types of research questions we would have with a productivity application (for example, can users equip a weapon? can users turn on highlighting text?), we don't often focus on whether a spreadsheet is fun to use. Indeed, the discount usability methods we commonly employ in our group are not particularly well-suited for quantifying user opinions in a reliable fashion (Nielsen, 1993; Pagulayan, Keeker, Fuller, Wixon, & Romero, 2007; Davis, Steury, & Pagulayan, 2005). Because the overarching goal users have when approaching a game is to have fun, we needed a way of quantifying it.

4.3.3 *The Solution*

Playtest is a large-sample, survey-based methodology we developed to measure and quantify users' perceptions, attitudes, and opinions about a game. Like many survey-based methodologies, Playtest is one way for us to get reliable attitudinal data from people. That is, if we ran the same Playtest (with different groups of participants) on the exact same game multiple times, our findings would be relatively consistent across tests. This characteristic of Playtest is very important for three reasons: (1) it allows us to have some degree of confidence in our results from any particular Playtest; (2) over multiple tests it allows us to see the effects that specific changes to the game have on users' enjoyment of that game; and (3) it allows us to reliably compare Playtest scores between games.

Playtest History at MGS

The application of survey research, with the sole intent on improving games that were in production, began over a decade ago at MGS in 1997. At that time, Playtest consisted of several PCs arranged in an open conference room. Participants would play a game for a short period of time and then answer a paper-and-pencil survey regarding their subjective impressions of the game. Although this first instantiation of Playtest was quite different from how it is today at GUR, and the data analysis process was quite cumbersome (that is, we had to meticulously transfer the paper-and-pencil survey data to a spreadsheet before we could even start analyzing it), it was an important first step towards measuring gamers' attitudes and opinions.

Over the next several months, we made radical changes to the process to ensure the validity and reliability of our Playtest data. Our survey question format, participant recruitment process, participant instructions, and lab configuration all were refined and standardized. For example, some of the first few PC game tests were conducted on computers that had different hardware configurations. Because we wanted to ensure that the gaming experience from one PC to the next was the same from a performance and hardware perspective, we decided to equip the lab with identically configured PCs (in other words, same sound cards, video cards, and monitors). In addition, the overall goal of Playtest changed in these first few months: The new

goal of Playtest focused on how to make a game better as opposed to evaluating how good or bad a game was. Hence, early Playtesting and early iteration in a game's production cycle were stressed, and Playtests were focused on more experimental and exploratory questions (for example, do users like weapon A better than weapon B; which vehicle do users like the most, etc.) as opposed to strict evaluation.

The early pioneers of Playtest at MGS (Bill Fulton and Ramon Romero) envisioned it to be less of a method and more of a research situation in which several participants could be run quickly and cheaply. Unlike usability testing, Playtest didn't require a trained engineer to directly observe each individual participant. Without that restriction, the User Research Engineer could easily, quickly, and efficiently run numerous participants at once—enough to make quantification of survey data possible. This was, and still is, one of the key utilities of Playtest: Fast and efficient quantification of user opinions about a game.

Playtest Today at MGS

Our Playtest of today starts in a similar fashion to any other user research (UR) activity—defining the user. Thus, if we are testing a racing game, we want to bring in racing gamers. If we are testing a real-time strategy game, we want to bring in real-time strategy gamers. After consulting with team members for a particular title, we agree on a user profile and then recruit participants from our database based on that profile. Participants then proceed through the following sequence of events:

1. After arriving at our Playtest labs, participants are greeted by a Playtest Moderator. Playtest Moderators are highly trained and skilled individuals who specialize in running Playtests. Because each Playtest is essentially a miniature research study, all of the normal precautions that would go into typical research involving human participants need to be heeded (for example, ensuring ethical treatment of participants and minimizing potential sources of bias that can creep into any study).

2. Participants are asked to sign a nondisclosure agreement form. This is a legal document in which the participant agrees that they will not talk about the nature or content of the Playtest outside of Microsoft.

3. Moderators give participants information and instructions on how the session will proceed and then answer any questions participants may have.

4. Participants play the game for a specified amount of time (typically 1 hour) and then answer a series of structured questions about their experience on an electronic survey.

5. After completing their survey, each participant is thanked for their time and given their gratuity for participation.

The electronic collection of survey data allows the User Research Engineer to quickly collate the data after a session and begin analyzing almost immediately. We typically send out a preliminary report to the team members within a day

after the Playtest and a full report within a week. The full report is much more extensive than the preliminary report and includes a point by point reference to each of the issues uncovered in the Playtest as well a set of recommendations from us on how to fix those issues in the game. Usually, after consulting with the team and debrief sessions with the full report, we agree upon fixes and wait for implementation into the game. Often, after the fixes have been implemented, we will test again.

4.3.4 *Things We've Learned Over the Past Ten Years*

Over the past ten years we have identified numerous factors within Playtest that require close attention to get the most out of the process. However, there are factors we consider fundamental. Assuming that your sampling process (which recruiting is subsumed under) is robust (a topic that is beyond the scope of this chapter), the following three things are critically important to a successful Playtest program.

1. **Standardization.** This is a fundamental aspect of research methods and because most of our backgrounds are in experimental psychology, it became apparent to us very early on how much impact this principle can have on the data. Without standardization, the reliability (and validity) of the data is severely compromised. Imagine you wanted to compare users' enjoyment between two games, so you run two separate Playtests: Playtest for Game A and Playtest for Game B. After analyzing the data, you come to the conclusion that Game B is rated more enjoyable than Game A. However, let's also say you failed to standardize how you asked players the question; in fact, you worded the enjoyment question differently in each test. Now, the dilemma becomes: Are the differences between ratings of the two games because one is more enjoyable or because of the confounding factor of differences in question wording?

 Keep in mind that standardization is not confined solely to question wording. Other components, including participant instructions, communication between participants and moderators, length of gameplay, hardware used, etc. all have to be carefully standardized in order to help ensure the integrity of Playtest data.

2. **Reference Data**. This aspect ties into standardization and reliability in that in order to make informed decisions about data gathered from a Playtest, you need some sort of "yardstick" with which to compare it to. In other words, it is difficult to run a Playtest in a vacuum and generate actionable data. For example, if 70 percent of users indicated they really liked the graphics in your game, is that good, bad, or indifferent? It becomes much easier to make a decision about a data point when you have something with which to compare it. Thus, if you had data from a released game that was highly acclaimed for its graphics indicating it scored a 72 percent on the same graphics question, you would know that you were within the ballpark in your game. Over the past decade, we have built up a database full of Playtest scores from released games in several genres. This

allows us to compare scores on any Playtest to any game in our database, on a variety of different gameplay topics.

3. **Focused Research Questions**. Good research questions are a requisite for most research situations, and this principle applies to Playtest as well. "Good" questions are both answerable with the tools at the user research engineer's disposal and are focused. With focused research questions, the user research engineer can more efficiently design the Playtest, write the survey questions, analyze the data, and generate recommendations for fixes. Unfocused research questions can lead you down the wrong road in which you become lost in possibilities while wasting precious resources (in other words, your time and money).

Having focused research questions before a Playtest has many benefits:

a. It helps you to ask the "right" Playtest questions and avoid asking unnecessary questions that bog the participant down

Asking the right Playtest questions (which are derived from your research questions) ensures that you are not adding a bunch of unnecessary questions to your survey; with each question added, the survey length increases as does the potential for respondent fatigue.

b. It helps you determine when you are finished writing your survey.

You know you are finished generating your Playtest survey when you can look at it and feel secure that the responses participants will give will answer all of your focused research questions.

c. It helps you determine when you are finished analyzing your data.

You know you are finished analyzing your data when you have answered each of your research questions with your analysis. Although you are free to do additional analyses beyond the scope of your original research questions, first and foremost those have to be answered.

d. It helps you more efficiently write your recommendations.

With focused research questions guiding your survey design, the data typically generated are much more actionable.

4.3.5 *Future of Playtest*

In our traditional description, Playtest is a tool used to quantify users' attitudes, opinions, and perceptions about a game; yet, we have been rapidly expanding its breadth and deriving additional user research tools from it. For example, we found that collecting ancillary behavioral data during a Playtest provides a more holistic view of the user experience. Around 2002, we began building out our system for tracking user behavior in real-time as they played games in our Playtest labs. We call this TRUE instrumentation (Tracking Real-time User Experience) and, over the past several years, have successfully used it on numerous MGS titles across multiple genres (Kim et al., 2008; Romero, 2008; Schuh et al., 2008). In parallel, we have

been developing methods for Playtesting multiplayer game modes. These methods have also been buoyed by our TRUE instrumentation (see Chapter 15 of this book for an in-depth discussion of TRUE instrumentation).

Over the past decade, we have been continuously refining and improving our Playtest methodology. The processes have changed, survey questions have changed, scales have changed, and types of analyses have changed. But at the core, Playtest remains the same as in its early instantiation; Playtest gives us the ability to get data from users quickly, cheaply, and easily, in large enough groups to make quantification of user opinions possible. It gives us a reliable way to get evaluative feedback from users on various aspects of a game and allows us to compare user ratings of one game to another. In the end, Playtest gives us a very powerful tool with which to help improve games in development, before they are released into the real world. For additional examples of how Playtest research was used to improve games, see Pagulayan, Steury, Fulton, & Romero (2003) and Davis, Steury, & Pagulayan (2005).

4.4 Researching Social/Party Games

4.4.1 *The Problem*

Social/Party games are games where multiplayer mode is a significant part of the user experience. These games are designed to be entertaining for social gatherings of various sizes. Karaoke games (such as *Singstar,* 2004, or *Karaoke Revolution,* 2004), music games (such as *Rock Band,* 2007), and trivia or board games (such as *Scene It? Lights, Camera, Action,* 2007) are often placed in this genre. The terms "couch experience" or "shoulder-to-shoulder" are sometimes used to highlight the fact that these games may be played by a group of people who are in the same physical space, using the same gaming console. Social interaction is an important feature, considered as important, and sometimes more important, than the single player experience.

For example, our research into karaoke games like *Singstar, Karaoke Revolution,* and *Rock Band* (although *Rock Band* is not a karaoke game, it does have a karaoke element) has shown that most people who play karaoke games do not like to do so alone. A typical *Singstar* purchaser, for example, might play the game alone once or twice, but no more than that. There seems to be a stigma against playing a singing game alone, which is reflected in player comments that solo play "feels weird." People who enjoy karaoke games prefer to play with groups of six people on average.

Compared to games played solo, social games present a new and unique set of research challenges. For example, if we know that people are playing a game in groups most of the time, or if the game is designed to be played primarily in a group/party setting, is it appropriate to test that game using only individuals? Traditional usability testing focuses on the experience of a single user. How can we adapt those methods to effectively gather data from groups of people?

While providing support for an Xbox 360 trivia game called *Scene It? Lights, Camera, Action,* we had an opportunity to address these questions. We learned that it is, indeed, very important to test using groups of people rather than individuals, and that traditional usability testing methods must be adjusted to be more effective in a group testing setting.

4.4.2 Why Test with Groups?

During usability testing of *Scene It? Lights, Camera, Action* and other social/party games for the Xbox 360, we observed several phenomena that led us to believe that group testing is indeed worth the cost and effort when working on a game in this genre.

1. Social/party games are designed to be played with groups of people in the same physical location. Testing such games in a group or social setting has higher ecological validity.

2. Playing with other people is more fun than playing alone. During our benchmark test of *Scene It? Lights, Camera, Action* we found a statistically significant increase in Overall Fun Rating among group players as opposed to solo players. We also found that solo players rated the game as being slower-paced than the group players did. The graphs below show the rating data from 135 benchmark participants, 35 who played the game solo and 100 who played in groups. The Overall Fun Rating asks players to rate "How fun was this game?" using a 5-point scale, where 1 means "Not Fun," 3 means "Somewhat Fun," and 5 means "Very Fun." (See Figure 4.1). The Overall Pace Rating asks players to rate "How was the pace of this game?", using a 5-point scale, where 1 means "Much too slow," 3 means "About right," and 5 means "Much too fast" (See Figure 4.2)

3. Many important behaviors occurred in group testing sessions (cheering, moving around, dancing, etc.) that we rarely saw, if ever, in individual testing sessions or group sessions with strangers.

4. The group presence led to emergent game strategies that we did not see in individual test sessions. For example, during *Scene It* testing, we saw a subset of players shouting out incorrect answers as a strategy, and also "pump faking" buzzing in.

5. Design elements of the game may facilitate or discourage social interaction. The designers need to be aware of how their work affects the social interaction because it could help or hurt the game.

4.4.3 Group Size

In a traditional usability test, the recruiting process is focused on gathering individuals who meet the selection criteria of the project. Recruiting groups of people for testing

FIGURE
4.1

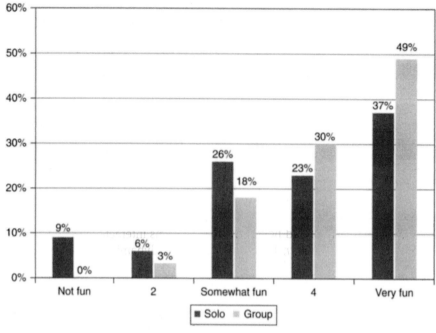

Overal Fun Rating

FIGURE
4.2

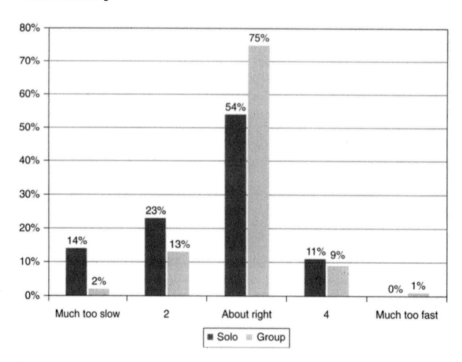

Overall Pace Rating

social/party games required us to answer two important questions. What group size did we need for our research? Should these be groups of strangers or people who know each other?

We found that the best group size for a research project depended heavily on the type of game we were studying. A game like *Scene It? Lights, Camera, Action* could, potentially, be played by a very large number of people at a party, depending on how many controllers they have and whether or not they form teams. We decided to test groups of three to four as well as groups of six to eight players. The three-to-four-sized groups represent people who are playing the game without teams, while the six-to-eight-sized groups allowed us to observe the dynamics of team play (*Scene It* only supports four player entities but many more controllers, so once you have more than four controllers, they are limited to being on a maximum of four teams). Studying team play was very helpful to the game designers because it allowed us to learn about how players shared the controllers, how they communicated with their teammates, and how the different teams interacted with each other.

Karaoke games, like *Singstar,* have different group dynamics than *Scene It.* Our observations of people playing karaoke games revealed that groups with less than four people are not as animated or interactive as groups with four or more. The smaller groups are also quieter and less likely to move around. The nature of the genre seems to be such that people are much more comfortable singing with larger groups of people than they are in smaller groups. The average group size when playing these games in real life is six people, according to our participants. As a result, we decided to recruit groups of four to six people for any singing game studies, and also for any games in which social interactions are critical for the gaming experience.

Karaoke games typically allow two to play at any given time. This means that the remaining two to four people we recruited for the test session were sitting and watching someone else play. A fun social/party game is often one which entertains both players and observers, or facilitates entertaining social interaction so that these people can entertain themselves. We decided that these observers are an important part of the social/party game experience both from an ecological validity and a game design perspective, and their behaviors may add to or detract from the fun of the game.

4.4.4 *Group Composition*

After some trial and error, we decided that it was best to use groups of people who know each other, rather than random groups of strangers. We made this decision for several reasons:

1. There is more ecological validity testing with groups of acquaintances than with groups of strangers if studying social/party games.
2. Players seem to be more relaxed when in a group of people that they know. This makes it more likely that they will behave as they do naturally, talking out loud,

cheering, jumping up and down, etc. Players grouped with strangers are generally more reserved.

3. Emergent behaviors are more likely to be observed when the players are relaxed and with their friends.

4. Players are more likely to speak out loud with people they know than with strangers.

Once we decided to focus on recruiting groups of people who knew each other, we found that the best way to do so was to differentiate between core players and cohort groups. The core player is the person who the recruiters call. This person must meet all recruiting criteria. We then ask the core player to come up with a list of friends/family/acquaintances to act as the cohort group. The list of criteria for the cohort group is usually much more lenient than those used for the core player. The core player is like a party host, while the cohort group is the set of people the core player has invited to the party.

4.4.5 Adapting Usability to Group Settings

One of the first changes we had to make when testing social/party games in a group setting was to remove any think-out-loud instructions (Editors' note: for more information about think-aloud techniques, see Chapter 5 in this book). We quickly realized that traditional think-out-loud instructions just don't work when you are observing a group of four people playing a game. Four people thinking-out-loud at once would be chaos, and it is difficult (or even impossible) to stop one person's comments from influencing another person's thoughts in this group setting. Removing the think-out-loud instructions, however, did not mean that we sacrificed the option of gathering verbal data from our test participants.

We found that groups of people who know each other will ALWAYS talk about the game and what they think of it while they are playing. After testing 200 to 300 groups of people on a variety of social/party games we have found that *all* the groups that were made up of people who knew each other would talk without any instruction to do so. Plus many of the comments were fairly high quality and related to the design of the game.

Another change that we had to make to our testing methods while working with groups was that we had to refine our task lists. Structured task lists that included individual tasks focused on specific design elements or features did not work very well with groups of people. Task lists that are more general, and focused on the game play elements we wanted the group to experience were much more effective. For example, when testing *Scene It? Lights, Camera, Action*, we found that we gathered the most useful data when we had the group sit down and play through the game with little or no interaction with the researcher. This allowed the group to focus on the game, forget that they were being observed, and behave more naturally. The observers noted any behaviors of interest so they could ask the group about them after the game play session.

Free play at the beginning of a test session has turned out to be a good way to allow the test group to settle down and adjust to the test environment. For example, when testing music games like *Singstar*, we found that allowing the participants to choose their own play mode and song in the beginning helped them relax and adjust to the lab environment. Once everyone had a chance to sing a song of his or her choice, the moderator could then ask them to play using specific modes or songs that we were interested in observing.

Interrupting a group during a play session with questions about their experience or comments very often seems to distract the group from the game play and decreases their comfort with the lab setting. Such interruptions also seem to decrease the frequency of the banter that occurs when groups of acquaintances play a game. We decided that the comfort of the group and the banter were important data sources, so all of our moderators were instructed to note any questions that came up during the play session and ask them after group play was over. When we were done with our testing the researcher would go into the participant room and facilitate a discussion of questions and issues, very much like a focus group. We have found that spending time on discussion at the end of the test session allows the group to play comfortably without interruption, while still providing us with the data that we needed from the test session.

4.4.6 *Future Developments*

Today we are continuing to gather data on social/party games and refining our group methods. There are still many open questions to explore, such as how we can adapt group-testing methods for other audiences, such as children. Do our results generalize to other cultures, which may differ in the value they place on social interaction? These are just some of the issues we are exploring. The data from these group studies have helped our development teams think about new ways of enhancing social interaction during gaming. Thinking about the experience of observers as well as players is not something that has often taken place in the past and requires a new approach to game design. In general, with relatively simple adjustments to traditional usability testing methods, we've been able to increase the ecological validity of our work, while providing our designers and developers with data that helps them to envision new and exciting social gaming experiences.

4.5 Researching Play in the "Real-World": Beta

4.5.1 *The Problem*

Playtest and usability are valuable tools for collecting consumer feedback on games. However, some game research questions may require hundreds or even thousands of participants to answer. For example, when trying to balance character progression

in a massively multiplayer online game you may need to study many permutations or combinations of variables, often over an extended period of play. Sometimes you need many players interacting simultaneously to test matchmaking processes or other aspects of the game that require a critical mass of players. Beta testing can be very useful in these circumstances.

A beta version of a product (sometimes in the productivity world called community technology previews) is usually the first public, though often restricted, release of the product to consumers. Developers typically release beta versions of products towards the end of the development lifecycle, when the software is nearly feature complete but still needs fine-tuning. Typically, the test (or QA) departments on development teams have been responsible for running and collecting feedback during beta programs. Test teams employ betas to investigate hardware/software compatibility, to identify difficult to find bugs or other technical issues with the software. Putting prerelease versions of a product into the public's hands can help assess compatibility with a much wider range of computer hardware and software configurations than testers could reasonably replicate in a lab. Even a large test team cannot cover the same ground that hundreds or thousands of beta testers can.

While the public beta testing of PC games and productivity software is relatively common, the beta testing of console games is relatively new. Newer still is the use of beta not just for finding bugs, but for improving the core experience of the game itself, through either the tweaking of game mechanics or for game play balancing, to ensure that the game is neither too hard nor too easy. At Microsoft Game Studios, the user research team manages the beta program and we are developing methods to make beta a valuable consumer feedback tool, like usability and Playtest, for improving games. There are, however, unique benefits and challenges when collecting consumer feedback in a beta test. In this section, we describe some of these and present a short example of using beta on a game in development.

Besides the number of players you collect feedback from, beta testing differs in several other ways from the methods of collecting consumer data that we have discussed. First, the game has to be more stable. Because the game is provided to players outside of our testing facilities, usually downloaded from a secure website or through Xbox Live, we have much less control over the testing environment. This means that the game should not crash very often and there should be few bugs that frustrate or confuse players. Further, because it is the first exposure of the game to the public, it has to be sufficiently polished and fun to play. For these reasons, beta testing usually occurs late in the development cycle.

Second, because the testing occurs in the players' home, not in the Playtest or usability labs which are onsite, it is more difficult to collect qualitative feedback. Therefore, when analyzing the instrumentation data we get from beta participants we often do not have a lot of the context for interpreting the data that we can collect during in-house testing.

Third, because the testing occurs outside the lab, we have less control over the test itself. We have no control over how (or even whether) the beta participants play the game. In-house Playtesting enables us to provide instructions and monitor

participant behavior while controlling for external sources of variability, such as instructing players to use only the sniper rifle or to race only with the Austin Mini. Therefore, we must lower our expectations about managing game play behavior in beta. Further, while we may be able to update build versions of the game we are testing weekly (or even daily) when testing in-house, it is difficult to update builds of the game while testing 20,000 or more beta participants.

Fourth, and one of the main benefits, is that beta testing affords extended testing. Typically, when participants come to our Playtest labs they play only once, for between two and six hours. During beta tests, players play many times over an extended period. Most games involve a significant amount of learning and experimentation. By collecting data from players in their homes over the course of weeks or months, we are able to look at longer-term trends and patterns in player behavior.

In the remainder of this section we discuss how we used beta testing for *Shadowrun* (2007), a game published by Microsoft Game Studios. *Shadowrun* is a multiplayer first-person shooter game for the Xbox 360 and PC. At the beginning of the game, players are able to choose from one of four different character classes, each with different abilities, such as trolls who are strong but slow, elves that are quick and adept at magic, dwarves or humans. At the beginning of each new round of the game, players are able to purchase weapons and additional skills with money collected during prior rounds. This design permits players a great deal of customization for their character. Not only are there many initial options for the creation of their character, but over the course of the game the player can further tweak and enhance their attributes in many different ways.

4.5.2 *Learnings from the Method, and Learnings Applied to Game Design Itself*

One of the questions we were interested in answering in the beta test was the relative effectiveness of the weapons available to the players. There were several different weapons, each intended to serve a specific purpose. There was a shotgun for short-range combat, a sniper rifle for long-range encounters, and few weapons in-between. Ideally, the various weapons would enable players to engage in a variety of different combat strategies, providing for several different play-styles. For example, some people like to play stealthy and shoot from long range; other players like to run-and-gun and jump straight into the action. However, there was some concern on the development team that some of the weapons were less effective and fun than the others.

To answer these questions we used both questionnaire feedback and automated data collection. We used the questionnaires as we typically use them in Playtest, to collect attitudinal data about participants' experiences. Questionnaires, however, have not proven reliable for collecting behavioral data. For a variety of reasons, we have found that participants are not good at accurately reporting data such as how often they play, what items they used when playing, or their success at the game.

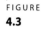
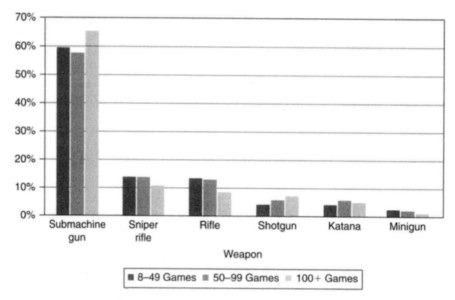

Weapons purchases by games played

Further, participants would not be able to report much of the data we needed, such as how far they were from opponents they "killed," how often they shot a particular weapon, etc. To collect this data, we used a system that automatically recorded participant behaviors (Schuh et al., 2008). To collect data relevant to our question about weapon use and effectiveness, the game automatically logged every time a player purchased a weapon, every time a player scored a "kill" with a weapon, as well as logging the coordinates of the players in the game world when these events occurred.

When examining the data at various intervals during the beta test, we discovered that the majority of time the players were purchasing only one gun, the submachine gun, and there were some weapons that players rarely ever purchased. Could this be a matter of players not having learned to use the other weapons? Were the other weapons too expensive? To begin answering this question, we broke down the analysis of weapon selection by the number of games a participant had played. As shown in Figure 4.3 (Weapons purchases by games played), the pattern in weapon preference was consistent across different experience levels. In fact, it appeared that the preference patterns for the weapons were even more exaggerated as players had more experience with the game. This allowed us to rule out inexperience with the game as a plausible explanation for purchase patterns and effectiveness with particular weapons.

Was the submachine gun overpowered, or perhaps it was more popular because they were cheap to purchase? To investigate further, we calculated a kills-to-purchase ratio, the number of "kills" logged for that weapon divided by the number of times players purchased that weapon. As shown in Figure 4.4 (Kills-to-purchase

FIGURE
4.4

Kills-to-purchase ratio

ratio), not only was the submachine gun the most popular purchase, it also appeared to be the most effective weapon in the game. For every 100 submachine guns purchased, there were 39 "kills," compared to 6 "kills" for every 100 rifles purchased. These types of analyses would be difficult or impossible using Playtest or usability as players need extended interaction with the game.

In the end, the beta test was useful for answering the weapon balance questions we had, as well as many other questions we had going into the beta test. In the end, we were able to provide this data to the development team, which then tweaked the weapon parameters to achieve their desired result—a variety of different weapons effective in different combat situations. However, the beta test provided many challenges we had to overcome that are not typically present in usability or Playtesting.

4.5.3 *Future Developments for Beta*

As discussed earlier, beta differs from Playtest and usability in several ways, many of which create unique opportunities and hurdles for beta testing. In order to improve beta as a consumer feedback and game design tool, there are several areas we need to improve. First, we need to move beta testing to occur earlier in the development cycle. Development and marketing teams are rightly concerned about putting early builds of the game into beta. If a potential consumer of the game has a bad initial impression, if it looks or plays poorly, it can affect consumer expectations of the final product and, potentially, affect sales of the game. Currently, most developers err on the side of polish over getting the game into beta for early consumer feedback.

Invariably, however, our experience has been that once teams see the benefit of consumer feedback, they wish they had started beta testing earlier in the development cycle. One of the main benefits of early beta testing is the opportunity for iteration. As we collect feedback from participants and designs are changed, we can distribute new builds to verify fixes or to iterate on new issues that arise.

Second, as we move towards focusing on game design and balance in beta, and relatively less so on technical issues such as stability and bug finding, how we recruit and select participants for beta becomes more important. Traditionally, beta testing has been conducted by technically savvy consumers who understand, and can cope with, instability and less user-friendly beta builds. This makes a lot of sense if you are primarily interested in technical feedback. However, when you start using beta to collect gameplay feedback, such as difficulty levels, you need to be more cognizant of who you recruit for your betas. If you want to look at balancing the game for a wide variety of different types of players, such as those with little experience to those who play a great deal, you will need to come up with a recruiting plan to ensure that these different gaming profiles are represented in your participant pool.

Another consideration for participants in a beta is attrition. In Playtest and usability, participants typically participate in one test: they come to the lab, play the game for a few hours, and the test is complete. Depending on the type of data you are collecting in a beta, like the weapon preference question for Shadowrun, you may need participants to keep playing anywhere from a day to several months. Further, some tests require a critical mass of simultaneous testers, while others only require a particular number over the course of the beta. How you keep players engaged in the beta and participating in the feedback process will vary, but managing the beta community to keep participants playing the game is critical for data collection.

One of the methods we have developed to minimize attrition is to invite existing communities of gamers and friends-of-friends. We have found that having other familiar players to game with helps maintain interest and participation in the beta. Other tools include contests and tournaments, opportunities to play with and interact with the development team, and so on. Lastly, it is very important to be responsive to participant feedback. Participants who feel like the developers care about their participation and feedback are much more likely to continue participating that those who do not.

4.6 The Importance of First Impressions: Trials and Demos

4.6.1 *The Problem*

Computer and videogame publishers have a limited number of ways to get their games into customers' hands. Historically, game publishers have sold their games

through traditional retail channels (for example, selling a game off the shelf or through an online storefront) and nontraditional ones, like the Internet (in other words, downloading a game to a PC or playing through a Web browser).

Until recently, console-based games were sold exclusively through retail channels. However, the latest generation of gaming consoles has opened up a new purchase path for the console audience, one in which consumers can digitally download games and game-related content (for example, game expansion packs) directly to their console hard drives through broadband Internet connections.

Microsoft's Xbox Live Arcade (XBLA) was the first console-based service to allow consumers to download and try a free, limited trial version of a game, and then immediately purchase and download the full version if they wished. For all practical purposes, this was the same basic model that publishers and consumers had used for many years in the PC space.

Using this model, Xbox Live Arcade found a sweet spot with the Xbox 360 customer base and exceeded almost every business expectation in terms of sales. A high percentage of consumers tended to buy the full version of the Xbox Live Arcade game after they had played the game's trial. These high "conversion rates" far exceeded those typically seen in the downloadable PC game market, even for XBLA games with the lowest conversion rates on the platform.

As the XBLA service matured and more and more games were made available to consumers, conversion rates began to flatten out with instances where games that were considered very good, in terms of consumer feedback during production and or positive industry reviews post release, occasionally experienced low conversion rates and sales that did not meet expectations, even though the game's trial was downloaded in very high volumes. Put another way, the game design was solid, marketing and merchandising were effective in ensuring downloads but the trials were not "closing the deal."

Potential purchasers of retail console videogames can gather a lot of information before they decide whether or not to purchase (for example, read online game reviews, play games on an in-store kiosk or using a game demo disk, or rent a game through an online service like GameFly.com or at the local Blockbuster Video). Xbox Live Arcade customers, on the other hand, have to rely almost exclusively on the game's trial experience to collect information about the game to inform their purchased decisions. Consequently, even a great game is at risk of selling poorly if the trial experience is not good. The clear, critical connection between the trial game experience and consumers' purchase decisions on XBLA led to an important question for the business: ***"How do we create good trial experiences for Xbox Live Arcade games that lead to better sales?"***

4.6.2 Methodology

The XBLA team understood that many factors, including the quality of the trial experience, figure into a consumer's purchase decision when considering whether

to buy an XBLA game. Is the genre interesting? Is the game known or is it brand new? How much does it cost? Are there other new games on the market? Was the game marketed well? The team also understood that of all these variables, the one that they have the most control over is the quality of the trial game.

When User Research was asked to look into the question of trial quality and how to improve it, there were already several dozen XBLA games in the LIVE ecosystem. This already-available information gave the team the opportunity to look at both the games' trial experiences and sales data to understand how each game performed in the market. The existing data allowed us to focus on particular games, such as those with sales and conversion rates that either exceeded or fell short of expectations.

However, before attempting to understand how and why specific games performed well or poorly, we sought to better understand the elements that make a good trial game by first hashing out an understanding of the general goals of a trial, and then thoroughly reviewing the trial experiences for existing XBLA games. The goals for trial games include showcasing some of the "cool" and interesting features of the game, and giving the player enough content and features to give him or her a sense of what the full game would be like, while not giving away so much that the player will not be enticed to buy the full version. We have seen that in games which tested very well, won awards and then failed to meet projected sales numbers. While we can't be sure of the cause, one highly plausible hypothesis is that the demo gave away too much. Armed with a better understanding of what trials are supposed to do and a comprehensive knowledge of the content of existing XBLA trials, we developed a set of "trial game design heuristics." The heuristics, which were intended to be used as a "first pass" assessment of the quality of trial games, were based on principles culled from publisher best practices, observations from past usability tests and Playtests that had included game trials, longstanding usability guidelines, and designer intuition.

Two sets of trial game heuristics were created. The first set contained questions about the trial that were designed to be objective and unambiguously answered for each trial game (for example, "Does the trial contain a controller map?"). The second set of heuristics was less objective, but each heuristic contained clear goals and examples (for example, "Is the trial's upsell message written in a positive tone?"). The heuristics were then informally tested for inter-rater reliability by having several user research engineers apply the heuristics to an identical set of games. Each of the individual heuristic questions was then assessed to identify those where evaluators differed in their assessments and modify them, remove redundant questions and refine the descriptions and examples of how each of the heuristics should be applied.

While the heuristics offered a way for user researchers to perform a "first cut" professional evaluation of trial games, a concurrent effort was underway to collect data from consumers to gauge their perceptions of trial experiences. To do so, user research engineers modified existing MGS Playtesting methods to make them more appropriate for a trial experience, which differs in important ways from a full

game. Both full games and trial games should be "fun," appropriately paced, and appropriately challenging. Trial games, however, are unique in that they are also sales tools that, like advertisements, must contain enough game content (for example, features and gameplay) to allow the player to have a good idea about what the full game will be like. In addition, the trial game must provide clear "upsell" messages that describe the important (and valuable) features and gameplay elements that the full game will have that the trial does not, and an easy path to purchase the full game. Modifications to our traditional Playtest questions included paring down the number to be more appropriate to shorter trial games. We also included questions designed to tap the trial-specific aspects of the experience, such as whether players felt they had adequate information to allow them to make a purchase decision and how they felt about the frequency and content of the upsell messages.

In our trial Playtests, players were given a choice of trials that they could play as much or as little as they wanted. After playing a trial, they then answered questions about some basic elements of the experience (for example, fun, challenge, pace). In addition, they answered several of the trial-specific questions described earlier (for example, "Did the trial provide you with enough information to make an informed purchase decision?" and "Did the upsell messages provide clear information about what additional features were available in the full version of the game?"). The goal was to create a tool to measure the overall quality of a trial from the consumer's perspective, and its effectiveness at meeting its goals as a "sales tool" for the full version of the game.

The modified Playtest method was then piloted using ten trial games that had already been released to market via XBLA. There were several goals for the pilot test. First, we wanted to assess the testing method to ensure consumers were experiencing and evaluating the trial games in a manner that mimicked, to the extent possible in a lab environment, how they might at home. Additional goals of the pilot test were to assess the specific trial games in the Playtest, extract general issues that consistently arose in the trials and recommendations to address them, and to assess the validity of the heuristics described earlier.

An additional goal for collecting data from consumers was to determine whether the multiple metrics could be combined and presented to the development team as a single score to make it easier to consume and understand. A factor analysis of the questionnaire responses from consumers established that there were four components composed of related items (these were Fun/Engagement; Challenge; Enough Information; Up-sell quality/frequency). Weightings for each of the factors was assigned based on the amount of total variance each accounted for, the weighted factors were combined and converted to a score out of 100 (for example, Game "Foo's" combined trial score is 67); this score was referred to as the game's "C-Score" or Consumer Score. Each individual metric was also reported, but providing the data in this fashion helped the team quickly understand the results because it was in a format familiar to them from Gamerankings and Metacritic-measures that are generally considered industry standards of a game's quality.

FIGURE
4.5

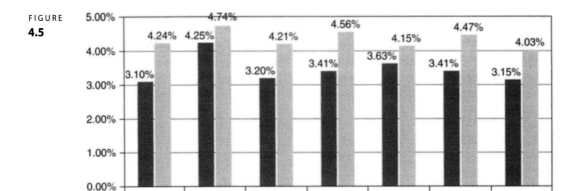

Trial Playtest metrics

Reporting the C-Score and metrics together allowed the game development team to quickly understand the current state of a game's trial user experience or if the trial had been tested multiple times, if its user experience was improving.

Figure 4.5 shows how the second iteration of a trial showed significant improvement on both the core Playtesting metrics as well as the trial's overall score.

By the end of the method development phase, the user research team had created and refined two sets of heuristics that could be applied to any XBLA trial, a new Playtesting method designed specifically to determine the trial's quality, and a composite score for trials that was easily distributed to and understood by the development team. In addition, the team generated a set of general trial design best practices based on the themes that emerged from the consumer data and had a running start on creating a rich comparison database of consumer assessments of a trial games. The next step was to continue to apply these tools to released games in order to collected additional data on trial experience to further grow the comparison database, refine the consumer trial game quality metric and expand on the trial game best practices document that can aid developers as they create trial game experiences. Importantly, the methods were then applied to in-development games while there was still time in the schedule to iterate on them to help ensure that their trials were the best they could be.

4.6.3 *What We Learned*

Over the course of this research program, we learned some valuable lessons about both trial games and general development practices. Although we were

able to create a set of best practices and iteratively evaluate a game's trial experience prior to release, it became evident that a well-developed trial could not guarantee that a game would sell well; after all, if the game itself is not fun or well-designed, a good trial experience is lipstick on a pig. We also discovered that certain games seemed robust enough to overcome a non-optimal trial. Games with very well-known intellectual property or an existing following can overcome a poor trial. Although those types of games may sell well, they likely could have sold even better if their trials were better; those games probably left money on the table.

On the flip side of the games that sell well regardless of the quality of the trial, is the reality that certain games are at a higher risk of poor sales if they have a non-optimal trial. Specifically, original games or games that fit into more of a niche market have a more critical need to showcase their wares in a good, if not spectacular, trial. As the trial experience is likely to be the consumers' only mechanism to determine the game's "fun" or "quality," there is very little room for error for these unfamiliar games.

4.6.4 Broader Context

This work not only empirically demonstrated the importance of game trials but also that their effectiveness can be measured with consumer data. What can be measured can be improved. This work has led to a subtle but important paradigm shift in the publishing model within Xbox Live Arcade. Trials were once little more than an afterthought in the development cycle, often not being considered until shortly before a game was released to the public. Now, there are multiple check points that focus on the game trial. In addition, it is now considered customary that trials are regularly investigated with usability tests and Playtests in order to ensure that they deliver the optimal user experience. This new focus on the trial experience has also required the game developer to better plan their trial experience and build it out much earlier in the development cycle so that it's playable enough to gather player feedback early, while there is still time to make substantive changes. This new focus is well summarized by this quote from an XBLA executive "It is marketing's and merchandising's job to get people to the trial, to download it; it is the trial's job to close the sale."

This work also has broader implications beyond Xbox Live Arcade games. The new console generation has given a much larger user population access to demos for full retail games that players can freely download to their hard drive and play; what was once a niche focused on the most hardcore audience (for example, those who purchased gaming magazines) is now available to the masses.

Although the goals and utility of a full game demo may be somewhat different than those of an XBLA trial, many of the design goals and best practice are similar. To this end, user research is expanding the scope of the trial research to cover full game demos as well.

4.7 Conclusion

User research at Microsoft Game Studios has evolved over the last ten years, and we will continue to explore methodological innovations that produce reliable, valid, and timely data that informs design and makes for exciting products. This chapter briefly describes four of our methods at a "high" level. Our accompanying chapter on instrumentation covers that topic in depth. Throughout our evolution we have been guided by some simple yet fundamental tenets which we call "the golden six."

1. Empirical data about users is the core of our contribution to product success.

2. Partnership with designers is essential when the product goal is a compelling experience.

3. Judicious investment in tools and techniques pays off by allowing us to generate large amounts of empirical data in a timely way.

4. Creating, evaluating and then standardizing methods is the key to reliability, validity, and efficiency.

5. Addressing management goals, for example, how much fun are our games and how can we make them better is the path to long term success.

6. Methods and their output must map onto both the culture and the development processes of your partners and your organization.

The past ten years have been highly rewarding for all of us involved in the development of tools and methods for Games User Research. We have been especially pleased not only by the success of MGS games but also by the recognition in the games and popular press:

> "Still the best in terms of developer support understanding how to make great games and a strong vision. Their usability is by far the best in the industry."

> Quoted from *Game Developer* magazine discussing Microsoft Game Studios in their annual publisher poll issue (Wilson, 2007, p. 12).
> Halo 3 How Microsoft Labs Invented a New Science of Play" (*Wired* magazine, cover story September 2007)

We look forward to the next ten years.

4.8 Acknowledgments

We want to thank all the members of the games user research group (past and present). They all contributed to the evolution of our thinking about game evaluation and research. We also want to thank Microsoft Game Studios Management, especially Ed Fries and Shane Kim, who supported this work over the years. Thanks

to David Holmes, our director, who has led us effectively over the last five years. We also thank the numerous studios and designers we have worked with over the years. We have learned much from them and enjoyed close collaboration. Finally, we thank the thousands of people who have participated in Playtests, our moderators who have actually run the Playtests, and the gamers who have loved our products and given us constructive feedback.

The opinions expressed here are those of the authors and do not necessarily reflect the views of Microsoft Game Studios or Microsoft Corporation.

4.9 References

Davis, J., Steury, K., & Pagulayan, R. (2005). A survey method for assessing perceptions of a game: The consumer Playtest in game design. *Game Studies: The International Journal of Computer Game Research, 5*. Retrieved February 7, 2008, from http://www.gamestudies.org/0501/davis_steury_pagulayan/

Ehn, P. (1988). *The Work Oriented Design of Computer Artifacts*. Stockholm: Arbetlivescentrum.

Entertainment Software Association (2007). Report Essential Facts about Computer and Videogame Industry. http://www.theesa.com/archives/ESA-EF%202007%20F.pdf

GoldenEye 007 (1997). [Computer Software]. Redmond, WA: Nintendo Co., Ltd.

Hunicke, R., LeBlanc, M., & Zubek, R. (2001). MDA: A formal approach game design and research. *Workshop at the AAAI (American Association for Artificial Intelligence) 2001 Conference, North Falmouth, MA*. Retrieved February 2, 2007, from http://www.cs.northwestern.edu/~hunicke/pubs/MDA.pdf

Karaoke Revolution (2004). [Computer Software]. Tokyo, Japan: Konami.

Kim, J.H., Gunn, D.V., Schuh, E., Phillips, B., Pagulayan, R.J., & Wixon, D. (2008, April). Tracking Real-Time User Experience (TRUE): A comprehensive instrumentation solution for complex systems. *Proceedings of the SIGCHI conference on Human factors in computing systems, Florence, Italy*.

Nielsen, J. (1993). *Usability engineering*. San Francisco, CA: Morgan Kaufmann.

Olson, J., & Moran, T. (1995). Mapping the method muddle: Guidance in using methods for user interface design. In M. Rudisill, C. Lewis, P. Polson, & T. McKay (Eds), *Human Computer Interface Design: Success Cases Emerging Methods and Real World Context* (pp. 269–303), San Francisco: Morgan Kaufman.

Pagulayan, R., Keeker, K., Fuller, T., Wixon, D., & Romero, R. (2007). User-centered design in games. In J. Jacko, & A. Sears (Eds), *Handbook for Human-Computer Interaction in Interactive Systems: Fundamentals, Evolving Technologies and Emerging Applications* (2nd ed., pp. 741–760), Mahwah, NJ: CRC Press.

Pagulayan, R.J., Steury, K.R., Fulton, B., & Romero, R.L. (2003). Designing for fun: User-testing case studies. In M. Blythe, K. Overbeeke, A. Monk, & P. Wright (Eds.), *Funology: From Usability to Enjoyment* (pp. 137–150), New York: Springer.

Rock Band (2007). [Computer Software]. Redwood City, CA: Electronic Arts.

Romero, R. (2008, February). *Tracking attitudes and behaviors to improve games: Successful instrumentation*. Presentation at the annual meeting of the Game Developers Conference, San Francisco, CA.

Scene It? Lights, Camera, Action (2007). [Computer Software]. Redmond, WA: Microsoft.

Schuh, E., Gunn, D.V., Phillips, B., Pagulayan, R.J., Kim, J.H., & Wixon, D. (2008). TRUE instrumentation: Tracking real time user experience in games. In K. Isbister, & N. Schaffer, (Eds), *Game Usability: Advice from the Experts for Advancing the Player Experience* (pp. 235–263), San Francisco: Morgan Kaufmann.

Shadowrun (2007). [Computer Software]. Redmond, WA: Microsoft.

SingStar (2004). [Computer Software]. Foster City, CA: Sony Computer Entertainment.

StarCraft (1998). [Computer Software]. Irvine, CA: Blizzard Entertainment.

Thompson, C. (2007). Halo 3: How Microsoft Labs Invented a New Science of Play. *Wired, 15*, 140–147. September.

Wilson, T. (2007). Top 20 Publishers. *Game Developer Magazine,* 6–16. October.

Let the Game Tester Do the Talking: Think Aloud and Interviewing to Learn About the Game Experience

Henriette (Jettie) C.M. Hoonhout is a senior scientist at Philips Research in Eindhoven, the Netherlands. Her research focus is on user interaction technologies (including applications in electronic games and toys) and user-centered research methodologies. Games and toys have her interest because of their captivating and motivating power, as a potential model for interaction design of other consumer electronics applications, and as an inspiration for modeling enjoyment. She graduated with a degree in cognitive psychology at the University of Utrecht (the Netherlands), and after graduation, started working in the experimental psychology department of that university. She was involved in various contract research projects in the field of process control (including work on simulation tools to train operators of chemical plants), HCI, and design of instructions. Next, she worked at the University of Maastricht, in the psychology department. Her work involved, among other things,

developing parts of the psychology curriculum, in particular for the cognitive ergonomics program.

5.1 Introduction

When conducting a usability test, independent of the product (game) or service that is being tested, the researcher ideally would like to be able to look "into the head" of the participants in the test: what are they thinking, what is their reasoning to select particular options and ignore others, what attracts their attention, and what not, how do they interpret the different labels, colors, icons, and other elements being presented to them? Current technology, unfortunately, does not (yet) provide us with the means to have a detailed record of the cognitive processes taking place in participants' brains while interacting with a device that would allow one to answer such questions.

However, there are ways to catch at least a glimpse of what might be going on inside the head of a participant. Asking participants to *think aloud* while working through the tasks presented to them in a test situation is one approach often used in usability testing. The reports of such verbalizations are called verbal protocols. Alternatively, the researcher could also *interview* participants about their experiences during the test, usually after having completed test tasks. The basic connection between the two approaches is that in both cases the participants are asked to verbalize their experiences, providing annotations on their interaction with a device.

Typical issues that the researcher may want to address in a test of a game are:

- Does the game pose an interesting and adequate challenge to the intended target group of players (Malone, 1982; Prensky, 2002; Fontijn and Hoonhout, 2007a)? Not too difficult, nor too easy? And is the challenge to be found in the game content, rather than in the game controls? The latter would almost certainly indicate a usability issue.

- Will it stay challenging until the end of one test session? And will it remain challenging after playing it for a long time, say for several sessions?

- Finding out whether an application is fun, or not, is only part of the answer; more important is how did the different elements in the application contribute to the experience (Malone, 1982; Fontijn and Hoonhout, 2007a)?

- How easily and effortlessly can a player learn how to "work" with the application? Can the player easily grasp what is expected from him or her? How much support is needed?

- In case of multiplayer games, how does the (social) interaction develop? Which elements in the application support social interaction, abd which interfere with it?

- Is use of the game controls easy and not hindering game play?

Basically any question that has to do with usability aspects of the game interface can be addressed in verbal protocol analysis. However, verbal protocol analysis

seems to be much less suitable to address the level of enjoyability of the game, to investigate the potential engaging power of a game: Having to think aloud is "killing" the experience, or at least changing it. Thus, participants might indicate what they like about the game, and what potentially might thrill them, but they will not be able to have the full experience and talk about it at the same time. This means that any test of a game will require a multi-method approach, with methods addressing different aspects of the game experience.

Think-aloud and verbal protocols (re)gained widespread attention after a publication from Ericsson and Simon (1984). They clearly stated in their framework, in which they make a distinction between various levels of verbalizations, that any inferences that the participant makes about their own cognitive processes or opinions should not be considered for analysis, because these would not represent reliable data. Instead, only verbalizations that refer to what the participant is attending to, and in what order, should be considered.

Nisbett and Wilson (1977) had already earlier collected data that suggest that humans are not very good at reporting the deep underlying factors that influence their decisions. They concluded that humans might be aware of the outcomes of their cognitive processes (for example,"I find this game boring"), but might not be aware of how they came to this judgment. With respect to verbal protocols Ericsson and Simon stated that this implies that these will mainly contain observed facts and results of decisions that then can be interpreted by the researcher, in order to come to an idea of the possible underlying cognitive processes.

Think aloud as applied in the usability evaluation context has in most cases diverted from Ericsson and Simon's notions of how to conduct such studies; Nisbett and Wilson's recommendations are also only rarely heeded (Boren and Ramey, 2000). However, originally verbal protocols were applied in experimental cognitive psychology studies to study, for example. problem-solving tasks, in order to learn about the underlying cognitive processes. In evaluating systems and interactions, other issues are addressed (Boren and Ramey, 2000), ranging from aspects that Ericsson and colleagues would consider reliable verbalizations (what is the participant attending to, in what order is the participant using the device and conducting the task), to aspects that are not in the scope of Ericsson's framework, but that are highly important for product evaluation, such as appraisals and opinions about interface elements. And even though verbal protocols might be less suitable for asking participants to describe in detail the cognitive processes that they employ during game interaction (in other words, asking them to make inferences about their own cognition), in a usability evaluation context adopting a less strict approach to think-aloud studies than advocated by Ericsson and Simon does result in usable and useful data about important product aspects.

5.2 Application of Think-Aloud

The basic approach in think-aloud studies is to ask participants to work with the interface, perform certain tasks, or in the case of games, to play the game, and to

verbalize their thought process while they proceed. In many cases, participants will be asked to think aloud *during* task performance, usually called *concurrent* think-aloud. However, since there have been concerns about the possibility that thinking aloud while working on the task might influence task performance, change it, or may distract users from proper task performance, some researchers advocate the use of *retrospective* think-aloud. Typically, participants carry out the tasks and their interaction with the game, while their behavior is being recorded on videotape; then next, in the second part of the session, the participants watch this video recording and try to verbalize the thoughts they had during the interaction. How easy or difficult this will be for the participants will depend for example on the length of the initial session, or on the speed of the interaction. Comparing both approaches, both have benefits and drawbacks. Studies have indicated that both approaches produce comparable usability evaluation results in terms of number and relevance, although concurrent think-aloud seems to lead more often to the "detection" of problems that can be observed as well, with the verbalizations underlining or explaining these problems, and retrospective think-aloud resulting in slightly more often revealing problems that are not observable, thus addressing issues that can only be detected through verbalizations of the participants (Van den Haak, de Jong, and Schellens, 2004). With regard to testing games, retrospective think-aloud seems to be the preferred choice, in order to preserve the experience during game interaction, and collect feedback on that game experience that cannot be inferred from observations alone; however, researchers may want to opt for concurrent think-aloud when usability of the game interface is of primary concern, because this is likely to point out more detailed aspects in the interface that hinder or help the player compared to the number of aspects and details that participants will be able to recall in retrospective think-aloud. Of course, one should take into account that retrospective think-aloud will result in a substantial increase in test session duration.

In all cases, it is important to think carefully about which participants to select for the test; they should be representative for the target group of the game to be developed, which is the most important criterion. But it can be helpful to recruit people who are relatively at ease with thinking aloud while performing a task. For the first tests of a game, it can be very welcome to invite participants who have had some experience with taking part in such usability tests.

Verbal protocols are an appropriate tool to let participants describe in which order items are considered, how they approach the interface, and the deliberations of the participant while using the interface ("what is the next step I should take? What would that button do?"). Verbal protocols potentially provide a rich source of data, and can offer very useful insights into the cognitive processes that guide the interaction of participants. And although it is a time-consuming activity, it is relatively easy to learn how to conduct. Also, no specialist devices are necessary—a recording device (preferably video recording, in order to capture the device and the setting in which the tasks are performed as well), and spreadsheet software for the data analysis would already be sufficient. Software packages are available that could further support the analysis of the protocols.

5.3 Limitations of Think-Aloud

Think-aloud/verbal protocols have been the topic of much debate (for example, Boren and Ramey, 2000; Bainbridge and Sanderson, 2005; Ericsson, 2006). The debate focuses mostly on the issue whether it is at all possible to verbalize ones thoughts about task performance in a reliable and valid way. The general conclusion seems to be that verbal protocols do result in valid data, provided the researcher realizes its limitations, and provided that the test is well-prepared and -guided.

There are a number of other well-known issues around verbal protocols of which anyone interested in using this method should be aware. Carefully designing and preparing the think-aloud session, and having a realistic view on what the data can bring is a start.

Researchers also must realize that collecting and analyzing verbal protocol data is very time-consuming. To give a rough indication: half an hour of recorded verbal protocol can easily mean six hours of transcribing and processing.

Verbal protocols are less suitable for asking participants to describe in detail the cognitive processes that they employ during game interaction, that is, asking them to make inferences about their own cognition. It is, therefore, up to the researcher to infer these processes based on the think-aloud data, and if possible combined with the interactions with the game.

Being asked to think aloud changes the task into, in essence, multitasking. But thinking aloud may even change the way the task is performed, for example, because the participant realizes while verbalizing that the task could be performed in a different way. Also, when there is more than one way to perform the task, the respondent might go for the one that is most easily described. Furthermore, think-aloud might result in the participant performing the steps in a task in sequence rather than at the same time as would be normally done.

The participant might not have the words to describe a task that is primarily physical in nature (think for one moment how you would describe in words how to tie shoelaces). Many things might happen in a short timeframe, making it difficult to keep up in verbalizing the events, or a person might even forget to mention aspects. Most people can think faster than they can talk! And with very fast-paced games, this is likely to be an even larger issue. Naturally, think-aloud is less suitable in combination with tasks that are quite verbal in nature; for example, consider games that require the player(s) to talk to other players frequently. Furthermore, tasks that include many subtasks that the player can perform in an automated or virtually effortless manner, thus hardly calling for any conscious thoughts, are also less suitable.

In addition, the social situation—with participants being aware that a researcher will later listen to what they are saying—might have an impact on what people are willing to verbalize. For example, they may wonder if what they say is appropriate or not, or they may want to please the experimenter by saying what they assume he/she wants to hear. Or the participant is careful not to sound irrational, hesitant, unknowing, or foolish. Of course, the likelihood that such biases will occur is even bigger in retrospective think-aloud, when it is easier for participants to consider their responses.

Thinking aloud is for most people an uncommon behavior, and it might make the participants feel awkward. To overcome this awkwardness, the researcher could consider letting people work together, although that also depends on the type of game as to whether or not this is at all possible. In tests with children, this is a commonly used approach (Als, Jensen, and Skov, 2005). Whether or not such an approach will work also depends on the composition of the team—if the participants differ greatly in experience and skill related to the application that is being tested, verbalizations might not at all result in an account that is useful for evaluating the interface. The verbalizations might quickly become more like instructions that a teacher might give to a pupil than a joint exploration of the device. Similar problems might arise if the participants differ greatly in verbal skills, or if one participant is much more dominant in social situations than the other(s). However, research has also indicated that pairs of children who are acquainted perform significantly better in detecting problems, both in amount and severity of the usability issues (Als et al., 2005).

5.4 How to Conduct a Think-Aloud Study

As with any other study, the quality of the results is largely determined by the effort put into preparing the study. The participant is asked to think aloud continuously, while conducting the task. A short training session might be necessary, as well as regular reminding during the session. These reminders should be brief and non-directive; neutral phrases should be used, like "keep talking," and not phrases like "what do you think of that?", which will force the user to make up an answer. It is important to make clear before the session what is expected from the participant, and what they are to report verbally. The instruction should emphasize that the participant should continue talking even when they think what they say is not making sense, or when they think that there is nothing important to say. As indicated before, it is important to realize that this is basically a very uncommon task for most participants, so a proper instruction, an example session, and some practice is highly recommended.

The verbal report is recorded and then later transcribed. However, making notes during the session is recommended also, to use as reference during the closing interview, but also to have as backup, and to support the analysis process later on.

Preferably, the recording of the verbal report is combined with a recording of the actual interaction with the game so that, for example, any reference to some event on screen that the participant is making ("now I see this character appearing in the corner") can be linked. Inevitably, the protocol will contain gaps—participants might not have been consistent in verbalizing, for any of the reasons mentioned before.

Analyzing the protocol is time-consuming, and there is not a clear recipe for how to do it; basically it involves ordering the raw material into categories at word level, phrases, or themes. The aim of the study will determine what the focus of the analysis should be; for example, if the researcher is interested in interaction elements that interrupt the game flow, than that focus will determine the range of categories you will use. On the other hand, if one is interested in the social interaction taking place

during game play, then the categories should reflect aspects related to social beha-
vior, such as communication, negotiation, turn taking, etc. In order to allow consis-
tency in the analysis, it is important to provide sufficiently detailed explanation with
the categories to ensure that the analyst can check during the analysis if the raw
material is still processed according to the same rules, in order to come to a consis-
tent processing (and hence ensure intra-rater reliability). It is good practice to do a
pilot analysis, and revise/extend categories as found necessary.

The process starts with dividing the raw material into chunks, followed by divid-
ing the chunks over categories; then in a later stage the meaning of the different
categories is analyzed. The researcher could also look at sequences of chunks that
repeatedly occur.

The best approach (but also the most resource-intensive) is to have more than one
researcher analyze independently of each other the raw material, and then compare
analyses. If the analysis process has been well prepared, and the different raters
have been well-briefed and trained, inter-rater reliability should be sufficiently high
(see for example Landis and Koch, 1977, for a discussion on inter-rater reliability
scores). The next step is then to analyze the structure of the processed results
(for example, frequency of occurrences etc.), possibly linked to data collected via
other means.

An excellent handbook on how to design and conduct verbal protocol studies, with
many examples, is published by van Someren et al. (1994). Although this handbook
is approaching verbal protocol studies from an experimental cognitive psychology
viewpoint, and not from the viewpoint of usability studies, it contains much practical
advice, and ample examples on how to process and analyze protocols.

5.5 Alternative Approach

A less-intensive, alternative approach that researchers might consider is that not a
formal think-aloud approach is adopted, but that any comments voiced by test par-
ticipants are analyzed. The resulting verbal protocol will of course not be "com-
plete" in the sense that it will not form a "running" verbalization accompanying the
interaction. However, from a usability evaluation point of view, this might still result
in useful feedback. This alternative approach should be adopted only in combina-
tion with other forms of data collection, for example logging of interactions, record-
ing observable behavior, conducting a closing interview, and perhaps administering
questionnaires, to ensure a richer "picture" of the issues around the game.

In the TOONS Toys project (Hoonhout and Stienstra, 2003; Stienstra, 2003),
such an approach was more or less adopted; the participants, children between
nine and eleven years old, were not specifically asked to think aloud, but since they
were playing in pairs, and depended on each other for good game results, it was
inevitable that they had to discuss game options and tactics. All utterances were
transcribed and analyzed, and in combination with an analysis of the observed
behavior, used to learn about differences between boys and girls in cooperative or

competitive behavior. But also other aspects of the interaction with the toys could be studied based on the utterances, in combination with the observation data.

In another study (Fontijn and Hoonhout, 2007b), we again did not specifically ask the participants in the test of a game to think aloud continuously, but still recorded all comments uttered by them. Also in this study, the participants tested and played the games in pairs. Their comments during the gameplay were used to collect feedback on potential unclear elements in the game interface, issues with the game controls, and more generally feedback on the enjoyability of the game. And again, these data were combined with data collected in a closing interview, questionnaire data, and an analysis of observed behavior.

Independent of the approach adopted around verbalizations—the more formal approach as advocated by Ericsson and colleagues, the modified approach as often seen in usability testing (Boren and Ramsey, 2000), or an informal approach as described above—it is very prudent to combine any of these approaches with other techniques, such as questionnaires, observations, logging of game interactions and interviewing. Several of these techniques are described elsewhere in this book. But because of the link with verbal protocol analysis approaches, especially when it comes to analyzing the raw data, interviewing will be briefly discussed in the remainder of this chapter.

5.6 Interviewing

One of the most natural things to do after a usability test is ask participants how they feel about the experience, which is basically the key issue researchers want to address and is, in fact, the start of any closing interview. Conducting an interview is a flexible means of gathering information about the experience the participants just had, about their opinion regarding the application, about previous experiences and how this one compares to earlier ones, about their perceptions, attitudes, thoughts, ideas, etc. It is also an opportunity to complement data collected via other means, for example, observations collected during a usability test, verbal protocol, logging of system use. Interviews allow the researcher to collect potentially a rich set of qualitative data, regarding opinions, attitudes.

The one-to-one character of an interview session, enabling direct and interactive contact with a participant, results in both benefits and risks. Interviews collect data on the participant's individual concerns, and let them voice their ideas, opinions, and issues. Any mistakes and misunderstandings in the question-answer flow can be more easily detected and corrected. Participants can be asked to further elaborate on answers that are not completely clear to the interviewer, or that are interesting enough to warrant more detailed treatment. An interview usually provides ample opportunity to address many facets of a topic, and discuss them in some depth (although a researcher might be tempted to bring up too many topics, resulting in a too-lengthy interview duration, and a too-confusing mix of topics). However, the success of an interview session largely depends on the skills and experience and preparation of the interviewer.

Different interview formats are distinguished, ranging from a structured interview in which the question wording and order is precisely defined. This is very close to an oral completing of a questionnaire. The opposite would be an unstructured interview, in which case the general topic or topics that need to be discussed are determined, but no detailed wording or question order has been set. Unstructured interviews are more commonly used in the very early phases of a project, when ideas and concepts are not yet clear. However, for interviewing participants of a test, an unstructured interview style is not really appropriate. A semi-structured interview style, in which the topics that need to be discussed are predefined, but the order in which these topics will be treated, and the exact wording of the questions is still open, would be much more suitable, because it will increase the likelihood that all relevant aspects of the interaction will indeed be discussed. The interview is also the ideal moment to address any issues that arose during the interaction with the game, that need additional clarification. For example, if the researcher observed that the participant consistently struggled with a particular interface element, this could be addressed in the interview, in order to find out about the participant's perception and opinion of that. Obviously, this implies that the researcher did make annotations during the test session that are then immediately available for the closing interview.

The interview can also be conducted while rerunning the recordings of the session, asking the participant to comment on the events. Basically, this is similar to retrospective think-aloud. Unfortunately, participants might not remember all details, but being shown the footage could definitely help to jog their memory (Van den Haak et al., 2004).

Conducting a good interview is a highly skilled task. So, it is important that the researcher conducting the interview is well trained, and aware of potential biases. The researcher should be careful in formulating questions, in order not to "coerce" participants in a certain direction, which seems an obvious interviewing principle. However, steering participants can already happen through very subtle wordings or behaviors, of which the researcher is not even aware (Oppenheim, 2000). It is beyond the scope of this text to discuss all possible biases in full detail here, but as a general rule researchers should approach the participant with open questions, such as asking "why," "how," and "can you elaborate." They should not use leading questions ("do you think that this is a very innovative game"?), nor a condescending attitude ("what, have you never heard of RFID?"). Furthermore, researchers should realize that an interview is a social situation, and as in all social situations, cultural conventions could play a role: participants might want to please the interviewer, and provide answers that they think the interviewer would want to hear; they might come with socially desirable answers and avoid providing embarrassing answers.

5.6.1 *Preparing an Interview*

Before starting with formulating questions to ask in the interview, the researcher should carefully think of the aim of the interview, and the key issues that need to

be addressed. If the objectives of the interview are not clearly worked out, the questions being formulated may lack coherence, and the overall structure of the interview is bound to miss direction, potentially resulting in data that turns out to be useless after all. In all cases, it is useful to conduct a pilot trial of the test and the interview, with two to three participants, to see how "workable" the procedures are.

The interview should be conducted in a comfortable, quiet location, preferably with the game interface within reach, in case the participant wants to illustrate a comment. In addition to recording the interview (audio, but preferably video, to capture non-verbal behavior as well), it is good practice to take notes as well, which can be later used in the analysis of the material. The recordings can then be processed as described earlier for verbal protocols.

Processing and analyzing interview data can be cumbersome and is time-consuming. Basically, the same process as described under analyzing verbal protocols could be adopted, that is, transcribing, dividing into chunks, categorizing, and then analyzing.

5.6.2 Tips and Tricks

When conducting an interview for the first time it might seem like a daunting job; however, keep in mind that most participants enjoy talking about their experiences, certainly if they have a devoted audience, in other words, the interviewer.

The interview should preferably not be too long; thirty minutes will in most cases be enough. Depending a bit on the topic, and the rapport the researcher has established with the participant, the interview could extend to approximately sixty minutes.

Some interviewers might be tempted to turn the interview into a "sales pitch" or an "instruction session," but the direction of information really should be one way: The participant provides all the information, and the interviewer only guides the interview by asking questions, asking the participant to elaborate on answers, to provide more details with answers, etc. It can be very difficult to stay "neutral" instead of defensive, therefore, in some cases, it might even be a good idea not to involve any of the developers in the interview session, but let a neutral, "outside" person conduct the interview session.

5.6.3 Limitations and Disadvantages

Conducting a proper interview resulting in the best quality answers possible is a difficult task, requiring (social) skills and training on the part of the interviewer. An important disadvantage of using interviews as a data gathering method is the unstructured nature of the resulting data, which can be easily mis-interpreted or censored. Furthermore, participants might not be able to provide answers. Answers might be incomplete, for example because the participant does not remember details, or because details are not triggered during the interview session, or because their answers might be biased for some other reason (see also Nisbett and Wilson, 1977).

And quite often, data collected in an interview appear to be in conflict with data obtained via other means. For example, participants might indicate in the interview that they thought that the interface was easy to work with, whereas the observation data clearly indicate otherwise. One should be careful to confront participants with such inconsistencies, but rather try to find out whether or not for example experience with other similar devices plays a role, or that they are very happy with certain aspects of the device, e.g. the aesthetic aspects, resulting in a much more friendly overall rating of the device than one would expect on the basis of observed usability issues alone.

The interested reader who wants to learn in more depth about how to design and conduct interview studies is referred to Oppenheim (2000), Wilson and Corlett (2005).

5.7 Discussion and Conclusion

Think-aloud and interviewing are approaches that are often used techniques for evaluating regular consumer products. However, because games differ from regular products in a number of ways, it is relevant to ask if these techniques can be applied for evaluating games as well. Most products are designed to fulfill a particular "useful" function, hence need to be effective and efficient, whereas games are designed to be entertaining, rather than "functional." This distinction implies that a game designer will not focus on how the user can achieve the games' goals efficiently and effortlessly but rather on ensuring that the game play is engaging, for example, by creating an appropriate level of challenge, which is seen by many as an important, if not the most important, aspect of a game (Malone & Lepper, 1987; Prensky, 2002; Fontijn & Hoonhout, 2007a). The core requirement of any goal in a game is that it appeals to the players. Generally, collecting points, reaching a finish within a certain time, collecting more points than the previous time, or than an opponent, are seen as playful goals. So the goals of a game call for quite different requirements compared to more purposeful products—playfulness rather than efficiency, challenge rather than minimizing effort. This obviously impacts the evaluation of games and toys. Think-aloud will be an appropriate technique to inspect the usability aspects of the game interface, but seems to be much less suitable to study the "fun factor" of a game—basically, thinking aloud while playing a game has a large impact on the game experience, because it involves basically conducting two tasks as the same time: interacting with the game and verbalizing one's thoughts on that. Think-aloud might easily interfere with game play and game experience, and might be seen as intrusive by the participants in a test.

Interviewing participants after having played the game, on the other hand, allows collecting of feedback on the enjoyability of a game. But using additional measures, such as observations, physiological measures, questionnaires, etc., is strongly recommended.

When comparing verbal protocols with interviews, the latter probably will result in more general information about the game and the game interface, whereas verbal

protocols will provide more information about details of the interaction in a particular context.

Conducting a think-aloud study generally requires that a prototype is available, or at least some form of a mockup that allows the participant to get an idea of the flow of interaction. However, this also means that any feedback collected comes quite late in the development process, which in most cases will mean that no longer fundamental changes can be made. Again, this points out that it is important to adopt a multi-method approach, in combination with continuous feedback sessions throughout the development cycle. And even more importantly, that adoption of a certain method or tool for evaluation should be guided by the question(s) one wants to address.

5.8 References

Als, B.S., Jensen, J.J., & Skov, M.B. (2005). Comparison of think-aloud and constructive interaction in usability testing with children. In: *Proceedings of the Conference on Interaction Design and Children*, Boulder, Colorado. ACM Library, pp. 9–16.

Bainbridge, L., & Sanderson, P. (2005). Verbal protocol analysis. In J.R. Wilson, & E.N. Corlett (Eds), *Evaluation of Human Work*. London: Taylor and Francis, pp. 159–184.

Boren, M.T., & Ramsey, J. (2000). Thinking aloud: reconciling theory and practice. *IEEE transactions on professional communication, 43*(3), 261–278.

Ericsson, K.A., & Simon, H.A. (1984). (A revised edition was published in 1993) *Protocol Analysis: Verbal Reports as Data*. Cambridge, MA: MIT Press.

Ericsson, K.A. (2006). Protocol analysis and expert thought: Concurrent verbalizations of thinking during experts' performance on representative tasks. In K.A. Ericsson, N. Charness, R.R. Hoffman, & P.J. Feltovich (Eds), *The Cambridge Handbook of Expertise and Expert Performance*. Cambridge: Cambridge University Press, pp. 223–241.

Fontijn, W.F.J., & Hoonhout, H.C.M. (2007a). Functional Fun with Tangible User Interfaces. In Proceedings of Digitel 2007; 1st IEEE Int. Workshop Digital Game & Intelligent Toy Enhanced Learning, 2007, Jhongli, Taiwan, pp. 119–123.

Fontijn, W., & Hoonhout, J. (2007b). Real balls, virtual targets: on the benefits of hitting a wall. In Proceedings of PerGames, 11–12 June 2007, Salzburg, Austria, pp. 135–142.

Hoonhout, H.C.M., & Stienstra, M.A. (2003). Which factors in a consumer device make the user smile?. In D. de Waard, K. Brookhuis, S. Sommer, & W. Verwey (Eds), *Human Factors in the Age of Virtual Reality*. Maastricht, the Netherlands: Shaker Publications, pp. 341–355.

Landis, J., & Koch, G. (1977). The measurement of observer agreement for categorical data. *Biometrics 33*, 159–174.

Malone, T.W. (1982). Heuristics for designing enjoyable user interfaces: Lessons from computer games, In Nichols, Jean A. and Schneider, Michael L. (eds.) *Proceedings of the SIGCHI Conference on Human Factors in Computing Systems*. March 15–17, 1982, Gaithersburg, Maryland, United States, pp. 63–68.

Malone, T.W., & Lepper, M.R. (1987). Making learning fun: A taxonomy of intrinsic motivations for learning. In R.E. Snow, & M.J. Farr (Eds), *Aptitude, learning and instruction*. Hillsdale, NJ: Erlbaum. pp. 223–253.

Nisbett, R.E., & Wilson, T.D. (1977). Telling more than we know: verbal reports on mental processes. *Psychological review, 84*(3), 231–241.

Oppenheim, A.N. (2000). *Questionnaire Design, Interviewing, and Attitude Measurement* (2nd edition) London: Continuum.

Prensky, M. (2002). The motivation of gameplay. *On the Horizon, Vol. 10*, no.1.

Stienstra, M. (2003). Is *every kid having fun? A gender approach to interactive toy design*, Enschede, the Netherlands: Twente University Press.

Van den Haak, M.J., de Jong, M.D.T., & Schellens, P.J. (2004). Employing think-aloud protocols and constructive interaction to test the usability of online library catalogues: a methodological comparison, *Interacting with computers*, 16, 1153–1170.

Van Someren, M.W., Barnard, Y.F., Sandberg, J.A.C. (1994). *The Think Aloud Method. A Practical Guide to Modelling Cognitive Processes*. London: Academic Press. Also available via: http://staff.science.uva.nl/~maarten/Think-aloud-method.pdf (last accessed at 15 April 2008).

Wilson, J.R. and Corlett, E.N. (Eds.) (2005). Evaluation of Human Work. Taylor and Francis, London

Heuristic Evaluation of Games

Noah Shaffer is an M.S./Ph.D. student at Rensselaer Polytechnic Institute, where he's focusing on usability and interaction design in games. Noah became a Certified Usability Analyst (CUA) in 2004. He's also completed internships doing usability evaluation and institutionalization at game companies, including Mobile2Win in India and SNDA in China.

6.1 Introduction

Does your team have the time and money required to do a formal usability study to find your usability problems? It's typical for game design teams to have tight budgets and ultra-tight timelines. There are other methods of usability testing that can be quite effective. These "discount methods" exist to find usability problems quickly and cheaply. They sacrifice some degree of thoroughness and statistical certainty for improvements in speed and cost.

Wouldn't it be great if usability evaluators could have a list of types of usability problems to guide their evaluation? A list of guidelines like this would allow for rapid, inexpensive usability evaluation. Such a tool would help with expert evaluation, which is what we call the process of an expert doing a review of an interface to find usability problems. Guidelines like these could even give useful results when used by novice evaluators. This guidelines-based method has been around for about twenty years (Nielsen & Molich 1990), and it's called heuristic evaluation.

The word "heuristic" means shortcut. To avoid confusion, I'll begin by noting how some other fields use the word, to help identify the difference when we use the word in usability. In the field of psychology, heuristics refers to shortcuts people use to solve complex problems with incomplete information (Kahneman, Tversky, & Slovic, 1982). Though the field of psychology acknowledges that heuristics are

adaptive and useful most of the time, the focus of psychology ends up being on ways in which heuristics cause problems or mistakes or biases. This can lead to a perception of heuristics as negative, which is entirely different from how we see heuristics in usability. I want to stress this distinction with reference to psychology specifically, because of the difference with regard to that negative connotation. The word "heuristics" is also used in the field of computer science, where it's a method computers use to make a best-guess at finding solutions. This sacrifices some accuracy to gain speed. This other use of the word heuristics is similar to the way we use it in usability, because in all cases it means some kind of shortcut.

In usability, heuristics are tools we explicitly learn to use for usability evaluation. Usability heuristics are shortcuts to finding usability problems quickly and cheaply.

6.2 Understanding Heuristics

6.2.1 Heuristics Before Games

Heuristics are one of a few "discount" usability methods. The idea with discount usability methods is that they sacrifice some degree of thoroughness and certainty in order to reduce costs. These discount methods are less useful for academic studies that seek to find statistical significance for generalization to many applications. However, these methods are very effective when the point is to come up with feedback for improvement of a specific interface.

Nielsen's 10 Heuristics

Visibility of system status

Match between system and the real world

User control and freedom

Consistency and standards

Error prevention

Recognition rather than recall

Flexibility and efficiency of use

Aesthetic and minimalist design

Help users recognize, diagnose, and recover from errors

Help and documentation

From Nielsen, J. *Usability Engineering*, 1993, p. 26.

The champion of heuristic evaluation is Jakob Nielsen. Nielsen started with thousands of usability problems and boiled them down to nine categories using factor analysis. He added one more for documentation, and this became the original ten heuristics (see the box for the original list) (Cockton, & Woolrych 2001, 2002). One criticism of these ten-heuristic lists is that they tend to be used to categorize the usability problems that experts find but don't actually prompt finding usability problems (Cockton, & Woolrych 2002, Connell and Hammond, 1990). This is especially problematic for novice evaluators, who don't necessarily know what to look for in usability evaluation. If the bullets a player is supposed to dodge are too small to be seen and avoided, a novice evaluator is unlikely to find that with Nielsen's heuristics (Nielsen, 1993). Other published lists of heuristics include Shneiderman's (1998) eight golden rules of interface design, Gerhardt-Powals research-based guidelines (1996), and Kamper's (2002) lead, follow, and get out of the way principles and heuristics.

6.2.2 *Heuristics in Games*

Heuristic evaluation has recently been brought to digital games. There have been several sets of heuristics tailored specifically for use with games. This section will be an overview of those heuristic lists.

A recent study found significantly large numbers of usability problems in games using Nielsen's heuristics (Laitinen, 2006). While this finding indicates that heuristic evaluation is promising, usability heuristics tailored for games should be even more efficient in finding usability problems. The experience-oriented nature of games changes some of what usability looks for, as compared to task-oriented interfaces. It's valid to do evaluation with Nielsen's heuristics, but there are other options with higher value.

Melissa Federoff (2005) did the first set of usability heuristics for games by working with a design team and finding frequently occurring usability problems. She combined the heuristics from the design team with heuristics that were supported by the literature and came up with a list of forty heuristics. A few of her heuristics include "Controls should be intuitive and mapped in a natural way," "Mechanics should feel natural and have correct weight and momentum," and "There should be variable difficulty level". Many of Federoff's heuristics focused heavily on game design issues that don't relate strongly to usability, and they were also quite general. (Game design issues are of course important when they're the source of usability problems, but the user researcher's primary goal is not to make design suggestions—instead, it is to find issues with user experience and report those back to the design team.) Despite those small shortcomings, Federoff's heuristics were a great start and critical for setting the precedent of using heuristics for usability evaluation of games.

The Heuristic Evaluation for Playability, or HEP, is another list of heuristics (Desurvire, Caplan, & Toth, 2004). The HEP has forty-three items spread across four

categories of heuristics: Game Play, Game Story, Mechanics, and Usability. The HEP is longer and more specific, which is promising. However, like Federoff's heuristics, many of the HEP heuristics focus heavily on issues of game design. Additionally, most of the usability heuristics are targeted at the learnability of the game. This leaves room for improvement in terms of guidelines for the user interface, intuitiveness, and sticking points.

Recently, a list of heuristics was designed for games for mobile phones at Nokia (Korhonen and Koivisto, 2006). The list they began with was only eleven items long, so it naturally suffered from some lack of specificity. However, they had better results when they expanded the list to twenty-nine items under three categories: game usability, mobility, and game play. These heuristics for mobile phone games are particularly interesting when compared to the white paper which is discussed later in this chapter (Schaffer, 2007), because both lists came from work on games for mobile phones. Games for mobile phones have special limitations, such as the need to allow short-duration play, small awkward control inputs, and small low-resolution screens. The Korhonen and Koivisto heuristics (2006) indeed address some of these kinds of issues with heuristics such as "interruptions are handled reasonably." For more comparison of these lists of heuristics, see the position paper from the ACE 2007 conference workshop (Schaffer and Isbister, 2007).

As part of an internship at Mobile2Win in Mumbai, India in 2006, I made a list of usability guidelines. The guidelines were made by identifying usability problems that frequently came up. These guidelines evolved into a set of usability heuristics which are written with the intention of allowing novice evaluators to conduct usability analysis of games. These heuristics have been released as a white paper (Schaffer, 2007) to promote the development of usability evaluation tools for digital games. The white paper includes a list of twenty-nine specific heuristics. These heuristics are more specific, including suggestions such as "use natural control mappings" and "don't make it easy for players to get stuck or lost" (Schaffer, 2007). In addition to the descriptions of the heuristics, every heuristic has an example given.

All these lists of heuristics are thorough and useful, though certainly none are perfect. As mentioned before, some lists include heuristics that aren't centered on the subject of usability so much as on game design. Some lists include rather broad heuristics like "create a great storyline" (Federoff, 2002) and "a good game should be easy to learn but hard to master" (Desurvire, Caplan, & Toth, 2004). Some lists include heuristics that are hard to predict until the game's production is almost completely finished, like "one reward of playing should be the acquisition of skill" (Federoff, 2002). The good news is that these lists of game heuristics haven't been confined to the traditional rule of using just ten heuristics. This leaves room for greater specificity. Even if some of these heuristics miss the target a little bit, they're still valuable and useful for usability evaluation. Table 6.1 is a more detailed comparison of various lists of heuristics. (Editors' note: There is also a list of heuristics to be used in expert evaluations included in the next chapter in this book.)

TABLE **6.1** Heuristics from research on applying heuristics to games.

Heuristics	Description	Room for improvement
Sauli Laitinen's application of Nielsen's original heuristics	Used Nielsen's 10 heuristics Found more problems than evaluation with no heuristics	Not tailored to games, specifically Could have more specificity
Melissa Federoff	40 heuristics 3 categories: Game interface, game mechanics, and game play First set of heuristics for games Very useful and appropriate for games	Could have more specificity Sometimes hard to judge until postmortem
Heuristic Evaluation for Playability (HEP) by Desurvire, Caplan, & Toth	43 heuristics 4 categories: Game Play, Game Story, Mechanics, and Usability Building on and improving Federoff's heuristics	Could have more specificity Sometimes hard to judge until postmortem
Nokia's Heuristics by Korhonen & Koivisto	29 heuristics 3 categories: game usability, mobility, game play	Could have more specificity
Schaffer's heuristics white paper	29 heuristics 3 categories: General, graphical user interface, and gameplay Greater specificity Examples to help understanding	Fairly rough and incomplete Some heuristics don't apply to some games

6.2.3 The Tradeoff: Advantages of Heuristics

Heuristics have many advantages. Evaluation is faster, cheaper, and easier than other methods. User testing requires compensation for participants' time, facilities to conduct testing, and the time of an expert facilitator. In contrast, analysis using usability heuristics requires only the time of three evaluators and access to the game. With heuristics that are more specific and have examples, costs can be cut even more by using novice evaluators. Additionally, unlike user testing, these heuristics can be used for analysis even before any prototype is ready. This is critical, because early implementation allows for easier and cheaper changes.

6.2.4 The Tradeoff: Disadvantages of Heuristics

The primary disadvantage to heuristic evaluation is that you're not testing with representative users. This leads to problems with validity. Sometimes, real users have problems that heuristic evaluation completely misses. For instance, I've done user testing where none of the nine users we tested understood what the goal of a game was, and my previous expert evaluation didn't anticipate that problem at all.

Also, more specific heuristics require a longer list. Analysis can seem more daunting or involved than a shorter and broader list. This is the downside to having greater specificity.

6.3 Implementation

6.3.1 When To Use Heuristics: Test Early, Test Often

Test early. Heuristics are especially valuable very early in the design process, because they can be used without a functioning game. Problems found early are cheaper and easier to fix. However, information from user testing sketches of screenshots will tend to give results that aren't very useful. With early sketches, very little of the actual game experience is there for a user to try out. Heuristic evaluation can be used very early to help find problems and avoid wasting any time with coding things that will later need to be changed for usability reasons.

Test often. Usability evaluation methods miss some problems. Fixes to usability problems can create new problems. And there are always other updates happening to elements of games throughout the design process. For all these reasons, it's critical to understand that one usability test is not enough. Several tests should happen throughout the design process, and heuristic evaluation is just one of the types of evaluation that can be done. This is why usability professionals often repeat that "usability is iterative."

Both heuristic evaluation and expert evaluation can be used earlier than user testing. Although a relatively functional game is needed, user testing has higher validity. Use heuristics for the earlier tests to scan for as many problems as possible, especially the more severe problems. User testing should be used for later evaluation, both to find severe problems that were missed or newly created and also to help find and polish subtler or more minor problems.

Understand the value of heuristics, but also the limitations. Heuristics are a discount usability method and will not find all usability problems. A game can easily have 200 usability problems, and heuristic evaluation with 5 evaluators will typically find about 150 (75 percent) of them (Cockton and Woolrych, 2001).

6.3.2 How to do Heuristic Evaluation

The methodology I'll discuss here for using heuristics can be found in Nielsen's book, *Usability Engineering* (1993). Though it makes sense to bring more game-specific

heuristics to games, the methods for applying them is fundamentally the same. While there have been some criticisms of heuristic evaluation (Cockton & Woolrych, 2002, Connell & Hammond, 2003), the methods for implementing the heuristics haven't changed since Nielsen's book (Nielson, 1993, Usability Professionals' Association, 2007).

Three to five evaluators are given the game for independent evaluation. Evaluation is done separately, using the heuristics. Evaluators will take each heuristic one at a time and look for violations of that heuristic in the design, like a checklist. So at the end of the first step of evaluation, each evaluator will have a separate list of usability problems. Each problem will have a severity rating and a note about which heuristic it relates to. Evaluators do not collaborate or coordinate during this first phase of evaluation.

The next step in heuristic evaluation is for the three evaluators to combine the three lists into one rough master list. Problems that at least two evaluators agree on stay on the list. Some problems may be identified by only one evaluator but stay on the list because other evaluators agree that those problems are present.

The final step is to ready the report. This will include basic editing of the list of problems, organizing the problems in order of severity, giving some recommendations for fixes for each problem, and perhaps adding screenshots for illustration. Note that the heuristics that relate to each problem remain listed with each problem, for the purpose of helping with understanding and lending credibility to the recommendations. The usability experts specialize in identifying the problems, not the solutions to those problems. So the design team may have better fixes to the problem than what the usability experts suggest. A viable discount alternative to a written report is a presented report. It's up to your team to decide which is most appropriate for your circumstances. With a verbal report, the team lead would show each problem with screenshots and talk through the problems and severity. This helps speed up the process of applying findings. (A few small suggestions about presenting results: if there are plenty of severe problems, consider skipping the less severe ones. You don't want to overwhelm your audience or make them feel attacked. Also, be sure to open your presentation by praising the work the team has done. Don't underestimate the value of encouragement, especially in helping with accepting constructive criticism.)

Evaluation is somewhat different depending on whether you use expert evaluators or novice evaluators. Nielsen differentiates between types of experts as single experts and double experts. Single experts have expertise in either the subject field (games) or in usability. Double experts have expertise in both fields (Nielsen, 1993). Each novice evaluator will find approximately 22 percent of usability problems. People who are double experts will each find about 60 percent of usability problems (Nielson, 1993). What kind of evaluators you choose will depend on cost and availability, but it's important to understand the difference.

Expert evaluators will tend towards using heuristics to categorize the usability problems they find, rather than to find usability problems in the first place (Cockton & Woolrych, 2002, Connell & Hammond, 1999). Even when this is the case, heuristics are useful as a lexicon that can be used for communication of usability problems.

Additionally, heuristics give some credibility to the results evaluators find. Generally, at least to some extent, heuristics will help to broaden the scope of expert evaluation. Experts should be guided through a more thorough and far-reaching search through heuristics.

It's important to know how to find expert evaluators. Since the criteria you're interested in is expertise, some things to look for are degrees in usability-related fields like HCI and Human Factors, certificates like the Certified Usability Analyst (CUA) certificate offered by Human Factors International, and experience doing usability work in industry. Experience or knowledge specific to games is valuable as well, since usability for a factory is fairly different than for a video or computer game. For a large game development firm, hiring expert evaluators may be feasible. To find such experts, contact the Computer-Human Interaction (CHI) association or Usability Professionals Association (UPA). Remember the difference that Nielsen talks about between single experts and double experts (Nielsen, 1993). However, for a smaller firm it may make more sense to hire a consultant company to do the evaluation. Expect an expensive hourly rate from a consultant, which is the downside to not hiring someone on a permanent basis.

Alternatively, novice evaluators can be used. The methodology is basically the same, except an expert should take over or at least be involved after the first phase, making the master list and such. Recall the downside that novice users find considerably fewer usability problems (Nielsen, 1993) so consider using more evaluators if you're using novice evaluators.

How to do Heuristic Evaluation of Your Game

Note that these are the steps for one iteration of heuristic evaluation. You'll want to do more testing as well, especially user testing.

1. Find usability experts or designate novice evaluators
2. Choose a list of Heuristics (if you have usability experts, they can help)
3. Evaluators *separately* analyze the game using the heuristics
4. Problems found are compiled, organized, and delivered as a written and/or presented report
5. Game team fixes problems in their respective areas

6.3.3 *Things* Not *To Do*

Don't confuse heuristic evaluation with user testing. Do not involve heuristics in user tests. If you've gone through the trouble of finding representative users, you need to see exactly what problems they have when actually using the game. Asking users to perform analysis will distract from the primary task of using the interface.

Don't confuse heuristics with standards. Standards give designers rules to follow, which speeds design time and reduces emergence of usability problems. With standards, you have a highly specific set of rules that the designers in your company follow to maintain consistency in order to improve intuitiveness. Those rules are set up with usability in mind as well, so that by following them, designers can help to reduce usability problems. In contrast, heuristics are guidelines for evaluation. They're not really geared for design. It's okay for designers to see heuristics in order to help them understand what to watch out for, but heuristics and standards are fundamentally very different.

6.3.4 *Choosing and Developing Your Own Heuristics*

Let me preface this by saying that you shouldn't stay up late at night worrying over exactly what heuristics you use. The heuristics matter, but they're just one piece of the puzzle. And just because you don't have a heuristic that points to a usability problem doesn't mean that an evaluator can't see the problem and take note of it.

I recommend starting with one of the published lists of heuristics and improving it. There is currently no definitive list, but I'd say to start with either the HEP (Desurvire, Caplan, & Toth, 2004) or the Nokia list (Korhonen and Koivisto 2006) if you can use expert usability evaluators (Editors' note: you may also consider using the list in the following chapter of this book). Consider my white paper (2007) if you're using evaluators with less expertise. Maybe take a little time to compare whichever one you start with against some of the others, looking for holes you can fill by borrowing individual heuristics. You'll end up with something to start with. As you begin to use the heuristic list, you'll find some problems that don't fit and some heuristics that aren't helping. Add new heuristics to catch problems that are being missed, and remove heuristics that aren't finding problems. This will allow you to develop an internal list that will be more tailored to find usability problems for you. Be sure not to tailor it to allow you to get away with usability problems you often have. In the meantime, keep an eye out for what the researchers publish. A more definitive list may well be on the horizon.

One valid criticism of some usability heuristics is that they're really centrally about game design, not about usability. This is because game design issues can be the source of some usability problems. When considering a heuristic, make sure that it's evaluating usability and not only game design. This will help separate the process of identifying user issues, from the process of solving them through design choices.

6.4 Conclusion

Heuristics are a useful tool for analysis of usability in games. Just as with traditional heuristic evaluation of other interfaces, heuristic evaluation of games is a

"quick and dirty" approach. In the world of digital game design, speed is absolutely critical. For instance, the lifecycle of the games made by Mobile2Win is sixteen to twenty-five days. With such fast-paced production, the speed of tools like these heuristics is extremely valuable.

For a complete usability solution, usability heuristics are just one tool among many. Usability should be 8 to 12 percent of any design project (Nielsen & Giluz, 2003), and games are no exception. Other tools are also important in a complete usability solution, such as expert analysis and especially user testing.

Usability in games is still a relatively young field, so it's not surprising that there's still room for improvement of the available heuristics for games. There is, presently, no definitive established list of heuristics for games. Instead there are several strong available lists. The lists that are available are good, but there is still some room for such lists to evolve. For instance, I've just published a study (2007) that tested the effect of quantity of animation on enjoyment, which ended up indicating that quantity of animation should not be included in a list of heuristics. Such empirical studies help to evolve a list of usability heuristics that's relevant to player enjoyment. Perhaps the evolution of heuristics will result in a longer, more specific list. Perhaps such evolution will result in a short list with more general heuristics. Or perhaps we'll end up with continued different lists competing, and being used on somewhat different types of games. It's an exciting new field, but regardless of which list you use, heuristics are a powerful tool at your disposal.

6.5 Acknowledgements

Thanks first and foremost to Katherine Isbister for all her guidance and assistance. Thanks to Mobile2Win for their cooperation and collaboration. Thanks to James Watt, Mike Lynch, John Sherry, and Steve Swink of Flashbang Studios for all their help on the animation quantity project.

6.6 References

Cockton, G., & Woolrych, A. (2001). Understanding inspection methods. In A. Blanford, J. Vanderdonckt, & P.D. Gray (Eds), *People and Computers XV*. Springer-Verlag. pp. 171–192.

Cockton, G., & Woolrych, A. (2002). Business: Sale must end: should discount methods be cleared off HCI's shelves? *Interactions, Volume 9*(Issue 5). Publisher: ACM Press, New York, NY. pp. 13–18.

Connell, I.W., & Hammond, N.V. (1999). *Comparing Usability Evaluation Principles with Heuristics*. Interact'99, Proceedings of the 7th IFIP TC.13 international conference on Human-Computer interaction Edinburgh, August–September 1999, pp. 621–636. Amsterdam: IOS press

Desurvire, H., Caplan, M., & Toth, J.A. (2004). Using Heuristics to Evaluate the Playability of Games. Conference on Human Factors in Computing Systems. New York: ACM Press. Vienna, Austria. pp. 1509–1512.

Federoff, M. A. (2002). Heuristics and Usability Guidelines for the Creation and Evaluation of Fun in Video Games. Masters Thesis at Indiana University. http://melissafederoff.com/heuristics_usability_games.pdf

Gerhardt-Powals, J. (1996). Cognitive engineering principles for enhancing human-computer performance. *International Journal of Human-Computer Interaction, 8*(2), 189–211.

Kahneman, D., Tversky, A., & Slovic, P. (1982). *Judgement under Uncertainty: Heuristics & Biases*. Cambridge University Press.

Kamper, R.J. (2002). Extending the Usability of Heuristics for Design and Evaluation: Lead, Follow, and Get Out of the Way. *International Journal of Human Computer Interaction, 14*(3–4), 447–462.

Korhonen, H. & Koivisto, E. (September 2006). Mobile entertainment: Playability heuristics for mobile games. Proceedings of the 8th conference on Human-computer interaction with mobile devices and services MobileHCI '06. ACM Press.

Laitinen, S. (2006). Do usability expert evaluation and test provide novel and useful data for game development? *Journal of Usability Studies, volume 1*(issue 2).

Nielsen, J. (1993). *Usability Engineering*, 26. Morgan Kaufmann, San Francisco.

Nielsen, J. & Giluz, S. (Jan 2003) *Usability Return on Investment*. Private Report. Nielsen Norman Group.

Nielsen, J., Molich, R. (1990). *Heuristic evaluation of user interfaces*. Proc. ACM CHI'90 (Seattle, WA, 1–5 April), 249–256.

Usability Professionals' Association. (2007). *Usability Body of Knowledge Website*. http://www.usabilitybok.org/methods/p275?section=how-to

Schaffer, N.M. (2007) *Heuristics for Usability in Games*. White paper. Available online at http://friendlymedia.sbrl.rpi.edu/lab-papers.html

Schaffer, N.M. (2007). *Animation Quantity in Computer Games*. Gamasutra masters thesis section. http://www.gamasutra.com

Schaffer, N.M. & Isbister, K. (2007). *Heuristics for Usability Evaluation of Electronic Games*. ACE 2007 conference. Can be found at http://ace2007.org/program/evaluating_games_ws.html

Shneiderman, B. (1998). *Designing the User Interface: Strategies for Effective Human-Computer Interaction* (3rd ed.), Menlo Park, CA: Addison Wesley.

CHAPTER SEVEN

Usability and Playability Expert Evaluation

Sauli Laitinen works as an usability specialist and project manager at Adage Corporation, a usability consultancy located in Helsinki, Finland. He is a psychologist specializing in human-computer interaction and is responsible for the games user research activities at Adage. He has also worked as a game designer on several mobile game development projects.

7.1 Introduction

Given the previous chapter in this book, it is useful to note here that the terms *expert evaluation* and *heuristic evaluation* are often used interchangeably. The term expert evaluation is used, when we want to highlight that the evaluators' experience and other sources of information, such as design guidelines, also play an important role in the evaluation. Expert evaluation doesn't always involve heuristics, although the method I'll recommend in this chapter includes heuristics.

In an expert evaluation, a group of evaluators review the game. They look for potential usability and gameplay problems that may hinder playing the game. After the review, the evaluators create a report in which they present the findings, discuss the reasons behind them, and suggest solutions how the problems can be addressed.

The goal of the evaluation is to aid the game developers to ensure that the user interface is easy to use and there are no challenges in the gameplay that the game developers did not intend it to have. These goals are important for several reasons. For one, poor usability may scare the players off, even before they get to play the game. For example, if learning how to play the game is difficult then the players may choose to play another game or they may decide not to even play any of the game at all.

Another reason is that playing games is supposed to be fun. Even the smallest glitch or hiccup in the game's user interface may otherwise render a good game into a rather annoying experience. For example, if managing the inventory of a role-playing game is not fluent or the restarting of a race in a driving game is a tedious and long process, the players are not likely to enjoy playing the games as much as they could. The same can also happen if the gameplay is not well-designed. Having to complete the same task too many times or not getting any meaningful and interesting rewards for the achievements will make playing the game more boring than fun.

There are also other reasons why good usability and a polished gameplay are important. One of them is that modern games are relatively complex. Even the simplest games tend to contain many features that the players are required to master in order to enjoy the game to its full potential. Making complex games both easy to learn and effortless to play, requires careful design and hard work.

Usability expert evaluation is an efficient and flexible method for achieving these goals. In this chapter, it will be described how an expert evaluation is typically done and what kind of results one can expect to get from it. It will also be discussed, what are the key strengths and weaknesses of the method and how it compares with other user-centered design methods that are commonly used in game design and development. Before moving on to these topics, the key aspects that are reviewed in a typical expert evaluation will be discussed first.

7.2 What Is Being Evaluated

In a typical expert evaluation, both the game usability and gameplay are reviewed. These aspects are complemented by taking the special needs, set by the platform and the game type, into account as required. What these are and why it is important that they are evaluated will be discussed next. The discussion is based on the review done by Korhonen and Koivisto (2006).

7.2.1 Game Usability

When reviewing the game usability, the evaluators study the user interface of the game. The user interface includes all the screens, menus, displays, controls and

other possible user interface elements that the player uses before, during and after playing the game. The evaluators review the user interface using usability heuristics and their knowledge of good design practices. Typical usability problems found in the games include, for example, menus that are cumbersome to use, displays whose meanings are not clear and controls that are difficult to learn.

The goal of evaluating the game usability is to make sure that the user interface is easy to learn, fluent to use, and that it supports the interactions that are typical for the game under evaluation. If these goals are met, the players can focus on playing and enjoying the game that the developers have designed. Otherwise, the players may end up struggling with the user interface and not the real challenges that they are intended to be fighting with.

7.2.2 Gameplay

Poor user interface may ruin a game that is otherwise good, but even perfect user interface will not save a game that is just not fun to play. Because of this, it is not enough to evaluate just the user interface of the game. The gameplay also needs to be evaluated as part of the expert evaluation.

When reviewing the gameplay, the evaluators ignore the user interface and focus on the game itself. They review the game's mechanics and study the interactions that occur within the game. The goal is to find and remove the challenges that are not intended by the game developers to be in the game and to make sure that the gameplay is as fluent and fun as possible. Typical gameplay problems include, for example, boring and repetitive tasks, the next target that the player should achieve not being clear, and a punishment for a failure in a way that cannot be considered fair.

The gameplay is evaluated in a manner similar to a game's user interface. The main difference is that gameplay heuristics are used instead of the usability heuristics. These heuristics are discussed later on in this chapter.

7.2.3 Platform and Game Type

Both the gaming platform and the type of the game type may set additional requirements that need to be taken into account of when evaluating the game. Mobile and casual games are good examples of such games. For example, when reviewing a mobile game, the evaluators must consider whether the game can be played well with the mobile devices and whether the game supports playing on the move. In the case of casual games, the evaluators must pay even more attention than usual to whether the game is easy to learn and master.

Evaluating the issues that are specific to the game type requires either adding new items to the list of the heuristic rules or emphasizing the existing ones in a way that special needs are taken into account.

7.2.4 Cover All the Aspects

Game usability, gameplay and the issues specific to the platform and game type are all connected to each other. All of these three areas must be addressed in order to make sure that the game reaches its full potential. If one area fails, then it is likely that that the players will not get to enjoy the success of the other areas either.

Another reason why the evaluators should pay attention to all of these three aspects is that solving a problem found often requires addressing more than one area of the game. For example, if a task within the game is considered repetitive and boring it may be necessary to change both the user interface and the gameplay in order to fix the problem.

7.3 How the Evaluation Is Done

An expert evaluation consists of evaluating the game, analyzing the findings and creating a report and presenting the results to the developers. Next, these phases will be discussed in more detail.

7.3.1 Experts

In a typical expert evaluation, two or three evaluators review the game. The reason why it is common to have more than one evaluator is that different evaluators tend to find different problems. Increasing the number of evaluators will increase the proportion of the problems found in the evaluation, without considerably increasing the calendar time needed for the evaluation. Having more than one evaluator will also improve the quality of the report. The different evaluators will bring in different points of view, and being able to discuss both the problems and the solutions to them will make the work easier for the evaluators.

On the other hand, experience has led me to believe that having more than three experts seldom brings any benefits. The number of new problems found does not rise considerably by having more than three evaluators, and the project will become more expensive and challenging to coordinate. It is recommended to only have two or three evaluators if there are no special reasons for having more specialists participate in the process. More might be wanted, for example, if several people who have special experience or knowledge about the game that you want included in the expert evaluation.

7.3.2 Double Experts

It is a common view that the people who evaluate the game and create the report should be experts in both usability and gaming. The double experts have the best understanding of what is important when evaluating the game usability and

gameplay, and they best understand the expectations of the game developers. The double expertise is also beneficial when reporting the findings and thinking about the ways in how the problems can be addressed. The background in usability will help to understand and explain the reasons behind the problems and the expertise in gaming will help to come up with good and realistic workarounds for the problems.

Unfortunately, it is often the case that there are not enough double experts available to make a full team. If this is the case, then it is often considered acceptable to have evaluators who are experts in only one area participate in the evaluation (see, for example, Laitinen, 2006). To ensure the quality of work, the person who leads the evaluation and compiles the report should, if possible, be a double expert. For more information about how the number and expertise of the evaluators affect the results of the expert evaluation, see for example Nielsen's (1993) book *Usability Engineering*.

7.3.3 *External Evaluators*

It is recommended that the evaluators not be the same people who design the game. This is because the people who have designed the game know how the user interface and the game mechanics work like the backs of their hands. This can make it difficult to spot issues that can be problematic for the players.

Use of external evaluators does not mean that the evaluators are not allowed to have had any prior exposure with the game. Close cooperation between the developers and evaluators is recommended and knowing how the game works can be beneficial when evaluating the game. These help to guide the work and to come up with better and feasible suggestions on how to solve the problems that are found.

7.4 When to Evaluate

The earlier the expert evaluation is done in the game development process, the easier and more cost efficient it is to address the problems that are found in the evaluation.

7.4.1 *Design Documents and Paper Prototypes*

One way to get started early is to evaluate the design document of the game, paper prototypes of the user interface and possible other sketches of the game. Based on these, it is possible to evaluate the basics of the game usability and gameplay even before the game or parts of it have been implemented.

The downside of evaluating the design documents and paper prototypes is that evaluating the gameplay can be difficult, because the evaluators do not get to try

out the most important parts of the game. This can be especially problematic if the gameplay contains a lot of novel features or the evaluators are inexperienced in evaluating the playability. Luckily, evaluating the game usability is easier. Spotting usability problems, for example, from the menus and displays is often relatively straightforward for people with some experience in usability.

These challenges can be tackled to some extent by complementing the evaluation by studying possible earlier versions of the game and benchmarking the game against other similar games. These help the evaluators better understand the game designers' intentions and to pickup problems that are not obvious based on the documentation.

7.4.2 Working Prototypes

Once the game reaches the implementation phase, the prototypes of the game can be evaluated. It is possible to evaluate a complete prototype of the game or to review parts of the game independent from each other. For example, if the way in how the character is controlled in the game is novel, then there may not be the need to wait for other aspects of the game to be prototyped before the controls are evaluated. Evaluating the parts of the game, as soon as the first prototypes of them are ready has the obvious benefit that the game developers do not have to wait for the feedback and they can address the problems straight away.

When working with the prototypes, it is very important that the evaluators are informed about known bugs and missing features. If this is not done properly, there is a real risk that everybody's time can be wasted by analyzing and reporting issues that are already known.

7.4.3 Nearly Complete Game

From the evaluators' point of view, reviewing an almost complete game is the easiest option. The evaluators can study all the aspects of the game and they can evaluate how the game works as a whole. This makes it easy to provide a complete and good quality report.

The main challenge with conducting the expert evaluation at the very end of the development process is that it takes some time to fix the problems found in the evaluation. Implementing minor or moderate changes does not necessarily take long, but it is not often feasible to make major changes to the game if it is soon to be released. This poses a risk for the usefulness of the expert evaluation. A reasonable amount of time and resources should be reserved for implementing the changes after the expert evaluation.

On the other hand, one should not exaggerate when reserving time and resources for implementing the changes. It is not the intention that all of the issues found in the evaluation should be addressed. The findings, which cannot be addressed in

the given time, can also be used as background material when designing a possible sequel for the game.

7.4.4 Expert Evaluation and Playability Testing

When the games are developed in a user-centered way, it is common and recommended that the game is not only evaluated by the experts but it is also tested with players from the target group of the game before it is published. To test the game with the players, a playability test should be conducted (see chapter 4 for more information).

If both an expert evaluation and a playability test are conducted, then it is recommended that the expert evaluation be done first. The expert evaluation can this way be used to find and fix the obvious usability and playability problems, so that players do not have to struggle with them when they get to play the game in the playability test. This will results in more novel problems found in the playability test and provides an excellent opportunity to verify the changes made based on the expert evaluation.

7.4.5 Multiple Evaluations Instead of One Evaluation

To summarize, the above expert evaluation is a very flexible method and it can be done at almost any point in the game development. Conducting the evaluation at the different points of the development process has different pros and cons. The optimal stage depends on the project at hand. If there is no specific reason to do the evaluation at an early stage or postpone it until later, it is recommended that the evaluation is done on a working prototype of the game. Evaluating a prototype gives the best results and most often leaves enough time for the developers to address the issues found in the evaluation.

If there is enough time and resources available, it is often a good idea to conduct several evaluations instead of one. For example, the early prototype of the game or parts of it could be evaluated first. Then, later on in the development, the almost complete game is evaluated. This will help to combine the benefits of testing both the early prototypes of the game and the nearly complete game. The obvious issues can be addressed early on in the development and when the game is more complete, it can be evaluated in more detail. This process is called iterative design, and it's highly recommended.

7.5 Process

The expert evaluation consists of several steps. First, the study is planned and the work is organized, then the evaluators review the game and discuss the findings. After that, the report is written and the results are presented to the game developers. These steps will be discussed in detail next.

7.5.1 *Planning the Work*

An expert evaluation begins with a meeting between the evaluators and the game developers. The goal of this meeting is to introduce the evaluators to the game and present the material that is to be evaluated and agree about the issues that are to be studied in the evaluation.

When the game is introduced, the developers describe what the game is all about, what makes the game unique and what the target group of the game is. This sets the background for the expert evaluation. Once the evaluators are familiar with the background, the material used in the evaluation should be introduced to them. It is important that the evaluators are informed about the missing features and bugs that may affect the evaluation of the game. This is also a good time to agree about the issues that should be evaluated. Often, it is the case that some parts of the game require more attention and others can be covered more quickly when evaluating the game. When the evaluators have all of this information, it is easy for them to focus on the important issues and to deliver solutions that take both the developers' intentions and the potential players of the game into account.

The kick-off meeting is also a good opportunity to discuss the practical issues related to the project, such as the presentation format of the report and to agree who the evaluators should contact if they need help, for example with the technical aspects of the game during the evaluation.

7.5.2 *Reviewing the Game*

Once everything is ready for the evaluation, the evaluators can start reviewing the game. It is recommended that evaluators review the game independent of each other. It is possible to evaluate the game as a group, too, but it is commonly thought that evaluating the game alone helps in finding more issues and coming up with more diverse suggestions for solving problems.

When evaluating the game, the evaluators go through the game systematically evaluating each part of the game that has been agreed to be evaluated. The goal is to find usability and gameplay problems that may affect playing the game. These problems are sought by using heuristic rules, knowledge of good design practices and experience gained in the work. The evaluators also take into account the target group of the game and the special needs that are set by the game type and the platform the game is being developed for.

The time it takes for one person to conduct the evaluation varies. Evaluating a prototype, that consists of one level and has most of the gameplay elements ready, may take from half a working day to one and a half days. If the game is complex or the gameplay changes dramatically over time, more time is needed for the evaluation. How much time is required varies depending on the game. In optimal circumstances, the evaluators should have enough time to thoroughly experience the game and different aspects of it. This will help in finding all the relevant problems and give a solid background for evaluating the severity of each issue found.

One way to reduce the time required for evaluating the game is to provide short-cuts, so the evaluator can try out different aspects of the game without playing the game all the way through. This, of course, has the downside that the experience is not as realistic as it would be if the evaluators had the time to play the game as it is intended to be played. This may hinder finding problems that become obvious only over time, such as boring and repetitive tasks in the gameplay.

7.5.3 Discussing the Findings and the Possible Solutions

After the game has been evaluated, the evaluators should get together and have a review session to discuss the findings they have made. The goal of the review session is to compile a list of the issues found, agree about the severity of the problems found and discuss how the problems could be solved. This review session forms the basis for creating the study report.

7.5.4 Reporting the Findings

Depending on the reporting format, it typically takes from one to three days to create the final report. Writing a detailed Word document takes longer than creating a compact PowerPoint presentation, where less attention is paid to describing the methodology used and discussing the reasons behind the problems. It depends on the situation and the organization, what is the optimal way to report the findings. A lightweight report is often good enough for internal use, but if the report is to circulate within the organization it is a good idea to deliver a proper report that describes both the methods and results in detail.

No matter what the exact presentation format is, the body of the report should consist of the problems found and the solutions on how they can be solved. In a typical report, four issues are covered for each finding. These are the title, severity rating, description of the problem and the suggested solution. See Tables 7.1, 7.2, and 7.3 for examples of typical problems found and how they can be reported.

The title describes what the problem is all about in one sentence. This is followed by a rating that indicates how important it is that the developers address the problem. The findings can be classified for example using the following scale: unclassified, minor, moderate, important, and critical.

Minor problems are such that they will have only a minor negative effect on playing the game. The minor problems should only be fixed if there is enough time and addressing them will not prevent the developers from fixing the more important issues. For example, a small glitch or hiccup in a setup menu that is only used once or twice when playing the game is a typical example of a minor problem found in an expert evaluation. A critical problem on the other hand is such that in the evaluators' opinion, it must be fixed before the game is released. This is because the problem is thought to be so severe that it may prevent the players from

TABLE **7.1** An example of a usability problem found, when evaluating a third-person action game where the player can collect items by walking over them.

Problem	No feedback is given if the player cannot pick an item.
Rating	Important
Description	Sometimes it happens that the player cannot pick up an item because there is no room in the inventory. If this happens, the player is not given any feedback. This is problematic as the player may not know why they cannot pick up the item. It is likely that the player will figure it out eventually, but the confusion and extra effort required are likely to cause frustration.
Solution	Give the user proper feedback in every situation where the user interacts with the environment. If the item cannot be picked up, inform the user of this with a sound and/or textual feedback.

TABLE **7.2** An example of a usability problem found, when evaluating a story-driven game where the player has to complete missions in order to progress in the game.

Problem	Changing of the mission objective can be difficult to notice
Rating	Important
Description	If the player does not pay attention to the dialogue, it may happen that a change of the mission objective may go unnoticed.
Solution	Provide the users with a clear notification about a new mission objective. It may not be enough to just inform the players about the new objective in the in-game dialogue.

TABLE **7.3** An example of a gameplay problem found, when evaluating a third-person shooter game.

Problem	The character moves rather slowly
Rating	Important
Description	Movement speed can be considered slow, when the player is required to walk over long distances to reach objectives. On the other hand, the movement speed seems to be good when fighting with enemies or moving short distances.
Solution	Consider implementing a running option. Take the movement speed into account when designing the levels.

playing the game or will affect the experience so negatively that it risks players abandoning the game. A poorly designed map display that is important for playing the game is a good example of a potentially critical problem.

The difference between the moderate and important problems is not as clear cut as the one between the minor and critical ones. Despite this, it is often a good idea to split the intermediate problems into these two categories. The categories help the developers prioritize their work when fixing the problems. A separate category for the unclassified problems can also come in handy if the game is still at the very early stages of development. The issues that cannot be evaluated before the game is more complete can be classified to this category.

The written description of the problem is an opportunity to explain the problem and the reasons behind it in detail. These can be useful if the problem is so complex that it cannot be described in the title only. Describing the reason behind the problem can also help the developers understand the problem better and avoid similar problems in the future. Screenshots can also be used to describe the problems. Screenshots make it easier to describe the problem and also often speed up the reading of the report and make it visually more appealing.

The suggested solution should give a concrete example, how the problem can be addressed. Most often this can be done in few sentences, but sometimes there may be need for an illustrative picture that describes, for example, the new layout of the screen or another aspect of the game that needs to be developed further. If a large number of illustrations are required, writing the report may take longer than usual.

The number of problems found in a typical expert evaluation varies from twenty to fifty. The complexity of the game and the material used affects the number of issues found. When reporting the problems, it should be kept in mind that the quality of the findings is more important than the number of the problems.

In addition to listing the problems found in the evaluation, it is a good practice to provide a summary of the key findings. Listing for example the three most important areas that should be improved at the beginning of the report will help to set a context for reading the rest of the report. It is also recommended that the key strengths of the game are briefly discussed at the beginning of the report. Listing these will remind the developers that they have done good work and they will also know to avoid changing these aspects.

7.5.5 Results Workshop with the Game Developers

After the report has been completed, a review session should be organized for presenting and discussing the findings. Having this review session is important, since the developers often have many questions regarding the report. The review session is also a good opportunity to discuss together how to proceed with addressing the problems found. When doing this, the expertise of both the game developers and the evaluators is often beneficial.

7.5.6 *Fast Lane*

If the evaluation is done in a textbook manner, it will take approximately from one to one-and-a-half weeks from the kick-off meeting to the results review session, where the findings are presented to the developers. The exact time required depends on the game and the scope of the evaluation.

If there is no time or need for a full-blown expert evaluation, there are many ways to shorten the time needed for doing the work. As mentioned above, writing the report can be speeded up by focusing only on presenting the problems and solutions in the report, and using screenshots to illustrate the issues found instead of describing them in words. The process can also be sped up by delivering the initial findings immediately after the evaluation has been completed. This way, the developers can start addressing the most important issues straight away and the final report can be delivered later on.

7.5.7 *Rules Used in the Evaluation*

In the expert evaluation, the evaluators review the game based on heuristic rules, knowledge of good design practices and the experience that they have gained when working with games. These will be discussed next in more detail.

7.6 Heuristics

For a more in-depth discussion of the merits of heuristics, and an outline of various prior approaches to using heuristics with games, see the previous chapter in this book. In this chapter, I divide the heuristics I use into two classes: usability heuristics and gameplay heuristics. Samples are provided for each.

7.6.1 *Usability Heuristics*

Usability heuristics are used to evaluate the user interface of the game. The user interface includes all the screens, displays, menus, controls and other user interface elements that the player uses before, during and after playing the game. A summary of the usability heuristics commonly used is presented next. The summary is based on the usability heuristics published by Nielsen (1993) and Korhonen and Koivisto (2006).

Consistency

The user interface should be consistent both within the game and between the games. Consistency is important as it facilitates learning how to play the game, reduces the number of unnecessary errors and makes using the user interface more fluent.

Consistency within the game means that there are no unnecessary exceptions in how similar functions are implemented. For example, the menus should function in a similar way throughout the game.

Consistency between games refers to following the common conventions and standards specific to the platform and the game type. Controls are a good example of the importance of this. If the controls used in the game are unconventional, the player must spend some time learning the controls before being able to start enjoying the game. From the player's point of view, this can be especially frustrating, if there is no obvious reason for breaking the convention. First-person shooter games provide many examples of this. Different buttons are used for the very same actions across different games in the genre.

Provide feedback

The game should provide immediate, adequate, and easy-to-understand feedback after each action taken within the game. The action can take place either while playing the game or while using the menus before or after playing the game. The action can be for example, a single press of a button, complicated input sequence like combos in fighting games or the character interacting with the environment within the game world. Walking over an item to pick it up is a common example of the player interacting with the game environment.

The feedback is important, so that the player understands that the action has been registered and it also supports understanding the consequences of the action. Being sure that the action has been registered will help to reduce unnecessary insecurities and providing good feedback aids in learning how to play the game.

Use easy-to-understand terminology

The terminology and language used in the game should be easy to understand. Technical terms should be avoided and the texts should be written from the player's point of view.

Minimize player's memory load

Requiring the player to remember information should be avoided. The information the player needs should be displayed clearly when the player needs it. The status of the character and the current state of the game are good examples of the information. For example, in a shooting game the player should have the information about the health and ammunition available whilst playing the game. Checking this information from a separate menu and trying to remember it while playing can be both difficult and frustrating.

Avoid errors

The user interface should be designed so that it prevents the player from making mistakes that are not part of the gameplay. It is especially important to prevent the

user from making irreversible errors that may seriously affect playing the game. This can be achieved, for example, by designing the user interface so that it facilitates making correct choices and does not provide opportunities for making mistakes. Limiting the options available, providing help and automating actions where possible, are other ways to reduce the number of errors the players make.

If an error occurs, provide an easy-to-understand error message that informs the player about the consequences of the error and what the player can do to recover from the error.

Provide help

Help and documentation should be provided within the game. Novice players need to be aided in learning how to play the game and experts may want to have more information about the details of the game. Providing help within the game is important, because the players do not often read the manuals or the manuals may not be available.

If a tutorial is used to provide the help, care should be taken that it is entertaining and it does not slow down the experienced players who do not need extensive support to start playing the game.

Simple and clear menus

The menus in the game should be as simple and clear as possible. The menus and the items within them need to be labeled clearly and it should be clear how the selections are made. There should also be an obvious way to exit the menu, without applying the changes made.

If there are multiple menus in the game, the menu structure should be as simple and logical as possible. This will help in locating the correct menu. Navigating between the menus should also be as fluent as possible and shortcuts should be provided, when applicable.

Device user interface and game user interface are used for their own purposes

It is recommended that the device user interface is not used within the game. For example, the standard Windows or mobile phone menus should not be used to present options within the game. This is because using standard user interface components that appear drastically different from the game and its user interface elements may break the immersion. Another reason for avoiding mixing the game and device user interface elements is that it should be clear to the player when the player is interacting with the game and when the player is interacting with the operating system.

Screen layout is efficient and visually pleasing

The screens and displays should be designed, so that the players are provided with the information they need. No extra or unnecessary information should be provided. The layout of each screen should be as clear as possible and care should be taken that the screen does not appear cluttered.

The screens, displays, menus, and the other user interface elements should also be as visually pleasing as possible without making it hard to read or difficult to use. Balancing the visual appearance and usability often takes a considerable amount of effort.

Audiovisual representation supports the game

The visual appearance of the game should support the playing of the game. The graphics and visual effects can be used to make the basic user interface elements, such as menus, both easy to use and visually appealing. The gameplay can also be supported by using the visuals to provide the player with information and feedback in a stylish and easy to understand way. Sound effects, music, and other audio can also be used for similar purposes. When designing the user interface you should, however, avoid using audio as the only way to provide information or feedback, as games are often played with the sound turned down or completely off.

Game controls are convenient and flexible

The controls should be easy to learn. This will make the game accessible for people who do not play games often and will help the more seasoned players start enjoying the game in less time. A good way to achieve this goal is by keeping the controls simple and following the conventions and standards.

The controls should also be suitable for the game and make completing the actions, taken in the game, as easy and fluent as possible. For example, in a real-time strategy game the controls used for choosing and commanding troops must be very efficient and fluent to use or otherwise there is a real risk that playing the game will not be fun. The more common the activity is, the more important it is that the controls are easy and efficient to use.

The player should also be provided and given the opportunity to configure the controls. Shortcuts should also be provided for experienced players, where applicable. For example, in a racing game a shortcut for restarting the race may help the players a lot.

7.6.2 Gameplay Heuristics

Gameplay heuristics are used to evaluate the gameplay. The goal is to find the problems that may negatively affect the gameplay experience and to remove the

challenges that were not intended by the game developers. The gameplay heuristics created by Korhonen and Koivisto (2006) are presented in this chapter, as their list of heuristics is relatively compact and covers the key aspects of the gameplay well.

The game provides clear goals or supports player-created goals

Achieving goals is at the very heart of playing games. Because of this, the player should always be aware of the next goal or goals. If the game is complex or long, there should be both short-term and long-term goals to keep the player motivated. The distinction between the long-term and short-term goals should also be clear. If the game does not provide goals, the player should then be encouraged to set his or her own goals.

The player sees the progress in the game and can compare the results

The player should always be informed on his or her progress within the game. This is because the feedback on the progress serves both as a reward and makes it possible to estimate how far away the player is from reaching the next goal. If the player does not see the progress, it can be difficult to maintain motivation.

Being able to compare the results is also an important source for motivation. This applies to both single player games, where the player can try to improve his or her own results, and multiplayer games where observation of an improvement ranking can be an effective reward.

The player is rewarded and rewards are meaningful

Rewarding the player is important because without rewards the goals lose their meaning. It is also important that the reward is meaningful for the player, because uninteresting rewards do not motivate the player. Rewarding the player should also be well balanced with the challenge and progression.

The player is in control

The game should convey the feeling that the player is in control. If too many surprises occur within the game, there is a risk that the player may start feeling that the game is more of a lottery than a game. This may negatively affect the gaming experience.

Challenge, strategy, and pace are balanced

The game should not be too easy or too difficult to play. The correct level of challenge will help to keep the player motivated.

It is often the case that there are many different strategies available for how the game can be played. It should be made sure that there is no single dominating

strategy. This is because if there is one strategy that overshadows the other possible strategies, it is likely that the players will use this and the gameplay never reaches its full potential.

The pace of the game should also be correct. If the player needs time for thinking, then the player should be provided adequate time for doing this. The intense and relaxed phases of the game should also be paced correctly. Intensive phases, for too long periods, will exhaust the player and too long periods of relaxed phases run the risk of boring the player.

The first-time experience is encouraging

The players often judge the games based on the first impression. Because of this, it is crucial that the first-time experience of the game and especially the first five to ten minutes are as pleasant and encouraging as possible.

The game story supports the gameplay and is meaningful

If there is a story in the game, it should be meaningful and support the gameplay. An irrelevant or uninteresting story is likely to hinder playing the game. The story telling should be implemented, so that it does not dominate the gameplay.

There are no repetitive or boring tasks

The player should never be asked to repeat the same task for too many times without changing at least some aspects of the task. Having too many potentially boring tasks should also be avoided too.

The game supports different playing styles

If the game is complex enough that it can be played in various ways, then it is likely that different people will enjoy playing the game in different ways. For example, the players in online role-playing games may orientate for example towards achieving game goals, exploring the game world, socializing with the other players or killing other players (Bartle, 1997). Different playing styles should be taken into account and supported in the game design.

The game does not stagnate

The player should have a feeling that the game progresses. If the game stagnates, the player may feel that that the goals cannot be achieved and may lose interest in the game.

The game is consistent

The game mechanics and game world should be consistent throughout the game. For example, if it is possible to climb over a fence at one point of the game then it should be possible to climb over similar obstacles at other points in the game.

If the game mechanics and the game world have counter parts in the real world, these should be consistent too. For example, a small fence should not be used to limit the area that the player can explore in a real game. Consistency between the game and real world will help the players to understand the meaning of the objects and actions and to use them correctly.

The game uses orthogonal unit differentiation

Using orthogonal unit differentiation means that different objects in the game should have different purposes. For example, in a driving game, the different car types should have different strengths and weaknesses. This will encourage the players to try out different strategies when playing the game and is most likely to result in a more interesting gameplay experience, than if the only difference between the different types of cars would be the top speed.

The player does not lose any hard-won possessions

If the player has spent a long time achieving something in the game, the achievement should not be taken away from them easily. For example, if the player has played the game for several hours to collect enough funds to purchase an item, this item should not be taken away from the player straight after the item has been purchased.

The players can express themselves

Giving the players the opportunity to customize the game's character, game world or other aspects of the game may help to get the players more involved in the game. Being able to express themselves or to customize the game is also so common today that many players expect to be able to do this in a majority of games.

7.6.3 Heuristics Specific to the Platform and Game Type

The usability and gameplay heuristics, presented above, are suitable for evaluating various types of games. Sometimes there may be a need to complement these generic heuristics with more specific ones that take the platform or game type better in account. This is the case, for example, with mobile games. When evaluating mobile games, heuristics such as can the game and play sessions be started quickly, does the game accommodate with the surroundings, and are interruptions handled reasonably become important (Korhonen & Koivisto, 2006). Specific heuristics have also been created for mobile multiplayer games (Korhonen & Koivisto, 2007).

7.6.4 Previous Experience and Knowledge of Good Design Practices

Previous experience in playing, designing, and evaluating games is also very useful, when conducting an expert evaluation. This experience will help to understand

what the heuristic rules mean in practice and help to find issues that are not covered directly by the heuristic rules. The experience will also help in coming up with good and feasible suggestions on how the problems can be solved.

The experience gained, when observing and analyzing playability tests, is especially useful when conducting an expert evaluation. This is because the playability tests give valuable information on how players play the games and what they think of the different design practices. This information can be highly valuable when reviewing the game for usability and playability problems and thinking about possible ways that problems could be solved.

7.7 Summary

The expert evaluation is a flexible and efficient method for finding and addressing the usability and gameplay problems that may hinder playing the game. The evaluation can be done at different points of the development process and it can be focused on the issues that are of the most interest to the game developers, at that point of the time. The method is efficient because the number of people needed for conducting the evaluation is small and the results that consist of both the problems and the recommendations on how to tackle them are delivered quickly. For the very same reasons, expert evaluation is also a very cost efficient way for improving the quality of the game.

Conducting an expert evaluation or evaluations will also encourage the development of the game in an iterative manner. Scheduling time for the gathering of feedback and refining the game based on it will help to deliver a better game. Employing usability and playability experts will also bring in new expertise that may be beneficial, if there are no user interface designers already in the team or the user interface of the game is complex.

When compared with user-centered development methods, the expert evaluation has the benefit that no players are needed in the evaluation process. This is beneficial when evaluating the early prototypes of the game. It is easier for the experts to ignore the missing features and bugs, than it is for the gamers who represent the target audience of the game. The other benefit, that of not having players involved in the evaluation, is that the risk of information leaks is minimal.

The fact that the players from the target group of the game are not involved in the evaluation process is also the main weakness of the method. The experts' views on the usability and playability of the game do not represent what the players think about the game. If feedback is desired on the players' opinions about the game, a playability test should be conducted (see Chapter IIA for more information). A playability test will also help to make sure that there are no major usability or playability problems in the game that have gone unnoticed in the expert evaluation. This may happen, as knowing how the players really play the game and what the exact issues are that cause the players difficulties can be challenging, for even the most experienced evaluators. Luckily, expert evaluation and playability testing

rather complement than exclude each other. They are suitable to be used at different parts of the game development and they represent different points of views that are both useful to the developers.

The expert evaluation should not be confused with the traditional quality assurance testing. The goal of the expert evaluation is not to find bugs, but to participate in the user interface and game design in a creative and collaborative manner. The evaluators, who conduct the expert evaluation, take an active part in the design process and provide the developers with feedback that they can use to improve the user interface and game designs. The result of this work is not fewer bugs in the game, but a better game that will be more fun to play than it otherwise would have been.

7.7.1 *How to Get Started*

Getting started with an expert evaluation is relatively straightforward. Next time you have a playable prototype of the game ready, contact a usability consultancy that has experience in evaluating games or choose people with suitable backgrounds from your company to conduct the work.

If it will be novices who conduct the expert evaluation, give them some time to familiarize themselves with the methodology, heuristic rules and expected results. In addition to this chapter, see for example any usability text book about conducting an expert evaluation and study the guides and reports available on the Internet. See the references and resources, at the end of this chapter, for information on where to get started.

Once the project has begun and the evaluators are doing their work, start preparing the results workshop. Invite to the workshop all the people from the project team who are potentially interested and may benefit from the results. This will help to make the most out of the evaluation and get people committed to making the changes that are required to improve the game.

If you, or the organization where you are working, have no prior experience in using the user-centered development methods (for example, playability testing) then conducting an expert evaluation is a good way to get started. Conducting the evaluation is quick and it does not require a great deal of resources. The results of the evaluation also provide an excellent taste of what can be expected from applying user-centered development methods to the game creation process.

7.8 References

Bartle R. (1996). Hearts, clubs, diamonds, spades: Players who suit MUDs. Retrieved May 28, 2008. form the World Wide Web: http://www.mud.co.uk/Richard/hcds.htm.

Koivisto, E. M. I. and Korhonen, H. (2006). Mobile Game Playability Heuristics, Forum Nokia. Available at www.forum.nokia.com/info/sw.nokia.com/id/5ed5c7a3-73f3-48ab-8ele-631286fd26bf/Mobile_Game_Playability_Heuristics_vl_0_en.pdf.html.

Korhonen, H. and Koivisto, E. M. I. (2006). Gameplay Heuristics for Mobile Games. Proceedings of MobileHCI, Helsinki, Finland.

Korhonen, H. and Koivisto, E. M. I. (2007). Playability Heuristics for Mobile Multi-Player Games. In Second International Conference on Digital Interactive Media in Entertainment and Arts: DIMEA 2007, Perth, Australia, 2007. Available at: http://delivery.acm.org/10. 1145/1310000/1306828/p28-korhonen.pdf?key1=1306828&key2=3984562021&coll=& dl=&CFID=15151515&CFTOKEN=6184618

Laitinen, S. (2006). Do Usability Expert Evaluation and Testing Provide Novel and Useful Data For Game Development? *Journal of Usability Studies,* 64–75. Available at: www.upas-soc.org/upa_publications/jus/2006_february/usability_game_development.html

Nielsen, J. (1993). *Usability engineering.* San Diego: Academic Press.

7.8.1 Additional resources

Desurvire, H., Caplan, M., Toth, J.A. (2004). Using Heuristics, to Evaluate the Playability of Games. In: Proceedings of the Conference on Human Factors in Computing Systems (CH1'04), ACM Press, New York, NY., pp. 1509–1512. Available at: www.behavioristics.com/ downloads/usingheuristics.pdf

Federoff, M. A. (2002). Heuristics and Usability Guidelines for the Creation and Evaluation of Fun in Video Games. Master Thesis, Department of Telecommunications, Indiana Univserity. Available at: http://melissafederoff.com/heuristics_usability_games.html

Forum Nokia-Games Usability Guidelines/Articles. Available at: www.forum.nokia.com/ main/resources/documentation/usability/games.html

Help you play-Interaction Design Pattern Library for Games. Available at: www.helpyouplay. com/

Microsoft Game User Research-Research, Publications, and Interviews. Available at: http:// mgsuserresearch.com/publications/default.htm

Schaffer, N. (2007). Heuristics for Usability in Game: White Paper. Available at: http://friend-lymedia.sbrl.rpi.edu/heuristics.pdf

EIGHT

Interview with Eric Schaffer, Ph.D., CEO of Human Factors International

Interviewer: Noah Schaffer

Dr. Eric Schaffer has been doing usability work since 1977, when it was referred to as "engineering psychology" or "personnel sub-system design." Since 1981, he's led Human Factors International, Inc., the largest company specializing in software usability. Dr. Schaffer began creating interface standards in 1982, and has now been responsible for over 250 customized standards for settings ranging from mainframes, to interactive voice response, to graphical user interface, to web and mobile environments.

I can understand the usefulness of interface design standards for a phone company or a bank. But how can you say standards are useful for game designers? Game designers need to have flexibility to make things interesting and challenging.

Flexibility is certainly important. Game designers need flexibility in crafting story line, and in optimizing the level of challenge and excitement in a game to create a

sense of flow and immersion. But players shouldn't have to get creative in trying to figure out which button the designer decided to make the FIRE button in *this* level of the game, or where the designer decided to show the player's health meter on the heads-up display.

The main application of standards for games is to the "container" of the game—the navigational and operational methods included in the heads-up display and in the control mappings of actions to input devices such as keyboard or controller. This part of the game is successful if it disappears and lets the user feel she is directly interacting in the virtual environment. This container will *not* disappear if it is inconsistent. So the most critical standards will refer to things like the shell menu, the HUD, and interactive controls.

Why are usability standards important?
I would go so far as to say that no professional interface designer would operate without a clear set of standards.

Usability standards increase the speed and cost of application development by about 10 percent. Designers don't have to reinvent the wheel in designing screens. Also software infrastructure can be made that will deliver standardized applications faster. Finally, application maintenance is made easier by standardization. So there is an easy business case for standards.

Standards also improve the quality of the user experience in two ways.

First, imagine a design competition. On one side is a poor overworked software developer on a tight timeline trying to come up with a setup screen. On the other side is a crack usability engineering team (with the latest user experience technology and research), and the best creative designers and business analysts in the organization. Because the standard will be amortized over hundreds of setup screen designs, the big team has enough time to do a top job. It seems pretty obvious the standards team will come up with a better design for a setup screen.

Even if the design is *not* better, standards provide greater consistency. There is consistency *within* an application. So you don't have conflicting rules for placement of material, naming, or operation. This means that the user can generalize their experience with one screen to another. Also within a family of applications, the user can generalize their knowledge of one to another.

Can you describe in more detail what an usability standard is, for those new to the term?
First when people talk about standards they can mean three different things.

There are **design principles**. This is fatherly advice about interface design. Badly done principles sound like "Write Clear Error Messages" (I've run across this brilliant "standard" a lot). Good ones read "Use short words, use short sentences, and write in the active voice." I was one of many that helped Sid Smith write the famous MITRE guidelines. This was several hundred pages of this type of advice, and I'm not sure if anyone ever read it all. It is just hard to integrate a large body of these

principles. This is why I would suggest using training instead. You can find such rules today in www.usability.gov for example. But you are better off taking a course.

There are **design standards**. These are very specific. If they are successful, the user sees a screen and thinks "I've seen one like this before" and then later finds "YES! It works just the way I expected." This might SEEM easy, but it takes some very hard work to make sure that that experience happens.

Finally, there are **methodological standards**. These are systematic processes of user-centered design. These are all very valuable guides to help the usability professional work efficiently and avoid forgetting key steps. But they *do not* inform the design at all.

So for game designers, which is the most important of these types of standards?
You need *all* of them! You need a methodology for systematically and reliably creating effective game user interfaces. You should also have access to the research-based principles and models for designing human-computer interactions. This means knowing the rules and methods for navigation design, information architecture, and detailed design. But the game designer needs more. On top of the principles that will make a design that the user *can* use, we must also apply the principles that ensure that the user will *want* to use the design. These are the hottest area of research in the user-experience field.

But the main focus of this discussion is the *design standard*. I'm a strong advocate of the benefits of including standards in the design process, and that includes game interface design.

What do design standards really look like?
The core of a good standard is reusable screen templates or examples. Then you can have a guide so the developer is told which screen to use for a given user task. In fact for a very small organization, I suggest just providing a set of screen examples for people to copy. There has been one recent variant on this idea. The idea is to create "patterns" that are standard components that can be compiled to make a screen design This has had some success, though there are complaints that the accumulation of patterns become intractable. Check out Jarred Spool's work for more on the topic.

Usability standards also include different types of rules that designers must follow. They'll include things like where to position the game publisher's logo on start screens, or what type of fonts and colors to use in save menus and setup screens. We try to keep standards relatively bare bones so that designers still have room to be creative. But the standards need to be rigorous enough so that the end user can recognize each standard screen and interface element type and find that the interface works the way they expect.

What does it cost to develop a standard?
There is certainly an investment required to develop a comprehensive standard. Large organizations often invest hundreds of thousands of dollars and perhaps eight

to twelve weeks in the effort to create standards for productivity software and web-sites. But it pays off fast. The Royal Bank of Canada reported that their standard cut their overall system development cost by over 10 percent. So it's a good business decision.

If you have a very small operation, you can sacrifice the detailed documentation and just make a set of examples that everyone can follow. This means a lot more effort to communicate what the rules really are. But this is better then nothing for sure. A small operation can put together good examples in a couple of weeks.

Tell me more about the process you use for making standards.
As with all usability work, management buy-in is critical. You're about to pull some key people away from other work they could be doing, and whoever controls the money needs to be fully supporting you. But the next level of getting buy-in is also critical. You don't just sit in a room and draw up the standards yourself, because no one will use them.

Instead, the creation of the standards is collaborative. You make the standards by committee. And the people on that committee have to be carefully chosen. The committee will be about eight opinion leaders. So these are the people on the design team who everyone else in that team comes to when they're uncertain or have a question. This is absolutely critical, because these are the people who will go out to the teams and say to follow the standards. And they'll push for it because they personally had a hand in creation, so they own it. Maybe by using a committee the standards have more problems and mistakes. But even if the standards end up being only 70 percent correct, that's still far better than a perfect set of standards that no one uses.

So once you have your committee, you're going to sit and design the heck out of each type of screen. On one particular interface, maybe it makes sense for one person on the design team to work on a screen for an hour or so. But because these designs will be used again and again, we have a bigger group spend more time. Maybe the whole committee spends a full day on that same screen. So after you've spent some weeks making the standards, you test the standards out by using them to make a game. Once you have that game, you do usability evaluation methods and find mistakes. And, of course, you generalize those mistakes to the standards as much as possible so that you can edit them. This leads to an improved, edited set of standards which gets turned into a document which is distributed through the company. Generally we follow this with one to three showcase interfaces made using the standards. But that's not the end.

At this point, everyone has the standards and you have opinion leaders pushing to use them. But you really need some education so that people really understand the standards. You'll need to make a revolving class, maybe a day or so, designed to teach the standards.

Then, even after all those other steps to be sure the standards get used, some-times some people won't use them. Then comes. . . the big E. . .

116

Euthanasia?

Close. Enforcement. We hope that no heads actually have to roll for violating standards, but sometimes it comes to that. Standards are *not* gentle suggestions. They're law. And when laws are broken, there must be law enforcement.

Wow. This whole process sounds pretty involved.

Yes, it's involved and expensive. But as I said, you can't consider yourself a serious design firm without usability standards. The benefits outweigh the costs. Standards are probably the first and most essential part of making a mature, process-driven design operation.

Are there exceptions? Such as a design firm that focuses on just one narrow category of interface? Some game studios are like this, developing in one genre exclusively.

As I said before, in a small operation, it may make sense to have a few basic screen examples for people to follow, if only to maintain some consistency within the few titles that company is producing. But this approach is wildly inefficient and impractical with a larger game design operation with many titles. I hope I've made the case that it's worthwhile to take the time to develop standards.

Thanks very much for your time and attention today. I think many people in the games industry will appreciate what you've had to say.

Master Metrics: The Science Behind the Art of Game Design

Chris Swain is an assistant professor at the University of Southern California School of Cinematic Arts, Interactive Media Division. He is a game designer, and co-author of the textbook Game Design Workshop. He co-directs the EA Game Innovation Lab at USC. His game design research specializes in matters related to original system design and new kinds of play. The lab seeks to change conventional wisdom about what games are and can be.

9.1 Overview

This chapter describes eight metrics-based game design techniques that can be used to help make better play experiences. The techniques have been culled from some of the leading game designers in the world via a series of personal interviews. All techniques are presented as "theory for practitioners"—meaning they are intended to be practical and hands-on for working game designers.

9.2 Background

Game design is the art of crafting player experiences. Creating good player experiences involves an iterative process wherein developers: (a) make game prototypes, (b) watch people play them, and then (c) revise the work. Developers repeat this process making tweaks and additions to the prototypes in each successive iteration. Historically designers have relied almost entirely on creative judgment to decide how to tweak their games to make them play better with gamers. Creative tinkering and trial and

error has been (and still is) the norm in game development for making tweaks between tests. Recently however more sophisticated techniques have bubbled up from the design community. These techniques have come about largely out of necessity to deal with the dramatic increases in complexity in our medium. This complexity has emerged because of rapid increases in processor power, media storage capacity, broadband connectivity, game complexity, production costs, team sizes, and other factors.

To create the list of techniques many developers allowed themselves to be interviewed and provided hard data from their work. Gathering the info is somewhat significant because in today's developer culture design techniques are generally not codified in writing but rather passed along verbally and refined through constant collaboration among individuals in a company. In cases where techniques are codified the info is generally kept internal to a company for competitive reasons.

Interestingly the techniques detailed below all share the fact that they involve a tangible metric, for example, something that can be measured. Sometimes the metric measures playtester behavior in some way. Sometimes the metric measures an element internal to the game itself. Sometimes the metric measures neither of these things. The fact that they all involve measurement and that they come from a cross section of our community is important because it indicates that our art form is figuring out how to embrace scientific method.

It is an exciting time to be designing games because there are so many rich uncharted areas to explore. Games can and will have increasingly meaningful impact on entertainment, education, journalism, the arts, and many other fields in the coming years. A creative embrace of scientific method and metrics-based techniques will help take us to these new places.

An Important Note

Metrics-based design techniques are tools to *assist* the creative process. Period. I don't believe you can or should put a formula on game design.

(Editors' note: Several of the techniques introduced in this chapter are described in greater detail in other chapters of this book. Where a method is mentioned that is included later in the book, we've indicated which chapter to turn to for more information.)

9.3 The Techniques

The techniques are organized by design type—for instance Feature Design, Level Design, Character Design, Mechanics Design, etc. Here are the titles for each:

1. Feature Design: Listen to Metacritic but don't be a Slave to Metacritic

2. Feature Design: Morphological Analysis is Analytical Creativity in Action

3. Mechanics Design—Quantify Types of Emotions Evoked–Offer Three or More

4. Level Design—Use "Heat Maps" to Track and Quantify User Experience

5. Level Design—Craft a Balanced Mix of Activities Using "Time Spent" Reports

6. Level Design—Track Engagement with Biosensors to Quantify User Experience

7. Control Design—Simplify Controls through Measured Complexity Models

8. Experience Design—Integrate Playcentric Design throughout Development

9.4 Feature Design: Listen to Metacritic but don't be a Slave to Metacritic
Source: Multiple Companies

Metacritic.com is a popular website that takes reviews from many sources and normalizes the rating from each into a 100-point scale. For example, if one reviewer uses a 4-star scale and another uses a 10-point scale, the ratings from each for a given game are translated into a uniform 100-point scale (for example, 3 stars equates to a 75, etc.). For games, Metacritic compiles ratings from up to 30 reviewers, normalizes the ratings, and, using a system of weighted averaging (in which more prominent reviewers have stronger influence) assign a "metascore" to the title. (Metacritic.com, 2008) This system is valuable because the opinions of many reviewers will average out and thus not be susceptible to the personal tastes of a single reviewer.

By analyzing games based on Metacritic scores, an (unsurprising) relationship between a high Metacritic score and high sales is revealed. In fact, a study by EmSense, Inc. shows that each 5-point increase on Metacritic translates to an approximately 50 percent increase in sales. This means that console games with a metascore of 75 achieve average sales of $5 million and console games with a metascore of 90 achieve average sales of nearly $50 million. (Note that these data exclude games based on movie licenses). (EmSense, Inc., 2008)

Talk of metascores has permeated many publishers and developers in the game industry, and it is common for game executives to be able to cite the metascores of dozens of current titles from memory. Electronic Arts (EA) has incorporated use of Metacritic into their development and marketing culture across their studios—largely based on the influence of the former Chief Creative Officer Bing Gordon. At EA it is common to project what metascore a game in production may achieve and even to discuss how many points an individual feature in development may increase a projected metascore.

Given the power of this metric, two questions for us as designers are:

- Can you analyze games on Metacritic score and derive guidelines about what feature sets or other qualities tend to work and what tend to fail?

- As a creative person would you want to do that?

Regarding guidelines for features that can be derived by analyzing metascores: firstly here is a list of high scoring console games from Metacritic.com. The list is given simply to provide context.

Playstation 2

- *Tony Hawk Pro Skater 3* (Metascore: 97)
- *Grand Theft Auto 3* (97)
- *Metal Gear Solid 2: Sons of Liberty* (96)

Playstation 3

- *Call of Duty 4: Modern Warfare* (94)
- *Elder Scrolls IV: The Oblivion* (93)
- *Rock Band* (92)

Xbox 360

- *Bioshock* (96)
- *The Orange Box* (94)
- *Gears of War* (94)

Nintendo Wii

- *Super Mario Galaxy* (97)
- *Legend of Zelda: Twilight Princess* (95)
- *Super Smash Bros. Brawl* (94)

It is difficult to measure elements of games from different consoles and different genres with real precision. This is because a hit game from one genre may be constructed in a distinctly different way from a hit game in another genre. For example counting the number of levels in a platform game is of no real value compared to the number of levels in a first-person shooter game because "level" means something different in each genre. That being said, we did examine lots of games in detail and, using some creative judgment, have culled out some guidelines for feature sets.

9.4.1 *Themes from High-Scoring Games*

Here are things that high-scoring games tend to have. They are ranked in order of importance.

1. Large in scope—20+ hours of content
2. Variety of player choice/activity
2. Highly replayable
4. Top quality visuals and sound
5. Responsive and easy controls

6. Engaging story/characters

7. Quality interactive world/artificial intelligence

8. Responsive camera

9.4.2 Themes from Low-Scoring Games

Conversely, based on examining lots of low-scoring games, here are things that tend to suppress metascore. These are also ranked in order of importance.

1. Gameplay undifferentiated from similar titles

2. Shoddy production values or controls

3. Player unsure what to do/just happened

4. Game mechanics disconnected from premise

5. Non-interactive environment—too linear

6. Does not flow—becomes too difficult too soon

7. Save points too spread out

8. Long, repetitive load screens

Now back to the question of whether or not as a creative person you'd want to use this information in your work.

To help answer this question, here is a chart by Rich Gold from Xerox PARC. It breaks down and describes the traditional mindset of Artists, Designers, Scientists, and Engineers.

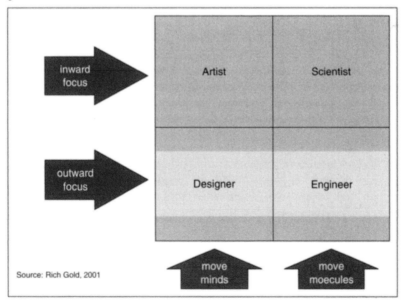

The chart is relevant to this chapter because we as game developers walk in all four quadrants. Notice that the Artist-Scientist row describes inward focused ventures—meaning these are people who explore their passion in a very personal way. Think about Pablo Picasso. It would be inconceivable for him to take his art to a focus group for feedback.

Conversely, notice that the Designer-Engineer row describes outward focused endeavors—meaning these people explore their passion with users and customers in mind. Although a game designer can technically be in the Artist-Scientist row the fact that we are so reliant on feedback from users to build our games argues the point that game design is an outward focused venture. Thus in nearly all cases—even for very artistic games-game designers operate in the Designer-Engineer row. This outward focus on players helps validate the idea of using Metacritic information (as well as the rest of the techniques below) when creating games.

9.5 Take-Aways

1. There are things to learn from the lists above, however it's important to not be a slave Metacritic data. In fact, doing so too literally would violate the first point on the list—"undifferentiated from similar titles."

2. There's a "know the rules so you can break them" effect. Hopefully, the analysis in this technique will provide some insights into what has proven to be functional so you can springboard off it.

9.6 Feature Design: Morphological Analysis is Analytical Creativity in Action
Source: Dan Arey, David Perry, Others

This second technique is inspired by the book *Thinkertoys* by Michael Michalko and has been adapted by multiple top game designers including Dan Arey and David Perry. In the book Michalko describes the concept of an "idea box" as a tool for generating lots of ideas very quickly. Here's the general idea from

Thinkertoys:

Step 1: Define aspects or parameters of the thing to be brainstormed.
For example if the concept is "flower" the list of parameters might include: petals, stem, color, smell, shape, etc.

Step 2: List as many elements under each parameter as you feel are necessary.

Step 3: Select and combine listed parameters to connect or form new ideas or things.

By brainstorming and listing parameters in various groups, and then recombining them, you can generate a large volume of new combinatorial ideas in a very short time.

Here are two examples of how this process has been adapted by game developers.

Example 1

Character Design for Jak and Daxter

When designing the hero for a new title Dan Arey and the team at Naughty Dog, Inc. broke down potential characters parameters into six categories and then brainstormed creative ideas under each. Here is what they came up with:

Heads	Eyes	Ears	Hair	Clothes	Weapon
round	deep set	*big*	long	monk	gun
egg-shaped	sunken	small	crew cut	armor	2 guns
hero chin	wide	fat	shaggy	belts	staff
small	beady	round	flat top	rings	sword
elongated	round	missing	mullet	*harness*	2 swords
oval	*large*	ringed	*colored*	goggles	energy
flat	boogey-man	wounded	crazy	*military*	magic
sharp	squinty	*sharp*	Einstein	uniform	flamer
domed	red	embedded	*tall*	naked	cross-bow
bell-shaped	swollen	sticking out	pointed	loose	grenades
	insane	curled	feathered	spandex	animal
	tiny	flat	bangs	tight	wolf
	bright		*ponytails*	camo	*sidekick*
	colored				
	clear				
	all black				
	dazed				

Once the team had developed the lists they highlighted ideas they found interesting for their hero. The team's highlights can be seen above in italics. This process was the beginning of the character design for Naughty Dog's original character Jak. When the brainstorm began they did not have a concept for a hero with an integral sidekick. However, through the Morphological Analysis technique process the idea for a sidekick emerged. It is worth noting here because the process generated ideas that had impact far beyond the original intent of a character design brainstorm, for example, gameplay in which a sidekick can be a weapon/comic relief/etc. This was the genesis of the Naughty Dog character Daxter.

125

Variations on this process have been used by designers across time including Leonardo da Vinci. Da Vinci created notebooks of a hundreds of facial features ranging from beautiful to grotesque—for example, mouths, chins, noses, brows, eyes, etc.—which he would reference and use in different combinations to create interesting characters in his paintings. (Michalko, 1991)

Example 2

Reverse Deconstruction Brainstorming

David Perry (founder of Shiny Entertainment and lead designer on dozens of games including the *Earthworm Jim* titles, and *The Matrix* titles) uses a variation on the above which he calls "reverse deconstruction brainstorming". (Perry, 2006)

His process works like this:

- Step 1—Choose the area you want to innovate in.

- Step 2—Deconstruct the area from macro to micro by generating ever more granular lists of elements. (Note: keep and update these lists for career long use)

- Step 3—Scan list and combine for inspiration whenever you want to innovate in the selected area.

In David's experience this process consistently enables teams to generate dozens of fresh ideas. A key to making it work is developing the granular lists. David shares his on his website at www.dpfiles.com.

Let's try it. For Step 1, the area we want to innovate in is: "a weapon never before seen in a video game". For Step 2, let's reference one of David's granular lists. Here is his list entitled "Ways to Die" (Perry, 2007)

Direct Causes of Death (in alphabetical order)	Indirect Causes (in alphabetical order)
> Animal Attack	> Altered Physical Laws
> Boiling	> Bad Luck
> Biological Weapons	> Blinding
> Bleeding to Death	- > Causes of Blindness
> Burning (immolation)	- > Indirect Causes of Death Due to Blindness
> Bursting	

Direct Causes of Death (in alphabetical order)	Indirect Causes (in alphabetical order)
> Capture and Slow Death	> Boredom
> Chemical Weapons	> Broken Heart
> Conversion/Transformation	> Deafness
> Critical Hit	> Hallucination
> Crushing Death	> Insanity
> Dehydration	> Loyalty Death
> Deletion	> Neglect
> Disappearance	> Sleep
> Disease (bacterial, viral, plague)	> Smell
> Disembowelment	> Stupidity (Darwin Awards)
> Drowning (in any liquid)	> Taste (indirect death)
> Elemental Causes/Natural Disasters	> Touch
> Execution/Assassination	
> Exhaustion	
> Explosion	
> Freezing to Death	
> Friendly Fire	
> G-Forces	
> Gravity	
> Grinding Death	
> Impact	
> Impalement	
> Imploding	
> Internal Invader	
> Laughing to Death	
> Life Force Removed	
> Liquefaction	
> Magic & Supernatural Causes	
> Mechanical Failure or Malfunction	
> Medical Failure	
> Melting or Vaporization	
> Metaphysical Revelation	
> Fooled You!	

On his website, hyperlinked under each of the categories above, David has written more granular descriptions. For instance, here are the granular descriptions under "Animal Attack".

Animal Attack
Defined as: a deadly attack by any non-sentient creature.

- Attacked by killer bees (or other stinging insects)

- Eaten alive by army ants or by piranhas or sharks

- Bitten by a deadly spider

127

- Crushed by a bear or a boa constrictor or python
- Savaged by wild dogs, wolves or coyotes or dingos, etc. Also by cats, lions, tigers, etc.
- Eaten by rats and mice
- Nibbled to death by ducks (or other birds)
- Swallowed by a whale
- Eaten or poisoned by fish or jellyfish
- Eaten by vultures while still alive

For Step 3 a developer can read the lists and combine concepts and gain inspiration for new concepts. Here is a weapon concept generated using David's Reverse Deconstruction Brainstorming process:

A jousting lance which shoots a biological virus into the target's body, that when stabbed and infected causes the victim's internal organs to rapidly expand, thus bursting my enemy's body from the inside out like a human balloon.

9.7 Take-Aways

1. Morphological Analysis is a tool which can generate a ton of ideas very quickly.
2. It provides an analytical approach to creativity.
3. Most importantly, it is a repeatable tool unconcerned with muse or inspiration.

9.8 Mechanics Design—Quantify Types of Emotions Evoked—Offer Three or More
Source: Nicole Lazzaro, XEODesign

(Editors' note: for an extended version of this theory directly from Lazzaro, see Chapter 20).

This comes from Nicole Lazzaro's research on player experience. Nicole has analyzed a broad spectrum of games and defines four types of emotion involved in player experience. (Lazzaro, 2007) The four types are:

1. Fiero (in other words, personal triumph)
2. Curiosity
3. Amusement
4. Relaxation/Excitement

Nicole's research shows that game titles that offer three or more of these types of emotion do better in the marketplace. She posits that this is because those titles offer more options for the player to feel (for example, more emotional satisfaction).

Developers can craft their games to evoke three or more different types of emotions by including a targeted mix of game mechanics and types of choices. This is because game mechanics tend evoke specific emotions. Nicole maps different game elements to the emotions as follows:

1. Fiero
 Fiero is an Italian word that means roughly "personal triumph". Mechanics that involve mastery tend to evoke Fiero. Other game elements that evoke this emotion include: goals, challenge, obstacles, strategy, power-ups, puzzles, score, levels, and monsters.

2. Curiosity
 Curiosity implies imagination, surprise, wonder, and awe. Game elements that tend to evoke this category of emotion include: iconic situations, exploration, experimentation, fooling around, role-playing, ambiguity, details, fantasy, and uniqueness.

3. Relaxation/Excitement
 Game elements that tend to evoke this category of emotion include: repetition, rhythm, completion, collection, meditation, working out, simulation, and study.

4. Amusement
 Nicole says choices with other people increase emotions and social bonds. Game elements that tend to evoke amusement include: cooperation, person-to-person competition, communication, performance, spectacle, characters, and personalization.

Given the framework above let's look at some case studies of commercially successful games and show the emotions they evoke. The ratings in each category are judgments by the author.

Sims 2	Grand Theft Auto: San Andreas	Nintendogs
Fiero: LOW Curiosity: HIGH Relaxation/Excitement: HIGH Amusement: HIGH	Fiero: HIGH Curiosity: HIGH Relaxation/Excitement: HIGH Amusement: MEDIUM	Fiero: LOW Curiosity: HIGH Relaxation/Excitement: HIGH Amusement: HIGH
Guitar Hero 2	**Call of Duty 4**	**Gran Turismo 4**
Fiero: HIGH Curiosity: MEDIUM Relaxation/Excitement: HIGH Amusement: HIGH	Fiero: HIGH Curiosity: MEDIUM Relaxation/Excitement: HIGH Amusement: MEDIUM	Fiero: HIGH Curiosity: MEDIUM Relaxation/Excitement: HIGH Amusement: MEDIUM

Zelda: Phantom Hourglass	World of Warcraft	Portal
Fiero: HIGH	Fiero: HIGH	Fiero: HIGH
Curiosity: HIGH	Curiosity: HIGH	Curiosity: HIGH
Relaxation/Excitement: HIGH	Relaxation/Excitement: HIGH	Relaxation/Excitement: HIGH
Amusement: MEDIUM	Amusement: HIGH	Amusement: HIGH

9.9 Take-Aways

1. To reiterate: the take-away here is that games that evoke three or more of the emotions: Fiero, Curiosity, Relaxation/Excitement, and/or Amusement tend to do better in the marketplace.

2. Nicole Lazzaro believes this is because those titles offer more options for the player to feel.

For more information about Nicole Lazzaro's research on player experience see her website at http://www.xeodesign.com (*Editors note: see also Chapter 20*).

9.10 Level Design—Use "Heat Maps" to Track and Quantify User Experience
Source: Microsoft User Research Group

(Editors' note: For more information about this technique in the words of the Microsoft group, see Chapter 15. See also an overview of several of Microsoft User Research Group's other techniques in this Section, Chapter 4.)

Microsoft Game Studios is the unchallenged leader when it comes to developing and benefiting from metrics-based design techniques. Their expertise comes from an embrace of formal user testing techniques since the inception of the company. In short, when the Microsoft started publishing games in the 1990s the company already had a strong culture of usability testing, which had evolved through their work on Microsoft Windows, Office, and other applications. Individuals in the Microsoft usability group were assigned to user test game titles and they quickly adapted techniques specific to the medium. That group became the Microsoft User Research Group. Their influence has spread into the game industry on the whole because many individuals who work on Microsoft-published games become enlightened to the power of user-centric and metrics-based design techniques and bring the mindset to their work at different publishers and developers.

The description of this technique is short because details about Microsoft's user research appear elsewhere in this book. In brief: Microsoft uses custom instrumentation software to track playtesters as they move through a game. One of the most powerful instrumentation techniques is called a "heat map." Among other things a heat map shows visually where events happen in a game level. For instance, for single-player levels a heat map can show how much time play testers spend on average at each place in a level. When a bottleneck in a level is identified by the heat map report the developers can tweak the design at that point and retest. So if play testers are taking a long time to figure out how to get through a door in a level then the developers might learn about that by looking at the heat map and then tweak the level by making the door more obvious. Microsoft repeats the process of building prototypes, testing on users, and tweaking until the play experience flows in a satisfying way. Microsoft finds that heat maps are much more convincing and useful for developers than written reports because they provide more precise and nuanced information.

A tenet of the Microsoft User Research Group process is to keep the people in the user research group purposely independent from the game developers. The reason is that the researchers, while passionate about making a great play experience, are dispassionate about design specifics in any specific game. Developers, on the other hand, tend to fall in love with their designs. Keeping the two separate helps ensure that reports from the researchers are based on data and not on personal bias. Microsoft typically has about three researchers work on user testing for a big title. John Hopson in the User Research Group led the team that built the heat map software. They used a generic analysis program called Tableau to make the software.

9.11 Take-Aways

1. Custom instrumentation software can be written to measure how play testers are playing a game.

2. Keeping user testers independent from developers helps ensure unbiased analysis of play test data.

9.12 Level Design—Craft a Balanced Mix of Activities Using "Time Spent" Reports
Source: BioWare Corp.

BioWare creates top selling role-playing games such as *Mass Effect*, *Jade Empire*, and *Knights of the Old Republic*, among other titles. They are generally considered the leader in games that provide rich story and characters.

BioWare utilizes a metrics-based technique called a "time spent" report to see how much time playtesters spend on each type of activity in a game level. The technique

is related to a heat map in that in-game behavior by playtesters is tracked by instrumentation software. However, all that is reported is the number of minutes spent on different activities as is shown below. BioWare is an example of a company that worked with Microsoft Game Studios and developed more sophisticated metrics as a result.

Let's look at example of how BioWare used time spent reports on a real project—*Mass Effect*. Here are time spent reports from two different pre-release versions of the *Mass Effect* level "Noveria".

Version 1	Version 2
Mass Effect—Noveria Time Spent Report (avg)	Mass Effect – Noveria Time Spent Report (avg)
Viewing Cinematics: 4 minutes	Viewing Cinematics: 5 minutes
Engaged in Combat: 22 minutes	Engaged in Combat: 32 minutes
Engaged in Conversation: 28 minutes	Engaged in Conversation: 20 minutes
Viewing Maps/Journals: 19 minutes	Viewing Maps/Journals: 8 minutes
Walking: 124 minutes	Walking: 57 minutes
Driving Vehicles: 11 minutes	Driving Vehicles: 10 minutes
Total: 207 minutes	Total: 209 minutes

To be clear: the minutes in the report refer to the average number of minutes playtesters spent while playing the level. Notice in Version 1 that the play testers were in Combat for 22 minutes and Conversation for 28 minutes. BioWare developers looked at this and decided that this time spent breakdown did not *feel* right for Noveria because it was supposed to create an exciting and action-filled experience in the *Mass Effect* story. They decided they needed to increase the number of minutes spent in Combat (e.g. more action) and decrease the number of minutes spent in Conversation (e.g. less talking). To achieve this they tweaked the level by adding more combat obstacles and editing out some conversation nodes. See the results in Version 2: Combat increased to 32 minutes and Conversation decreased to 20 minutes. The developers made a creative judgment that Version 2 felt right and the game shipped with this version of the level.

An important point here: the time spent metric provided analytical data that the developers used to make creative judgments. Some people wonder why, if game tweaks always come down to a creative judgment, developers need analytics at all. In other words, why don't they scrap the analytics and just observe testers playing? Why not just make creative judgments based on how playtesters react? BioWare's Iain Stevens-Guille provides two reasons why analytic data is valuable:

1. There's a difference between *playtester perception* of what happened and the actual numbers. Tester perception of what happened is easily skewed by factors such as a cool battle (which would skew them to think positive things about the

whole level) or a bug in the game (which would skew them to think negative things about the whole level).

2. There's a difference between *designer perception* of what happened (to a play-tester) and the actual numbers. Designer perceptions are frequently skewed because they become infatuated with their designs and lose objectivity. For example a designer might be in love with a particular scene and dialog exchange that he has crafted. He may not be able to accurately perceive that it is the dialog he has written that is making the experience drag.

Iain says that numbers from a time spent report provide objective information to help a team assess what is happening in a level. Numbers are particularly useful in a collaborative environment when different team members have different perceptions of the problem.

9.13 Take-Away

"One measurement is worth fifty expert opinions."

Howard Sutherland

9.14 Level Design—Track Engagement with Bio-sensors to Quantify Player Experience
Source: EmSense, Inc.

(Editors' note: For alternative perspectives and further information about using bio-metrics and biosensors in games research, see Chapters 13 and 14.)

This technique comes from the San Francisco-based technology firm EmSense, Inc. EmSense has created cutting edge biosensor technology that measures a player's physical response to game experiences. They have a headset that measures brain-waves and other sensors that measure temperature, breath, heart rate, physical motion, and eye movement.

They take the data that come in from these sensors and derive biometric responses. Here are three of multiple things EmSense tracks:

1. Adrenaline—does your game excite players?

2. Thought—when do players engage mentally in activities?

3. Positive Emotion—how rewarding are different game activities?

There isn't room in this chapter to get into the science that makes these translations credible—meaning that the data that comes in legitimately represents engagement, emotion, etc. So for now let's assume the translations are credible.

The rationale for using this technology versus just asking players what they think is that this bio-sensor data is precise (and can map to specific places in a game level) whereas humans often can't explain their thinking and behavior in words. Humans tend to focus on a bad or good event and that event skews their perception of the whole play experience. This is similar to what we learned in the BioWare example above.

EmSense works with many different game companies, including large publishers like THQ, testing game levels. In addition EmSense has tested the top fifty console games in the market on their own in order to build a database of comparative media. And they are continuously adding data from more games to the database.

Here is a description of the physiological data generated by a boss battle in *Zelda: Twilight Princess*. This pattern is typical for battle sequences.

- Beginning of Battle: Adrenaline spikes, Thought drops (which is a normal human response to immediate danger)

- Middle of Battle: Adrenaline normalizes but is still very high, Thought returns as player has to think of strategies for how to defeat the boss, Positive Emotion drops dramatically because it is not pleasurable to be fighting a really hard boss.

- End of Battle: Adrenaline drops down to normal in relief, Positive Emotion peaks as player is pleased to receive a new item to use in *Twilight Princess*.

Here are two case studies from games tested by EmSense.

Case Study 1 Medal of Honor: European Assault

In the level "Lights Out in the Port City" playtest data consistently showed a long period of low engagement triggered near the middle of the level where players typically ran out of lives for the second time. The data showed that it was taking 15 minutes for players to get from low engagement back to normal. When asked, playtesters described being frustrated and wanting to quit the game during the middle of this level, however they did not know why they felt this way.

Through analyzing data from *European Assault* (and other games) EmSense realized three things:

1. Long periods of low engagement are frustrating for players because they get bored.
2. Long periods of high engagement are also frustrating for players because they get burned out.
3. Short cycles of high/low engagement are satisfying for players.

Case Study 2 Gears of War

By testing *Gears* EmSense saw engagement ebbing and flowing in short cycles of about one minute. They noticed that players were particularly satisfied after periods of defending a captured position (such as in the level "Knock Knock"). By analyzing the whole game EmSense determined that 8 of the 10 most satisfying moments in *Gears of War* occur when the player is defending a captured position.

Given only this information a level designer might conclude that building a slew of capture-defend situations would be a great thing. However by looking at the biosensor data more closely one can see a pattern of 1-2 minutes of reduced engagement (after capturing a position) followed by an intense increase in engagement when the position is attacked and must be defended. The thing that makes defending a captured position compelling is the opportunity to rest for a few minutes (low engagement) followed by an intense spike in action (high engagement).

The lesson from this case study is:

1. Periods of forced relaxation create more intensely satisfying events.

2. Players like an ebb and flow of intensity level of engagement in short cycles of approximately 5 minutes.

9.15 Take–Aways

1. Designers can use biosensor data from their games to track player engagement.

2. Designers can tune the length of time between high and low engagement events to create a satisfying flow experience for players.

9.16 Control Design—Simplify Controls through Measured Complexity Models
Source: Activision Central Design and 21st Century Game Design

This metric-based design technique comes to us from the Activision Central Design Group. It was inspired by the book *21st Century Game Design* by Chris Bateman and Richard Boon. It is a system for measuring control complexity which Activision calls Control Dimensionality (CD).

A good control scheme is integral to a providing a good play experience to players. This is because it represents the interface between human and machine. Andy Gavin from Naughty Dog says "Control is half the battle in game development. And after that, it's the other half as well." Thus, it is no surprise that game companies have developed dozens of different types of game hardware controllers (ranging from single button on a console controller to peripheral dance mats to plastic guitars to complex keyboard + mouse schemes that involve tiers of commands) in order help create the best player experience as possible. And it's no surprise that one of the key aspects being tested during playtesting is accessibility of on-screen and hardware controls.

A general rule of game design is to strive for as few controls as possible for core gameplay. However even with developers working to reduce controls down to the absolute minimum one of the most common complaints from playtesters (and reviewers) involves difficulty of controls.

Control Dimensionality (CD) is a measure of the degree of complexity inherent in a control mechanism. (Bateman & Boon, 2006) Comparing CD across various games will give a fair assessment of where your control spec sits in your genre and if you might have problems.

Here is how Activision calculates CD for a title:

Step 1: Determine basic movement scheme by choosing one of the following:

Movement on one dimension (left-right). CD = 1

Movement on two dimensions (left-right, up-down). CD = 2

Movement in three dimensions (left-right, up-down, in-out). CD = 3

Step 2: Add to CD for each secondary dimension of control. Here are some examples of secondary dimensions:

+ 1 For each additional movement dimension (such as strafe back-forth, accelerate-brake, rewind-fast-forward time, etc.) This is typically achieved with two buttons.

+ .5 For each embedded action (such as jump, attack, rotate, etc.) This is typically achieved with one button.

Here are two examples of games and their Control Dimensionality ratings:

Tetris	Half-Life
CD = 1.5	CD = 7
Calculated as: movement on 1 dimension + .5 for the embedded action rotate	Calculated as: movement in 2 dimensions (left-right, in-out) + view in 2 dimensions (left-right, up-down) + .5 for shooting, +.5 for jumping + .5 for ducking, +.5 for weapon change, +1 for swimming.
	Note that there are minor additional control options that have been subjectively ignored.

Notice from the examples that calculating CD involves some degree of subjectivity. This should not skew the metric as long as when a developer calculates CD for different games in a genre the subjective rules are utilized consistently.

Here is a graph that shows the maximum Control Dimensionality for controllers on consoles going back to the Atari 2600. The Atari 2600 has a joystick (+2) and one button (+.25). A modern controller like the Xbox 360 has two joysticks (+4) plus ten buttons (not counting start, back). The only thing the graph is really showing is how controller complexity has steadily increased over time. Designers can choose to layer on more complexity by doubling or tripling up on buttons, or they can use less.

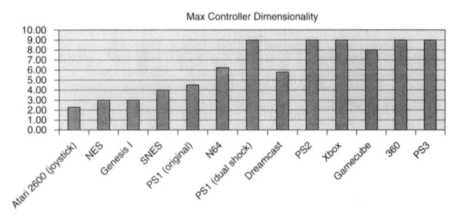

Finally here is a table that lists Activision game titles with their Control Dimensionality ratings. The important thing to examine is the far right column. It shows the CD differential for each title from the competing titles in the same genre. The number is expressed in standard deviations. Notice that the first ten titles on the list are labeled "high-risk." This means high-risk because the CD is higher for those titles in relation to competing titles in the same genre. The bottom two titles are labeled as "low risk" because their CD is lower in relation to competing titles in the same genre. Activision se eks to keep the CD for their titles low in relation to the market because buyers prefer simpler controls.

Activision Titles Sorted by Differential from Competing Products (in Control Dimensionality)

Risk Factor with Control Scheme	Title	Control Dimensionality	Genre	Differential from Competing Products in Genre (in Standard Deviations)
High-risk	*X-Men: The Official Game* (Iceman)	6.75	Driving Combat	+3.75
High-risk	*Fantastic Four*	9.5	Brawler	+3.57

Risk Factor with Control Scheme	Title	Control Dimensionality	Genre	Differential from Competing Products in Genre (in Standard Deviations)
High-risk	*Marvel Ultimate Alliance*	7.75	Brawler	+2.05
High-risk	*X-Men: Legends II*	7.5	Brawler	+1.83
High-risk	*Gun*	8.5	3rd Person Shooter	.59
High-risk	*True Crime 2* (shooting)	8.5	3rd Person Shooter	+1.59
High-risk	*True Crime 2* (fighting)	7	Brawler	+1.4
High-risk	*Call of Duty 2: Big Red One*	8	1st Person Shooter	+1.2
High-risk	*Spider-Man 3*	6.75	Brawler	+1.18
High-risk	*X-Men: The Official Game (Nightcrawler)*	6.75	Brawler	+1.18
Neutral	*True Crime 2* (driving)	4	Driving Combat	+0.76
Neutral	*Transformers* (robot)	6.25	Brawler	+0.75
Neutral	*Ultimate Spider-Man*	6.25	Brawler	+0.75
Neutral	*X-Men: The Official Game* (Wolverine)	6.25	Brawler	+0.75
Neutral	*Guitar Hero 2*	3	Arcade	+0.64
Neutral	*Madagascar*	5.75	Platform	+0.36
Neutral	*Transformers* (driving)	3.5	Driving Combat	+0.22
Neutral	*Quake 4*	7.25	1st Person Shooter	−0.19
Neutral	*Shrek 3*	4.25	Brawler	−0.99
Low Risk	*Call of Duty 2*	6.75	1st Person Shooter	−1.11
Low Risk	*Call of Duty 3*	6.75	1st Person Shooter	−1.11

9.17 Take-Aways

1. Control Dimensionality is a metric that helps developers understand the complexity of their control schemes in relation to competing titles.

2. In general, developers should strive for the simplest control scheme possible.

9.18 Experience Design—Integrate Playcentric Design throughout Development
Source: Game Design Workshop

This final technique comes from the book *Game Design Workshop* by Tracy Fullerton, Chris Swain, and Steven Hoffman (2004). In short, Playcentric Design means designing games with the player experience as the central factor driving design decisions. In other words, the designer is the advocate for the player and makes tweaks to the game in order to provide the player with a better experience.

Best results come from integrating playtesters into the design process from the beginning of the project and continuously testing and refining the work until the very end.

As mentioned at the beginning of this essay, player experience is gauged by observing play testers. The techniques above all provide some means of quantifying player experience and thus can assist the designer in figuring out what tweaks to make in their games.

9.19 Take-Aways

1. Embrace rapid early prototyping, playtesting, and revision throughout development

2. Apply metrics to player experience to help make informed creative judgments

Special Thanks

My USC colleague Dan Arey who conceived of the concept of studying metric-based design and conducted multiple developer interviews for our joint talk on the topic at the 2008 Game Developers Conference.

9.20 References

"About Metascores" Metacritic.com 2008, http://www.metacritic.com/about/scoring.shtml

EmSense, Inc., Corporate presentation, 2008

Michalko, M. (1991). *Thinkertoys*. Berkeley: Ten Speed Press.

Perry, D. (2006). David Perry's Game Designer's Reference Guide, http://www.dpfiles.com/dpfileswiki/index.php?title=DAVID_PERRY%27S_GAME_DESIGN_REFERENCE_GUIDE

Lazzaro, N. (2007). *The 4 Most Important Emotions of Game Design*, Game Developer's Conference 2007 presentation

Bateman, C., & Boon, R. (2006). *21st Century Game Design*. Hingham, Massachusetts: Charles River Media, Inc.

Fullerton, T., Swain, C., & Hoffman, S. (2004). *Game Design Workshop: Designing, Prototyping, and Playtesting Games*. San Francisco, CA: CMP Books.

PART III

FOCUS ON SPECIAL CONTEXTS AND TYPES OF PLAYERS

The Strange Case of the Casual Gamer

Nick Fortugno is a co-founder and President of Rebel Monkey, a NYC-based casual game studio. Before Rebel Monkey, Fortugno was the director of game design at gameLab, where he was a designer, writer, and project manager on dozens of commercial and serious games, and served as lead designer on the downloadable blockbuster *Diner Dash* and the award-winning serious game *Ayiti: The Cost of Life*. Nick teaches game design and interactive narrative design at Parsons The New School of Design, and has participated in the construction of the school's game design curiculuum. Nick is also a co-founder of the Come Out and Play street games festival hosted in New York City and Amsterdam.

Casual games present a new frontier for the game designer. The success of casual games across a variety of platforms—from the standard PC-downloadable format to the infiltration of casual games into hardcore consoles such as XBox 360 to the incorporation of casual game thinking into new console design (in the case of the Wii)—made it clear that a well-made casual game could likely be played by people of all ages, all genders, and all levels of game play experience. The opportunity to design a game that could be played by anyone, another Tetris, is an incredibly appealing one, but also one fraught with design challenges, even for designers fluent in making games for more restricted audiences.

Of course, the term "casual games" is one used in different ways by a variety of people from every side of the game industry, so clarification is in order to determine exactly what we are discussing. There are parts of the game world that limit casual games merely to games available online, while other commentators will point to short RPGs and shooters. What makes something a casual game? Is it a question of medium, of play length, of content, or market reality? All of these things are factors

in the design of a casual game, but when thinking about design, which is the most critical?

In my own design practice, I always begin by thinking about the intended consumer of the design. The intended (or emergent, as we will see shortly) audience brings with it a host of expectations and experiences which inform what they consider intuitive, challenging, and fun. So questions of physical interface, core mechanics, and overall interactive design stem first from who the player is and what they desire from a game.

But the primacy of audience in the design process makes casual games a unique challenge in the game industry, because rather than designing a game for an audience reared on a particular set of game experiences, you must design a game for everyone. The important thing about designing for everyone is that you are **not** designing a game for a particular class of dedicated gamer. I will argue that dedicated gamers have a set of metaskills that transcend the particular games that they enjoy and in which they excel. Gamers are something with which game designers are quite familiar.

The critical thing to consider in the casual game is that significant portions of the audience, and the majority of that audience in the billion-dollar downloadable game market, are non-gamers. The demographics of this non-gaming segment of the downloadable market are women in their forties and fifties; that segment makes up something from 50 to 70 percent of the purchasing audience of downloadable games. Given the typical consumer of games since the inception of digital games (young and male), it is an accurate assessment that many casual game players have little or no experience with digital games and that, independent of games played with children, have limited exposure to games at all as an adult.

While PC downloadable games make up a large portion of what we think of as casual games, we see similar audience segments (although not in as large numbers) in other platforms where casual games appear. A significant number of mobile game users are women focused exclusively on casual games. Microsoft strategy on the development of the Live Arcade system specifically targets how the primary gamer of the house buys the Xbox 360 console, but that non-game playing family members will also use the console for casual game play through the Arcade downloadable service. And perhaps most strikingly of all, the Nintendo Wii has become a gaming device for retirement centers, and people in their 60s, 70s and 80s, perhaps the least digitally savvy age demographic, are active participants in Wii Bowling tournaments and Wii Golf games. Across multiple platforms, casual games have been a gateway for non-gamers to engage in digital play.

The question then for usability in casual games is what design considerations and constraints arise given the relative lack of game experience of the significant portion of that audience. Considering the expectations and play history of that portion of the audience, there are a number of important parameters to the design of casual games:

• Casual game players do not approach games with the same skill sets as hardcore gamers, and thus have different levels of self-motivated exploration and patience for failure.

- The interfaces of casual games are less informed by prior games than by other digital and real-world experiences.

- Information display and feedback that casual games provide require an extremely high level of clarity.

Each of these points is a key component of successful casual game design, and each is explored in more detail below.

10.1 Hardcore Gamers Are from Mars...

One obvious difference between the experiences of hardcore and casual gamers is the exposure to conventions of digital games. Over the years of digital game development, games have developed interactive standards that are recapitulated in genres and evolved as titles add new functionality and reach for new challenges. The standards have become near truisms in hardcore game play: asdw for movement of an on-screen avatar, left analog stick to move and right analog to control camera in console play, health represented as hit points, or inventory screens to manage equipment. These interactive features have become so standard that in many cases games no longer need to offer tutorials or in-game help to explain them. An experienced gamer often requires nothing more than the genre of a given game (military FPS, real-time strategy game) to know most of the core game controls of it (mouse-to-look and keyboard-to-move, mouse-click a unit to select and get more information). The collected knowledge of these interactive conventions is a core part of what makes someone a hardcore gamer.

But knowledge of genre-specific game control schemes is not the only thing that gamers pick up in their years of gaming experience. In fact, one of the key features of games is the way in which games are learning systems. As James Paul Gee explains in his insightful book *What Games Have to Teach Us about Learning and Literacy,* all games teach players as a natural part of the play process. When players first encounter a game, such as a platformer like *Super Mario Brothers*, they immediately begin to experiment with and analyze the system the game presents. Some of that experimentation takes place at the physical level of which button causes Mario to jump and what Mario does when the down arrow on the directional pad is pushed. That's only one part of the learning, though. Moving in from the controller, players must also learn the nuances of the mapping on the controller to the avatar: how many pixels Mario rises when he jumps and how much screen movement results from a tap of the controller. Beyond that, there is the behavior of the enemies (how fast is a Koopa Troopa compared to a Bullet Bill?), the geography of the levels (where are the enemies? Where are the coins?), and at the most advanced level, what are the game strategies (what is the best combination of moves to defeat said enemy? What is the best route to complete the level with the most points?)

The above analysis holds true for all games, from the most complex PC simulation to the simplest Web game. All games are systems that are to some extent unknown to players at the game start and that players learn and master through continued play.

More complex games offer more challenging and deeper learning environments, but the basic learning principle exists regardless of complexity. Nonetheless, there are two significant ways in which hardcore games differ from casual games in terms of learning, and this set of differences informs the difference in these two-player groups, and thus the differences in usability that must be considered in these design processes.

First, the primary teaching technique of hardcore games is trial and error disciplined by failure. Taking the Mario example a second time, the way a player learns how to defeat a Hammer Brother is by trying to do it. Most likely, the player fails the first few times to figure out how to avoid the hammers, and Mario dies. The player is expected to try the attack multiple times, and fail multiple times, before figuring out the proper approach. This pattern is repeated for every enemy and every board, which means in a typical Mario game, Mario can die many, many times. Mario is not unique in this regard, and Mario is nowhere near the most complex or unforgiving game one could play. This means that a typical hardcore gamer has played through a number of tough games, and has become accustomed to harsh penalty as a component of game learning.

This conditioning to failure as a part of the learning process leads to the second significant difference: the hardcore tolerance for frustration. Since failure is such an integral part of so many digital games, these games both select for and train gamers who accept and enjoy the challenge of threat of loss as a result of experimentation. This breeds a kind of player who is interested in exploration and experimentation, who is patient through periods of confusion or difficulty, and who is often willing to struggle with a clumsy control scheme or unclear interface in a play experience. In fact, part of the fun is that very struggle.

We can sum this up with a series of observations about what a history of play creates in a hardcore and core base:

- Gamers are regularly tasked with learning complex, unforgiving systems that require exploration and repeated experimentation for victory.

- Playing many of these games exposes players to a number of gaming conventions in terms of physical interfaces and information displays.

- In addition to this specific game knowledge, players with this background have been trained to experiment with control schemes and explore the geographies and world laws of these spaces. This is understood to be a core part of the experience of playing a game.

- Alongside this expectation of experimentation is an expectation of failure. Players with a good deal of game experience tend to be more patient with failure and more tolerant of frustration and struggle.

- While this kind of player conditioning allows for an increase in the amount of complexity and difficulty a game can have, it also can allow a game to get away with significantly less intuitive and sometimes even broken interactive elements. Players may tolerate a certain degree of faulty interactive design as part of the challenge of the experience.

10.2 Casual Gamers Are from Venus

The previous section outlined the learning process that gamers go through in regards to game usability. This process is in large part conditioned by the design of more hardcore gamers. But a major part of the audience of casual games has not had that game history. The lack of exposure to these earlier games leads to a whole other approach to game play.

An interesting point to keep in mind when considering the development of casual games is that the original PC downloadable game sites that remain the primary distribution channel for casual games were not initially intended to market to women in their forties. When game portals such as the Real Arcade and Shockwave.com first appeared, they assumed that their player bases would be the same as other game markets: young men. When games such as *Bejeweled* (or *Diamond Mine* as some early versions were called) and *Collapse* were found to be played by a majority of older female players, everyone was surprised, and both game developers and portals retooled their designs and marketing to aim at the audience that made those early games blockbuster successes. Since that point, casual game portals have redefined their consumer as a non-gamer who played casual games.

Of course, the connection between non-gamers and casual games wasn't expected or premeditatedly constructed by the new group of players either. It's hard to imagine that as people who did not play digital games they would have gone searching on the internet for a game experience they did not know existed. Therefore, the most likely scenario is that the discovery of casual game sites and the growth of the casual downloadable game market was something that emerged as a result of a web surfing process. It was only after a certain critical mass was reached and portal marketing money went toward attracting older women to game sites that these players were actively pursuing these games.

But if this is an accurate picture of how the casual game player came into existence, there are lessons to learn from how casual gamers learned to play games. One clear point is that casual gamers came to games first as *internet users*. They did not think about the computer as a game-playing device as much as a Web-surfing device. And even when casual games became prominent enough to be a primary use of a home PC, the experience of casual gamers (either because they discovered the first game as Web surfer, or because they deliberately went to a game site that had developed around the former group) was primarily framed in the experience of internet activity rather than the previous game history.

This difference in experience shaped a player with very different skills and expectations. First and perhaps most obviously, casual players did not grow up with an interactive language established in a thirty-year gaming canon. Keyboard navigation commands and three-dimensional conventions had not been established in previous game plays, and thus casual gamers did not have the easy, intuitive access that more core gamers had to game conventions.

But perhaps more importantly, casual gamers had not been conditioned to deal with failure in the same way as core gamers. If you approach a game from an

internet perspective, the idea that a game would present frustrating obstacles and confusing interfaces would not be acceptable as a play experience. Instead, the very struggle that a more hardcore gamer found to be enjoyable would instead be seen as exasperating, off-putting, or simply too difficult. Frequently dying, particularly in the early part of the game, would be a flaw in the game experience rather than an incentive to try harder.

This different set of expectations would lead to different set of design criteria. The games would be significantly less complex and less punishing. But more important for the question of usability, the control schemes, feedback structures, and information architecture would all be designed to create a more intuitive system. The game would still be a learning environment, but the learning methodology would be less open-ended and more guided. The combination of these factors would lead to shorter, simpler games that were more easily accessible to people who had not played digital games before—in other words, casual gamers.

As the audience for casual games continued to grow and more casual games were developed, a set of parameters around casual game design and usability in casual games began to emerge. These usability issues cluster around a few different topics: game control schemes, user feedback, and game instruction.

10.3 Game Control Schemes: Familiar Interaction

The first place we see the effects of this alternate approach to gaming is in the control devices that casual games use. The non-gamer audience of casual games is famously unfamiliar with the typical console controller. The original XBox controller was particularly vilified for being too big for women's hands, but that claim ignores the core problem. Game controllers are typically condemned for having too many joysticks and too many buttons—in short for being too confusing. Casual games, regardless of platform, require users to be familiar with relatively simple controls.

10.3.1 *Casual Games and the Left Mouse Button*

In the PC downloadable/Web segment of casual games, the control scheme tends to be mouse-centric. The vast majority of online downloadable games are played with only the mouse position and the left mouse button. This principle is so standard in the casual game industry that in an industry keynote at the Casual Connect Europe conference in Winter 2006, PopCap co-founder Jason Kapalka dedicated a whole section of his "10 Ways to Make a BAD Casual Game" to the problems with using the right mouse button. Despite the diversity of game mechanics and play styles found in casual games, the left mouse button rule remains the standard.

The dominance of the left mouse button is unsurprising given the way that casual gamers were first exposed to games. If web browsing was the method by which these players first came to the games, it makes sense that the control method

they would gravitate to games that used the control scheme they used for that web browsing. By doing so, casual games avoided the learning curve that the controllers in other games regularly face: just figuring out what one of a multitude of buttons does.

That said, the use of the mouse in casual games takes a variety of forms. In games such as *Bejeweled* and *Collapse*, the mouse is used in a fashion typical to general internet use; the left mouse button interacts with, by grabbing or deleting, the object the mouse is over. In other games such as *Ricochet: Lost Worlds* or *Feeding Frenzy*, an in-game object is mapped to the mouse's movement, so that the paddle and the fish (respectively) move in a similar way to the cursor. Click management style games including *Diner Dash* and *Cake Mania* use the player's left mouse button click to determine the position an avatar will move to. Still other games, such as *Lemonade Tycoon* or *Fairy Godmother Tycoon*, are about menu navigation and the mouse is used in an entirely typical way, selecting an object from a list. These are a handful of kinds of interactivity seen in PC downloadable games, but almost all of these games are exclusively left mouse button play.

It is interesting to note the dominance of the left mouse button as the sole control even when that style of interactivity is less efficient than other methods. For example, the game *Turtle Odyssey* is a game of the platformer genre—the player controls an avatar that needs to navigate a two-dimensional space by jumping over holes and defeating enemies (often by jumping on them). *Turtle Odyssey* is fundamentally identical to Mario games and the literally hundreds of platformers that have appeared since, almost all of which relied on a directional pad control for movement. The directional pad is a good control for these kinds of games, because precise position of the avatar is often important, and a directional pad can, in skilled hands, provide a player with the ability to make small tapping movements for fine control. Nonetheless, despite the obvious utility of arrow keys to this kind of play, *Turtle Odyssey* also includes a method of playing the game using only the mouse. Even though the use of the mouse in this game is awkward and players would have more fun with the game if they were forced to use the arrow keys, the developers of the game are attempting to broaden the game's appeal by sticking to the physical interface that its player base understands.

Of course, there are a handful of successful games in the downloadable market that deviate from the left mouse button formula. The *Super Granny* brand is another set of downloadable platformers that force players to use the arrow keys to play. There are also a few successful games that use the right mouse button. The genre of inlay games, in which players solve tangram-like puzzles by using pieces that appear on a conveyor belt, have a now standardized approach to interaction: left-mouse button to pick up and place a shape, right mouse button to rotate the shape. However, even successful games that attempt to use the right mouse button sometimes fall into the same interactive trap. A classic example is the puzzle game *Zuma*. In *Zuma*, the player can use the right mouse button to switch the current ball with the next ball in the cue. But despite the fact that the game tutorial, help screens, and game tips explicitly detail this functionality, many *Zuma* players never

use, or in some cases discover, this feature. So even games with elegant controls that offer players real advantages can be ignored by casual gamers if they deviate from the control schemes that players understand.

10.3.2 *Peripherals for the Casual Gamer*

Downloadable games are not the only platform in which we see this interface design issue with casual gamers. Nintendo has been a company that in the last few years has targeted casual gamers, and its two most recent platforms, the DS handheld device and the Wii, have physical interfaces that are manageable by non-gamers. On the DS, there have been a number of games that have crossed over the gamer line and appealed to a brand new handheld player base. Three of the critical games in this movement were *Nintendogs*, *Brain Age*, and *Cooking Mama*. All three of these games deviate from traditional handheld control schemes, relying on a variety of ways to use the drawing and mouse-like tapping ability of the DS stylus and touch screen, and the DS microphone input. In *Nintendogs*, the player interacts with the dog by "petting" it with the stylus and talking to it through the microphone. *Brain Age*, a game that lead senior citizens to buy the DS, employs mechanics that requires the player to write numbers and words, and occasionally speak an answer to a question into the microphone. (On a related note, the display in *Brain Age* forces the player to orient the DS sideways, like a book, a move that Nintendo deliberately made to make the game more appealing to the seniors.) And the gameplay of *Cooking Mama* has the player mimic the cutting, stirring, and other actions that are part of real-world food preparation. All three of these games ask players to do physical actions with which they were already familiar (petting, writing, cooking) to play the game, and that intuitiveness of the control scheme is part of the appeal of these games to non-gamers.

The Wii takes this idea of real-world analog to game action to a further extreme. The success of *Wii Sports* with retirement homes is an undeniable sign of that game's success with a deeply non-gamer audience. But what *Wii Sports* provides is a very close mapping to the real-world activity it simulates. So to bowl a ball in *Wii Bowling*, the player must make a motion with the Wiimote that emulates bowling (an underhand toss of the ball); in *Wii Tennis*, the player swings the Wiimote like a tennis racket. The comparison between the real sport and simulated one does not stop there. The movements detected by the Wiimote for the *Wii Sport* games are mapped to what creates successful moves in the real sport. For example, if a player does not follow through with a swing in *Wii Tennis*, the ball will go wide, just as it does in actual tennis when a player fails to follow through. Similarly, the exact position of the player's wrist in *Bowling* or the precise speed and angle of a player's swing in *Wii Golf* is factored into the success of the move. What this means is that a player with real experience in one of these sports can bring that experience directly into the game and excel after only a short adjustment period. The player's familiarity with the movements and the resulting intuitiveness of the play allowed the game

to reach an entirely new market of non-digital game players that were versed in the real-world versions of these sports.

We can even point to games on hardcore systems that have had non-gamer crossover which show a similar move to a more intuitive physical interface. Take the recent success of *Guitar Hero* and *Rock Band*. Both of these rhythm-action games are in many ways extremely similar to earlier Harmonix games *Frequency* and *Amplitude*. All four games involve songs that are mapped into a series of colored spots that are then organized into tracks that scroll towards the player. The player must hit the button corresponding to the colored spot when the spot reaches a line on the screen. Despite this nearly identical play, *Frequency* and *Amplitude* were only played by hardcore gamers, whereas *Guitar Hero* and *Rock Band* enjoyed widespread success with both core and casual gamers. The primary difference between these games is that *Frequency* and *Amplitude* used the PS2 controller, while the more successful games mapped the buttons on to a fake guitar and drum kit. The move to a more intuitive physical interface made an identical gameplay accessible to a whole new audience.

The point here is that beyond the simple lack of experience with the traditions of game interactivity, non-gamers lack familiarity with even the most basic control schemes that have become standard in game play. In the absence of this experience, non-gamers rely instead on the interactivities which they find intuitive: control methodologies from internet use and analogs to real-world actions. One key to successful casual game design is remembering the experiences of the casual game audience, and creating interactive systems that will be intuitive to that audience.

10.4 User Feedback: A Different Sense of Failure

The second piece of the usability puzzle as it relates to casual games is connected to the different experience that gamers and non-gamers generally have with frustration. As discussed previously, digital games have typically used failure as a teaching device. Players are expected to explore and experiment in order to determine how the system works. At a certain level of difficulty (depending on an individual player's skill or experience), this becomes a trial-and-error struggle against the limits of a player's ability or the answer to a gameplay riddle. It is in that moment that players experience frustration.

Insofar as all games are about the player struggle in an artificial challenge, this learning process and the potential for players to become stuck and frustrated is as possible in a casual game as in any other game experience. All games struggle with the issue of player frustrations, and game developers in every discipline must dedicate time to making the experience simple and clear. Nonetheless, casual game players have a different tolerance for frustration, given that most non-gamers are not accustomed to interactive systems that are built explicitly to be intuitive and transparent. So casual games have evolved a number of design principles to help remove confusion, guide play, and avoid frustration. Two of the most significant principles

are the use of micro-rewards as encouragement and the emphasis on clear in-game feedback.

10.4.1 *Making Every Player a Winner*

One obvious way that casual games differ from hardcore games is in the amount of positive visual feedback. In casual game development circles, this is called "polish" or "bling." Casual games tend to abound with rewards from every player action. A striking example of this reward inundation is the PopCap game *Peggle*. *Peggle* is a pachinko-style game in which a player drops a ball attempting to hit certain pegs and finally land in a valuable bucket at the bottom of the screen. The gameplay is largely random as it is extremely difficult to see where the ball will go after two or so bounces, and it is easy to repeatedly miss the needed pegs, so the potential for failure is high. However, *Peggle* counteracts this direction with an abundance of reward effects.

Every time that the player's ball hits a peg, the player scores points, accompanied by a flashy disappearing-peg graphic and punchy sound effect. Hitting a bonus peg or a goal peg has all of these effects at a greater intensity. The rewards ramp up even further when the player completes the level goal. The game zooms in on the ball as it collides with the final peg in slow motion. The words "EXTREME FEVER" flash as the "Ode to Joy" plays. A rainbow shoots across the screen and a series of bonus points quickly accumulate to the sound of ever more rewarding beeps. The overall effect most closely resembles the jackpot of a slot machine: a cacophony of reward sounds and color.

This game is an extreme case, but it points to a common direction among casual games. Much of Peggle is functionally unknowable due to the complexity of the ball's physics, and this can lead to a frustrating play experience. But the emphasis of the game's feedback is on the things that go *right*—the points earned, the good shots–even if those elements are as much determined by luck as the failures. (It is also interesting to note that there is much less feedback when a ball is a failure; there is only a quick bit of negative audio feedback and then the game continues to the start of the next ball.) The emphasis of the feedback is further reinforced in other elements of the game: the clear indication of the progress through levels on the Level Complete screen, the instant replay button for power shots, and the fanfare surrounding the acquisition of a new character. The game's focus is clearly on rewarding the player for success and not on punishing the player for failure.

The idea of emphasizing success over failure in a video game seems an obvious statement, but the degree to which casual games do it draws attention to how different they are in this regard from other kinds of games. For example, if one looks at a typical hardcore game (from first-person shooters to real-time strategy games to action games), the average successful action passes with relatively little fanfare. An individual unit is defeated without comment, and the defeat of an enemy has no further reward than a short grunt and a collapsing body. A sense of achievement is

saved only for longer-term victories such as level completion or the defeat of a particularly powerful enemy, and in some more immersive games (such as *Bioshock* or *Half-Life*) even those moments are denied a powerful moment of reward feedback in order to preserve narrative consistency. Failure, on the other hand, has dramatic consequences. The game abruptly stops with an ominous or mocking tone while new screen boldly declares "Game Over!" with the occasional accompaniment of dripping blood or camera fade to black.

This is clearly a generalization about hardcore games; there are games that are hardcore that offer more frequent rewards or less punishing failure. But many hardcore games do follow this model, and in doing so, they teach players a lesson about achievement. Short term achievement is something in which one should not put much stock; reward is earned only for major and sustained victories. Failure is noted and punished. This structure further conditions players in a hardcore mindset, where the game is perceived as a struggle to be completed in which rewards must be earned.

Casual games, as exemplified by *Peggle*, take the opposite approach. Every minor success is rewarded. Each time a brick is destroyed, a gem is eliminated, a customer is served, or an object is found, the player earns points. The points are always displayed on screen along with reward sounds and graphics of the points being added to the total or of the game object exploding from the screen. In a game such as *Diner Dash*, points are given for every single action the player does, from seating a customer to collecting their dirty plates, and in that sense every action is a positive one. Casual games still have level-achievement awards with their own corresponding effects, but the moment-to-moment play is filled with micro-rewards that regularly congratulate the player on good (or, in some cases, lucky) play. On the other hand, failure at the level of an individual action is often de-emphasized. Failure sounds and effects are more minimal, and often losing a game is nothing more than rapidly restarting the level.

A similar philosophy is at work in the greater reward structures of the game. For example, the vast majority of casual games ask the player to move through a series of separate levels to win. In games of this sort, the levels are almost always short (approximately 3 to 6 minutes long) and displayed on a central map screen as a kind of checklist. As the players complete levels, they are regularly brought back to the level screen to see the list of accumulated stars. In many games, notably the click-management genre of games such as *Diner Dash*, each level also gives the player an additional trophy for level completion: a new powerup, an additional character, or even a purely visual improvement such as better wallpaper for the restaurant or a new outfit for the character. So just as there are an increasing number of rewarded moments in an individual level, the short duration of levels, the use of the level map as a literal progress checklist, and the often used unlocked trophies at every level extend the focus on achievement to greater chunks of play.

By using these methods, casual games are attempting to diminish the sense of the game as a frustrating struggle toward eventual victory. Instead, by spreading rewards throughout the game experience, the game's design changes the moment-to-moment

feel from one of struggle to one of regular achievement. The game is not a long slog through obstacles; it is a series of short-term moves that the player regularly achieves. And since the player is regularly achieving, the feeling is less one of irritation at not achieving goals than one of confidence at constant achievement.

Nonetheless, there is a final caveat. For all of the focus on achievement, the fun of games still arises from challenge. If the game becomes too easy or the achievement too unrelated to what players actually did, players will become bored and disenchanted. A good example of this problem can be seen in the original *Arcadia* downloadable game. The game has an innovative mechanic in which the player plays four simple mini-games at the same time. The player's score is the product of the scores of the four games. Of course, playing four games at the same time has a steep learning curve, so the easy mode of the game was designed to be extremely simple. Given that the four scores were multiplied, this meant that the player's score in the easy mode could be astronomical, reaching the quadrillions, on even a decent game. While achieving scores this high was a thrill for the first group of players, eventually everyone realized how easy it was to achieve to get a ridiculous score and became embittered, claiming that the game was no fun because it was too easy. So as much as achievement is important to casual gamers, it is equally important to retain some degree of challenge and struggle to keep the game interesting.

10.4.2 *Avoiding Confusion through Transparency*

Interface design and regular game feedback is another area where casual games have traditionally strived for simplicity and clarity. Interactive systems have a tendency to increase in complexity as users get more familiar with them. Games are no exception. As players get accustomed to the standard features and displays of a game, they begin to internalize those elements and can process the same information in a less explicit way and in more precise detail. As a result, certain interface elements, such as timers, can become very small and unobtrusive, while other elements that involve a lot of decision making, such as inventories or party/team management, can be moved to separate screens and exploded in complexity. Neither of these trends is beneficial to the casual gamer. Without the experience of lots of similar games, casual gamers need much more explicit feedback to avoid confusion.

One example from my own design experience occurred in the development of the downloadable game *Plantasia*. In *Plantasia*, the players earn points by growing and harvesting flowers, which are then spent to restore parts of a garden. To win a level, the player must restore a certain number of garden statues before time runs out. This makes the timer in *Plantasia* a critical game element which players need to monitor. We originally designed the timer as a sundial-like object occupying a small corner of the interface. We also include an effect where the lighting of the level would change as the timer progressed. However, in testing, players complained that time was running out in the level without any warning. We were surprised by this result, and assuming we did not make it clear enough that there were time limits

in the level, we re-wrote the copy to emphasize the time limit and had a tutorial bubble point out the timer. There was no change in player feedback. We then went through several different designs of the timer. Still, players did not notice the timer. We finally changed the timer to a clock and introduced text that popped up over the screen to warn the player at two different points that time was running down and that the level was almost over. It wasn't until we took the drastic measure of making the timer literal and effectively shouting warnings at the player that players began to consistently recognize a core game element.

This experience taught me a number of lessons about casual game design. The most important of these lessons was that hardcore gamers have training in handling rapidly changing complex information that casual gamers do not. This means that in the chaos of a reasonably complex game, a casual gamer will not necessarily remember information that is immediately evident, even if that information is essential to successful play. As a result, casual games tend to have interfaces that dramatically display the critical game elements. Huge time meters and giant flashing point displays are often the order of the day. The flipside of this strategy is to move as much of the game information to the main play area as possible. Thought balloons of character desires, glowing squares to mark next moves, and (as in the case of *Plantasia*) warnings and announcements flashed over the main game stage make it impossible for the player to ignore what is going on. Casual games use these dramatic techniques to ensure that the player does not miss a vital piece of information.

A similar design philosophy applies to the general user experience of a casual game. For example, very few successful casual games allow players to navigate their way through different game screens by their own whim. In games in which players do need to make decisions on different screens, the game usually controls the movement between screens, determining which part of the game the player will experience at a given time. A good example of this design can be seen in sim games such as *Insaniqarium* or *Fairy Godmother Tycoon*. In both of these games, the player uses a set of resources (pets and recipe ingredients) to navigate a level of play. The screens in which the players choose their inventory are complex, containing many different possible combinations. The games control this complexity by forcing the player to make the decisions about the resources and then the use of the resources in two distinct steps. Every turn, players first choose the resources they want, and then they deploy the resources. Because players cannot go back and forth between these screens at will during play (as they could in a more core sim such as *SimCity*), the confusion of too much information is drastically reduced.

It is also important to point out that detailed instructions do not necessarily make complexity more manageable. One way in which casual and hardcore gamers are similar is that neither reads help text with any regularity. Assume immediately that the help screen in a casual game is for a very small minority of the player base, and that even in that small group, most are only looking at the help page for the art. Tutorials are a much better solution, as they force the information in front of the player, but if the tutorial is something that the player reads and clicks through, there's a very good chance that the player will click through it with only a skim, if

they bother to read it at all. The best tutorials for casual gamers are ones that lock the game screen until the player performs the necessary action, but players will still get frustrated if they are stuck in a limited tutorial for too long. It is always preferable in a casual game to have something simple that requires less explanation than to try for something complex and hope that text will make it clear.

The basic point is to remember that these are *casual* games. Casual game players do not expect to keep of hundreds of minute variables in their minds at once, and they focus most of their play attention on the most prominent game elements. This means that casual games need to bring whatever information they require to convey to that main stage and either deemphasize, compartmentalize or eliminate complexity that cannot be displayed there.

10.5 The Rise of Hardcore Casual Games

Having given all of these warnings, it is also important to remember that *all* interactive systems evolve towards more complexity, and casual games are no exception. *Bejeweled,* the game that is usually credited with beginning this recent wave of casual games, was released in 2001, so the casual game market has had seven or so years to create a player base. Also, given the try-before-you-buy model that casual games adopted, casual game players have often tried many more games than they have bought, so there is certainly a strong foundation of experience in the casual game market. These factors would lead one to expect that casual games would themselves become a tradition with its own path of more complex evolution. Looking back over the history of games verifies this expectation.

The easiest example to demonstrate this fact is the development of the match-3 mechanic pioneered in the downloadable space. *Bejeweled* is an extremely simple and straightforward game; the entire game consists of the same single element, swapping two adjacent gems to make a set of three or more, without any modifiers, power-ups, additional goals, or framing elements. Many additional match-three games have appeared in the casual game market since *Bejeweled*, but few of them, particularly recently, have matched that level of simplicity. The game researcher Jesper Juul has conducted an extensive study of the evolution of the match-3 game which demonstrates this point clearly. By the time we see *Big Kahuna Reef,* we see match-3 games that have already made a number of changes: background tiles that need to be changed to beat a level, irregular board shapes, and power-up squares. *Jewel Quest* also added a narrative to the match-3 genre, extending its complexity in another way. In 2008, no match-3 game is released without some of these extensions. Perhaps most telling of all, when *Bejeweled 2* was released, even it had power-up squares and a loose space travel metaphor to make it a richer experience. The fact that all of the games mentioned here have been commercial successes is a clear sign that the audience for match-3 games has grown in complexity since its origins in 2001.

Of course, is not the only example of the increasing tolerance for complexity in casual games. The most striking case is the evolution of the hidden object

game. Hidden object games ask the player to look at a complicated, cluttered picture and find a series of particular objects. In the original downloadable version of these games, *I Spy*, there was nothing more to the game than the above mechanic. However, as more hidden object games appeared, additional elements began to be added to the mix. Games such as *Mystery Case Files* and *Mysteryville* introduced narratives to the mechanic, where the object finding became a vehicle for a mystery story. These games also introduced other kinds of visual logic puzzle mechanics as interstitial games, such as tile sliding puzzles or picture matching games. But the most interesting evolution can be seen in the later games such as *Azada*, *Dream Chronicles*, or *Hidden Secrets: The Nightmare*. In these games, a level will start with a hidden object mechanic component where the player needs to find a handful of objects that either change on mouse-over or that appear on a list. However, once players find the objects, they can combine them to make new objects, or use them on other objects in the environment to access new spaces. This play mechanic is then combined with a series of simple logic puzzles, and success in these game activities slowly unlocks a narrative. These games are more like *Myst* than *I Spy*; amazingly, the hidden object genre is evolving into the old adventure game from years ago! The fact that these games are among the highest-selling games in the downloadable market means the audience has grown to the point where a fairly complex (and perhaps even slightly hardcore) game genre is an acceptable choice. At the time of this writing, these are all recent changes; only time will tell how far down the adventure game road casual audiences are willing to go.

In addition to this evolution, the casual game space is also bearing more complex game styles as successes. The game *Build-a-lot* is a more sophisticated sim than the downloadable market has seen. In *Build-a-lot*, the player must build a set of houses using seed money, and then use the rent from those properties to enhance and expand their real-estate empire. The interface of the game resembles a more core PC sim, with several tabs for different kinds of resources, and unlike the sims mentioned previously, *Build-a-lot* forces players to make purchases during the course of their building play, so the player must weigh both the acquisition and deployment of resources at the same time. This marks a significant increase in sophistication from previous casual sims. Other games such as *Tradewinds* and *Chocolatier* have brought a trading game mechanic to casual players. In both of these games, player must pick up and trade different resources across a world map. Players must keep track of several simultaneous quests, the ports where different commodities can be found, and the markets where those goods can be sold for profit. The games require players to retain information across several screens, each of which can have multiple displays. All three of these games require a greater tolerance for complexity and information management than previous casual games, and thus demonstrate a changing face of the casual game audience.

As the market is only seven years old, it's hard to predict exactly how far casual games will evolve in complexity towards the levels of core and even hardcore games. The arrival of casual games on platforms such as the Wii, Nintendo DS, and XBox 360 certainly points to a bridge between these categories. And the success of

more sophisticated games, both as the evolution of early games and the arrival of more core genres to the casual space, indicates that some of the "non-gamer" audience that makes up of the casual game market is becoming a type of gamer after all.

10.6 Conclusions

Casual games are at an exciting moment in their history. Casual games are present on every game platform, and even in the hardcore console space, casual games rank among the most successful products on sale. The audience for casual games is growing each year, and the fact that these games are played by all kinds of gamers, from the hardest core to the least experienced, means that a good casual game could actually be played by people of all ages. The reach of casual games is by far the widest of any part of the game market.

But as we have seen, the fact that casual games appeal to all kinds of players, particularly non-gamers, creates a set of particular concerns and constraints that influence the design of these games. Play cannot rely on the time-honed conventions established in the rest of the game canon. This doesn't simply mean that the interactive conventions of hardcore games cannot be taken for granted; there are also a series of tolerances and expectations that hardcore gamers share, but casual gamers lack. This means that casual game design must first consider the least experienced players, and create systems and mechanics that are universally accepted. Mechanics must be intuitive. Interfaces must be clear. Achievement is prized over struggle. Above all, designers must create games that challenge players without confusing or frustrating them, by using the devices, styles, and interactive languages in which the players are fluent to come up with new manifestations of play and fun.

Of course, casual games will continue to evolve, and the more games these players try, the more refined their gaming skills will become and the more complex and challenging system they will demand. It's impossible to predict exactly what this new breed of gamer will desire. Will today's casual gamers gravitate towards the core and hardcore genres that have already been established, or will they create a whole new kind of "hardcore casual" experience? The evolution is inevitable, but it's up to today's designers and players to determine what games we'll be playing in the next few years.

(Editors' note: See the Interview in Chapter 11, for some thoughts from a casual games company about the merits user testing and their particular strategies for when and how to do tests.)

Interviews about User Testing Practices at PlayFirst®

PlayFirst

PlayFirst is the leading publisher focused exclusively on casual games. The company's game portfolio includes the *Diner Dash®* series, *Wedding Dash®, Chocolatier®,* and *Dream Chronicles®.*

We asked PlayFirst to give us perspectives from multiple team members about user testing and how it works at their company, to provide readers with a multi-faceted understanding of how one casual games company uses some of the methods described in this book.

Craig Bocks, Director of Publishing

What is your company's general approach to handling customer feedback about games?
Customer feedback and player usability are a critical part of the successful product design and development formula at PlayFirst. By listening to our end user at various times throughout the process of making each game, we are able to create the best possible game play experience. For each game, we make it an important focus to solicit and react to player feedback in a number of different ways, which is evident in several of the best practices at our company. We target specific user demographics when doing the up-front game design, test and react to player input during the development of each game, and respond to the feedback once the game is out in the market.

Do you conduct usability studies of your games during production generally? What kinds of studies? What about post-production? What kinds of studies there?
Each project uses the following means to handle customer feedback about our games.

- Game Panel Testing—local users register to participate in short game play sessions at our offices, in order to give input, evaluation, and comments on in-progress games. These are one to one tests carried out between the game leads and the end user.

- Third-Party Usability Testing—focus group participants attend a 30- to 60-minute usability session moderated by an objective professional usability company. A written analysis and discussion on player response and reaction is carried out.

- FirstPeek Testing Program—registered users of this program are sent a version of each PlayFirst game that is near complete, evaluating it and providing feedback through a survey response and measured game play metrics. Summary reports of each set of feedback is compiled and used to make final decisions prior to a game's release to market.

- Website Forum—as each game launches, discussion typically ensues among the active members of the PlayFirst website community, where game play reactions and feedback on specific game features are shared. Game teams monitor these forums for trends in customer feedback that would require attention. Other means to solicit post-launch feedback come through our customer support department (reactive—typically used to respond to a technical problem) and our marketing department (proactive—typically used to run surveys and solicit response to a game feature).

What sorts of issues and opportunities have these sorts of studies allowed you to uncover?
Depending upon the stage in the product's development cycle, we can uncover a wide variety of issues and/or opportunities. For example, during a usability study in the earlier stages of development we might determine that a feature we designed for the game needs to be improved, revised, or even removed. At a later stage in development, for example during our beta testing, the focus of the feedback is typically centered on how the game increases in difficulty from level to level and we'll make final adjustments based upon the trends shown by a large sample size of users.

- An example of the first type of feedback from our hit product *Diner Dash* would be the noisy customers that were planned for the sequel in *Diner Dash 2* as another thing that Flo has to serve in her restaurant. During the study players reacted negatively to cell-phone yakking customers and did not know what to do with them; yet players had the opposite reaction to noisy families. Even though the two customer types worked essentially the same way, players loved the families and immediately knew how to respond to them in the game. As a

direct result of XEODesign's* study, PlayFirst swapped the order of these two customer types so that the families appear right from the start to get players excited about this new challenge in the game. XEODesign's observations of these subtle moment to moment player reactions to player actions are easily lost in a post-play focus group or survey. Diner Dash's one million paying customers is further proof that emotion works well in casual games.

Would you recommend doing this to others in your genre space? Why so (or why not)?
Usability is one of the most important parts of the game design and development process for our company. PlayFirst has placed a great deal of emphasis on integrating best practices that focus on getting consumer feedback on our games. We would fully endorse a well rounded program that solicits input in a number of different formats from users at various stages of a project's life cycle. The time and money spent to listen to the people that buy our products is always well spent.

Aaron Norstad, Senior Producer

When you worked on The Nightshift Code™, did you use player testing/usability studies of any kind? How so?
While working on *The Nightshift Code* we did a Usability Study at XEO Design with seven 1-hour moderated test sessions. The game designer along with the PlayFirst Publishing team watched in person, and the developer's executive producer patched in via video conference. We had a long, full day of studies, with multiple debrief sessions throughout the day and at the end of the night had an entire blackboard of immediate take-away issues for us to begin addressing.

What sorts of things did you learn as a result?
Usability testing is always so interesting because you start off with top line issues, and often discover an entirely new set of larger problems. Specifically with *The Nightshift Code*, we went into the study knowing we had some user interface concerns around a fairly sophisticated puzzle, but we didn't understand the full extent of the problems. After watching one person after another struggle with the puzzle and say they would stop playing because the game made them feel inadequate, we knew we had a major problem. However, because we were able to watch the positive and negative reactions and probe the players as they were testing, we learned they were very excited by the concept of the puzzle, but were completely lost with how to play it. Instead of scrapping the puzzle altogether, we rewrote the tutorial, made some art and content changes, and then continued iterating on it. Now that the game has shipped, we have data from hundreds/thousands of users saying they love the puzzles!

*Chapter 20 in this book outlines a theory of fun types by the CEO of XEODesign, Nicole Lazzaro.

Would you recommend doing this to other developers? Why so (or why not)?
Usability is invaluable. It's not a question why or why not, but rather *when*. The time, money, and resources spent on usability will easily pay off once your game ships; provided you take the time to address design changes. PlayFirst has been able to maximize the results and the effectiveness of usability by doing it early in alpha. In alpha, we have a fairly solid and somewhat polished first hour of game play and thus are able to go into usability and allow users to sit down and play through the first five to ten levels, and even jump forward to test advanced features.

The great thing and perhaps the obvious advantage of usability is just dedicating a full day to completely focus on usability issues. Informal play testing is great, and the point isn't that six or seven people performing a usability study will have all the answers and uncover all of the problems, but the focused time of having the entire design team altogether watching a professional third party team test and evaluate a game is incredibly eye-opening.

Anything else you'd like to add about game usability and player testing in general?
Continuing from the point above, as a publisher who has a history of making great games, it is second nature to push a developer to make changes with the goal of improving the quality and ultimately increasing the sales potential of a game. Conversely, it can be really difficult for designers to respond to design changes, especially when they are so passionate about a project. Usability then provides the opportunity for everyone to learn the unbiased feedback about what is working, what needs to be tweaked, and what is just simply broken.

Angel Inokon, Producer

When you worked on Wedding Dash, did you use player testing/usability studies of any kind? How so?
The PlayFirst culture places a high value on player feedback throughout development. One of our top games, *Wedding Dash*, shines as an example of the power of player feedback. At about alpha when the game was functionally complete, we sent it to XEODesign to perform in-depth usability testing.

What sorts of things did you learn as a result?
We received surprisingly polar results on a couple key indicators. Players gave the game an overall rating of less than 5 out of 10. However when asked to rate the concept of a wedding game, they gave it a 9 out of 10. There was a huge gap between implementation and concept. In a marketplace glutted with new content, ideas are cheap. Strong implementation matters. Addressing that gap is really where skilled usability research is invaluable. On a road with infinite destinations, the findings from the study focused the changes we had to make. Now I marvel when I look back. Our fixes included designing a new main character, adding the wedding planning

mini-game, and simplifying the interface. The result: *Wedding Dash* is a mega-hit. *Wedding Dash's* success declares the importance of listening to our players and working until it is right.

Would you recommend doing this to other developers? Why so (or why not)?
Usability helped take the blinders off. It's easy for developers to get so close to a game, they lose the player's perspective. Also developers will get an intimate peek into the minds of their audience. They will meet the core causal gamer that plays 15+ hours a week and the newbie that fails the tutorial. At the right point in development, it can be just the shock of reality you need to make your game a market success.

Anything else you'd like to add about game usability and player testing in general?
A word to the wise, usability can be lethal to a project if not used properly. Enjoy responsibly following a few of my usability Do's:

- Do take time to really watch players and understand the context of the comments.

- Do build time in your schedule to address changes.

- Do pick the changes that make sense for the vision of your game. Not every problem will be solved.

- Do understand a test is just a snapshot. Your game is constantly changing, so don't wait too long to get it evaluated. Test it around alpha when the game is functional.

TWELVE

Interview with Roppyaku Tsurumi, Roppyaku Design

*Interviewer:
Kenji Ono, game journalist,
IGDA, Japan*

Roppyaku Tsurumi began working in project development in 1989 at Sega Corporation on projects such as *Michael Jackson's Moonwalker*. He moved to SCEJ in 1996 and focused on producing overseas games for the Japanese market, including series such as *Crash Bandicoot* and *Spyro the Dragon*. Tsurumi produced overseas games for the Japanese market as a freelancer beginning in 2001, such as the *Ratchet & Clank* and *Jak and Daxter* series.

12.1 The Relationship between Localization and Usability

In the Japanese videogame market, games developed in Europe and the United States are called *yōgē* [an abbreviated form of *yōmono gēmu* or "Western game"],

which is synonymous among Japanese players for games that are "difficult to play." Exceptions to this rule are the highly rated *Crash Bandicoot*, *Spyro the Dragon*, *Jak and Daxter*, and *Ratchet & Clank* series released by SCE, all of which have a high usability evaluation and are often mistakenly regarded as games developed in Japan. The original games themselves are excellent, and they were localized especially well for the Japanese market. Compared to many games that are localized during the final stages of development or after a product has already been released, these four series were developed from the planning stage for release in the world market in close cooperation with individuals in charge of localization from various regions. For the PS3 game *Ratchet & Clank Future* (SCE, 2007), for example, data for fifteen languages was put on one Blue-Ray Disc so that the game could be released to the world simultaneously.

Roppyaku Tsurumi was involved with the production of all four of these series and supervised their localization as the producer for the Japanese language editions. He was involved not only with the translation of data from English to Japanese, but game details as well. As a localization specialist, Mr. Tsurumi was asked a number of questions concerning the relationship between game localization and usability.

12.1.1 *Localization beyond Translation*

Thanks for agreeing to this interview.
No problem. I've been thinking about a number of things to discuss with you since I received your request for an interview.

When considering usability in relation to the localization work I do, people tend to believe that Japanese players will enjoy a particular game as much as American players if we simply translate the game contents.

I've heard that before.
But that's not the case.

The Japanese word for usability is *tsukaigatte*, which is used to describe something that is "easy to use." People play games in order to have fun. I can't think of a better English word for "usability," but it means something like the Japanese *tanoshimigatte* or "enjoyability."

That's a great word.
I'd like to make this the focus of our discussion today. I want to talk about what's important for a game other than accessibility and usability, and what localization involves besides translation.

For example, the "select" button on the PlayStation controller is either the ○ button or the × button depending on the region. On overseas controllers the × button is the "select" button, while in Japan it is the ○ button. But even if such operation differences were altered or English messages were rendered into Japanese, this would in no way mean that the playability and usability of a game would improve. These are merely basic level issues.

In Western countries an "X" is used to mean "check," so the × button is metaphorically the "select" button. In Japan, however, "X" means "no good."
That's right. So whether it is the × button or ○ button that has the "select" function is determined by the historical and cultural differences specific to each market. I'd like to discuss how we modify things based on the historical background of players that will play the game, such as changing which button represents what function.

It's especially important that a designer's intended gameplay value and style is conveyed to the user based on things as simple as button functions, and in more complicated cases, names and character designs. That's all that matters. A designer might create a game with the hope that players will find it interesting, but once the game appears overseas it might be met with a completely contrary reception and lose all of its meaning. We try to remedy this during the localization process.

Is that because the original expressions and representations do not convey their intended meaning in different markets?
Exactly. They simply don't work. I've been localizing games designed in Europe and the United States for the Japanese market for twelve years now—I probably should have mentioned that earlier (laughs)—and during this time I produced both the *Crash Bandicoot* and *Ratchet & Clank* series, which garnered franchise recognition in Japan. I believe that our localization efforts contributed to this recognition. Meanwhile, when I am playing other games I sometimes wonder why certain things weren't done during the localization stage.

What was the first title you worked on?
I didn't get involved with the first *Crash Bandicoot* until midway through the project, so I suppose it would be more accurate to say that *Crash Bandicoot 2* was my first title.

At the time that was a rare exception among Western games for its high usability. Even I was convinced for a long time that it was developed by a Japanese studio.
That's because it was made after much discussion with the general producer, Mark Cerny, and by taking into account the minutest details so that players would think it was a Japanese game.

Japanese players have the impression that usability is the result of the Japanese game industry's accumulated know-how.
That's true, but there's more to it than that. What is understood as usability has expanded overseas and in Japan as the two markets creatively influence one another. But overseas makers will stop paying attention to the Japanese market if it shrinks, which may result in a breakdown of emergent properties. So when looking at games produced for different regions, it is important to keep in mind what works, to identify those things that might be universally acceptable, and to continue to make improvements.

The importance of the Japanese market may have diminished from the perspective of overseas publishers since 2003 during the end of the PS2's run.
I agree. It's generally believed that if overseas producers ask producers in Japan about details concerning the vital points of the Japanese market, and if Japanese producers provide the relevant information, better products will be made. But if games are made without a consensus on what these vital points are, they'll simply arrive with orders to localize them for the Japanese market, which is extremely difficult. The result is usually a game lacking usability.

When a game is localized, some parts can be changed while others are not, right?
That's right. Also, each console tends to have games that are received better by certain demographics than others. Titles sold for the Japanese PlayStation3, for example, tend to include elements favored by male users in their twenties and thirties. Such games usually have sexually suggestive elements or appealing material that makes them hot topics on the internet. Sophisticated male users won't dive into a game with a simple keyword like "adventure" in its title. But this sort of thing can't be changed with localization. It's a game marketing problem, not a usability problem.

So when I say that games should be localized after taking usability into consideration, I mean those modifications that must be made to pure game contents, not those tied to marketing, in order for a game to be accepted in Japan to the highest degree. That's why I am confident that users who are not convinced by marketing elements such as packaging and advertisements will enjoy *Ratchet & Clank Future* if they give it a try.

So the packaging and advertisements are not directly tied to pure game content?
The potential that a game might have for a certain target audience changes for each region. This is true for things such as subject material, but the game value doesn't change much. Anyone can have fun dodging enemy bullets, shooting their gun, and taking out the enemy. That's why the first-person shooters that don't sell well in Japan are so much fun if you just give them a try. *GoldenEye 007* (Nintendo, 1997) for the Nintendo 64 was a hit in Japan, and the PC game *Battlefield 1942* (EA, 2002) enjoyed great reviews among gamers. So the game value is really not that different.

The interest factor and "enjoyability" are not the only things associated with *gēmusei* (literally, game properties or "game-ness"), but how we deal with them depends on the language and transition movies, the visual and verbal elements. And we also consider tactile sensations as well. How to deal with such things is the key to localization.

I wonder what the English equivalent for gēmusei is.
I often say "game-play value" or "pleasure derived directly from game play." For example, old games were enjoyable even if their graphics were a simple amalgam of ASCII art. Minesweeper is a fun game even without actual pictures of mines. In

that sense, the pleasure derived simply from playing a game is not very different. However, other factors vary greatly from market to market.

Games are more complicated now, so the importance of these "other factors" is increasing.

That's right. What we call *gēmusei* in Japanese is the reward offered for a player's discernment during game play. It's the fundamental pleasure inherent to a game. The structure doesn't change, and the point is whether or not a reward is recognized as a reward.

And players want that reward, right?
To put it another way, participating in a dating game is fun if the girls are attractive. "Getting the girl" is pure *gēmusei*. But what passes for an attractive woman differs from region to region, and we localize for each region based on their respective criteria. The key is how we fix the things which make games attractive to players that exist outside of the structural *gēmusei*.

Let me take this argument a step further. A player makes some decision, and if they are right they get a reward, but if they are wrong they are penalized. Now just imagine what would happen if the information available to a player to help them make a decision wasn't provided according to the designer's intent.

That's the key to usability?
Exactly.

12.2 Camera Algorithm Adjustments Unique to Japan

Information for making game-play decisions reminds me of the various hints placed throughout a game.
There are all types of hints in games, from those that are so obvious they might as well be posted on a bulletin board, to those you would never catch at a glance. But the quality and volume of the necessary hints is different depending on the proficiency of the player. That's why a player who is not familiar with the way first-person shooters work will need many more hints.

It seems there is a number of ways to interpret what is meant by hint.
That's true. Users who are accustomed to the way games operate can understand what they need to do with fewer hints. But beginners aren't even sure how things work at first, and they learn game-play mechanics by making mistakes and doing the correct procedures. We often say that we need to give careful consideration to hints, otherwise players won't be able to start at the same baseline since the prerequisites are different depending on a player's skill level.

Do Japanese players tend to want more hints?
It depends on the game genre. That's why we conduct difficulty tests when making a new game. We have a number of users from various demographics play a game and record data such as how far they progress and what sort of mistakes they make. When we looked over such data while we were making *Crash Bandicoot 2*, it became clear that there are two game genres that Japanese players are not very good at: racing and flying games. Japanese players just seem to have trouble with these two types.

Why is that?
I have no idea. But when I was watching people playing the game, I noticed some who were not very good at certain operations and others who didn't understand what was going on. All of this depends on the individual, of course, but what causes such difficulties is a mystery to me. All I really know is that, in general, Japanese players are not very good at racing and flying games.

You mean games in which a player must navigate three-dimensional space.
Generally, that seems to be the case. *Spyro the Dragon* (SCE, PS, 1998), for example, is an action game in which characters fly freely about in three-dimensional space. And there are racing parts in the *Ratchet & Clank* series. There are some players in Japan who are really good at these games, but the average player isn't. That's why if we leave the difficulty setting at the American level, the game will be too difficult for most Japanese players and they will ultimately get frustrated with the game.

I for one felt that the space battle level in Ratchet & Clank Future was especially difficult.
That's just the sort of thing I'm talking about. The English version of *Ratchet & Clank Future* has a challenging difficulty setting. It's possible to clear the game, but you need to work at it. The difficulty setting wasn't changed for the Japanese version. The adjustments made to the difficulty setting for *Jak and Daxter 2* was not good enough, and the racing parts were too difficult for Japanese players. I've heard a lot of stories about players having an awful time trying to finish that game.

What could have been done in that sort of situation?
Just lowering the difficulty level would have helped. This can be done by lengthening the time limit for some levels, for example. But this would leave skillful players feeling unsatisfied, so we also make adjustments to assist player operations automatically. *Jak and Daxter 3* was not sold in Japan, but I've heard from a number of sources that the time-limited missions in the previous game were really hard to clear, so it was modified to adjust automatically to match a player's skill level. Racing games in a three-dimensional space, especially those that don't indicate direction, are simply too difficult for most Japanese players.

It sounds like this is something that requires further investigation. There must be some reason for this handicap.

It's impossible to make generalizations, because there are too many potential places that should be fixed to make a game better. That's why adjustments are made only when they are needed. For example, many people lose track of the objectives in a three-dimensional environment, including myself. This example might be too specific, but many people have trouble flying in reverse (by pressing on the "down" key, flying vehicles turn up). This can be changed in the options settings, but some people still can't get used to it.

A major reason for this is that a lot of Japanese people tend to get motion sickness.

Now that's an interesting topic. There are a number of reasons for motion sickness, including lateral camera movements and how a camera follows a character. If the camera moves according to the laws of inertia, the number of people who experience motion sickness increases. People also feel sick when playing a game if the camera moves too fast or too slow. People won't get sick if the camera doesn't follow character movements too fast, but a player will start to feel queasy if the camera doesn't move in a preferred manner. If the camera follows a character's movements too quickly, for example, the player will get dizzy and start to feel sick. These are the two cases associated with character/camera movements, and the only way to solve this problem is to determine the mean between both of these extremes.

A number of years ago it was necessary to make the default camera speed for Japanese versions of foreign games obviously slower, because Japanese players were that prone to feeling dizzy. The settings aren't very different anymore, but the camera speed for Japanese games is still slightly slower.

Have Japanese players adjusted more to three-dimensional games as a result?

I think so.

What about other types of camera movements?

The two main types of camera movements are rotation and parallel translation. So far we have been discussing lateral rotation movement along the Y axis. Movement becomes a problem solely with rotation, because parallel translation doesn't normally cause motion sickness. Parallel movement of a camera in a lateral direction is the same kind of movement used for two-dimensional landscape scrolling games. This is true for vertical scrolling games as well. Parallel movement is really not a problem. However, rotation movement along the X axis is a major issue. Motion sickness sets in when the camera moves up and down rotationally.

It can turn one's stomach when the camera follows a character along the X axis after a jump is performed. Remember that game called *JumpingFlash!* (PS1, SCE, 1995)? It was enough to make people sick. In *JumpingFlash!*, the camera was pointed straight down and the floor would zoom in and out when the character jumped. Since this involved a sudden change in the camera angle, it wasn't too bad. But

171

when the image of the ground wavered as the camera continued to spin around little by little, the resulting nausea was almost too much to endure. I am sure that people who are prone to motion sickness will understand the sensation I am talking about.

Is there a trick for parallel translation?
Stabilize the camera. Motion sickness is caused when the camera is made to move very precisely with a character's up and down movements. The normal method for stabilizing the camera is to use a still camera and move the camera only when the character goes above a certain height on the screen. And as I mentioned before, it is important to move the camera no faster than a certain speed.

So when you put all of these techniques together, you can imagine that the camera follows a character around on a suspension system fitted with a spring and damper. In this way it is possible to follow a character's movements without feeling sick, because the screen doesn't wobble around. That's the best sort of camera.

So, camera movement became very important with the advent of three-dimensional games. It's fascinating that something that went unnoticed in two-dimensional games suddenly became so important for three-dimensional games and also differs from region to region.
That's true. The first time this became an issue for us was back in 1998 when we were developing *Spyro the Dragon 1*. The problem was how to make a camera for the Japanese market that didn't cause motion sickness. That's why the Japanese release was delayed until 1999, while the overseas version was already out in 1998. Also, people only started to feel sick when their character kept running, so levels were designed in the Japanese editions to force characters to stop moving from time to time.

We started placing hints throughout the game, like writing clues on bulletin boards, at key locations. But bringing your character to a halt in the middle of a game can be quite difficult. We later realized that placing road signs in the game to prevent motion sickness actually resulted in a loss of interest in game play.

Because it interfered with the flow of the game, right?
In hindsight, this method was a failure. But in defense of our team and the developer, Insomniac Games, if we hadn't gone to such lengths, players in Japan would have continued to get sick and the game would have been a flawed product. It was simply something we had to do. Anyway, the way to deal with motion sickness is to adjust the camera movements.

Since the camera provides the player with information during a game, would you agree that it is fundamental to usability?
Yes. In the end, it's all about how to present the player with visual information. To be successful with this we need to make adjustments to games while keeping age,

player, and regional differences in mind. That's really the first thing we are confronted with during the localization process.

12.3 Textual Elements and the Indispensability of Usability

Screen information also has a textual element to it.

I've definitely noticed that lately.
Really? Why's that?

When I was playing Ratchet & Clank Future, I was so happy when I saw the large on-screen text, but that it didn't interfere with game play even on a small monitor. That was such a bold innovation. But now that we are in the age of High Definition technology, it is getting difficult to read the on-screen text in more and more games.
You're right. That's so true.

Isn't there an industry standard stating that text shouldn't be smaller than a certain size?
There are no industry standards. It's all a matter of trial and error.

On-screen text started to get smaller after the release of the Xbox 360, right?
Yes. And games are now designed to be played on a TV connected with a High-Definition Multimedia Interface (HDMI). The text in such games would be illegible on a Standard Definition (SD) TV if its screen layout were used. By the way, a single DVD-ROM for *Ratchet & Clank Future* has data for 15 languages on it: American English, British English, German, French, Italian, Korean, Spanish, Portuguese, Dutch, Danish, Swedish, Finnish, Norwegian, Chinese, and Japanese. When you change the language display setting on the PS3 console, the language displayed in the game will change to match it.

That's just what you would expect for PS3: worldwide implementation. But the time and screen space required to convey the same message in Japanese and English is different, right?
The spoken Japanese language conveys far less information than English in the same amount of time. That's why the movies for the transitional event scenes are so difficult to localize. We need to choose words so that the length of the dialogue and the movement of a character's mouth match as much as possible while retaining the same meaning. Scenes that are meant to be humorous, for example, continue to be the most challenging. There are a lot of movies in the *Ratchet* series that include jokes. But the Japanese and English languages are so different that it's impossible to include the same information. So we reduce the spoken parts or use different words to create lines that convey the same meaning.

Sometimes lines are added to the Japanese edition of a game even if there are no spoken parts in the English version. So when Captain Quark spins around in the Japanese edition, he says things like "*kuru-rin*" [something like "spin-spin ho!" in English] or "yeah." If we don't do this, the humor will feel too flat.

What about the text? English requires so many more characters than Japanese to convey the same meaning. Does this work OK with the same screen design?
Sure. Once things are decided for the English version, we can do whatever we want to make the Japanese language work. Even though English requires more characters, alphabet letters are proportional (they have a variable width) while Japanese fonts have a fixed width. Ultimately, however, the necessary space for text doesn't change that much in the Japanese and English editions of a game.

In Japan, the length of a message will change if Chinese characters are used. I was surprised to learn that Ratchet & Clank Future was the first time they were used in a Japanese game.
Good point! There is a limit to how many characters can be used so that a player can catch the meaning of a message at a glance. It's sometimes too cumbersome to extrapolate meaning instantaneously if only *kana* characters (phonetic characters with no intrinsic meaning) are used. The *Ratchet & Clank* series only utilized *hiragana* and *katakana* [the two phonetic *kana* alphabets indigenous to Japan], but Chinese characters were integrated into the text for the first time with *Ratchet & Clank Future*. It's much more similar to the way English is displayed and read on a screen this way. We tried to get around this problem in other ways before finally settling on Chinese characters.

But doesn't the use of Chinese characters limit the target age group, since the text might be too difficult for younger children to read.
This actually wasn't a problem. But it probably would have been best to provide a phonetic reading guide for the Chinese characters. Take the word "weapon," for example. Younger children might not have learned the Chinese characters for the word "weapon" at school yet, but they're able to figure out the meaning from the game's context. We thought it might work if we used common words that would be easier for children to recognize.

You can use Chinese characters for the user interface in a game, but I imagine this wouldn't work for messages that are integral to storytelling in RPG games.
Right. That's exactly what I was trying to say.

I didn't notice that before.
Chinese characters are also used for the subtitles in the movies. It would probably be best to include phonetic guides for the Chinese characters in the subtitles as

well, but this really isn't a problem since the characters are also speaking their lines. I don't think this would have worked at all if the characters didn't talk. Writing intermixed with Chinese characters and *kana* is probably too difficult for younger primary school children, but it's not a problem for kids in higher grades. Students learn 1,006 Chinese characters at primary school in Japan, but there was a time when we were unsure how to use characters they hadn't studied at school yet in games meant for children. We now know that this really isn't a problem.

I understand that Japanese game developers are debating how to design user interfaces that include text for Japanese games that are planned for release overseas. Since it requires more words in English to say the same thing in Japanese, a text box that is used to convey something in Japanese might not be able to contain the English equivalent. As a result, there are many cases in which the Japanese characters are intentionally made smaller to ensure enough space for the English text when developing the Japanese edition of a game. But when this is displayed on an SD television, the Japanese is difficult to read. Some Japanese players feel that it's unreasonable that there is such small text in a text box with plenty of extra space.

One way to solve this would be to change the design of the user interface for the overseas versions. The design of the message windows for Dragon Quest VIII: Journey of the Cursed King (Square Enix Co., Ltd., PS2, 2004), for example, were modified for the overseas version, right?
That's not a simple task. Also, we didn't do that for *Ratchet & Clank Future* since we had to master it for a simultaneous world-wide release. But we had already taken things such as the user interface into consideration, so it wasn't necessary to refashion them later on.

Different administrative game designers are in charge of the field, battle, and item management scenes for RPG games, so the menu designs are not similar, which in some cases leads to reduced usability. Recently some teams have a space allocated for a game designer who specializes in user interfaces.
Whether or not there is a position on a team for that doesn't really matter as long as there is a step in the development process for looking into this sort of thing. We started doing this for the *Ratchet & Clank* series with the first game. Insomniac Games actually have data managers and programmers that specialize in localization. They wouldn't be able to make all those titles for more than ten different regions if they didn't. Such localization specialists are, of course, integrated into the development pipeline.

So it would be impossible to produce versions for various regions without localization being closely aligned with the development process.
Impossible. There are a number of programmers and people who specialize in localization that can make planning decisions. That's why I sometimes go to Insomniac Games to work in one of their cubicles whenever I am stuck on something.

I'm surprised that there is a specialist team in the development studio, because normally the overseas version of a game is not made until after the domestic version is finished. And sometimes a publisher will just buy the rights to a game and do the localization themselves.

That's not enough to work with in our case. We've been doing localization for more than 10 years now, and know what we are doing.

12.4 How the Right or Wrong Names Can Greatly Influences Usability

Let's move on to matters related to the naming process for games. So far we've been discussing explicit issues, but there are some implicit things within games that affect usability as well.

Names and proper nouns are types of information that bring certain associations to the minds of players. This is because of the name itself or the way it sounds, which is why a lot of popular monster names in Japan start with "ga-gi-gu-ge-go" type sounds (i.e., Gojira [Godzilla] and Gamera). That's also why weapons with "cool" English names, for example, must be modified to have an equally "cool" Japanese name for the Japanese edition of a game.

Could you give me an example?

The most powerful weapon in the *Ratchet* series is called "RYNO." It's an acronym for the English "Rip ya a new one," which is another way of saying "I'm going to tear you a new asshole."

The RYNO initially appeared in the first *Ratchet* game in a humorous transition movie. We didn't know how to convey the humor in the name and were concerned since the sound of the weapon's name wouldn't strike a chord for Japanese players. We didn't know how to convey the impression of this weapon with a name that was also humorous. And we also had to find something that would synchronize with the mouth movements for "Rip ya a new one" in the movie. We were at a complete loss.

The worldview of *Ratchet & Clank* was established with elements that would appeal to teenagers, had a certain narrative style, characteristic names, etc. And it's funny, too. The problem was to come up with a Japanese name that conveyed the same image as the English word RYNO. In the end we called the RYNO "Launcher No. 8" for the Japanese version. We had the character say "laun-cher num-ber eight" in the movie so that it match the mouth movements for "rip-ya a-new one." We skipped numbers one through seven and choose eight, because the Japanese word for eight [*hachi*] is a homophone for the word bee, and we had the character say "it's called *hachi* (eight) as in bee (hachi) hive" [in Japanese, the expression "*hachi no su ni suru*" (turn you into a beehive) means "to fill an enemy with bullets"]. Beehives are littered with holes, so our alteration maintained a similar humor

level to the English "Rip ya a new one" since it included a play on the words "bee" (*hachi*) and "eight" (*hachi*).

I feel sorry for you since you had to go to so much trouble.
I know it seems kind of silly, but we needed a name that people would remember, sounded a bit like a code name, and was also humorous. Thus, "Number Eight."

And then there was a weapon in the second *Ratchet* game called RYNO2. We called it "Launcher No. 9" in the Japanese edition. The items are the same in the English and Japanese editions, but the names are worlds apart. For *Ratchet & Clank Future*, the sixth game in the *Ratchet* series, there is a weapon called "RYNO No. 4." We ultimately integrated the RYNO name and the numbered launcher series in both the English and Japanese editions of *Ratchet & Clank Future*. I seem to be wandering off topic.

Sounds like you've been on quite a journey.
We change great English weapon names without hesitation if they don't sound cool in Japanese. And the weapon names must be categorized according to the name conventions unique to the *Ratchet & Clank* universe so that players can recognize weapon types based on their names. Games are filled with proper nouns: items, weapons, events, etc. A number of English words for weapons and locations don't register as such in the ears of many Japanese players. In that case, what the player derives from a name is completely different from being told what a thing is with an in-game message such as "you've acquired a ~." So we try to make weapon name categories. We named the gloves in *Ratchet & Clank*, for example, "XX-*n gurabu*" [XX Glove], which is why the glove used to throw mines is called "*jirai-n gurabu*" [Mine Glove]. We came up with this Japanese naming system on our own, and try to use a lot of "ga-gi-gu-ge-go" and "za-ji-zu-ze-zo" type sounds in the names.

So sounds can viscerally convey meaning. I'm thinking specifically of the Dragon Quest series. The basic healing spell for this game is "hoimi" and the stronger healing spell is "behoimi," which helps to suggest a sense of group unity.
Exactly. That's just the sort of thing we need to change for Japanese editions. Especially when a player gets a weapon and it's indicated by a movie or message. If a player doesn't know what kind of weapon it is, the sense of achievement will be lessened. And that's not what the designer wants to happen. The player's motive should not be misdirected during a game, which is why we create Japanese name categories for things.

But we won't change a name if the English word conveys the same meaning and image to the Japanese player. There are two ways that people receive images from sounds; one is universal, and the other is region specific. Choosing a name that will evoke nostalgic emotions when it is heard or seen is extremely important in Japan, such as the names of weapons in *anime* programs that kids grow up watching.

What's the trick?

When we are deciding whether or not to change a name, we want something that will be easy to say or has an approximate equivalent in Japanese. If there is a similar word, then it's easier for players to recall. I can't think of a good example at the moment, but if a similar word exists in Japanese, and if the name is easy to say and remember, it will easily become fixed in a player's mind even if it's a little peculiar. Also, for the very reason that it is a little unusual, the worldview of a game can be enhanced even more. That's what we endeavor to capture in a name.

Kind of like the fire spell names gira and mera for the Dragon Quest series? (In Japanese, gira and mera are onomatopoetic for, respectively, reflecting light and burning flames.

That very sort of thing. If we directly translate the English proper nouns, the impression of the game will change. In story- and character-driven games, players are constantly mentally mapping information such as the relationships between character and place names while proceeding through the game. As a player progresses through a game, they develop the desire to fill in those blank areas of their mental map. And it's because players have this sort of desire that they are able to recognize hints that will help them complete their mental map when they appear. Because the mental maps of Japanese- and English-speaking players differ, the same hints will not be recognized by a Japanese player when they play the English edition of a game.

Is this sort of technique commonly used in Europe and the United States as well?

Yes.

So, because I'm Japanese, I would have trouble playing the English edition of a game because I wouldn't be able to recognize hints when they appear?

That's right. The experience is totally different. You wouldn't be able to comprehend a game based on the Christian culture, for example, unless you were rooted in that culture yourself. You wouldn't find the subject matter stimulating at all, and you wouldn't be able to recognize important game items even if they were indicated to you as such.

To put it another way, what we do is modify English words into proper nouns that evoke subliminal images rooted in language and culture that are easy for players to internalize and incorporate into their mental maps. Hey, I think I stated that quite nicely.

In that sense, not explaining everything is an essential element for enhancing usability.

Exactly. A player might understand a provided explanation, but they would never pay it any attention. It's necessary to alter names so that they are understood viscerally. This isn't just important for the game-player dichotomy, but for information exchange amongst players as well.

Information exchange within a community is so common nowadays, and we take that into account when we create a game. We need to envision the target age group and the location of their community. Take kids, for example. School is a very important place for them. So if we don't utilize words commonly used at school, there can be no information exchange.

Words used in a game will spread faster among Internet communities if they are easy to type or have a potential word play in Japanese, such as interesting Chinese character compounds or abbreviations. The key is to come up with as many such words as possible. But there is one thing we can't do: alter the original game's image. *Ratchet* should remain *Ratchet*. We make decisions about things we should change and the things we can't or shouldn't change, and work proactively on the changeable things. I do this according to my own rules, because I think that people do their best work when they establish rules for themselves. That is very important.

When do you start the name-changing process?
Character names are set during the planning stage so that we can make requests to change things if we don't feel they will work in Japan. Place and event names are decided on a case-by-case basis. Event names that are based on American television programs won't make sense to most Japanese, so we change those regularly.

12.5 Usability and the PlayStation 3

May I asked you a few questions unrelated to localization?
Absolutely.

In the Ratchet & Clank series, the color design work was enhanced so that things appeared very realistic, such as explosion effects, for example. But the color saturation of the entire screen was diminished as a result, and some Japanese players felt that this made it difficult to look at the screen. Does this sort of thing have a major effect on the usability of a game?
Definitely.

I don't think this is limited to the Ratchet series, however, because many Japanese players tend to feel that the screen is too dark in Western games. How was this issue changed for the PS3 Ratchet & Clank Future game?
I thought things looked a lot better once the PS3 came out. And since the screen resolution has increased so much with High Definition, it is now possible to see the smallest details. HD can display things far in the distance, and the number of colors and color resolution has increased. It's therefore now possible to design the screen so that explosions stand out really well against a realistic background. I think the PS3 *Ratchet* combines color richness and effects to a degree far higher than the PS2 *Ratchet*. But this is outside of my particular field of specialization.

I see.

You can notice the difference with an SD television as well, but the visuals look way better in High Definition.

Is there any difference between the two systems in terms of sound quality?

The *Ratchet* series has been employing the 5.1-channel surround system for the PS2 in order to emphasize the sound. Since *Ratchet & Clank Future* is for the PS3, it includes a dramatically greater amount of sound information, which is why the sound effects are so much more enjoyable for players to hear. If you've ever heard the sound effect that is played when Ratchet is collecting bolts, then you know what I mean. Sound helps to motivate players as well. I didn't notice this when I played the game using standard television speakers, but it was quite clear when I used 5.1 surround. I was totally enraptured by the sound.

Better hardware came make such things possible, which is extremely beneficial for usability. Don't you think the color for *Ratchet & Clank Future* is richer than the original PS2 versions?

The backgrounds are indeed fantastic. The amount of information looks immense. And I was glad that the text and icons were big enough to make the user interface easy to read even with an SD television.

The text has to be large. The artists at Insomniac Games produce really high quality work. It's very impressive.

Doesn't high definition (HD) often result in small text?

That's true for a number of games, because it looks cool. It's a consequence of planning a worldwide release with a single master disc from the start.

So when you're making a single master disk, you take into account the prospective ratio of players that have HD and SD televisions?

We can't, really, because we're in the middle of a transition period. That's why games are made to work with both. But when we're making a game for HDTV, we do keep in mind that there is a size difference between American and Japanese living rooms. Don't you think the size of a living room greatly affects game play?

I bought Wii Fit (2007, Wii, NINTENDO), and unfortunately the TV is too close so I have to play it with the TV down low and at an angle to where I'm standing.

Localizers take player environments into consideration and make requests based on this information to the developing team. How the main developing team of a project accepts those requests for localization and comes up with a project plan is very important. In that sense, *Ratchet & Clank Future* was well thought-out from the start. It gets to the point where the main project team can begin to predict what sort of requests they will get and start working on those issues before they're even asked.

Like what, for example? Screen designs?

Screen designs, for sure. I was really impressed with what they did before I said anything. I wasn't aware of this when I was working on just *Ratchet*, but there were times when I would notice things in other games and think, "this is terrible," which made me realize how good the screen designs for *Ratchet* really are. That's why series are so great. As long as the same team works on the games in a series, the quality will continue to increase.

What sort of things have you found disappointing when playing an overseas game localized for Japan?

Often the names. But there are some that sound great in the original English, of course.

Other than that I would say the learning curve. Every game has things a developer hopes players will do first with their game. They should first have players run through the tutorial at the lowest difficulty setting to learn any difficult maneuvers. After that players can advance to an intermediate level and learn to be more creative before finally moving on to the advanced operations. The number of challenges built into a game determines the fun factor, after all.

Players are made to proceed through the stages appropriate for learning all the game mechanics so that they'll get the most out of a game. It's not just a matter of the difficulty level, but rather helping players understand things that might not be clear initially. There are various steps and processes set up in a game to convey this sort of information to the player. It is naturally more fun for players to get better and play higher levels, so the learning process is fun for them. A game wouldn't be fun if players were suddenly supplied with all sorts of information without having to go through certain learning stages to get it.

Because the information needed to proceed through a game is forced onto the players?

Yes. And there are many examples of this. So a potential field for localization is to develop and incorporate into a game steps that will help Japanese players grasp difficult information in the game. If this isn't done properly, it becomes unclear what a player is supposed to do.

So there is a right and wrong way for providing players with information It sounds difficult.

Still, giving players too much information is better than nothing. It's just awful when a player doesn't have access to enough information. So in that sense, forcing information on a player is still better, because as they get used to a game they'll start to realize its significance. If a player doesn't experience this often enough over the course of a game, then the game itself is no good.

More and more Western games are providing a greater number of game-play hints. For example, it's not uncommon for possible button operations to be displayed at

the top of the screen on some levels, as is the case with Gears of War and Assassin's Creed. Many players appreciate this, but there are some games that don't display the appropriate button operations on the screen when they should, which can make things very confusing.

In such cases, the game is not adjusted well enough. It's something I want to be very careful about as a producer myself, because it's an extremely important factor for a game's usability. An ideal game is one that provides a player with information without them realizing it.

Games involve a repetition of input and output, by which a player begins to establish an information model in their mind that makes them realize if they perform a certain action a certain result will follow. So when it comes to what sort of hints a player must be provided with for this process to be successful, game play becomes muddled if hints are suddenly provided for some reason other than what has come before or are not provided at all.

Yes, that's exactly right. The *Ratchet* series, for example, has a Help Desk voice. The voice actor who recorded the voice data for the first and second *Ratchet* games changed, and we got a lot of questions wanting to know why this happened. Just by changing the voice actor resulted in subtle changes in the way players extracted hints from the game. Players wouldn't miss important information when it was provided to them by the same person with the same tone of voice during a game. This is very important.

It sounds so meticulous.

And it's better if a really good voice actor is hired to do the recordings. We happened to employ Atsuko Tanaka, the voice actor for the character Motoko Kusanagi in the anime *Ghost in the Shell*, for Japanese editions of games, and I am always just amazed by how good she sounds when we're working on the recordings. When you hear her voice in a game, the important information just sticks in your brain.

I feel that games have become so complicated to operate now that it is impossible to provide enough hints on the screen during a gaming session. I think that voice and controller vibrations will become more necessary than visual information for guiding players through a game as time goes on.

We began using voice- and text-based tutorials and help functions with the first *Ratchet* game. Text messages were also necessary, because the voice functions were inaccessible to people with hearing difficulties. But information provided with a voice carries much more information than the textual equivalent. For button operations and icons, however, visual information is easier to understand. It's very difficult to know what works best and cannot be categorically described. That's where the fine tuning of a game comes into play.

Both voice and text messages are used for major rules, but if we find a place during the focus group testing process that is difficult to understand, we'll add more voice guidance specifically for that location. Unfortunately, this can result in a lot more work if there are many places like that. Ultimately, the end result will differ depending on the time and cost spent on tuning, but regardless this is a very important step in a game's development.

By tuning do you mean quality assurance measures prior to debugging (game testing)?
That's right.

Quality assurance is a part of the development process in Japan and is not a section in and of itself, but I've heard that development and quality assurance divisions are independent overseas.
That all depends on how a producer chooses to divide up their team's responsibilities. SCE (Sony Computer Entertainment, Inc.) has a section that performs quality assurance, which both debugs software and offers other suggestions. The size of the team, volume of work, allotted time, and at what stage the quality assurance reports will impact game development all depend on the producer and the game in question. A game with a lower target age group or concerns that an overseas game might be difficult for Japanese players will affect the focus of quality assurance reports. It's all determined on a case-by-case basis.

For example, there are no regional differences if you're making a soccer game, but cultural differences become apparent with story comprehension for RPG and adventure games. Even in such cases, however, a developer might insist on some changes or conduct rigorous focus testing. It's ultimately up to the producer to decide what is worth spending budget allocations on, which can affect a game at the fundamental level.

But since Ratchet & Clank Future was developed overseas, the Japanese quality assurance was performed when the game was already completed to a certain degree, right?
That's right. But *Ratchet & Clank Future* was a sequel title, so it was comparatively easy to make. It's also the first in the *Ratchet* series made specifically for the PS3, so there were a lot of basic conventions from the previous installments that we had to consider and figure out how to present to the players. But most of the basic parts were already figured out.

It sounds like the amount of required work is totally different for games with an established franchise and original titles.
That's right.

In that sense, was the first Ratchet game the most difficult?
The first *Ratchet* game was a lot of work. I thought I was going to work myself to death at one point. I was practically living in the smoking room at SCE. I'd work

in the smoking room, go to my desk to take a thirty-minute nap, and then start the whole process all over again. When I had to fly to the United States on business, I'd calculate the time left until departure and go home just to do laundry before rushing off to the airport. It was the first game in the *Ratchet* series, so there were all sorts of things I had to make first-time decisions about. I even had to design the Japanese font for the game all by myself, one pixel at a time.

Wow! But I thought developers normally got licenses to use existing commercial fonts.
That's the case now, which is why we've used commercial fonts for the latter installments in the *Ratchet* series. But for the first game we didn't know what kind of font would display on the screen well and simultaneously convey a sense of the *Ratchet* universe. So I had to make the font from scratch and determine on my own if it would be easy to read. It's important to know how to localize a game from the very first stage of the developing process, such as designing the game's structure. The first *Ratchet* game was very challenging work.

When I'm working on an original title, there are all sorts of things I need to investigate, such as camera algorithms, how hints are revealed, and making sure a character doesn't stray off course when they are supposed to travel along a predetermined route. I can talk about matters related to usability in this way now, but that's only because I've learned so much since the first *Ratchet*.

I'm sure there will be more games to come in the Ratchet series for the PS3, and I look forward to them and other original titles from you in the future.
I'll do my best.

Thank you very much.

PART IV

ADVANCED TACTICS

THIRTEEN

Using Biometric Measurement to Help Develop Emotionally Compelling Games

Richard Hazlett is on the faculty at Johns Hopkins University School of Medicine; he also offers private consulting to businesses. He has a Ph.D. in psychology and has spent his research career developing methods to better measure emotional experience and product desirability. He has applied these methods to understanding the computer user and the video gamer, and has presented his findings and methods at numerous conferences and in publications in leading journals. As a consultant, he works with Fortune 500 companies as well as startups to help them with product development and marketing.

13.1 Introduction

To be entertaining and enjoyable, videogames need to evoke some heightened level of emotional experience during play (Keeker et al., 2004). With this heightened emotional experience comes the experience of being immersed in the game environment so that the player's attention is fully on the game and he/she is not easily distracted from gaming. This immersion and enjoyment isn't just a function of positive emotion. In fact, a common emotional experience in role-playing, action and many other types of games is the build up of tension and negative emotion during

challenge that is followed by a positive emotional spike when the challenge is over-come. Different game genres will have different goals for the player's emotional experience, and varying emotional profiles that include both positive and negative emotion (Ravaja et al., 2004). Most, if not all, games will involve shifting the player from one emotional state to another, and that experience is what makes playing the game so compelling. Whether the game is a causal game to pass the time on the way to work, or an intense RPG that consumes hours of a player's time, if the game does not grab the player's attention, shift their emotion, and lift them out of their ordinary routine, the game will not be successful. Maximizing the emotional power of a game during its development cycle requires ongoing feedback about the emotional experience of players as they encounter the various features of the game. In order to better understand how to assess the player's emotional experience, we must first briefly look at the nature of emotion and the issues related to emotion measurement.

13.2 The Nature of Emotion

Emotion organizes and energizes human behavior, and therefore underlies the gam-ing experience and the player's attitude toward the game. Research has shown that emotional phenomena can best be organized into two overall emotional/motivational dimensions (Watson et al., 1999). The first dimension encompasses the various discrete positive emotions such as joy, pleasure, love, interest, hope, etc., and the more attentional and motivational concepts of energy, immersion, and engagement. The second dimension encompasses the discrete negative emotions of fear, sad-ness, anger, etc., and the more motivational concepts of stress and tension. At the behavioral level these two dimensions of positive and negative emotion are often reciprocal and reside as the anchors at the opposite ends of a bipolar factor called emotional valence. Behaviorally, when positive emotion and associated behaviors increase, negative emotion behaviors usually decrease. When positive and negative emotions are placed on opposite ends of this bipolar scale, the second dimension in this emotion space then becomes the intensity of the emotion. A model of this two-dimensional space can be constructed using an xy coordinate system with the dimension of valence (negative–positive) as the x-axis, and the intensity of the emo-tion as the y-axis. One can place emotions and emotionally stimulating media in this two-dimensional space using the xy coordinates.

Recently I conducted a study on people's emotional responses to images flashed on the screen. The respondents selected the emotion word that best represented their reaction to the images while the intensity and valence of their emotional response were measured with biometric methods. Most of these studies results are beyond the scope of this chapter, but in Figure 13.1 I have shown the results on how the different emotions lay in this two-dimensional space. Intensity of emotion and emotional valence and are represented in this graph on a 1 to 9 scale, with 5 being the mid-point that separates negative from positive emotion. Media like

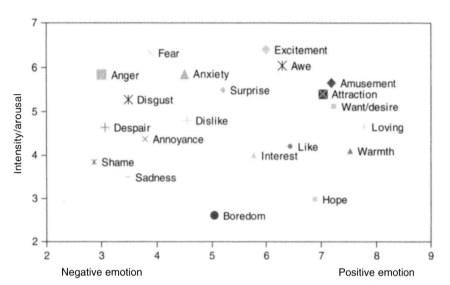

FIGURE
13.1

Two-Dimensional Emotion Space

TV commercials, programming, videogames, and various media elements such as visual game scenes, music, etc can be placed as well on this coordinate system. Placing games and media elements in this emotion space, and calculating the 'emotion coordinates' can help describe, understand and compare the emotional impact of games and game elements.

Emotional reactions occur almost instantly, and without much conscious thought. People might contemplate how and why they feel a certain way, have memories and associations about their experience and reflect on those experiences, but all that happens after the gaming experience. When a gameplayer is in the moment of gaming, they are feeling excitement, challenge, tension, frustration, pleasure, etc, and are making judgments based on their feelings; but they are rarely thinking about their feelings. If you stop the player to ask them how they feel, or why they did something, you interrupt the experience and alter their feeling. This is the challenge in measuring the emotional experience of the player: attempting to understand their ongoing emotion without interfering with the natural gaming experience.

13.3 The Measurement of Emotion

To measure enjoyment and emotion the developer must go beyond measuring ease of use and debugging tests. Techniques that can measure moment to moment as games unfold over time will be able to give designers specific feedback on the emotional power of the features and designs they are developing. The moment to moment gameplayer experience is delicate to measure because the intrusiveness of an ongoing measure will likely alter the experience. A technique like asking the

player to think-aloud and report their experience as it happens is an example of an experience interfering technique. Post-interaction questions and interviews can be helpful for overall feedback but they lack the ability to give reliable and uncontaminated reactions to events and features that occurred minutes previously, and which may have been followed by many more events and features. Video taping of the gameplay and then the reviewing of the playback attempts to get around this dilemma of having to choose between contaminating the play experience or depending on remote memory. With this approach the video of the gameplay is reviewed with the player and the player retrospectively thinks-aloud. This technique can be useful for understanding the player's cognitive elaborations and preferences, but less so for behavior and emotional responses.

A fundamental problem with these verbal measures is that emotional experiences are not primarily language-based: cognitive effort is required to put emotional experience into words, and this effort can contaminate measurement. Many people are not that adept at putting feelings into words, and also are often not that aware of what impacted them to make them feel that way. If one is involved in developing children's games this difficulty is only exacerbated, as children have less developed cognitive and language abilities, and are even less able to verbalize their feelings.

13.3.1 *Physiological Measurement of Emotion*

Certain physical changes usually accompany different feeling states. For example, when we get excited, our heart rate and breathing increases, when we feel pleasure we smile, or when we are annoyed we frown. These physical reactions can provide information about how the player is reacting to the game. The biologic system offers the advantage of a continuous readout of the player's moment to moment emotional experience. The moment-to-moment level of positive emotion, tension, effort, and arousal is valuable information with which to evaluate the quality of the game elements in play. The advantage of physiological measurement is that it can provide a biometric marker that accompanies changes in emotional state, and doesn't require cognitive effort or memory to produce.

13.3.2 *Arousal Measures*

Measures reflecting autonomic nervous system activity like heart rate and skin conductance indicate levels of arousal or emotional intensity. These measures do a limited job at best in indicating emotional valence. For example, Anttonen and Surakka (2005) found that heart rate was only able to differentiate between positive and negative stimuli at 6 seconds post-stimulus onset, and not during the first 5 seconds. For a moderate to fast-paced interactive session this delay would be very problematic for linking interactive events with emotional responses. For most user experience questions, knowing the emotional valence of a player, whether he/she is

feeling in the negative or positive realm is important. Sometimes though, emotional valence may be obvious, or not important for the questions being asked, and level of arousal is enough information for evaluating a game experience. Then heart rate or skin conductance can be useful measures. One of the difficulties with heart rate is that it is affected by the metabolic demands of the situation, and not just the emotional aspects. Therefore, level of activity needs to be controlled across situations that are being compared for heart rate to be an accurate measure of arousal.

13.3.3 *Measuring Emotional Valence with Facial Expressions*

One physiologic system that has been found to display emotional valence and is a natural emotion marker is the face. Charles Darwin first wrote about the changes in human facial expression as reflecting the individual's current emotional state and to be a means of communicating emotional information. Paul Ekman, a prominent emotion researcher at UC Berkley, and his colleagues have shown that certain configurations of facial muscle movements have been identified with the expression of specific emotions across disparate cultures. In order to measure changes in facial expressions that reflect emotional experience, Ekman and colleagues developed the Facial Action Coding System (FACS), which codes observable facial muscle movements (Ekman & Friesen, 1978). There also have been developed several computer programs that use digital video analysis to automatically code facial expressions into emotion categories (e.g., FaceReader by Noldus Information Technology). However, whether the observer of the face is human or computer, human faces are not consistently expressive enough to note ongoing emotional state. The few attempts reported in the literature that used these systems to record emotional reactions to various media found that there were too few facial expressions to score. These results reflect the findings in emotion research at large: Mild to moderate emotional stimuli are often not accompanied by visually observable changes in facial expressions.

There is, however, a much more precise and sensitive method to measure changes in facial expressions than visual observation. Electromyography (EMG) measures small changes in the electrical activity of muscles, which reflects minute muscle movements. Electromyographic techniques have been applied to certain facial muscles, and facial EMG has been shown to be capable of measuring facial muscle activity to weakly evocative emotional stimuli even when no changes in facial displays have been observed with the FACS system (Cacioppo et al., 1992). Even when subjects are instructed to inhibit their emotional expression facial EMG can still register the response. Facial EMG studies have found that tension of the corrugator muscle, which lowers the eyebrow and is involved in producing frowns, increases when negative mood increases, or when the media being experienced is rated as more negative (Larsen et al., 2003). Activity of the zygomatic muscle, which controls smiling, is associated with positive emotional stimuli and positive mood state. Level of enjoyment and positive emotion therefore will be reflected in increases in smiling (zygomatic EMG level) and decreases in frowning (corrugator EMG level).

During interactive tasks the corrugator muscle EMG also has been found to provide a sensitive index of the degree of exerted mental effort (Waterink & Van Boxtel, 1994), and to increase with the perception of goal obstacles (Pope & Smith, 1994). The corrugator EMG can also measure the more negative emotional responses of the computer user, reflecting their tension and frustration during usage (Hazlett, 2003). During video gameplay therefore increases in the corrugator EMG reflect level of tension, negative emotion, and effort. For the gameplayer perhaps the best overall label for what the corrugator EMG reflects is tension.

13.4 Measuring the Player's Emotional Experience with Biometrics

13.4.1 *Validation of Facial EMG as a Game Emotion Measure*

In order to validate the usage of facial EMG for gaming, I conducted a study with boys playing a car-racing videogame. I will report the method in some detail as it illustrates various aspects of game testing methodology (for a fuller report on the results, see Hazlett, 2006). Thirteen boys played the car-racing videogame *Juiced* (THQ, 2005) on an Xbox platform while facial EMG data was collected. This game involves the player in choosing and customizing a race car, and then picking from various race courses and conditions to race a number of other cars. The races tested in this study were all circuits, and the player raced for several laps against 3-5 other cars that were controlled by the game's AI. Displayed on the screen was various information such as current place, speed, and time from other cars.

Before the actual testing, three experienced players of the game were observed while they played the game and were interviewed about what they found to be clearly identifiable positive and negative events in the game. Identified positive events were passing other cars, making other cars crash and advancing one's standing in the race, and winning a race. Identified negative events were being passed by another car, being hit by another car, mechanical trouble, and running off the course or "wiping out."

Each of the thirteen players was tested alone in a naturalistic living room setting with the EMG testing equipment and experimenter unobtrusively positioned behind a low partition. The player used the smaller "S" Xbox controller and watched the game on a 52-inch Pioneer TV monitor from a distance of 175 cm. Each boy first practiced for several games and then chose a level and course that they felt would be challenging but also that they had a chance of winning. Then each boy ran two races while facial EMG data were collected. The boys were asked not to talk during the races that data were being collected.

Through video review positive and negative events during play were identified. It was found that the zygomaticus EMG was significantly greater during positive events as compared to negative events. Also, the corrugator muscle EMG was found to be significantly greater during negative events as compared to positive. Figure 13.2

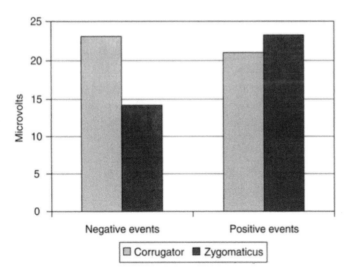

FIGURE
13.2

Mean Facial EMG by *Juiced* Race Events.

shows these results by events and muscles. One can see that the negative and positive events had a different pattern of emotions. The negative events results were particularly striking, but the positive event results, though not as large, were still significantly different. This study demonstrated that positive and negative emotion can be measured in real time during video gameplay. Now that we see that this method can measure the player's emotional experience, how can it be applied to developing more compelling and entertaining games?

13.4.2 *Developing a Game's Emotional Profile*

Different game genres will have particular emotional signatures based on the objectives of the game and the methods used by the designers to engage the player. We will look at several genres to illustrate the approach, and to show how the measurement of a game's emotional profile might be helpful for game development.

One of the most common game designs is to provide the player a challenge to overcome, and then when successfully overcome the player moves to a higher level with new powers, abilities, etc. Then the player faces a new challenge and the cycle continues as he/she advances through the game. When the player is immersed in overcoming the challenge, their emotional tone is tenser, and then upon success their emotion shifts to the positive. The right amount of tension, not too easy and not too frustrating, is critical to get the greatest positive emotional spike. The balance between tension and positive is an important aspect of a game's emotional profile, and the reason many games offer to the player choices in level of difficulty. Consider the driving game Juiced that we just looked at. Though not reported on in the validation study, the moment to moment emotional readout shows the player

having bursts of negative emotion and increased tension when something bad happens like being run off the road and bursts of positive emotion when the player passes another car or wins the race. For driving games, there is a fairly ever-present mildly elevated tension level associated with concentration on driving, and bursts of positive and negative emotion throughout the race related to game events.

A genre with a different emotional profile is the action role-playing game (RPG). We will examine play with *Fable* (Lionhead Studios), a successful and critically acclaimed game when it came out in 2004. This game consists of "the hero" developing skills and acquiring possessions such as weapons, and overcoming challenges that lead him through a portal to another place while he is hunting the "Jack of Blades." Figure 13.3 shows the emotional readout from facial EMG of a fifteen-year old boy playing *Fable* through three complete challenge cycles, just over 6 minutes, and leaves off with him in the fourth cycle. The positive zygomatic response is in blue, and the negative/tension of the corrugator is in orange. One can see the pattern of increasing tension during the challenge as he engages in combat, and then a positive spike when the challenge is overcome, and the hero moves onto the next place and the next challenge. This increasing EMG gradient is common in sustained tasks and is associated with increasing level of tension and effort (Malmo & Malmo, 2000).

FIGURE
13.3

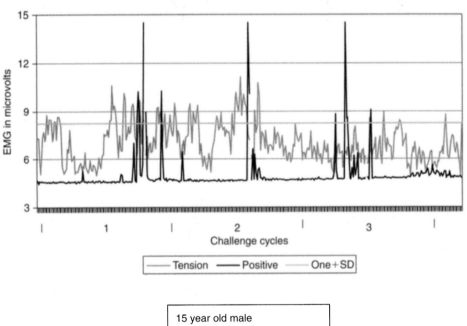

15 year old male
388 Total seconds
Positive Mean: 5.0, +1SD: 5.5%
Tension Mean: 7.0, +1SD: 17%
Positive/Tension ratio: 0.32

Fable Play.

Only the third challenge is missing the consistent tension build up where we would expect to find it. If we were going to analyze this data to help with game design, then as the developer we would be on the look out for patterns like this amongst players. Do most players lack the tension build up at that particular place in the game, or was this lack something idiosyncratic for this particular player? Using the immediate readout of EMG data to help with asking post-game questions is a particular usefulness for EMG, and will help the developer zero in on difficulties or emotional dead spots in the game that would have been overlooked with just traditional data collection.

One method of describing the emotional profile of a game is to count the number of seconds that the two emotional traces are at least one standard deviation above their mean. Since people vary on the absolute value of their EMG in microvolts, the standard deviation gives us a way to compare between players and games. In Figure 13.3, one standard deviation above the positive emotion mean is represented by the green line. This gives us a way of noting at a glance what places in the gameplay did heightened positive emotion occur. The same can be done for levels of tension. The percentage of time the EMG is elevated one standard deviation above the mean is related to the skewness of the data series, or how many and how lengthy are the spikes in the player's emotional record. In this example of *Fable* the positive level is elevated for 5.5 percent of the series, and the tension level is elevated for 17 percent. The ratio of positive elevated moments to tension is 5.5/17, or 0.32. At this point in game research there is no database that we can compare this ratio to and find out if this is a favorable positive to tension ratio for an action RPG. Again, we are looking at one player in this graph, and it will be important to calculate this emotion ratio based a selection of players. Though there are no norms yet developed, this calculation does represent an opportunity to quantify the shifts in emotional experience that underlie enjoyment and immersion, and would give a quantitative score to help compare and evaluate games of the same genre.

The virtual board game or party game *Mario Party* (Nintendo) has a decidedly different emotional profile than *Fable*. *Mario Party* offers the player a series of short challenges called "mini-games" that are fun without too much work. Figure 13.4 shows a profile of a nine-year old boy playing *Mario Party 6* on Gamecube for 6½ minutes. In comparing this emotional response profile to the *Fable* profile, we first of all see a much greater duration of elevated positive emotion. Positive emotion is elevated above one standard deviation 18.6 percent of the time, and tension is elevated 14 percent of the time, resulting in a positive/tension ration of 18.6/14, which yields the emotional profile number of 1.33. This number is quite above the emotional profile ratio of *Fable* and well in the positive range (1.00 would be the value when positive and negative elevations are balanced).

Mario Party is designed for multiple players, and that is one of its fun elements. But for this test we control the social interaction and have the player play solo. He is playing Mario, while the console is controlling the three other players. For the first mini-game the player first rolls the dice and then hops to the proper space based on the dice roll. That ends at around second 80, and then there begins a mini-game called "Take a Breather." All 4 players hold their breath and go underwater, and

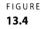
FIGURE
13.4

9 year old male
390 Total seconds
Positive Mean: 8.44, +1SD: 19%
Tension Mean: 4.39, +1SD: 14%
Positive/Tension ratio: 1.33

Mario Party Play.

Mario stays under the longest and thus wins the game at 105 seconds. From the graph, you can see the dramatic increase in positive emotion that occurs when the game is won. The interesting thing that this data shows us though is that in contrast to playing Fable winning challenges isn't the only way that the player experiences increases in positive emotion. We can see this pattern in the next thing that occurs for Mario. He begins a long dice roll and walk at around 160 seconds, which lasts for about 50 seconds to second 210. During the roll he becomes giant size and he gets doubles, but at the end of the roll he lands on a space that loses him several points. In looking at the graph one can see that the player experiences elevated positive emotion all through Mario's turn until the end when he loses points and then the positive emotion goes down.

The next *Mario Party* mini-game illustrates heightened positive emotion during the mini-game. Beginning at second 250 the player engages in a mini-game called "Candle Light Flight." For three times the players chase each other around in the dark, and there is very little feedback to the player on how he is doing. Only at the end of the three mini-games do the players find out who won. The three positive emotional spikes at seconds 260, 300, and 315 correspond exactly to the playing of the three games. The sharp increase in positive emotion occurs while the player is using his controller to

elude the other players. Figure 13.4 tells us that this is the fun element for the player. At the end of the three games the player actually finds out that his character Mario lost. After that loss the player goes on to engage in another series of dice rolls and moves, which as we can see, are very enjoyable. By looking at the positive emotion trace we can also see which of the mini-games the player enjoys the most. For example, this player finds the "Candle Light Flight" more enjoyable than "Take a Breather."

So in summary, for a party game the player does experience pleasure when winning, but in contrast to the action RPG most of the pleasure occurs during the play no matter what the outcome is. The game designers recognize this, and have many fun elements, like giant sizing, genies, etc occurring during the play. The graph for *Mario Party* also illustrates how tension levels stay low and spikes are minimal, indicating that tension is not a predominant element in the emotional experience of the player for this genre. These two profiles were used to illustrate how different types of games will evoke different emotional experiences. The player of an action RPG can tolerate and enjoy a much lower tension to positive emotion ratio than the player of a fun causal game like *Mario Party*.

Recent trends indicate that the growth in the gaming industry may lie in areas other than the traditional fare of hardcore gamers. There has been a recent increase in popularity in causal games and causal game platforms, serious games, and games targeted for seniors and baby boomers. These new players appear to be seeking a different gaming experience that involves different emotional profiles. In order to understand and design for these emotional experiences the accurate assessment of the emotional experience of these new gamers is vital. Since these new players do not fit the typical hardcore gamer demographic developers now more than ever can't expect that their gut reactions and interests will be similar to the intended player. Facial EMG can give feedback to the developer on what features of the game enhance emotional experience, and what mini-games, scenes, places, characters, challenges etc work best.

Warning

There are many infamous disasters in advertising and marketing that have occurred when executives thought that the intended consumer's reaction to an ad or product would be similar to what the executive's reaction was. Don't make the same mistake in game development and assume you know what the potential player's preferences and experiences will be. Testing the player's experience and emotional responses are vital to successful game development.

13.5 Practicalities of Using Biometric Measures

Using physiological measures in game testing is a step up in the complexity of measurement. It takes some extra equipment and technical knowledge. However,

it takes training and expertise to conduct any type of user experience and usability study. Physiologic measurement is not as daunting as it may first appear, and there are equipment makers, consultants and written resources that one can turn to for help. This section will give a brief overview of what is involved in emotional measurement of games using facial EMG.

Physiologic testing of gameplayers is conducted preferably in a living room setting, simulating a natural environment as much as possible. Two tiny micro-sensors are placed over the zygomaticus and then the corrugator muscle (see Tassinary et al., 1989 for more complete description). A common ground sensor can be attached anywhere on the body. Convenient ground attachments are a wrist bracelet or an ear lobe clip. The facial muscle sites are cleaned with alcohol and a conductive gel is used to make the connection between the skin and the sensor. Figure 13.5 shows a gamer at play with the EMG sensors attached. An experienced technician can hook up a player and be ready to test in less than five minutes. These sensors on the face may seem like they would interfere with the player's experience. However, experience shows that people soon forget them as they get involved in the game, just like test subjects forget about the one-way mirror in a two-room testing situation. The wires from the sensors connect to a bioamplifier for each muscle that amplifies the signal, and these bioamplifiers connect to an analogue-to-digital (A/D) converter (Psylab, made by Contact Precision Instruments, is one of the

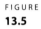

FIGURE
13.5

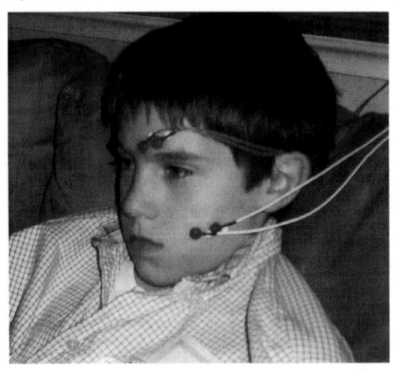

Player with EMG Sensors, focused on gameplay.

better systems). In order to filter out noise, the EMG signal is typically filtered to only allow 30 Hz to 500 Hz to pass. Also researchers often use a 60-Hz notch filter to block out AC line interference. The raw EMG signal is in the form of a bipolar sine wave, and needs to be rectified so the absolute values reflect the magnitude of the muscle contraction. Figure 13.6 shows both the raw bipolar signal, and the rectified version of the same raw signal. The signal can then be averaged and smoothed through a hardware device called an integrator, or it can be sent to the computer for software processing and averaging. Figure 13.6 shows the steps in this processing from raw EMG signal to the final smoothed signal that can then be related to game events. The sampling rate of the EMG signal is usually on the order of 1,000 Hz, so large data files are produced rather quickly (see Cacioppo et al., 1999 for overview

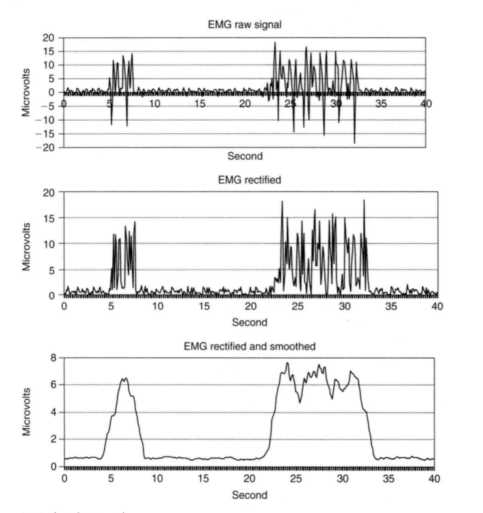

FIGURE
13.6

EMG Signal Processing.

of EMG methods). Averaging to 100 msec or even 1 second values produces a workable time series that can then be synchronized with the video of the gameplay.

Tip

At 1,000 data points collected for each second, testing for a few minutes quickly produces large data files, and not only is disc space a concern but time to process starts to rise. One can minimize the processing time with writing some reusable code to rectify and aggregate the data that can be plugged in quickly. Sometimes a better alternative is to have the data crunched with a hardware device called an integrator and then sent to the computer. Sensitivity does seem to be affected by this approach though and some researchers, including myself, prefer to manage the larger data files for the sake of precision.

This EMG methodology is likely more of a quantitative approach than most are use to taking, but with a little preliminary work one can set up a system that you can use over and over again with little extra work. For example, an Excel spreadsheet can be made with the formulas for mean, standard deviation etc already in cells, and after the initial data capture and averaging, the positive data series and the tension data series can be dropped in two data columns of the Excel worksheet. The summary values of interest are then instantly calculated and available for use.

During the actual gameplay the EMG signals can be of use as well, without any extensive data analysis. The tester can observe the gameplay and also have an eye on the EMG readout that is flowing across the screen. When there is a particular positive or tension spike on the screen the tester can note what the gameplay was, and then after the play session ask the player what might have been occurring for him/her at that moment. The EMG readout then can be quite valuable in directing the tester's attention to significant reactions and events in the gameplay that would have gone unnoticed otherwise.

Warning

In any type of player experience testing the presence of others is a powerful influence. Other people are strong emotional elicitors, and social interaction will overwhelm reactions to the game. The tester should always strictly control this aspect of the testing situation, or risk invalidating the data and learning little about the game.

Players are usually tested alone, as the presence of other people influences smiling and the report of positive emotion. Basically, sharing experiences with others

increases one's enjoyment. Of course, if one is interested in testing the multiplayer experience, then the involvement of other players would be important. But as in any method of testing, the social variable can have a potent effect on the player's experience and should be strictly controlled from test to test. To get a good sample it would be wise to test at least 6-8 players at a minimum, and more if one has the time and resources. This requirement is similar for any type of testing that a developer would want to conduct, and not just EMG methods.

> **Note**
>
> Biometric methods in general require fewer subjects than verbal methods to be valid, as the error variance is usually less. However, the more players one can test the more confident one can be in their results. The balance between collecting enough data and costs in time and money is always an issue.

13.6 Applications for Biometric Methods

There are many interesting game development applications for biometric methods. We have already taken an in-depth look at some of the possibilities with the *Fable* and *Mario Party* examples, so here we will expand some on the possibilities. The emotional profiling of games gives a useful evaluation of a game's impact on a player, how compelling they find the game, and how the game measures up to other games in its genre. If there are weaknesses in the game, the moment-to-moment emotional profile can help pinpoint where those weaknesses lie. Individual elements of a game can be tested separately or compared to other variations so one can choose the variation that has the strongest emotional impact. This can be any element such as static visual scenes, music, characters, story, etc. The elements don't have to be finished versions, but it needs to be kept in mind that the more barebones something is, the less of an impact it will have. That is why one would want to compare things that have the same level of finish to them. The causal games that are becoming evermore present on phones and handhelds often depend on short simple experiences of fun for their addictive quality. Facial EMG is well-suited to measure the intensity of positive emotional bursts associated with this fun, and to allow comparisons amongst games and mini-games.

> **Note**
>
> If you are testing reactions to a series of visual or auditory features like scenes, music, characters, etc., it would be important to vary the presentation order between players so that there are not order effects in the testing results.

Another example of application of biometric methods to games comes from the Serious Games area, and involves the assessment of post-traumatic stress disorder (PTSD) treatment approaches using game technology. Treatment of PTSD is aided by creating controlled re-immersion experiences for patients, and researchers are now using videogame technology to create such therapeutic environments (for more information, see DeMaria, 2006). Intensity of the experience needs to be in a therapeutic range: high enough to activate the emotional memories, but not too intense so they overwhelm the player and he/she can't emotionally process. Biometric methods can help researchers determine the state of the player and keep it in optimum range.

When successful treatment has been achieved the trauma environment will not cause such a high level of arousal to occur for the player. Gaming with biometric measurement therefore is also a superior method for assessing treatment success and the achievement of game goal objectives. An example of successful PTSD treatment with virtual reality immersion is shown in Figure 13.7. This data is from a female patient I assessed who had been held up at gunpoint and subsequently developed PTSD. She was assessed at the beginning and the conclusion of PTSD treatment. The typical assessment paradigm for PTSD is to immerse the patient in three different environments: relaxed or neutral, general stress, and traumatic. The neutral and general stress environments are used as control conditions to make sure the biometric changes measured from before and after treatment only occurred in the trauma condition, and therefore are caused by changes in reactivity to the trauma cues. Heart rate was measured during a 5-minute exposure to each of these

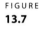

FIGURE
13.7

Pre- and Post- Treatment Response to Virtual Reality Immersion of Trauma Victim.

three virtual environments, and the means are shown in Figure 13.7. As can be seen, the trauma changes were much larger and more significant than the other two environments. (Note: the assessment and treatment in this case only used virtual reality immersion with video of appropriate environments for each of the three environments. The addition of actively involved gaming in assessment and treatment for this type of patient would be an advancement, and is on the drawing board.)

This example of PTSD treatment illustrates that when the goal of a game is beyond just entertainment, player experience assessment can provide another function besides feedback to help game design. Biometric player assessment can inform about the success of each player in achieving game goals. This is of course important for the player, but also a log of cumulative player success can then provide performance and ROI data about the game itself. Information such as percentage of players that achieved game goals, amount of time and effort required to achieve goals, and so on can be used for interested parties such as stakeholders and for marketing and sales purposes. This information becomes important with serious games because unlike entertainment games, the purchaser of the serious game may likely not be the intended player, and personal play experience is not a source of information for the purchaser.

13.7 Summary

In this chapter, I have tried to give the reader a brief introduction to the nature of emotion, and how the player's emotional engagement and reaction is the fundamental driving force of the gaming experience. Game development is enhanced by feedback about the emotional experience of the player, and this information can be used to arrive at an emotional profile of the game. The challenge is in measuring the emotional experience of the player without interfering with the natural gaming experience. The player's verbal report is not so informative about their moment to moment emotional experience so physiological measures have been turned to. The best physiologic measure for tracking emotional valence is facial EMG. These methods were described and shown to have validity for measuring emotion during gaming. Even though the EMG methodology is more quantitative than most approaches, there are ways to collect and analyze the data that minimize the work.

One of the main goals of biometric assessment in game development is to provide information on the emotional profile of the game, and how the different elements of the game enhance or detract from the game's approach to engaging the player. In this chapter, biometric assessment of an action RPG and a party game demonstrated how different game genres have different emotional profiles and methods for emotionally engaging the player. In addition to entertainment games, biometric assessment can be useful with serious games. We saw how serious games have a somewhat different assessment need than entertainment games, and how biometric assessment might be useful in providing feedback on the less objective

outcomes desired for some of these games. Appling game and virtual reality technology to help with the treatment and assessment of PTSD gave us an example of how gaming with biometric measurement can achieve the game's objectives of providing the player with controlled immersion and active learning. The biometric assessment also becomes useful for quantifying the effectiveness of the game.

13.8 References

Anttonen, J., & Surakka, V. (2005). Emotions and heart rate while sitting on a chair. In: *Proc. CHI 2005*. ACM Press, pp. 491–499.

Cacioppo, J.T., Bush, L.K., & Tassinary, L.G. (1992). Microexpressive facial actions as a function of affective stimuli: Replication and extension. *Psychological Science, 18*, 515–526.

Cacioppo, J.T., Gardner, W., & Berntson, G. (1999). The affect system has parallel and integrative processing components: Form follows function. *Journal of Personality and Social Psychology, 76*, 839–855.

DeMaria, R. Games for health 2006: *Addressing PTSD, psychotherapy & stroke rehabilitation with games & game technologies*. Serious Games Source. http://seriousgamessource.com/features/feature_052306.php

Ekman, P., & Friesen, W.V. (1978). *Facial action coding system (FACS): A technique for the measurement of facial actions*. Palo Alto, CA: Consulting Psychologists Press.

Hazlett, R.L. (2006) Measuring Emotional Valence during Interactive Experiences: Boys at Video Gameplay. *Proceedings of CHI 2006 Conference on Human Factors in Computing Systems*, ACM Press, 1023–1028.

Hazlett, R.L. (2003) Measurement of user frustration: A biologic approach. *Proceedings of CHI 2003 Conference on Human Factors in Computing Systems*, ACM Press, 734–735.

Keeker, K., Pagulayan, R., Sykes, J. and Lazzaro, N. (2004). The untapped world of videogames. *In Proc. CHI 2004, ACM Press,* 1610–1611.

Larsen, J.T., Norris, C.J., & Cacioppo, J.T. (2003). Effects of positive and negative affect on electromyographic activity over zygomaticus major and corrugator supercilii. *Psychophysiology, 40*, 776–785.

Malmo, R., & Malmo, H. (2000). On electromyographic (EMG) gradients and movement-related brain activity. *International Journal of Psychophysiology, 38*, 143–207.

Mandryk, R. (2004) Objectively evaluating entertainment technology. *Proceedings of CHI 2004 Conference on Human Factors in Computing Systems*, ACM Press, 1057–1058.

Pope, L.K., & Smith, C.A. (1994). On the distinct meanings of smiles and frowns. *Cognition and Emotion, 8*, 65–72.

Ravaja, N., Salminen, M., Holopainen, J., Saari, T., Laarni, J. and Järvinen, A. (2004) Emotional response patterns and sense of presence during videogames: potential criterion variables for game design *Proceedings of the third Nordic conference on Human-computer interaction*, ACM Press, 339–347.

Tassinary, L.G., Cacioppo, J.T., & Geen, T.R. (1989). A psychometric study of surface electrode placements for facial EMG recording: I. The brow and cheek muscle regions. *Psychophysiology, 26*, 1–16.

Waterink, W., & Van Boxtel, A. (1994). Facial and jaw-elevator EMG activity in relation to changes in performance level during a sustained information task. *Biological Psychology, 37*, 183–198.

Watson, D., Wiese, D., Vaidya, J., & Tellegen, A. (1999). The two general activation systems of affect: Structural findings, evolutionary considerations, and psychobiological evidence. *Journal of Personality and Social Psychology, 76,* 820–838.

13.9 Additional Resources

Cacioppo, J.T., Tassinary, L.G. and Fridlund, A.J. The skeletomotor system. In ed. Cacioppo, J.T., Tassinary, L.G. *Principles of psychophysiology,* Cambridge University Press: New York, 325–384.

J+J Engineering. The I-330-C2 6 channel biofeedback device. http://www.jjengineering.com/C6.htm

PsyLab. Contact Precision Instruments. http://psylab.com/

CHAPTER FOURTEEN

Physiological Measures for Game Evaluation*

Regan Mandryk is an assistant professor in the department of computer science at the University of Saskatchewan in Canada. Her research focuses on the design, implementation, and evaluation of user-context sensing technologies and on incorporating context into the design of interaction techniques. She focuses on the affective and cognitive aspects of user context, and applies her methodologies in computer game environments. Having received her Ph.D. in computer science from Simon Fraser University, her M.Sc. in kinesiology from the same, and her B.Sc. in mathematics from the University of Winnipeg, Dr. Mandryk is uniquely positioned to explore the mathematical modeling of user emotional state, based on physiological signals, while users play computer games.

14.1 Introduction

Given the success of physiological metrics for evaluation in other domains such as human factors, it is logical to assume that physiological signals would also be good indicators of user experience with computer games. Physiological signals yield large amounts of contextually-relevant data, provide an objective indicator of user

* (Editors' warning: This chapter is not for the faint of heart—it contains far more scientific terminology and details than other chapters in the book. For a simpler introduction to using some of these measures in your research, see Hazlett's chapter. We included this material for those who are interested in diving even deeper, and are thus willing to pick up many new concepts and terms.)

experience without impacting the gameplay experience, and can be used to infer underlying emotional states relevant to gameplay. It would be a boon to the game evaluation community if there was a plug-and-play system, where a user is sat down in front of a computer game, physiological sensors are attached, and a few minutes later we know how much fun she is having, and which parts of the game are more fun than other parts. Unfortunately, using physiological signals is not this straightforward, and there are complexities in data collection and analysis that currently prevent us from achieving this plug-and-play level of ease. But research in this area is advancing, and the ease of a plug-and-play system is not far off.

This chapter will provide you with the necessary information to introduce physiological measures into your player studies, and will point you to in-depth resources available for further study.

14.1.1 *Overview of Our Research*

Along with several co-authors, I conducted a series of experiments to develop a new method for continuously modeling user emotional state in interactive play environments based on a user's physiological responses. The goal was to develop an evaluation methodology for games that: captures usability and playability through metrics relevant to ludic experience; accounts for user emotion; is objective and quantitative; and has a high evaluative bandwidth (continuous measurement). Our approach was to collect physiological data as a direct indication of user experience. We explored the following physiological measures: galvanic skin response (GSR), heart rate (HR), electromyography (EMG) of the face (jaw, forehead, cheek), and respiration.

In an initial experiment we explored how physiological signals respond to interaction with play technologies. We collected a variety of physiological measures while observing participants playing a computer game in four difficulty conditions, providing a basis for experimental exploration of this domain. Collecting and analyzing physiological data requires a controlled approach that is hard to balance with the need for ecological validity when measuring behavior within gaming systems. Guidelines for conducting research in this domain based on results from our initial experiments can be found in (Mandryk et al., 2006).

In a second experiment, we investigated how physiological signals differ between play conditions, and how physiological signals co-vary with subjective reports (Mandryk and Inkpen, 2004). We observed different physiological responses when users played a computer game against a co-located friend versus a computer. When normalized, the physiological results mirrored subjective reports. By integrating the methods in Mandryk et al. 2006, we showed that physiological measures can be used to objectively measure a player's experience with computer games.

In a third experiment we developed a method for mathematically modeling emotion using physiological data. A fuzzy logic model transformed four physiological signals (GSR, HR, EMG smiling, EMG frowning) into the emotional dimensions of arousal and valence. A second fuzzy logic model successfully transformed arousal and valence into four emotional states: boredom, excitement, frustration, and fun.

FIGURE
14.1

Quadrant display including a) the screen capture of the biometrics, b) video of the participant's face, c) video of the controller, and d) a screen capture of the game. Audio of the participant's comments and audio from the game were included in the quadrant video.

The modeled emotions' means were evaluated with test data, and exhibited the same trends as the reported emotions for fun, boredom, and excitement, but modeled emotions revealed statistically significant differences between three play conditions, while differences between reported emotions were not significant. The details of the fuzzy logic model can be found in Mandryk and Atkins (2007). while the validation of the model and its potential use in interactive systems can be found in Mandryk et al. (2006). For details on our work and related literature in the area, see Mandryk (2005). Figure 14.1 shows how we collected the data. Cameras captured a player's facial expressions and their use of the controller. All audio was captured with a boundary microphone. The game output, the camera recordings, and the screen containing the physiological data were synchronized into a single quadrant video display, and recorded onto a hard disk. The audio from the boundary microphone, and the audio from the game were integrated into the exported video file.

To conduct work in this area, we learned lessons the hard way: by trial and error. By sharing our knowledge stemming from years of experimentation with physiological sensors and games, I hope that you will be in a well-informed position to incorporate physiological sensors into your own work.

14.2 Comparison to other evaluation techniques

Choosing which evaluation technique to employ is an important decision that should be based on what information you want to discover about the user's experience,

what skills and resources are available, and what kind of budget and schedule you have for the evaluation process. For an in-depth discussion of how to decide on an evaluation method, investigate the DECIDE framework (see Chapter 13 of Sharp et al., 2007). (Editors' note: there is also a matrix in Chapter 21 of this book,which compares methods.)

If you are considering using physiological measures as an evaluation metric, see Figure 14.2 to understand how they relate to other approaches for evaluation. If your goal is to understand the attitudes and preferences of gamers, subjective approaches such as interviews or surveys are most appropriate. If your goal is to find usability or playability problems, heuristic evaluation is likely the best choice. However, if your goal is to gather quantitative data on a user's experience while they are playing a game, observational analysis or physiological metrics are best. Both approaches are objective and quantitative, and can be measured throughout the play experience.

If your primary deciding factor is budget or schedule, discount approaches like heuristic evaluation, and surveys are generally fast and inexpensive compared to other evaluation methods. Collecting physiological measures in the past has required expensive sensors; however, there are now cheap and robust sensors on the market which can be added to your user study. Adding sensors only slightly increases the time needed for a user study as individual baseline measures must be gathered and participants may need to rest in between games or experimental conditions to return to their resting baselines. Processing and analyzing physiological data is not as time-consuming as rigorous observational analysis, but still adds an

FIGURE
14.2

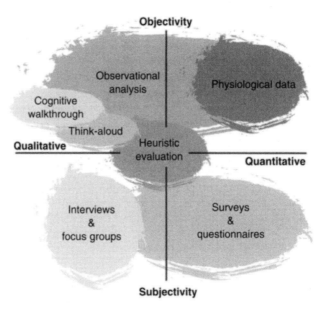

Current methods for evaluating entertainment technologies. Evaluators have a lot of choice depending on their goals.

extra step. Even so, the detailed information about user experience that physiological measures provide is worth the additional time commitment.

This chapter should provide you with the necessary information to introduce physiological measures into your user studies, but to perform rigorous scientific research in this area requires a certain skill set that will take time to develop. Although measuring a user's galvanic skin response while they play a game is not a complex task, using GSR data to make inferences about your game environment is not as straightforward.

14.3 Which Sensors to Choose

Which sensors to use?

Choosing appropriate sensors depends on what you want to measure, and what your setting is like. Use the following as a guideline:

Psychological Counterpart

- Arousal: Increases in psychological arousal are best measured by increases in galvanic skin response (GSR), but can also be seen in increased respiration, decreased blood volume pulse (BVP), and increased heart rate (HR).

- Mental effort: depending on your setting, decreasing heart rate variability (HRV) or greater pupil dilation can be used to measure increases in mental effort. Increases in jaw clenching (through EMG sensors on the face) or brow-raising (EMG of the forehead) may also be indicative of increased mental effort. Increased respiration rate and a decrease in the variability of respiration rate are also associated with mental effort.

- Positive versus negative emotions: The *valence* of an emotion (whether it is positive or negative) can be measured through facial muscle analysis (EMG) over the brow (frowning) and cheek (smiling). Some potential has been shown in the use of heart rate, irregularity of respiration, and pupil diameter as indicators of valence.

Ease of Use in Gaming Environment:

- Sensitivity to movement: Blood volume pulse (BVP), respiration via stretch sensor, and galvanic skin response can be sensitive to movement.

- Sensitivity to physical activity: Most physiological measures are sensitive to fluctuations in physical activity. Be aware of this when testing users.

- Individual differences: Most physiological measures show large differences between users and between the same user on different days or at different times of day. Use normalization procedures to correct for fluctuations.

When choosing which physiological sensors to use, there are two questions you must ask yourself: what do I want to know about the user's experience, and whether using a given sensor will intrusively impact the user's gaming experience or be impacted by the play experience. The former question is straightforward, and this section provides details on what aspects of user experience are measured by which physiological sensors. The latter question is more difficult because the environments of game playing and psychophysiological experimentation are in opposition to each other. When playing a game, users should be unrestricted and immersed in the play experience. In contrast, traditional experiments involving physiological measures have taken place in tightly-controlled laboratory environments.

In this section, we describe a number of physiological sensors. Organized by anatomical system, each subsection presents: the measure; its psychological counterpart; other factors it is affected by; and devices used for measurement. In addition, we discuss how each measure might impact a gaming experience, and whether the act of playing a game will prohibit its use.

14.3.1 *Skin: Electrodermal Activity*

Electrodermal activity refers to the electrical properties of the skin. Also called the galvanic skin response (GSR) or the psychogalvanic reflex, it is easily measured as either skin resistivity or skin conductance, although the most common use is as a measure of skin conductance. Electrodermal activity is one of the most commonly used physiological responses in psychophysiological research and in computing systems that integrate body responses.

There are two components to the electrodermal response: the tonic baseline and the short term phasic responses superimposed on the baseline (Stern et al., 2001). The tonic baseline (which can vary greatly over different individuals) refers to the general conductance of the skin, while the phasic responses (which we are interested in measuring) are deviations from the baseline resulting from a stimulus. It is thought that the electrodermal response evolved for locomotion, manipulation and defense (Stern et al., 2001). There are specific sweat glands, called the eccrine sweat glands, which are used for measuring GSR. Located in the palms of the hands and soles of the feet, these sweat glands respond to psychic stimulation instead of simply to temperature changes in the body. For example, many people have cold clammy hands when they are nervous. In fact, subjects do not have to even be sweating on the palms of the hands or soles of the feet to generate differences in skin conductance because the eccrine sweat glands act as variable resistors on the surface. As sweat rises in a particular gland, the resistance of that gland decreases even though the sweat may not overflow onto the surface of the skin (Stern et al., 2001).

Psychological Counterpart

Galvanic skin response is a linear correlate to arousal (Lang, 1995) and reflects emotional responses as well as cognitive activity (Boucsein, 1992). GSR has been used

212

extensively as an indicator of stress and mental workload in both non-technical domains (see Boucsein, 1992 for a comprehensive review), and technical domains. It is considered the most sensitive response used in the detection of deception (lie detectors) (Boucsein, 1992) and has also been used to differentiate between anger and fear (Lang, 1995).

Although electrodermal activity is widely recognized in psychophysiology, there are other factors that affect the galvanic skin response including age, sex, race, temperature, humidity, stage of menstrual cycle, time of day, season, sweating through exercise, and deep breathing (Boucsein, 1992 Stern et al., 2001, Venables and Christie, 1973). There are also individual differences stemming from personality traits such as whether an individual is introverted or extroverted (Boucsein, 1992). Due to these differences, it is difficult to compare GSR across groups of individuals or in the same individual across different test sessions. In a single session, skin conductance does not have to be corrected for baseline level, whereas skin resistivity does (Stern et al., 2001).

Measurement Devices and Use

Devices used to measure GSR range from simple circuits attached to aluminum foil finger cuffs to high-end systems used to detect deception. Wearable devices, devices that are embedded into clothing or accessories, have recently been designed to decrease interference from bulky equipment. The MIT Media Lab has designed a glove called the galvactivator, GSR rings and bracelets, and GSR shoes (Affective Computing Group, 2008). A brief visit to the Lego Mindstorms community bulletin boards (2004) revealed a few instances of using Lego components to build simple lie detectors using GSR. For scientific research, Thought Technologies (2008) produces a number of physiological sensor units and the accompanying GSR sensor. For less rigorous applications, a less expensive and more robust alternative, such as the biofeedback hardware from Wild Divine (Journey to the Wild Divine, 2008) will suffice.

In our work, we measured GSR using surface electrodes sewn in Velcro straps that were placed around two fingers on the same hand. Previous testing of numerous electrode placements was conducted to ensure that there was no interference from movements made when manipulating the game controller. We found that finger clips were as responsive to GSR as pre-gelled electrodes on the feet, while electrodes on the palms suffered from movement artifacts (Mandryk, 2005).

GSR feedback has been used in the medical community for relaxing and desensitization training, and in the treatment of excessive sweating and related dermatological conditions. As an input to gaming systems, GSR has been used in the *Relax-to-Win* racing game (Bersak et al., 2001) in *AffQuake* (Affective Computing Group, 2008), and in *The Journey to the Wild Divine* meditation game series (Journey to the Wild Divine, 2008).

14.3.2 *Cardiovascular System*

The cardiovascular system includes the organs that regulate blood flow through the body. Measures of cardiovascular activity include heart rate (HR), interbeat interval (IBI), heart rate variability (HRV), blood pressure (BP), and blood volume pulse (BVP). Heart rate indicates the number of contractions of the heart each minute, while HRV refers to the oscillation of the interval between consecutive heartbeats. Blood pressure is a measure of the pressure generated to push blood through the arteries, veins, and capillaries, while BVP refers to the amount and timing of blood flowing through the periphery of an individual.

Blood Pressure

Blood pressure indicates how much pressure is needed to push blood through the system of arteries, veins, and capillaries. Although blood pressure is known to be affected by age, diet, posture, and weight, it is also affected by the setting (clinical vs. normal) and by highly stressful situations (Stern et al., 2001). Generally, BP is collected using an inflated arm cuff (sphygmomanometer) that is inflated, and subsequently deflated while readings are taken. As a result of cuff inflation and deflation, blood pressure responses to stimuli cannot generally be collected in real-time. There were some sophisticated and expensive pieces of equipment that were developed to collect BP continuously, but these systems were removed from the market due to their lack of commercial success. Automated machines have been developed for use with polygraph machines, but cannot accurately take more than one reading per minute (Stern et al., 2001). Generally, technologies that measure BP are restrictive and invasive, and not suitable for gaming environments.

Blood Volume and Pulse Volume

Blood volume reflects slow changes in the tonic level of an appendage while pulse volume is a phasic measure of the pulsatile change in blood flow related to both the pumping of the heart and to the dilation and constriction of blood vessels in the periphery (Stern et al., 2001). Thus, pulse volume (BVP) measures the amplitude of individual pulses. BVP increases in response to pain, hunger, fear and rage and decreases in response to relaxation (Stern et al., 2001). BVP is difficult to collect outside of a clinical environment because it is affected by room temperature and is very sensitive to placement and motion. Due to these same factors, comparison between subjects is not possible.

Devices and Use

BVP is collected using a plethysmograph. Photoelectric plethysmography uses a photocell placed over an area of tissue (for example, finger). A light source is passed through the tissue (or bounced off the tissue), and the amount of light passed

through (or bounced back) is measured by a photoelectric transducer (Stern et al., 2001). Impedance plethysmography employs two electrodes through which a high-frequency alternating current is passed. Changes in blood volume affect the electrical impedance giving a reading of BVP (Stern et al., 2001). Strain gauge plethysmography uses a strain gauge placed around the finger or toe. Changes in resistance or voltage of the strain gauge can be considered an indirect measurement of blood volume (Stern et al., 2001). Venous occlusion plethysmography uses two inflated cuffs on the same appendage. As with BP measurements, since cuffs are used, real-time continuous measurements are not possible (Stern et al., 2001).

BVP is generally collected using the finger or toe. Since blood pulses through the earlobe, one might think that the earlobe is a convenient location to measure BVP. However, for BVP measurements, the earlobe is not as responsive as the finger to typical laboratory tasks (Stern et al., 2001). We did not collect BVP in any of our experiments because the sensing technology used on the finger is extremely sensitive to movement artifacts. As our subjects were operating a game controller, it wasn't possible to constrain their movements. If BVP is a desirable metric, consider measuring it using a plethysmography sensor on a toe.

Heart Rate

Heart rate (HR) indicates the number of contractions of the heart each minute, and can be gathered from a variety of sources. HR has been used to differentiate between positive and negative emotions, with further differentiation made possible with finger temperature (Papillo and Shapiro, 1990). Distinction has been made in numerous studies between anger and fear using HR (Papillo and Shapiro, 1990) (for a comprehensive review, see Cacioppo et al., 2000).

In addition to the psychological differences that HR elicits, it is also affected by age, posture, level of physical conditioning, breathing frequency, and circadian cycle (relating to a 24-hour period). We measured HR using electrocardiography, but a standard exercise HR monitor would suffice for most uses of HR in an interactive game environment.

Heart Rate Variability

Heart rate variability (HRV) refers to the oscillation of the interval between consecutive heartbeats (IBI). The heart rate of a normal subject at rest is irregular. This irregularity is called sinus or respiratory arrhythmia (Kalsbeek and Sykes, 1967). Fluctuations around the mean heart rate are respiratory-related, baroflex-related (relating to blood pressure), and thermoregulation-related. We are most interested in the baroflex-related fluctuation. Blood pressure changes are detected by baroreceptors in the aorta. An increase in blood pressure causes a sympathetic inhibitory response, and in turn, the effects of this response cause a decrease in blood pressure, creating a negative feedback loop (van Ravenswaaij-Arts et al., 1993). The passage of the neural signal from the baroreceptors through the

brainstem is associated with a time delay of about 1 sec (Mulder, 1979). This time delay creates a phase shift and causes the system to oscillate. The oscillation frequency is about 0.1 Hz (Mulder, 1979). If IBI is fairly constant, then HRV will be low, whereas if IBI is changing (regardless of absolute value), then HRV will be higher.

In 1963, Kalsbeek and Ettema (1963) found a gradual suppression of heart rate irregularity related to increasing task difficulty. Later, Kalsbeek and Sykes (1967) tested a motivated group versus a non-motivated group (using money as a motivator), and found that the motivated group maintained a constant level of suppression while the non-motivated group started at a lower level of suppression and continued to decline. Since then, many researchers have attempted to use HRV as an indicator of mental effort.

HRV has been used extensively in the human factors literature as an indication of mental effort and stress in adults. In high-stress environments such as ambulance dispatch (Wastell and Newman, 1996) and air traffic control (Rowe et al., 1998), HRV is a very useful measure. When subjects are under stress, HRV is suppressed and when they are relaxed, HRV emerges. Similarly, HRV decreases with increases in mental effort (Rowe et al., 1998) and cognitive workload (Wilson, 1992), but as the mental effort needed for a task increases beyond the capacity of working memory, HRV will increase (Richter et al., 1998, Rowe et al., 1998). Many researchers have found significant differences in HRV as a function of mental workload, while others have not (Meshkati, 1988, Mulder, 1979). HRV has also been used to differentiate between epistemic behavior (concerning the acquisition of information and knowledge), and ludic behavior (playful activities which utilize past experience) in children (Hutt, 1979).

One method of determining HRV is through a short-term power spectral density analysis of interbeat interval, which is described in the next section. HRV can be measured using electrocardiography, but less expensive alternatives, such as the Wild Divine biofeedback hardware (Journey to the Wild Divine, 2008), can also be used. If heartbeats can be accurately measured, then HRV can be determined and is suitable for measuring on a user interacting with a game console.

Spectral Analysis of Sinusarrhythmia

Power spectral density analysis describes how power is distributed as a function of frequency. Using the interbeat interval (R-R interval on an EKG, see Figure 14.3), power spectral density analysis provides a measure of how the heart fluctuates as a result of changes in the autonomic nervous system (Rowe et al., 1998). The high-frequency component (0.15-0.4 Hz) is associated with parasympathetic nervous system activity (resting and digesting), while the low-frequency component (0.04–0.15 Hz) is associated with sympathetic nervous system activity (fight or flight) (Jorna, 1992, Meshkati, 1988). A ratio of the low-frequency to high-frequency energy in the spectral domain is representative of the relative influences of the sympathetic to parasympathetic influences on the heart.

Recently, researchers have used spectral analysis of sinus arrhythmia (heart rate variability) to provide an objective measure of mental effort. Measuring HRV using the 0.1 Hz frequency component has the important advantage of being able to discriminate between the effort-related blood pressure component, and the effects caused by respiration, motor activity, and thermoregulation, since these other factors influence other parts of the power spectrum Vicente et al. (1987).

In order to perform spectral analysis, researchers used to convert the interval signal to an equidistant time series using interpolation, or filtering (Mulder, 1979). Recent digital technology produces a measure of the interbeat interval at 4 Hz, which can be used directly. This time series data is then smoothed and Fourier-transformed. The frequency range sensitive to changes in mental effort is between 0.06 and 0.14 Hz (Vicente et al., 1987), while the area between 0.22 and 0.4 Hz reflects activity related to respiration (Jorna, 1992, Mulder, 1979). Integrating the power in the band related to mental effort provides a measure of HRV. Vicente recommends normalizing the measure by dividing by the average of all resting baselines and subtracting from one (Vicente et al., 1987). Then, a value between 0 and 1 is produced where zero indicates no mental effort and one indicates maximum mental effort.

To assist researchers or developers who want to use HRV as an indicator of mental effort, many hardware systems perform the signal processing, and output HRV as a value. Although it is good to understand how HRV is calculated, users of physiological sensing systems do not have to perform the signal processing themselves, but can rely on the hardware to correctly determine HRV.

Electrocardiography

EKG (Electrocardiography) measures electrical activity of the heart. During each cardiac cycle, a wave of depolarization radiates through the heart (Martini and Timmons, 1997). This electrical activity can be measured on the body using surface electrodes. An example of an EKG signal is shown in Figure 14.3.

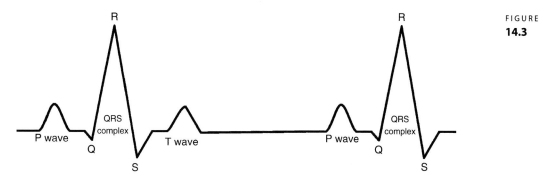

FIGURE
14.3

EKG signal. The P wave appears as the atria depolarize, the QRS complex accompanies the depolarization of the ventricles, and the T wave denotes ventricular repolarization. The R to R interval is the interbeat interval used to determine heart rate variability.

Heart rate (HR), interbeat interval (IBI), HRV, and respiratory sinus arrhythmia (RSA) can all be gathered from EKG. Although there is a standard medical configuration for placement of electrodes, any two electrodes placed fairly far apart will produce an EKG signal (Stern et al., 2001). The main placement method is on the chest with the negative electrode on the right shoulder, the positive electrode on the abdomen, and the ground on the left shoulder (see Figure 14.4 A), although the forearm provides a good measurement location for less intrusive measurement (Figure 14.4B and C). EKG provides a good signal with which to derive the aforementioned physiological cardiac measurements.

In our work, we placed three pre-gelled surface electrodes in the standard configuration of two electrodes on the chest and one electrode on the abdomen (see Figure 14.4A). Body hair can interfere with an EKG signal, and shaving the regions for electrode placement is a common clinical practice. As an alternative, we screened our participants to have little to no body hair on the chest or abdomen.

14.3.3 *Respiratory System*

Respiration can be measured as the rate or volume at which an individual exchanges air in their lungs. Respiration can be characterized by the following metrics: tidal volume (VT), which is the volume that is displaced in a single breath; duration of inspiration; duration of expiration; and total cycle duration (Wientjes, 1992). Minute volume (VMIN) is calculated as the tidal volume divided by the respiration rate, and indicates the volume that is displaced during one minute (Wientjes, 1992). The commonly used measures in psychophysiological research are simply the rate of respiration and depth (amplitude) of breath (Stern et al., 2001).

Emotional arousal increases respiration rate while rest and relaxation decrease respiration rate (Stern et al., 2001). Although respiration rate generally decreases with relaxation, startle events and tense situations may result in momentary respiration cessation. Negative emotions generally cause irregularity in the respiration pattern (Stern et al., 2001). In addition, states of pain, apprehension, anxiety, fear, threat and anger have been associated with hyperventilation (Wientjes, 1992). Mental effort, stressful mental task performance, and high cognitive activity have been associated with an increase in respiration rate and VMIN, and with a decrease in VT, depth of respiration, and in the variability of respiration (Wientjes, 1992, Wilson, 1992). Besides its psychological counterparts, respiration is affected by physical activity. Also, a deep breath can affect cardiovascular measures because respiration is closely linked to cardiac functioning.

Respiratory measures are most accurately measured by gas exchange in the lungs, but the technology inhibits talking and moving (Stern et al., 2001) and thus is inappropriate for users of gaming consoles. Instead, chest cavity expansion can be used to capture breathing activity using either a Hall effect sensor, strain gauge, or a stretch sensor (Stern et al., 2001). In our experiments, we used a stretch sensor sewn into a Velcro strap, positioned around the thorax, which works well in a

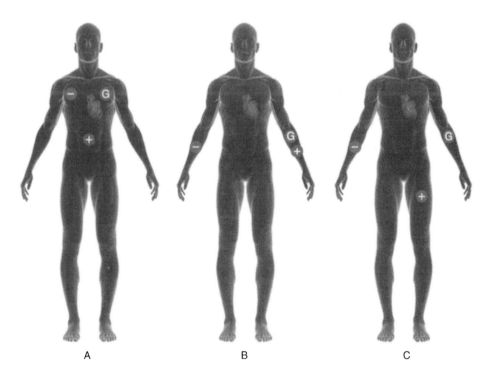

FIGURE
14.4

A B C

Three common electrode placements for EKG. (A) Chest placement. (B) Forearm placement. (C) Forearm and leg placement. (Adapted from Thought Technologies, 2008).)

gaming environment, although the data can be quite noisy if users are talking or frequently shifting position.

14.3.4 *Muscles: Electromyography (EMG)* *

Electromyography is the measure of muscle activity either through needles or surface electrodes. EMG measures muscle activity by detecting surface voltages that occur when a muscle is contracted (Stern et al., 2001). Two electrodes are placed along the muscle of interest and a third ground is placed off the axis.

In isometric conditions (no movement) EMG is closely correlated with muscle tension (Stern et al., 2001); however, this is not true of isotonic movements (when the muscle is moving). When used on the jaw, EMG provides a very good indicator of tension in an individual due to jaw clenching (Cacioppo et al., 2000). On the face,

* (Editors' note: the chapter from Hazlett in this book (13) provides an excellent overview of the application of EMG to game user research.)

EMG has been used to distinguish between positive and negative emotions (Fridlund and Cacioppo, 1986). EMG activity over the brow region (corrugator supercilii, the frown muscle) is lower and EMG activity over the cheek (zygomaticus major, the smile muscle) and preiocular (orbicularis oculi) muscle regions are higher when emotions are mildly positive, as opposed to mildly negative (Cacioppo et al., 2000). These effects are stronger when averaged over a group rather than for individual analysis, and have been able to distinguish between positive, neutral and negative valence at a rate greater than chance when viewing pictures or video as stimuli (Partala et al., 2005). Tonic activity from EMG on the forehead (musculus frontalis, the eyebrow-raising muscle) has been used as a measure of mental effort (Fridlund and Cacioppo, 1986). In addition to emotional stress and emotional valence, EMG has been used to distinguish facial expressions and gestural expressions (Stern et al., 2001).

EMG feedback is generally used for relaxation training, headache, chronic pain, muscle spasm, partial paralysis, speech disorder, or other muscular dysfunction due to injury, stroke, or congenital disorders.

In our experiments, we used surface electrodes to detect EMG on the jaw (indicative of tension), and on the forehead (indicative of frowning), and cheek (indicative of smiling). On the jaw and cheek, we used three electrodes preconfigured in a triangular arrangement. Because of the small size of the corrugator supercilli muscle, we used the extender cables to collect EMG on the forehead. The disadvantage of using surface electrodes is that the signals can be muddied by other jaw activity, such as smiling, laughing, and talking. Needles are an alternative to surface electrodes that minimize interference, but are not appropriate for non-clinical settings. Body hair can interfere with an EMG signal, and shaving the regions for electrode placement is a common clinical practice. As an alternative, we screened our participants to have clean-shaven faces in any of the regions where electrodes were to be placed.

Although highly useful as an indicator of emotional valence (positive versus negative emotions), EMG can be difficult to measure in a non-clinical setting, and requires care with electrode placement. Interference from other facial muscles is common, and users who are sensitive or easily embarrassed may not want to place sensors on their face.

14.3.5 Alternative Physiological Sensors

Although other physiological sensors are relevant to evaluation, we have not specifically investigated their use within the context of a computer gaming environment.

Electroencephalography (EEG)—a technique for recording electrical activity from the scalp related to cortical activity—has been successfully demonstrated as input to a computer game (Hjelm, 2003). For evaluation, EEG can be useful as an indicator of emotion as reliable patterns can be visually observed (Stern et al., 2001). In addition, evoked responses to specific stimuli—known as event-related potentials (ERPs)—could have interest as they are time-linked to particular stimuli (Stern et al.,

2001). We have not used EEG in our previous work and readers interested in the use of EEG for game evaluation should investigate the FUGA research project (Fuga: Fun of Gaming Research Group, 2008).

Pupillometry is the study of the dilation of the pupil (Stern et al., 2001); pupil dilation is a useful measure as it is affected by mental effort (Porter et al., 2007). Unfortunately, pupil diameter can also be affected by changing light conditions, color, or spatial pattern, and target motion of the visual input (Li and Sun, 2005, Porter et al., 2007). More research needs to be conducted to make pupil diameter effective as an evaluative physiological feature for use in interactive gaming environments.

14.4 Considerations for Collecting Physiological Data

It would benefit everybody in the game development industry if physiological measures were plug-and-play. Unfortunately, physiological measures are sensitive and finicky and are generally collected in controlled experimental settings, which is not ideal for evaluating computer games. However, our research shows that following some simple rules can support the successful collection of physiological data.

In one of our first experiments, we had participants play a game in four difficulty levels; we called the experiment 'Goldilocks' as we were looking for user to feel like the game was too hard (eliciting frustration), too easy (eliciting boredom), or just right (Mandryk et al., 2006). Although our participants did not respond consistently to the changes in difficulty level, this experiment revealed issues in our methodology that were potentially confounding our results. When examining play environments, researchers face unique issues, not apparent when examining typical productivity software. For example, variability of game intensity is incorporated into game design as a method of pacing the play experience. Collapsing a time series into a single point erases the variance within each condition, causing researchers to lose valuable information.

We incorporated the lessons we learned from this first experiment into our subsequent experiments. More details on our process of learning to conduct research in this domain can be found in Mandryk et al., 2006, but we summarize the most important considerations here.

14.4.1 *People are Different*

Physiological metrics have high individual variability, making comparison across subjects impossible without some form of normalization. Figure 14.5 shows GSR data from 10 users playing a computer game either against a friend or against a computer. Although 9 of the 10 participants had higher GSR values while playing against a friend, and the average increase in GSR was 36 percent of the total GSR span when playing against a friend, Figure 14.5 also shows how individual baseline GSR values vary.

To correct for these individual differences, you can normalize the data in a number of ways. The most common method is to represent the GSR value as a

FIGURE

14.5

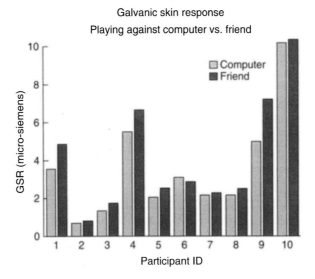

Average GSR values for ten participants playing either against a friend or against a computer.

percentage of the total GSR span. For example, if a user had a minimum GSR value of 4.6 μS and a maximum GSR value of 8.7 μS, their GSR value at time t of 6.3 μS would be represented as:

$$GSR_{normalized} = \frac{(GSR(t) - GSR_{min})}{(GSR_{max} - GSR_{min})} * 100 = \frac{(6.3 - 4.6)}{(8.7 - 4.6)} * 100 = 41.5\%$$

Normalizing the user data in Figure 14.5 would yield the results for average GSR shown in Figure 14.6. The GSR differences between the two play conditions are much more apparent once the data has been normalized. One of the drawbacks with normalizing user data is that you must know the minimum and maximum values for a user, requiring that all analyses happen after all of the data has been collected, rather than in real time while the data is being collected. If your application requires that you analyze the data as it is collected, then consider relative values rather than inferring meaning from absolute values. For example, consider that a user's GSR signal is rising or falling, or that the user just experienced a local peak, rather than inferring something from the fact that their GSR value is presently 5.6 μS. Normalizing sensor values also allows you to compare between individuals, although you still must be careful as normalization procedures are only based on the available information. If a user is having difficulty relaxing during a rest period, her arousal during the game (inferred from normalized GSR) will appear to be lower, as her resting levels were higher.

Galvanic skin response (normalized)
Playing against computer vs. friend

FIGURE
14.6

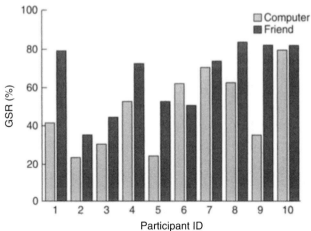

Normalized GSR values for the same ten participants playing either against a friend or against a computer.

14.4.2 *Sensors Measure More than User Reaction to Your Game*

As shown in the previous section, users' physiological signals vary due to multiple stimuli. As such, it is important to remove confounding factors from your studies. Whenever using physiological data, ensure that other factors that affect physiology (for example, physical activity, changing light, moving, talking) are controlled as much as possible.

In our initial experiments, we found that the process of interviewing our participants in between play conditions caused significant physiological reaction from each of the players. This could be because the interviewer was unfamiliar to the participants, of the opposite sex, within their personal space, or simply because the process of answering questions was arousing for the participants. One participant began to stutter during the condition interviews even though he had not stuttered in previous casual conversation with the interviewer. We expect that some combination of these reasons contributed to the participants' reactions. As a result, considerable experimental effects were observed. For example, one participant's GSR signal over the course of the experiment is shown in Figure 14.7. GSR tends to drift, but note how the increases in the GSR signal over time are catalyzed by the interview. The areas shaded in light grey represent when the participant was being interviewed. The extreme reaction to the interview is seen at the beginning of each light grey shaded area. The areas shaded in dark grey represent when the participant was

FIGURE
14.7

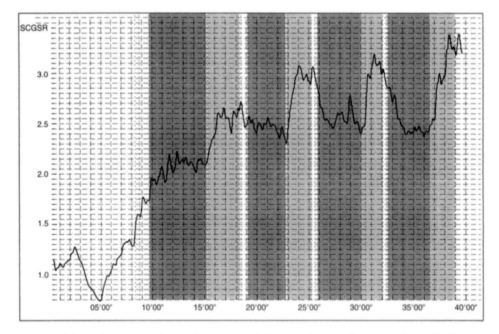

One participant's GSR signal over the course of the experiment. The areas shaded in light grey represent when the participant was being interviewed. The areas shaded in dark grey represent when the participant was playing the game.

playing. The GSR signal drops off at the beginning of each game condition from the reaction to the interview process. These interview peaks cannot be excluded from the analysis, because there were no rest periods in between play conditions. The effects of relaxing post-interview and being excited by the game are inseparable, thus the interview peaks cannot be eliminated. To correct for this, ensure that you include resting periods in between play conditions so that the effects of the experimental setting don't overshadow the effects of the game you are studying. The act of applying sensors to the body and monitoring body responses can be a stressful experience for a participant, and every effort must be made to allow the participant to relax and feel at ease.

In our initial experiments, we also found that resting rates of some physiological measures were higher than game play rates. Anticipation and nervousness seemed to have caused the resting baselines to be artificially high. This creates a problem for a researcher who wants to use resting rates to normalize the data. Vicente et al. (1987) recommend collecting a number of baselines throughout the experimental session and averaging them to create a single baseline value. In addition, using participants who are familiar with the process of being connected to physiological sensors would help lower the resting values. Beginning the experiment with a training or practice condition, before collecting the resting values,

might also help the participants to relax. Finally, in subsequent studies we used relaxation music during the resting periods to help us achieve consistent resting baselines.

14.4.3 *Sensor Error*

As previously mentioned, sensor readings can change for reasons not related to the user's experience. Although some of these factors can be controlled, there are interferences that produce error in the sensor readings. Noisy data occurs when the sensor produces random fluctuations, whereas sensor error occurs when other factors systematically or knowingly (but unintentionally) affect the sensor readings.

As an example of sensor error, a stretch sensor around the chest measures respiration, but as a user shifts in their seat or stretches, the sensor will reflect this movement. Variations like this aren't technically noise because the sensor is measuring what it is intended to (for example, expansion of the chest), but for a researcher hoping to measure respiration rate, these variations obscure the useful data. In another example, measuring EMG of the jaw (clenching) can give you an indication of frustration or stress, but talking and smiling will also activate this sensor. In this case, the sensor is functioning as intended (in other words, measuring jaw clenching), but interference is causing the sensor to pick up other muscle activations.

One of the most prevalent examples of sensor error is with the contact electrodes used in GSR sensors. Because the GSR sensor measures the conductivity of the skin between two contact electrodes, if the contact between the electrode and the skin varies, GSR will appear to change. For example, if you place GSR electrodes on the palm of a participant's hand using standard sticker electrodes, and she bends her hand so that the palm "scrunches," the likely result is that the electrode won't be contacting as much skin as when the palm is stretched out. As a result GSR will appear to drop (since the conductivity drops), when the user's actual GSR did not change. Alternative electrode placements (for example, toes, finger clips) can alleviate this particular problem.

Dealing with Sensor Error

If you know the time periods when sensor errors occurred, you can simply remove these data from subsequent analysis. For example, if you have video (or time stamps from observation or chair sensors) that show when a user shifts in their seat, you can ignore respiration for this time frame. If the data is noisy, with minor random fluctuations, there are standard signal processing methods you can use to clean up your data.

The two most common methods of cleaning up noisy time-series data are smoothing using a moving-average window, or filtering using a low-pass filter. In the moving-average window—also called a rolling-average window—a specific number

of frames (N) to form the window is chosen. The average for N frames is calculated, replacing the current value. The window is moved down the time series by one frame, and the process is repeated. As a result, the minor fluctuations are smoothed out over the entire time series. With a low-pass filter, the short-term oscillations are removed by a filter that passes over the low-frequency signals, but reduces the magnitude of signals with frequencies higher than a cutoff frequency. Thus, the slower changes are kept, while the rapid increases and decreases are removed. While both methods achieve a smoother signal, the moving-average window can easily be achieved with simple spreadsheet programming, while the low-pass filter requires more mathematically-powerful tools and approaches. On the other hand, the low-pass filter approach is more powerful, allowing you greater control over which frequencies you keep and which you discard.

14.4.4 Other Variations

Many physiological signals are susceptible to day-to-day variations, time of day, levels of caffeine consumed, tiredness, stress, and a host of other factors. Although some work has been conducted on dealing with these day-to-day variations, it is important to try to eliminate them from your data. Sitting a user down in front of one game on a Wednesday morning and collecting their GSR does not mean that you can expect the same baseline GSR values when sitting them down in front of a different game on Thursday afternoon. In fact, with sensors that are sensitive to electrode placement (for example, GSR, EMG), removing the sensors and reattaching them can change the baseline values.

Awareness of sources of variations will help you to gather clean data, while collecting a number of baseline measures over the course of your study will assist greatly in ensuring consistency.

14.5 How to Analyze Physiological Data

In addition to the techniques already mentioned (normalization, filtering), there are other considerations when analysing physiological measures. A significant challenge in analysing physiological data for game evaluation is in averaging time-series data. When collecting samples of data at a certain frequency, researchers in other domains have converted the time-series data to a single point through averaging (for example, HR mean) or integrating (for example, HRV) the time series. This method has been used successfully in the domain of human factors but doesn't apply well to gaming. For example, an air traffic controller would suppress their anxiety and cope with stress, essentially flattening HRV and minimizing variability in other measures. In games, engagement is partially obtained through successful pacing. Variability, in terms of required effort and reward, creates a compelling situation for the player. Collapsing the time series into a single point erases the variance within each condition, losing valuable information.

Luckily, there are other approaches for interpreting physiological data. Figure 14.7 shows how a user's GSR signal changes over the course of an experiment. Not only could we average this time series, but we could look for local peaks and valleys in the signal. We could consider when the signal is rising versus falling or flat, or we could look at how sharply the rises and falls occur. In signal analysis, these examples of characteristics of the signal are called local maxima, local minima, and slope respectively, and are easily calculated using spreadsheet programming or more complex analysis tools like Matlab™. Consider what you want to discover about a user's experience in order to decide on the processing approach. For example, if you want to know which of two artistic approaches in a game are more relaxing for users, you may simply want to test users in both conditions and average the GSR signal, similar to how we tested users playing against a friend or computer (Mandryk and Inkpen, 2004, Mandryk et al., 2006) (see Figure 14.6). If you want to know whether a narrative cut scene is relaxing or exciting, you may want to graphically examine users' GSR signals (or respiration rate or HR) before, during, and after the cut scene, like we did when we graphed the data surrounding goals scored and fighting in NHL 2003 by Electronic Arts™ (Mandryk and Inkpen, 2004, Mandryk et al., 2006). Figure 14.8 shows one participant's GSR data after scoring a goal once against a friend and twice against the computer. If you want to determine whether users are feeling positively or negatively towards your game while playing, you may want to use EMG sensors on the face and look at points where smiling or frowning activity exceeds a certain threshold; we took a similar approach when determining the valence (positive versus negative feelings) of users playing *NHL 2003* against a computer, stranger, or friend (Mandryk and Atkins, 2007, Mandryk et al., 2006).

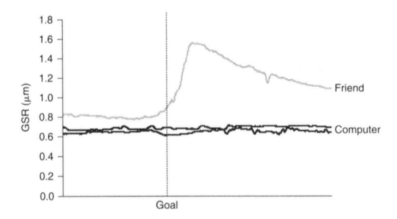

FIGURE
14.8

One participant's GSR response to scoring a goal against a friend and against the computer twice. Note the much larger response when scoring against a friend. Data were windowed 10 seconds prior to the goals and 15 seconds after.

Using the whole time series, rather than simply an average of the time series is an informative and powerful approach. For example, if you wanted to know whether users smiled more when playing your game when they could either create their own avatar or use pre-rendered stock avatars, you could collect EMG from smiling activity over both play conditions. Averaging the data over the entire time series might tell you that people smiled more, on average, when using an avatar of their own creation. But you wouldn't know whether the users were smiling more often, smiling with bigger smiles, or maintaining a generally higher smile level throughout the experience. Depending on your goals, it might be enough to just know that users smiled more in one condition, but there are situations where you might benefit from more information. Assume that you looked at the data and found that when users created their own avatars, they were smiling bigger smiles when their avatar was on screen. In this case, you have contextualized the user's response by considering their data in the context of their play experience.

Advantages of Physiological Data

- Continuously collected to evaluate process, not just outcome

- Doesn't interfere with gameplay experience

- High bandwidth; lots of data

- Can be used to infer underlying emotions

Limitations of Physiological Data

- High variability between individuals

- Sensor error, interference, and noise is prevalent

- Requires baselines and normalization techniques

- Invasive and can impact ecological validity of task

14.6 Advanced Uses of Physiological Data

14.6.1 *Inferring a User's Emotional State*

In the previous section, I mentioned a user's "feelings". Although the discussion of inferring emotion from physiological measures is beyond the scope of this chapter, there is an active research community working on this exact problem. In our recent work (Mandryk and Atkins, 2007, Mandryk et al., 2006), we have successfully developed a mathematical model of four emotional states—based on physiological signals—that are relevant to computer games.

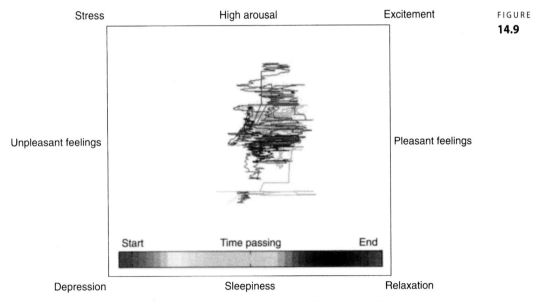

FIGURE
14.9

The experience of a participant in arousal-valence space while playing *NHL 2003*.

The results that we gathered in our initial experiments formed a basis for developing our models of user emotion, based on physiological reactions. Our first model transforms four physiological signals (GSR, HR, EMG smiling, EMG frowning) into levels of arousal and valence. Representing a participant's experience in arousal-valence space is a great method of objectively and quantitatively measuring their experience when engaged with entertainment technologies. Figure 14.9 shows a visual representation of a participant's experience continuously in arousal-valence space, representing the positive and negative stimulation that the participant feels as they engage with the technology.

Our second model transforms arousal and valence into four emotions: boredom, excitement, frustration, and fun. Emotions modeled from physiological data provide a metric to fill the knowledge gap in the objective-quantitative quadrant of evaluating user interaction with entertainment technologies (see Figure 14.2). We compared the modeled emotions to subjective reports and found the same trends for fun, boredom, and excitement; however, modeled emotions revealed differences between play conditions, while the differences between the subjective reports failed to reach significance.

Our modeled emotions were based on fuzzy transformation functions from physiological variables to arousal and valence, and then from arousal-valence space to emotions. For more information on the development of the mathematical models, see Mandryk and Atkins (2007), while a validation of the modeling approach, as well as a description of its use in HCI can be found in Mandryk et al. (2006).

Although we successfully demonstrated models of four emotional states based on a user's physiological reactions, the work in this area is still quite preliminary. Although a developer or researcher with little experience in the area can successfully gather user information from physiological measures, the process of inferring emotional state based on these measures requires expertise in signal processing, experiment design, psychophysiology, and the theories of emotion. Issues related to baselining the data, scaling the physiological responses, dealing with individual variability, and processing the data all become more complicated when the measures are used to infer emotional state.

We, along with other researchers in the field, are continuing to advance the state-of-the-art in modeling emotion based on physiological signals. Currently, our models only represent four basic emotional states, and we are considering other relevant emotions that can be described by arousal and valence, such as disappointment, anger, or pride. More complex emotions relevant to game design, such as *schadenfreude* (taking pleasure in the misery of one's enemies), are more difficult to describe in terms of arousal and valence, and we are conducting research on how to model these complex emotions which are less easily defined.

Aside from the methodological issues, there are also theoretical challenges associated with inferring emotional significance from physiological data. After having identified correlations between events related to the game, psychological events, and physiological data, the eventual goal of an emotional model is to be able to index psychological events from sensor readings. Although possible, there are myriad issues to address. For a very simple example, if when playing a computer hockey game, a user's GSR reading drops after every period of a hockey game and rises at the beginning of the next period, it is apparent that arousal is lower between hockey periods. However, basic logic prevents us from inferring that every time a user's GSR drops, it means that they are in between hockey periods. This seems like an obvious example, but it illustrates the care that must be taken when making inferences.

Cacioppo discusses four classes of psychophysiological relationships called outcomes, markers, concomitants, and invariants (Cacioppo and Tassinary, 1990). These relations are based on the specificity (one-to-one vs. many-to-one), and generality (context-bound vs. context free) of the relationship between the psychological event and the physiological response (see Figure 14.10). Outcomes are many-to-one, situation-specific relationships, and reflect the fact that a physiological response varies as a function of a psychological event in a specific situation. When the physiological response follows the psychological event across situations (generality), the relationship is concomitant (many-to-one, cross-situational associations). With outcomes and concomitants, it is unclear whether the physiological response only follows changes for that psychological event or whether other psychological events (specificity) can also inspire the same physiological response. Markers are one-to-one, situation-specific relationships, and reflect that a physiological response can predict the occurrence of a psychological event in a specific situation. Invariants are like markers, except that the psychophysiological relationship is maintained across situations (one-to-one, cross-situational associations). Invariants provide a strong basis for inference;

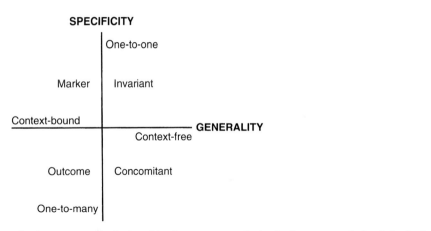

The four types of relationships between psychological events and physiological responses as defined by Cacioppo (Cacioppo and Tassinary, 1990).

the issue for a researcher is in establishing the invariant relationship instead of simply assuming that the relationship between a psychological event and a physiological response is an invariant.

14.6.2 *Triangulation with Other Data Sources*

You may want to combine modeled emotions with other evaluation methods. Triangulating a number of approaches found in this book will produce a complete and robust understanding of a user's experience with gaming environments. For example, modeled emotions could be used to reduce the time commitment associated with observational video analysis. Given a time series of emotional output, researchers could identify interesting features—such as a sudden increase or decrease in an emotional state—and then investigate the corresponding time frame in a video recording. This method would drastically reduce the time required to examine video of user interaction with entertainment technologies. Modeled emotions could also be used in conjunction with other methods of evaluation, such as heuristics.

14.7 Conclusions

Incorporating physiological metrics into your user studies is not as straightforward as attaching sensors to an individual and then reading their emotional state from a computer printout; however, progress is being made that is moving this methodology towards the ease of a plug-and-play system. When determining whether or not to use physiological measures, you must first decide on your goals for your evaluation. If a continuous, objective, and quantitative representation of user experience is desired, then physiological measures are a great choice.

Choosing which sensors to use should also be based on your evaluation goals. Different physiological sensors can provide indications of different user states such as arousal, valence, and mental effort. But in choosing your sensors you will also need to consider the sensor's impact on the gameplay experience, and the game's impact on the sensor.

Although it can be intimidating to use physiological sensors in your work, following the guidelines for the collection, analyzes, and use of physiological data provided in this chapter will help you to achieve valid, useful, and rich data on user experience. Consider adding physiological measures to your suite of evaluation techniques and using them in concert with more familiar methods to achieve a robust and complete picture of user experience with games.

How to Use Physiological Metrics

Decide what you want to measure (for example, valence, arousal)
Choose the appropriate sensors
Control your task and environment
Process the data according to which sensors were chosen
Make inferences and iterate on game design.

14.8 Acknowledgements

Thank you to Dr. Kori Inkpen, Dr. Stella Atkins, Dr. Tom Calvert, and Dr. Kevin Stanley for their contributions to this work. In addition, thanks to the National Sciences and Engineering Research Council of Canada and Electronic Arts for funding the research.

14.9 References

Affective Computing Group. Retrieved March 2008, from http://affect.media.mit.edu/; Galvactivator. Retrieved March 2008, from http://www.media.mit.edu/galvactivator/; Affective jewelry. Retrieved March 2008, from http://affect.media.mit.edu/AC_research/projects/affective_jewelry.html; Affquake. Retrieved March 2008, from http://affect.media.mit.edu/projects.php?id=180.

Bersak, D., McDarby, G., Augenblick, N., McDarby, P., McDonnell, D., McDonald, B., and Karkun, R. (2001). Intelligent biofeedback using an immersive competitive environment. Paper presented at UBICOMP 2001 Workshop on Ubiquitous Gaming.

Boucsein, W. (1992). *Electrodermal activity*. New York: Plenum Press.

Cacioppo, J.T., Berntson, G.G., Larsen, J.T., Poehlmann, K.M., & Ito, T.A. (2000). The psychophysiology of emotion. In *Handbook of emotions*. M. Lewis, & J.M. Haviland-Jones (Eds), New York: The Guilford Press. pp. 173–191

Cacioppo, J.T., & Tassinary, L.G. (1990). Inferring psychological significance from physiological signals. *American Psychologist, 45*(1), 16–28.

Csikszentmihalyi, M. (1990). *Flow: The psychology of optimal experience.* New York: Harper Perennial.

Desurvire, H., Caplan, M., & Toth, J.A. (2004). Using heuristics to evaluate the playability of games. In *Ext. Abst. CHI 2004*, ACM Press, pp. 1509–1512.

Ekman, P., Levenson, R.W., & Friesen, W.V. (1983). Autonomic nervous system activity distinguishes among emotions. *Science, 221*(4616), 1208–1210.

Fisher, C., & Sanderson, P. (1996). Exploratory data analysis: Exploring continuous observational data. *Interactions, 3*(2), 25–34.

Fridlund, A.J., & Cacioppo, J.T. (1986). Guidelines for human electromyographic research. *Psychophysiology, 23*, 567–589.

Fuga: Fun of gaming research group. Retrieved March 2008 from http://project.hkkk.fi/fuga.

Fulton, B., and Medlock, M., (2003) Beyond focus groups: Getting more useful feedback from consumers. In *Proc. Game Dev. Conf.*

Hjelm, S.I. (2003). The making of brainball. *Interactions, 10*, 26–34.

Hutt, C. (1979). Exploration and play. In *Play and learning*, B. Sutton-Smith (Ed.), New York: Gardner Press, pp. 175–194.

Jorna, P.G.A.M. (1992). Spectral analysis of heart rate and psychological state: A review of its validity as a workload index. *Biological Psychology, 34*, 237–258.

Journey to the Wild Divine. Retrieved March 2008 from http://wilddivine.com/.

Kalsbeek, J.W.H., & Ettema, J.H. (1963). Scored regularity of the heart rate pattern and the measurement of perceptual or mental load. *Ergonomics, 6*(306).

Kalsbeek, J.W.H., & Sykes, R.N. (1967). Objective measurement of mental load. *Acta Psychologica, 27*, 253–261.

Lang, P.J. (1995). The emotion probe. *American Psychologist, 50*(5), 372–385.

Lazzaro, N. (2004) Why we play games: 4 keys to more emotion. *In Proc. Game Dev. Conf.*

Lego mindstorms community bulletin boards. Retrieved January 2004, from http://mindstorms.lego.com/eng/forums/

Li, Z., & Sun, F. (2005). Pupillary response induced by stereoscopic stimuli. *Experimental Brain Research, 160*(3), 394–397.

Mandryk, R.L., & Atkins, M.S. (2007). A Fuzzy Physiological Approach for Continuously Modeling Emotion During Interaction with Play Environments. *International Journal of Human-Computer Studies, 6*(4), pp. 329–347.

Mandryk, R.L., Atkins, M.S., & Inkpen, K.M. (April 2006). A Continuous and Objective Evaluation of Emotional Experience with Interactive Play Environments. in Proceedings of the Conference on Human Factors in Computing Systems (CHI 2006). Montreal, Canada, pp. 1027–1036.

Mandryk, R.L., Inkpen, K.M., & Calvert, T.W. (March–April 2006). Using Psychophysiological Techniques to Measure User Experience with Entertainment Technologies. *Behaviour and Information Technology* (Special Issue on User Experience), Vol. 25, No. 2, pp. 141–158.

Mandryk, R.L. (2005). Modeling User Emotion in Interactive Play Environments: A Fuzzy Physiological Approach. Ph.D. Dissertation, School of Computing Science, Simon Fraser University, Burnaby, BC, Canada.

Mandryk, R.L., & Inkpen, K.M. (2004) Physiological indicators for the evaluation of co-located collaborative play. In *Proc. CSCW 2004, ACM Press*, 102–111.

233

Marshall, C., & Rossman, G.B. (1999). *Designing qualitative research*. Thousand Oaks, CA: Sage Publications.

Martini, F.H., & Timmons, M.J. (1997). *Human anatomy* (2nd ed.), Upper Saddle River, New Jersey: Prentice Hall.

Meshkati, N. (1988). Heart rate variability and mental workload assessment. In P.A. Hancock, & N. Meshkati (Eds), *Human mental workload*, North-Holland: Elsevier Science Publishers., pp. 101–115

Mulder, G. (1979). Sinusarrhythmia and mental workload. In N. Moray (Ed.), *Mental workload: Its theory and measurement,* New York: Plenum, pp. 299–325.

Nielsen, J. (1992). Evaluating the thinking-aloud technique for use by computer scientists. In *Advances in human-computer interaction*, H.R. Hartson, & D. Hix (Eds), Norwood: Ablex Publishing Corporation pp. 69–82.

Norman, D.A. (2002). Emotion and design: Attractive things work better. *Interactions, 9*(4), 36–42.

Pagulayan, R.J., Keeker, K., Wixon, D., Romero, R., & Fuller, T. (2002). User-centered design in games. In , *Handbook for human-computer interaction in interactive systems*, J. Jacko, & A. Sears (Eds), Mahwah, NJ: Lawrence Erlbaum Associates, Inc., pp. 883–906

Papillo, J.F., & Shapiro, D. (1990). The cardiovascular system. In *Principles of psychophysiology: Physical, social, and inferential elements* L.G. Tassinary (Ed.), Cambridge: Cambridge University Press, pp. 456–512.

Partala, T., Surakka, V., and Vanhala, T. (2005). Person-independent estimation of emotional experiences from facial expressions In *Proceedings of the 10th international conference on intelligent user interfaces,* San Diego: ACM Press, pp. 246–248.

Porter, G., Troscianko, T., & Gilchrist, I.D. (2007). Effort during visual search and counting: insights from pupillometry. *The Quarterly Journal of Experimental Psychology, 60*(2), 211–229.

Richter, P., Wagner, T., Heger, R., & Weise, G. (1998). Psychophysiological analysis of mental load during driving on rural roads- a quasi-experimental field study. *Ergonomics, 41*(5), 593–609.

Rowe, D.W., Sibert, J., and Irwin, D. (1998) Heart rate variability: Indicator of user state as an aid to human-computer interaction. *In Proc. CHI '98,* 480–487.

Sharp, H., Rogers, Y., & Preece, J. (2007). Interaction Design: Beyond human-computer interaction. West Sussex. England: John Wiley & Sons Ltd.

Stern, R.M., Ray, W.J., & Quigley, K.S. (2001). *Psychophysiological recording*. New York: Oxford University Press.

Sweetsner, P., & Wyeth, P. (2005). GameFlow: A model for evaluating player enjoyment in games. *ACM Computers in Entertainment, 3*(3). Article 3A.

Thought Technologies. Retrieved March 2008 from http://thoughttech.com/index.htm.

van Ravenswaaij-Arts, C.M.A., Kollee, L.A.A., Hopman, J.C.W., Stoelinga, G.B.A., & van Geijn, H.P. (1993). Heart rate variability. *Annals of Internal Medicine, 118*(6), 436–447.

Venables, P.H., & Christie, M.H. (1973). Mechanisms, instrumentation, recording techniques, and quantification of responses. In *Electrodermal activity in psychological research*, W.F. Prokasy, & D.C. Raskin (Eds), New York: Academic Press, pp. 2–124.

Vicente, K.J., Thornton, D.C., & Moray, N. (1987). Spectral analysis of sinus arrhythmia: A measure of mental effort. *Human Factors, 29*(2), 171–182.

Wastell, D.G., & Newman, M. (1996). Stress, control and computer system design: A psychophysiological field study. *Behavior and Information Technology, 15*(3), 183–192.

Wientjes, C.J.E. (1992). Respiration in psychophysiology: Methods and applications. *Biological Psychology, 34,* 179–203.

Wilson, G.F. (1992). Applied use of cardiac and respiration measures: Practical considerations and precautions. *Biological Psychology, 34,* 163–178.

Wilson, G.M., and Sasse, M.A. (2000) Do users always know what's good for them? Utilizing physiological responses to assess media quality. *In Proc. HCI,* Springer (2000), 327–339.

FIFTEEN

TRUE Instrumentation: Tracking Real-Time User Experience in Games

Eric Schuh, Daniel V. Gunn*, Bruce Phillips*, Randy J. Pagulayan*, Jun H. Kim, and Dennis Wixon*

Microsoft Game Studios

Eric Schuh has been interested in games ever since a square white ball bleeped and blooped across his screen in the early 1970s. He has been a member of the Games User Research team since 2002. In that time, he's worked on franchises such as *Fable, Project Gotham Racing, Forza,* and *Crackdown,* developing innovative research techniques to answer complex research questions. Eric has a long history doing user research on how people use technology dating back to 1993, working on projects as varied as MSN, Access, printers, and network administration tools. Not a bad career for a guy who almost, but not quite, got his PhD from the University of Washington in social psychology.

*For photos and biographical information about these authors, see Chapter 4's introduction.

Jun Kim is a User Research Engineer for Microsoft Game Studios and has been a member of the User Research group since 2000. He has worked on numerous games in the group and is currently working on creating innovative tools, data analysis, and methods to collect user behavior and attitudinal data. Before joining Microsoft, Jun received three years of postgraduate study in developmental and neurobiology at the University of Washington, studying primate models of human developmental disabilities.

Objectives in the Chapter

The present chapter describes a robust instrumentation solution that the Games User Research group at Microsoft has developed to improve user experience in games. The objectives of this chapter are to walk the reader through the development of our TRUE instrumentation, describe some case studies in which it was used successfully at various stages of the development cycle to improve games, and leave the reader with our lessons learned over the course of its development. It is our hope that the reader can take this information and successfully implement TRUE instrumentation in their games. We hope that not only will individual titles benefit from using our approach but that user experience in games overall will be improved with wider adoption of TRUE instrumentation.

Abstract

Collecting customer feedback on how people play your game—identifying where the design is too confusing, too easy, too lethal, and so on—can dramatically improve the users' experience with the game and increase its chances of success in the marketplace. Although there are many methods for collecting users' impressions and experience of games—focus groups, usability testing, playtesting—feedback from these is based on a limited exposure to the game. When these methods are used, there is a pragmatic reason for limiting the feedback from users: it is labor intensive to observe people playing the game at a level of detail that is needed to spot problems and identify their underlying causes.

This chapter outlines a system for the **automated** collection of gameplay feedback, enabling development teams to understand how people experience the **entire length** of the game. By having the game automatically log behaviors of interest—player deaths, items collected, levels completed—it is possible to collect large amounts of data efficiently. When paired with other data streams, such as captured video and in-game surveys, it is possible to understand what people are doing in your game, what elements of the design are causing them to behave the way they

do, and how they feel about their experience of the game. In many cases, understanding behavior, its causes, and user evaluation is precisely the information you need in order to improve your game.

Automated capture of user data is not new. In games, post-match stats and leaderboards have been around as long as videogames have. Although relatively rare, using these data to improve a game is not unique: Valve has used automated data capture and Steam to tweak the difficulty of *Half Life 2: Episode 2* after it was released. This chapter will provide details on how to use automated data collection to improve a game *before* it is released, improving the quality without negatively impacting the schedule. We will illustrate how Microsoft Game Studios has used automated data collection to improve games at various stages of development. In addition, we will share best practices we developed in the course of using this form of data collection for the past five years on over thirty games.

15.1 The Genesis

15.1.1 *Voodoo Vince*

In September 2003, Microsoft Game Studios (MGS) released a little platformer developed by Beep Industries, a title by the name of *Voodoo Vince*. The titular hero is a voodoo doll who must jump, collect, jetboat race, ride rats, lure zombies, self-immolate, and battle his evil twin in an attempt to rescue Madam Charmaine from the clutches of Kosmo the Inscrutable. Besides a quirky hero and infectious score, *Voodoo Vince* also marked the first time MGS utilized instrumentation to collect consumer feedback about play throughout an entire game.

15.1.2 *The Problem*

The problem we were trying to address was fairly straightforward—we wanted to understand what issues people encountered late in the game, why they were having those difficulties, and have a good idea of what we needed to do to fix those problems.

We contemplated using some of the standard user research techniques we typically employ at Microsoft Game Studios. We considered doing traditional think-aloud *usability testing*, where we bring target gamers in and observe them playing the game and doing specific game-related tasks (See Figure 15.1) (Dumas & Redish, 1999; Fulton, 2002; Medlock, Wixon, McGee, & Welsh, 2005; Nielsen, 1993; Medlock, Wixon, Terrano, Romero, & Fulton, 2002; Pagulayan, Keeker, Fuller, Wixon, & Romero, 2007; Pagulayan, Steury, Fulton, & Romero, 2003). We felt that we couldn't afford the ~160 hours of observation time that testing would cost. The results would be irrelevant by the time it was finished because the design of the game would have changed by the time the results were analyzed.

FIGURE
15.1

Usability lab at Microsoft with observer side (left) and participant side (right).

Another option is *Playtesting*. Although a common term in the game industry, playtesting means different things to different teams. At Microsoft Game Studios, Playtesting refers to a structured method for collecting *consumer* feedback via a survey about different aspects of the gameplay experience (Pagulayan et al., 2007). Typically, participants play the game for a set period of time and then fill out a questionnaire asking them to rate different aspects of the game, such as fun, graphics, goal clarity, frustration, and so on. Because the data collected in Playtest are survey responses (and not observations of what people do), it is possible to collect data from multiple participants simultaneously. Our Playtest labs at Microsoft Game Studios support data collection from up to fifty-one gamers at one time. Figure 15.2 shows one of the three Playtest labs.

The fact that data can be collected from people simultaneously in playtest helps bypass the time-consuming nature of usability testing—it is be possible to collect feedback on 20 hours of gameplay from fifty-one people in a long weekend spent in the playtest labs. However, the tradeoff is granularity—you detect big things that are wrong (say, a common perception that aiming was too difficult), but not more nuanced problems (say, vertical aiming with the sniper rifle being too difficult when trying to headshot a Brute). You simply don't have the fidelity of data from broad survey responses to detect this level of interaction—and problems often lurk at this layer of complexity.

By 2003, we had completed a lot of usability testing to improve the core mechanics of Voodoo Vince (platforming, combat, powered attacks, puzzle solving) and the initial experience. We conducted Playtesting to determine the broad satisfaction of things like character movement, combat effectiveness, and double jump responsiveness, and funneled that feedback back into the game design. But the team wanted

FIGURE
15.2

One of three Playtest Labs at Microsoft Game Studios: Entire lab (left) and an individual station (right).

more information. Were the platforming sections in the carnival portion of the world (the last level) too difficult? Where were people missing jumps? What puzzles were people failing to complete throughout the game, and why? How long did it take to beat the bosses, and how many attempts did it take?

15.1.3 *The Solution*

In order to attempt to answer these and other questions, we built a small application for users to log their basic behaviors (for example, click a button to indicate that you started a level, click a different button to log a death, another one to indicate confusion with a puzzle, and so on). We deployed this in our Playtest labs, and had a group of seventeen people log their own activities and perceptions as they played the game for 8 hours. The resulting data were noisy—some people forgot to use the logging application as the session went on, others double-clicked rather than single clicking (inflating frequency counts). Nonetheless, the data were promising. We had a rough idea of where people were dying and why, how long it was taking to complete a level, and which puzzles were most confusing.

Our next step was to take the noise out of the system. Rather than having users log every time they died, we instrumented the game, setting hooks into the code itself to automatically record each death and write it to a logfile. This allowed the user to concentrate on playing the game rather than logging data, producing more accurate, detailed, and actionable data.

We then had seventeen participants play the instrumented version of the game in our Playtest lab one late summer Saturday. On reviewing the resulting data,

FIGURE
15.3

Voodoo Vince riding a rat in the Rat Race Rodeo level.

we noticed people spending an inordinately long time and having lots of falling deaths on Chapter 19 (of 32)—*The Rat Rodeo*. This level is a Boss Battle involving a screeching opera statue (the boss), a crumbling floor, falling bricks, and our hero Vince riding a flea-bitten rat as shown in Figure 15.3. The player must guide the rat around a circular room, maneuvering so that falling bricks hit Vince on the head (he is a Voodoo Doll, after all, so hurting him hurts his enemies) while jumping over pits that open up as the floor disintegrates. Making matters worse, the enraged statue periodically shrieks, sending out a shock wave that pushes poor Vince into a waiting pit.

The chapter proved very difficult—it was hard to tell where the falling bricks would land, so it was tricky to maneuver the rat into the proper position; the floor would disintegrate with little warning, sending players to their doom; and it was difficult to judge where the shock wave was, making it almost impossible to avoid. As a result, people were dying left and right, were spending over an hour in the chapter, and were generally frustrated. See Figure 15.4 for a chart of deaths in this portion of the game.

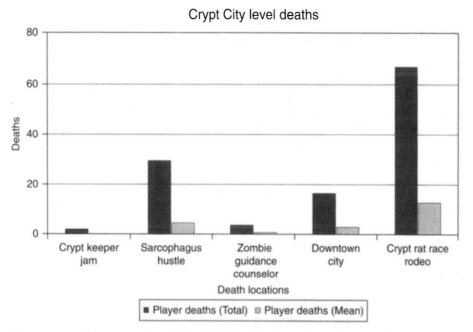

FIGURE
15.4

Frequency and mean number of deaths in Voodoo Vince for each Crypt City level.

15.1.4 *Design Impact*

Based on these data, we made several changes designed to reduce the deaths and time spent while still retaining the challenge needed for this to qualify as a boss battle. We added shadows to the bricks, making it easier to see where they would land and providing a spot for players to aim for while steering their rat. The disintegrating floor got a makeover, wherein soon-to-disintegrate pieces got a warning animation and visual highlight that helped users identify those pieces early enough to avoid them. Finally, a red glow was added to the statue's sonic blast, making it easier to see and therefore easier to jump. These changes combined to make a chapter that had previously been nearly impassable beatable after a few attempts— a fitting challenge for the completion of this portion of the game.

15.1.5 *Our Instrumentation Refinement*

Although *Voodoo Vince* didn't find success in the marketplace (it was a platformer on a console that skewed heavily toward first-person shooters, sports, and racing games), the game had lasting impact. The basic idea of instrumenting the game to collect extended gameplay feedback from consumers was deemed a great success so development effort was set aside to build a tool that could be used by all games to collect this information.

We developed a series of requirements for this tool which formed the foundation for what we have called the TRUE (Tracking Real-Time User Experience) method. The hallmarks of TRUE instrumentation include:

1. Collection of attitudinal feedback via in-game surveys.

2. Collection of contextual data as well as the main data or interest

3. Utilizing captured video to better understand the data

15.1.6 *Surveys*

When specifying the requirements for the TRUE instrumentation tool, we looked at the shortcomings of the data collected in Voodoo Vince. One of the biggest flaws was that we only captured behaviors and not any **attitudes**. Recording what people do is vitally important, but it only tells an incomplete story. It captures the mechanics and dynamics of a game but not its aesthetics (Hunicke, Leblanc, & Zubek, 2001). Knowing that someone died ten times against a particular enemy is interesting but hard to interpret. Is the person frustrated by the repeated deaths at the hand of the same enemy, or are they enjoying the challenge associated with figuring out how to take out an effective adversary? Put differently, are these ten deaths a problem that need to be addressed, or are they a key component to the overall enjoyment of the game that should be preserved? Without collecting the attitudinal data, we will never know.

To address this shortcoming, we added the ability to include brief surveys within a game itself. At certain points of a game, the game would pause and display brief questions on the screen as seen in Figure 15.5. The participant would use the controller to select a desired response, and then hit the A button to register that feedback. There were 3 main categories of in-game surveys we wanted to support, each suited for answering different sorts of questions. These categories are:

- Event-based surveys—surveys that are displayed when a certain event occurs, such as completion of a mission, player death, or solving a puzzle. This type of survey is useful for getting basic feedback about the experience that led up to the event (e.g., "How difficult was that mission?").

- On-demand surveys—surveys that the user can bring up whenever they want to provide feedback. This allows people to spontaneously indicate whenever they feel lost, bored, confused, or happy.

- Time-based surveys—surveys that appear after a set interval of time. These surveys are particularly useful for assessing satisfaction with progression or mapping out enjoyment over time. One danger of using time based surveys is making sure that they do not negatively intrude on the gameplay experience itself. If the participant is interrupted every minute asking how much fun they are having,

FIGURE
15.5

Example screenshot of an in-game survey.

eventually they will become frustrated with this constant intrusion. To avoid this problem, we recommend that you display surveys as *infrequently* as needed to get the information you need (we have ranged from every 3 minutes to every 10 minutes), and that they are displayed when there is a natural break in the action (after combat is complete, not in the middle of a sword swing).

15.1.7 *Contextual Data*

Another important factor for collecting effective survey data—and this applies to the behavioral data as well—is to provide the relevant *contextual information* needed to interpret the result. Don't just record that a participant indicated the game was "Not fun"—indicate the timestamp of the survey response, what level of the game the player was on, whether they had just succeeded or failed the relevant quest, and so on. In order for information to be actionable, you need to understand the context in which it was collected. The specific contextual information will vary based on the details of the genre and game being tested, but there is some information that we always collect with every data point (both behaviors and survey responses). These are:

- Build number—ideally you are going to be testing the game several times, so you are going to want to know which build a particular data set is related to.

- Test name—you may have different studies going on with the same build, perhaps a test of novice vs. expert players and want to retain the ability to

FIGURE
15.6

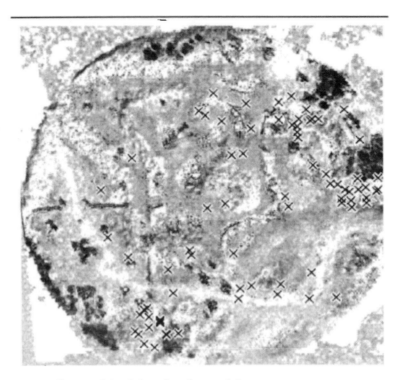

X Y coordinates of death locations in a real-time strategy game.

separate or combine the data from the two different groups. Having a test name field recorded with every data point allows you to do so.

- Participant ID—you want to be able to identify which participant the data are coming from.

- Timestamp—you need to know when the data were collected.

- Difficulty setting—you want to be able to tease apart whether a problem you identify in the data is common for everyone, or just people playing a certain level of difficulty.

- Chapter name/mission name/quest name/level name/map name—the specifics will depend on what type of game you're testing, but there should be some indication of what portion of the game the data come from.

- Position coordinates—recording the x, y, z coordinates of every piece of data allows you to display that information on a map, which is an incredibly powerful way of identifying where problems are occurring. See example in Figure 15.6.

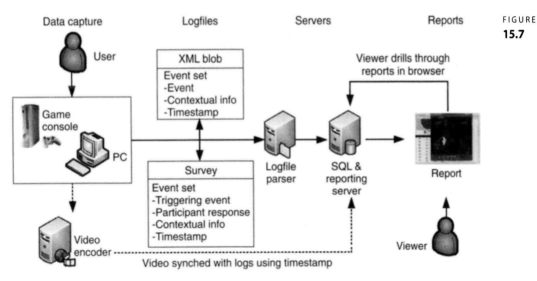

FIGURE
15.7

The TRUE data flow.

15.1.8 *Video*

We also added captured video to our instrumentation so that while participants play the game, a video capture card records their on-screen activity. These videos are then synched with the instrumentation data using the always-present timestamp information. The combined data can then be included in a SQL database, upon which detailed reports can be built (see Figure 15.7). The resulting reports allow researchers and team members to skip painful hours of reviewing videos, instead jumping directly to the item of interest (a death, a level completion, a survey response of "I'm lost", etc.).

15.2 Putting it Together: TRUE Instrumentation

Coming out a little over a year after *Voodoo Vince, Halo 2* made extensive use of our TRUE instrumentation solution. We were interested in smoothing out the rough spots of the single player campaign, so we captured data from nearly 400 participants over approximately seven weeks using 13 different builds in the summer of 2004, covering each mission anywhere from three to eight times. Such a feat would not be possible without instrumentation.

15.2.1 *A* Halo 2 *Example*

Halo 2 is a first-person shooter video game released in the fall of 2004. There are twelve single-player missions that take approximately ten to twelve hours to complete.

FIGURE
15.8

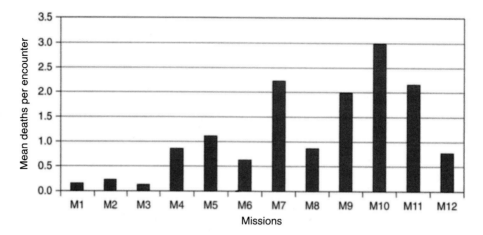

Mean number of player deaths over each mission in Halo 2.

The missions are linear, containing between ten and thirty smaller encounters. Overall, there are over two hundred encounters in the *Halo 2* single-player campaign.

To implement the TRUE method, we partnered with designers and engineers and automatically recorded player deaths, which enemy killed them, what weapon the enemy was using, and other combat related variables. We also recorded the relevant contextual information with each data point—what mission, which encounter, and what time the event occurred. For the attitudinal data, we used a time-based in-game survey (approximately three minute intervals) asking players to rate their perception of the game's difficulty and their sense of progress through the game. Finally, we captured video as each participant played the game and synched that up with our instrumentation data.

On average, a given testing session consisted of approximately 25 participants that came onsite to play through the campaign over the course of two days. After a given session, we were able to quickly view participant performance at a high level across the individual missions (see Figure 15.8). In this example, we were interested in the number of times a player died in each mission.

As shown in Figure 15.8, there were more player deaths in Mission 10 (M10) than in the other missions—more than we had expected. However, viewing total deaths across missions did not tell us how participants died or whether participants found this frustrating.

To better understand what was happening, we drilled down into the specific mission data to see how participants died in each of the encounters comprising this mission (see Figure 15.9). Using a Web front end, we could simply click on the bar of interest in the graph to drill down to another level of detail to the average deaths for each encounter within Mission 10. From there, we observed a potential problem in the third encounter of the mission, as you can see clearly in Figure 15.9.

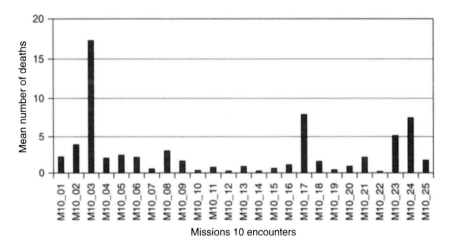

FIGURE
15.9

Average number of player deaths in each encounter for Mission 10.

Although these data helped us locate the area of a potential issue with the mission difficulty, it did not provide sufficient information to explain what, in particular, was causing participants difficulty. We knew that during this particular encounter in the mission, participants were fighting successive waves of enemies in a large room. However, we did not know what specifically was causing them to die.

To figure this out, we drilled down even further into specific details of this encounter. Specifically, we were able to break out deaths into the particular causes. In this example, the Brutes (one of the enemies the player had to defeat) were responsible for 85 percent of participant deaths.

Drilling down into the data even further (again, by the click of the graph), we identified three primary ways participants were dying: Brute Melee attacks, Plasma Grenade Attach (the grenade sticks to the player), and Plasma Grenade Explosions. Being able to isolate the exact cause of deaths was important because in *Halo 2* there are numerous ways enemies can kill a player. This successive drill down approach allowed us to quickly discover the main causes of participant deaths within minutes.

However, we still did not completely understand how this was killing the participants. Because the combat system in *Halo 2* is complex, we turned to the designers of that system to provide further insight and also took advantage of a key component of our instrumentation—captured video. For each death we could link to a video that showed us exactly what happened. With the game designers by our side, we viewed several of the participant deaths—in particular, deaths where participants died due to direct hits from a plasma grenade.

After watching these videos, the designers were able to immediately pick up on a subtle nuance in the game mechanic that only they were able to identify. The Brutes in this section of the game threw grenades faster and with less of an arc (compared

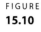
FIGURE
15.10

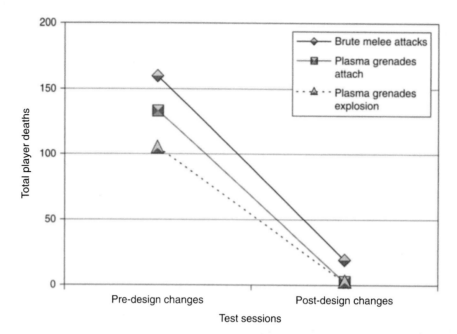

Number of player deaths before and after design changes were implemented.

to other enemies which could throw plasma grenades) which gave participants less time to react.

Using this information, the designers made several changes to reduce difficulty. Specifically, they prevented Brutes from throwing Plasma Grenades altogether (for that encounter). In addition, they reduced the overall number of enemy waves and spawned enemies in only one location. Previously, enemies could spawn from several locations in the room players were fighting in. This minimized the chance that players would get melee'd from behind.

A week later, we tested a new build of the game that included the fixes the designers had generated. We brought in a different set of participants, had them play the game, and then checked to see whether the design changes worked. In looking at the new data, we saw a dramatic reduction in the number of deaths, especially those from Brute Melee's and by plasma grenades (See Figure 15.10).

So, we solved the problem of too much death. But did we go too far? In tweaking the Brute behaviors (who are supposed to be scary and lethal) and the way plasma grenades were to be used (which are supposed to be devastating), did we make this encounter too easy? We turned to the in-game survey data to answer that question. Similar to the way we drilled into the death data, we were able to quickly assess the frequency of responses for the time-based survey data. As Figure 15.11 shows, the changes did not negatively affect how people perceived this encounter. The percentage of responses indicating that the level of difficulty was "about right" jumped

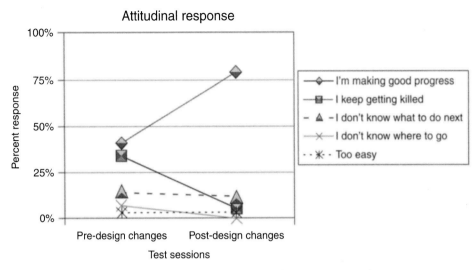

FIGURE
15.11

Percent of player responses before and after design changes were made.

from 43 to 74 percent, while the percentage of people who felt the encounter was "too easy" stayed incredibly flat and very low (only 3 percent indicated it was too easy after making the changes).

As a reminder, the real-world example we've been discussing pertains to only 1 of the 211 encounters in *Halo 2*. We discovered many issues across the entire campaign, worked with designers on changes, and verified that those design changes worked. This would not have been possible without TRUE instrumentation as well as the experiences gleaned from doing this sort of research on a variety of games in various points of the development cycle.

The following sections provide examples of what data collection and impact can look like at various points in the game development lifecycle. We start off with a simple, straight-forward, example of assessing design intent during the polishing phase of production utilizing TRUE. Next, we discuss the utility of TRUE testing during the beta phase of a project. Finally, we demonstrate how TRUE can be successfully utilized to inform demo construction of a game.

15.3 *Forza 2*: Production and Polishing

The bulk of the data collection will be done at the end of the production phase as the builds stabilize and polishing occurs. During the latter part of this time period, any user research that gets done needs to be done at an extremely fast pace. Features are being tweaked and locked down much more quickly than earlier in the product lifecycle, and this frantic pace mandates that any user feedback coming in needs to be in step with production—or it cannot be responded to. When instrumentation is done right, it allows us to keep in synch with the feverish pace of late production and to maintain the feedback loop between end user and the production

team right up until ship. We conducted one particular TRUE test on Forza 2 during late production which demonstrates how valuable data can be gleaned very quickly, very late in production, and still have a tremendous impact on a game.

Forza 2 is a racing simulation game released in the Spring of 2007. One defining characteristic of the game is its realistic driving physics; thus, trying to drive a Ferrari F430 GT is considerably more challenging than driving a Ford Focus (as it would be in the real-world). The game includes two single player modes, Career and Arcade, in addition to a multiplayer mode. In Career Mode, players start off with access to slow, low-end, cars and gradually earn credits and access to faster cars by doing well over multiple races. In Arcade Mode, players have the ability to jump right in and race faster high-end, and typically more difficult to handle, cars. While we used TRUE to help balance and tune progression in Career Mode during production, there was one big aspect in Arcade Mode that we wanted to get user feedback on before the game shipped, and that was the Time Trials. Yet, our window of opportunity for testing the time trials in Arcade Mode came at a point very late in production. In fact, we had only one week to run the test, turn the data around, and make changes to the time trials before they were locked down permanently. The following example relates to our efforts to polish the Arcade Mode time trials.

Forza 2 contains 25 different time trials in Arcade Mode. The player's goal for each trial is simple: Complete at least one lap on the track faster than the pre-specified target lap time for that trial. If the player successfully beats the target lap time, the car used for that trial is unlocked and added to the player's Arcade Garage. If the player is not successful, the car remains locked and players cannot use it in other parts of Arcade Mode. One challenging aspect for players is that the car, the track ribbon, and the target lap time to beat are all preset. Thus, if players would typically shy away from racing with the powerhouse Nissan Silvia Top Secret (a car not available until well into Career Mode) because of its notoriously intractable handling, in order to beat time trial #3, they would have to use that Silvia. In addition, it wouldn't be the Silvia on an oval track, it would be on a challenging real-world racetrack (i.e., Tsukuba) and the lap time would need to be under 46 seconds to boot!

While the design intent behind the time trials was that they be challenging for players, the designers did not want them to be overly frustrating. Indeed, what could be more frustrating to a player than the inability to unlock a car for their arcade garage because of a target lap time they perceive to be impossible beat after the 50th unsuccessful lap? Luckily, the Forza 2 designers had a clear design intent for the time trials that we could use to test against: The time trials should be challenging to players but approximately 80 percent of the target users should be able to complete any particular time trial and unlock the car after ten laps.

15.3.1 *The Problem*

At the point in production that the twenty-five time trials were finally getting locked down, we still did not know whether the design vision for them was being realized.

The target lap times for each trial were determined by several members of the team but not tested with users. Although each trial target time felt challenging, but doable, by the members of Design and Test that helped determine them, these team members were no longer "typical players" for *Forza 2*. In fact, they had been racing on some of the same tracks with the same cars for several months during the game's development. This fact presented us with a problem: we didn't know how close the target times determined by the team members mapped onto the skill level of the typical player. If the target times were set too low, less than 80 percent of the target population would be able to complete each one after ten laps. Our research question became, "What percentage of typical *Forza 2* players can complete each time trial after ten laps on a track?"

15.3.2 *The TRUE solution*

We brought people in and had them play through all twenty-five time trials. For each time trial, players raced ten laps, and we automatically recorded lap time, lap number (e.g., three of ten), and other contextual variables. We then calculated the percentage of players that beat the target lap time for each time trial. The results can be seen in Table 15.1.

As can be seen in the table, the design intent that we tested against was far from being realized in the target audience. The target times preset by the team members

TABLE **15.1** Forza 2 Time Trials: Target lap time and percentage of participants beating it for each trial

Trial #	Target Lap Time (secs)	Participants that beat after 10 laps
1	33.81	24 percent
2	44.69	41 percent
3	45.697	0 percent
4	51.292	97 percent
5	55.602	7 percent
6	56.033	54 percent
7	57.132	37 percent
8	57.782	19 percent
9	58.731	59 percent
10	59.964	8 percent
11	62.8	8 percent
12	68.5	12 percent
13	73.8	19 percent
14	77.5	12 percent
15	78.5	12 percent

TABLE **15.1** Continued

Trial #	Target Lap Time (secs)	Participants that beat after 10 laps
16	78.8	4 percent
17	83.4	0 percent
18	85.8	8 percent
19	98.3	0 percent
20	98.8	6 percent
21	101.8	29 percent
22	111.8	0 percent
23	118.4	30 percent
24	236.7	0 percent
25	409.6	0 percent

were consistently too difficult. In fact, only one time trial (that is, #4) met the design intent criteria. Indeed, six of the twenty-five time trials were unbeatable by players after ten laps.

15.3.3 *Design Impact*

Prior to our TRUE test, the target times for each trial were considered shippable. Based on the data from the TRUE test, we ended up changing the car used on some trials and the target time was adjusted on almost every single time trial. Once again, the data collected from our TRUE test helped Design determine where the new target times should be set. Not only had we collected pass/fail info for each player with respect to each time trial lap, but we also collected their exact lap time. Utilizing these data we calculated the minimum, maximum, and average lap times for "passed" laps as well as "failed" laps which helped to determine where to place the new adjusted target time.

Had we not had the robust TRUE instrumentation in place and run the test, the typical player experience of the time trials in the released version of the game would be considerably different from what the designers intended. While the target times might have felt about right for team members, they were too difficult for the typical users. Indeed, based on our data, there would have been time trials in which significantly large portions of the target audience most likely could not have passed. Yet, the testing to uncover these issues did not take weeks of planning, orchestrating, and analyzing of the data. Instead, because of where it happened in production, the uncovering of these issues and implementation of changes to fix them happened in a much abbreviated timeframe—a process that could have only been possible with TRUE instrumentation.

15.4 *Shadowrun*—Beta

There are times when the research questions we have require a large number of players—more than the fifty-one that we can simultaneously accommodate in our playtesting facilities. For example, we may need to test matchmaking systems that support thousands of simultaneous players, balance game economies, or tweak the attributes of character classes. In some cases, we can get the data we need from players individually interacting with a game. Sometimes, we need many—often thousands—of players simultaneously interacting with both the game and one another. In these situations, we beta test the game and collect instrumentation data from many thousands of players over an extended time. In this section, we discuss the use of instrumentation in the *Shadowrun* beta.

15.4.1 *The Problem: Class Selection*

Shadowrun is a multiplayer, round-based, first-person shooter game for the Xbox 360 and PC. *Shadowrun* allows players to choose their character class, skills, and weapons. At the beginning of the game, players choose from one of four different character classes, each with different abilities. Players can pick trolls who are strong but slow, elves who are quick and adept at magic, or dwarves or humans, each with their own special abilities. While this provided a lot of options to the player, it also created a challenge for the designers. Specifically, they needed to balance the game so that no character customization path would dominate while making all customization paths enjoyable to play.

We had many research questions for the *Shadowrun* beta, one of which we discuss here. We were interested in the popularity and effectiveness of different character classes. The number of combinations and permutations of classes in a game was large and potentially overwhelming to the test team, and so we used beta to test the popularity and effectiveness of character races with the players.

15.4.2 *The TRUE Solution: Class Selection*

We collected data from ten thousand participants who downloaded and played *Shadowrun* multiplayer from their homes with each other on their Xbox 360 using the Xbox Live online service. Using instrumentation we had a real-time stream of data about players' choice of character classes and weapons as well as many other game events and behaviors. The game designers used these data to tweak game parameters and then deliver an updated version of the game to the participants. This iterative process of collecting and interpreting data and updating the game took place over the course of four months.

Our first research question concerned the popularity of the character classes. There were four classes in the game, each with different abilities. The designers' intention was that each character class should provide strengths and weaknesses that

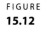
FIGURE
15.12

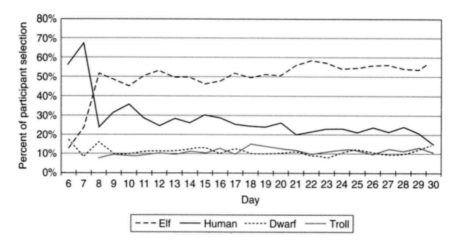

Character classes participants selected over the course of a month of the Shadowrun beta test.

differentiate it from the other classes and therefore appeal to different play-styles. To gather the relevant data, the game logged each time a player joined a game and chose a character. We were able to look at both the choices of each player in each game as well as the choices of each gamer across the many games they played. This way, we could determine both overall trends in choices as well as individual preferences for character races. We also logged the success of each player both in terms of how well they individually did in a game and whether their team won or lost.

We found, by tracking character choices, that over time one character class was clearly preferred to all of the others. If the classes were all as fun or effective, we would expect to see each being selected approximately 25 percent of the time. Figure 15.12 shows the actual character classes participants selected over the course of a month of the beta test. The Elf class, the top line in the graph, was significantly more popular than the other classes. The fluctuating popularity of the character classes shown on the left of Figure 15.12 (the beginning of the month) occurred during a period when we introduced 1000 new participants into the beta. The popularity of the races fluctuated as the new participants explored each of the races. A few days later, however, the preference for Elf once again emerged. This illustrates the advantages of beta testing over an extended period of time. A research methodology that limited our investigation to a few games—or even a few days of gaming—would have given us a misleading picture of character class preferences.

15.4.3 *Design Impact: Class Selection*

Over the course of the beta, the designers used these data to tweak the attributes of the character classes. Through several iterations of the game, the design team was able to realize their original design intention for a balanced selection of character

classes. Each character class had its strengths and weakness, but no class was clearly dominating the others.

Beta testing with instrumentation enabled us to tweak the class variables in the game to achieve the designers' intent of having a game with well-balanced and differentiated character classes. Conducting the beta test over several months enabled us to collect data that showed both how new users approached the game as well as patterns in players' behavior over the course of many game sessions. The large number of participants in the beta test also enabled us to examine the variables of interest with many different types of players in many different game situations. Further, being able to iterate on the game and continue testing with the same participants enabled us to verify design changes before the game was available to consumers, none of which would have been possible using in-house testing or without instrumented data collection.

15.5 *Crackdown*: Demo

In some cases, information gleaned from instrumentation of the game can be used to inform the creation of a demo. When done correctly, game demos can increase sales of the retail game. Moreover, the prominence of demos in console gaming is skyrocketing thanks to online distribution via Xbox Live or PlayStation Network. Yet, demos suffer from a lot of constraints—they are produced extremely late in the product cycle (sometimes after the retail code is finalized) by an understaffed and exhausted team, working on a tight deadline if the demo is to come out before the release of the game. Building a quality demo can be very challenging under these circumstances. As a result, leveraging information gained from instrumentation can be a boon.

15.5.1 *The problem*

Crackdown is an action game developed by Realtime Worlds and released in the spring of 2007. You play the role of a super-powered Agent who is capable of jumping tall buildings, throwing cars three city blocks, creating massive chain reaction explosions, driving powerful vehicles though crime-laden streets, all while battling gangs and taking out bosses in a giant urban sandbox. You start the game as a normally powered agent, but eventually level up your strength, agility, weapon proficiency, driving ability, and explosives destruction by collecting orbs associated with each trait. The game is sandbox-style, where users can go anywhere in the world and do anything they want right from the beginning.

The issue was how to capture the essence of *Crackdown* without giving away too much of the game. Sandbox games are not very amenable to parceling into demo-sized chunks. Moreover, the unique joys of *Crackdown* come from leveling up and experiencing the super powers the Agent gains—things that take hours of gameplay to achieve in the retail game. We were tasked with coming up with a demo that showcased the game and the Agent's abilities that gave people a sense of what the game was like but leaving them hungry for more.

15.5.2 *The TRUE solution*

We did extensive instrumentation work on the retail version of the game to understand how people progressed through it, how many orbs they collected, when they leveled up, and so on. Further, we knew from the included surveys that the game went from being somewhat fun to being incredibly fun once people started leveling up their stats by collecting the orbs. Once people leveled up, they stopped viewing the game as another action/racing hybrid clone but the unique sandbox that is *Crackdown*—and they loved it.

15.5.3 *Design Impact*

The demo consisted of one (of five total) island in the game, so it included almost 20 percent of the content in the game. There was much concern that we were giving too much of the game away, so we knew we had to time limit the demo. But we didn't want the clock to start ticking too soon, before people experienced the fun of the game. Our solution was to start a 30-minute timer, which started immediately after people leveled up for the first time. And to ensure that this happened quickly and that people got to the fun of the game right away, we had a dramatically accelerated skill progression curve. In order to create this accelerated skill progression curve, we looked at our instrumentation data and saw how many orbs of each type people had collected at the 10-, 20-, 30-, and 40-minute mark. We used those values to set the requirements for leveling up in the demo, then tested that demo to see what people thought. They leveled up right as we thought they would, and they absolutely loved the demo. They got a great taste of what it would be like to be a powered up Agent, but were hungry for more when the time ran out. This is exactly what we were hoping to achieve, so we shipped the demo with those settings. The *Crackdown* demo then went on to be the most downloaded demo in the history of Xbox Live at the time being downloaded more than 1 million times in the first month it was out.

15.6 Next Steps and Resources

15.6.1 *TRUE Instrumentation and the Product Development Cycle*

Instrumentation activities, like other major activities in the development process, take place at different points. Much of the work will be front loaded in the schedule. You should plan for this fact, but the good news is that the early work ensures that there's less work later, when other demands on your time get really nasty. Below is a general list of the major "milestones" that should be reached at each point in the cycle. As always, these are guidelines rather than strict rules.

1. Preproduction
 - A high-level instrumentation plan is in place. This consists of the types of research questions, rough timelines, and agreements on roles and responsibilities.
 - The person who will be doing the instrumentation should start familiarizing themselves with the game code.

2. Production
 - A detailed instrumentation plan is in place a year prior to release. This plan consists of the research questions, the mock reports, a list of roles and responsibilities, and a timeline.
 - All of the main hooks are set by Code Complete. There may be some minor iteration of hooks post-Code Complete, but the bulk of the heavy lifting should be done.
 - Data collection starts, reports are iterated as needed. For some additional examples of reports generated from our TRUE instrumentation for Bioware, see DeRosa (2007)
 - http://www.gamasutra.com/view/feature/1546/tracking_player_feedback_to_.php

3. Polish/Bug Fixing
 - Data collection continues at a frenzied pace, the game itself is iterated and verified to improve.
 - If you're doing an instrumented beta, it probably happens here.
 - Any work on the demo also occurs here.

4. Post-release
 - In the case of key franchises, you may want to collect some data to better understand these franchises.
 - The data will be a small set, and no attitudinal data should be included
 - It is possible to use these data to refine a game you have already released, as in http://www.steampowered.com/status/ep2/ep2_stats.php
 - It is desirable to use these data to benefit your audience in the form of stats pages, as in http://www.bungie.net/

15.7 Lessons Learned

Successful instrumentation studies are complex and difficult to execute well. The instrumentation infrastructure for a game is built on a changing platform—that is, the game itself. The number of variables collected, the consistency with which states are defined, the knowledge of game and the programming expertise of the

instrument builders all play a role. Below we outline some of the lessons we have learned over the years of conducting successful instrumentation projects.

15.7.1 Lesson 1: Plan for instrumentation early, make sure there is time for iteration

Instrumentation can be a time-consuming (but rewarding) effort, involving a variety of resources at different points in the game development lifecycle. As such, it needs to be planned and scheduled, like any other project in the game. Stakeholders need to be identified, timelines need to be spelled out, and dependencies need to be identified early. If the instrumentation effort is not well planned and is pulled together right at the end of development, it is likely to cause more problems than it solves.

One of the biggest things to be sure to schedule for is ample time for iteration. There needs to be iteration of the research questions, iteration of the reports, iteration of the variables that are tracked, and most importantly, iteration of the testing.

The point of doing instrumentation, indeed any form of user research, is to improve your game. It is not enough to simply understand what problems people are having—you need to address those problems and then verify that those fixes work. The Halo 2 example cited earlier illustrated that we not only identified a problem, but that we made significant gameplay changes, tested again, and saw that those problems went away without introducing any new problems.

A testing schedule where you test over the weekend, make changes during the week, and retest over the following weekend is common during the final balance and polishing stages of game development.

15.7.2 Lesson 2: Start with your research questions

Although this may be obvious, many first-timers overlook this step. There is a temptation to automatically start thinking about what variables to track because those variables are typically more concrete and easy to think about. It is more difficult to contemplate what questions you are trying to answer, and **then** go to the information that is needed to answer those questions. However, clearly identifying the research questions ahead of time will ensure that you are collecting the data you need—and *not* wasting time collecting information you will never use.

Identifying the research questions should be a multidisciplinary effort. The Design team is a good source to tap, as they are likely to have lots of questions and will be the ultimate consumers of the information produced. The Test/Quality Assurance team is another good resource as they are intimately familiar with the various nooks and crannies of the game as well as sensitive to balance issues due to their constant playing of the game. Producers and marketers can frequently identify broad questions based on the vision of the game and the needs of the target audience. And, naturally, if a User Researcher is available, they should be involved as their whole discipline involves turning vague research questions about consumer interactions with the product into actionable data.

15.7.3 Lesson 3: Keep the number of variables you are tracking to an absolute minimum

Once you start thinking about your research questions, it becomes tempting to track everything. The thought process that leads to this temptation makes perfect sense— in order to understand a system, it is natural to want to track all of the inputs into that system. For example, if you wanted to understand what weapons people used in a role-playing game, you might think that weapon choice is a function of weapon availability, which is a function of the amount of money and the cost of the item in the local store, which is a function of how the NPC shopkeeper feels toward the player, which is a function of the player's stats, which is a function of what quests have been completed, which is a function of ... well, you get the point. However, collecting data on too many variables causes all sorts of unintended consequences, such as:

- More time spent hooking the variables
- Decreased reliability of hooks—setting hooks is as much as an art as a science, and errors are common. The more hooks, the more chance of error. And errors in one variable cause people to question the validity of **all** of the data.
- More time spent testing hooks to make sure they are recording data correctly
- More reports to create, review, and understand. There is increased likelihood of losing sight of real problems in the sea of data

Rather than tracking everything, you should limit yourself to the handful of variables (and related contextual information) needed to know whether there is a problem. For example, if you want to identify problematic combat encounters, all you need to track are deaths, cause of death, and how the player felt about the death. That is sufficient to say "there's a problem here," and you could review the synched video in order to understand why that problem is occurring. Depending on the game, we typically recommend that you track no more than 15 different events, along with related contextual information (timestamp, x and y coordinates, etc.). When determining what variables to track, the maxim "less is more" truly holds.

15.7.4 Lesson 4: Build sample reports BEFORE you set your hooks

Hooking your variables of interest is time, and developer, intensive work, so you should take steps to prevent unnecessary rework. Even if you start with your research questions (Lesson 2), it is easy to forget to include certain hooks or to request tracking variables that you will never actually use. One of the best ways to avoid these pitfalls is to mock up reports populated with fake data, and then have all interested parties (Design, Test, Producers) review the reports to see if they contain everything that is needed to identify problems and make needed design changes. Inevitably, once reports are mocked up and passed around, people identify

missing variables, come up with new research questions, or concede that certain pieces of information they thought would be important are actually not needed.

Other benefits of mocking up reports before setting the hooks include:

- Helping the developer who is setting the hooks make decisions on *how* to set the hooks. Frequently, developers can set hooks in multiple ways, including ways that affect what the data mean. When they know what you are trying to achieve, they can make better decisions on how to set the hooks.

- Getting buyoff from the stakeholders on what the instrumentation effort will yield. For many people, seeing is believing.

- Quicker turnaround of reports after data collection. If you mock up your reports in your reporting tool, you can simply change the data source from the fake data to the real data, and your reports are instantly updated. If you wait until the actual time of data collection to build your reports, there will be a substantial delay between when you collect the data and when you can actually use it. At this phase of the game lifecycle, time is the most precious element, so quick turnaround of data is essential.

15.7.5 *Lesson 5: Represent the data visually*

There is so much data to consume, you need to build reports that are easy to understand. One of the most powerful visualizations is a map of the level, upon which your data can be displayed (see Figure 15.6). For example, this image displays the unit deaths of a person playing a real-time strategy game.

In order to display data on top of a map, you need to:

- Get a screenshot of the level
- Note the x, y coordinates of all 4 corners
- Record the x, y coordinates of every event (as part of your contextual data)
- Use your data visualization tool to plot the event x, y coordinates relative to the coordinates of the image

15.7.6 *Lesson 6: If possible, have Design specify their design intent so we can compare actual with intended performance*

Even if you include in-game surveys, it can be difficult to identify whether there are subtle problems with progression or level design. It can be very helpful to have the Design team specify what sort of experience they were trying to create at different parts of the game. Depending on the designer, this could be very general ("ok, so they just defeated the Mega Boss, so this part of the game is supposed to be a bit of a rest. People should be exploring here, but not dying too often") or very specific ("I

want 90 percent of people to get a lap time of 2:00 or less within 5 attempts in a D class car or 3 attempts in a C class car.") (Romero, 2008). Knowing the design intent vastly simplifies issue identification. It is possible to build reports that show deviations from expected levels of performance, quickly highlighting problematic areas.

Even if design intent is not explicitly stated, designers implicitly know how they want their game to be played. Designers are so intimately familiar with the game and the experiences they are trying to create, they can often spot problems in the data that others overlook. For this reason, designers should always take the time to review the data after each test. And because they will be doing so, it is vital that Design be involved in focusing the research question (Lesson 1) and reviewing the reports (Lesson 4).

15.7.7 Lesson 7: Test to make sure your instrumentation is recording data reliably

Game code is constantly changing during the production phase of development when you are likely to be doing instrumentation. Thus, hooks that were working in one build can be broken the next—either not recording data, or recording nonsensical values. Nothing damages the overall credibility of instrumentation more than producing data that are obviously wrong—faith in the entire system is extinguished if even one piece of data is wrong.

As a result, testing the build is vital. You simply do not want to discover an error in your data collection after twenty people play your game for twenty hours over the weekend. Having the Test/Quality Assurance department verifying the instrumentation is working correctly is vital before any data collection.

15.7.8 Lesson 8: Integrate into the source tree so you always have an instrumented build

Integrating the hooks can either be done by hand every time you need it, or done once and checked into the source tree so that it is included with every build. We strongly recommend integration in the source tree so that you always get a build (saving time and reducing the risk of having the build you include hooks in not working properly). Time is tight, so any steps you can take to increase the turnaround and flexibility of your instrumentation is worthwhile.

15.7.9 Lesson 9: Instrumentation does not replace other forms of getting feedback

Instrumentation is very well-suited for collecting data about how people perform in a game over extended periods of time, but it doesn't replace the need for detailed research on the initial gameplay and core mechanics (typically done in usability) or

collecting attitudinal feedback on what people think about different aspects of the game (such as in playtests).

In reality, instrumentation can work hand in hand with other user research techniques (Kim et al., 2008). For example, we used instrumentation and usability testing together to improve a real-time strategy game. In this series of studies, people played the single-player campaign over the course of a weekend. The single-player campaign consisted of a series of missions which had to be completed in order for the game to progress. We used instrumentation to get a rough understanding of which missions were most problematic, and then did a detailed follow up usability study on only those problematic missions. We simply did not have the time needed to do the detailed usability testing of every single mission. By doing the instrumentation, we were able to identify which missions were most problematic and focus our research energies there.

15.8 References

Bungie.net website. (n.d.). Retrieved February 6, 2008, from http://www.bungie.net/

Crackdown (Computer software). (2007). Redmond, WA: Microsoft.

Davis, J., Steury, K., & Pagulayan, R. (2005). A survey method for assessing perceptions of a game: The consumer playtest in game design. *Game Studies: The International Journal of Computer Game Research, 5.* Retrieved February 7, 2008, from http://www.gamestudies. org/0501/davis_steury_pagulayan/

DeRosa, P. (2007). Tracking Player Feedback to Improve Game Design. *Gamasutra, 7.* Retrieved February 2, 2007, from http://www.gamasutra.com/view/feature/1546/ tracking_ player_feedback_to_.php

Dumas, J.S., & Redish, J.C. (1999). *A practical guide to usability testing (Rev. ed.),* Portland, OR: Intellect Books.

Forza 2 (Computer software). (2007). Redmond, WA: Microsoft.

Fulton, B. (2002). Beyond Psychological Theory: Getting Data that Improve Games. *Proceedings of the Game Developer's Conference, San Jose, CA.*

Half-life 2 instrumentation stats webpage. (n.d.). Retrieved February 6, 2008, from http:// www.steampowered.com/status/ep2/ep2_stats.php

Halo 2 (Computer software). (2004). Redmond, WA: Microsoft.

Hunicke, R., LeBlanc, M. & Zubek, R. (2001). MDA: A formal approach game design and research. *Workshop at the AAAI (American Association for Artificial Intelligence) 2001 Conference, North Falmouth, MA.* Retrieved February 2, 2007, from http://www. cs.northwestern.edu/~hunicke/pubs/MDA.pdf

Kim, J.H., Gunn, D.V., Schuh, E., Phillips, B., Pagulayan, R.J., & Wixon, D. (2008). Tracking Real-Time User Experience (TRUE): A comprehensive instrumentation solution for complex systems. *Proceedings of the SIGCHI conference on Human factors in computing systems, Florence, Italy.*

Medlock, M.C., Wixon, D., McGee, M., & Welsh, D. (2005). The Rapid Iterative Test and Evaluation Method: Better Products in Less Time. In R. Bias, & D. Mayhews (Eds), *Cost Justifying Usability: An Update for the Internet Age* (pp. 489–517), NY: Morgan Kaufmann.

Medlock, M.C., Wixon, D., Terrano, M., Romero, R.L., & Fulton, B. (2002). Using the RITE method to improve products: a definition and a case study. *Proceedings of Usability Professionals' Association 2002 Annual Conference, Orlando, FL.*

MGS Games User Research Website. (n.d.). Retrieved February 6, 2008, from http://www.mgsuserresearch.com/

Nichols, T. (2007). User Research in the Games Industry: Opportunities for Education. *HFES Bulletin, 40*(4), 1–2.

Nielsen, J. (1993). *Usability engineering.* San Francisco, CA: Morgan Kaufmann.

Pagulayan, R., Gunn, D., & Romero, R. (2006). A Gameplay-Centered Design Framework for Human Factors in Games. In W. Karwowski (Ed.), *2nd Edition of International Encyclopedia of Ergonomics and Human Factors* (pp. 1314–1319), Boca Raton, FL: Taylor & Francis.

Pagulayan, R., Keeker, K., Fuller, T., Wixon, D., & Romero, R. (2007). User-centered design in games (revision) (2007). In J. Jacko, & A. Sears (Eds), *Handbook for Human-Computer Interaction in Interactive Systems: Fundamentals, Evolving Technologies and Emerging Applications* (pp. 741–760), Mahwah, NJ: CRC Press.

Pagulayan, R.J., Steury, K.R., Fulton, B., & Romero, R.L. (2003). Designing for fun: User-testing case studies. In M. Blythe, K. Overbeeke, A. Monk, & P. Wright (Eds), *Funology: From Usability to Enjoyment* (pp. 137–150), New York: Springer.

Romero, R. (2008, February). *Tracking attitudes and behaviors to improve games: Successful instrumentation.* Presentation at the annual meeting of the Game Developers Conference, San Francisco, CA.

Shadowrun (Computer software). (2007). Redmond, WA: Microsoft.

VALVE STEAM website. (n.d.). Retrieved February 6, 2008, from https://steamcommunity.com/

Voodoo Vince (Computer software). (2003). Redmond, WA: Microsoft.

WOW Jutsu website. (n.d.). Retrieved February 6, 2008, from http://wowjutsu.com/world/

CHAPTER SIXTEEN

Interview with Georgios Yannakakis, Assistant Professor at the Center for Computer Games Research, IT-University of Copenhagen

Interviewer:

Katherine Isbister

Georgios Yannakakis is the chair of the newly-formed IEEE (Institute for Electrical and Electronics Engineers) task force on player satisfaction modeling. His current research interest lies in the investigation of intelligent mechanisms and cognitive models for optimizing player satisfaction within human-machine interactive systems (for example, computer and augmented-reality games). More specifically, he investigates the correlation between the user's perceived satisfaction from play, player models of different levels of human response (cognitive, physiological, emotional) and adaptive online learning.

The IEEE task force on player satisfaction modeling (PSM) is a community of academics and game developers interested in heterogeneous approaches for capturing and optimizing player satisfaction in human-computer interactive systems. Games, a prime example of such systems, constitute the main application test-bed for the approaches investigated by the members of the task force.

Georgios, what exactly is this PSM task force and why might it be valuable to game developers?
The task force focuses on a wide range of approaches regarding quantitative player satisfaction modeling and artificial intelligence (AI) for improving playing experience. The idea is to encourage a dialog among researchers in the AI, human-computer interaction, cognitive modeling, affective computing and psychology disciplines who investigate methodologies for improving user (player) experience.

Optimizing player satisfaction is the second research focus of the community. That is, given successful models of player satisfaction how can we adjust the interactive systems in order to improve player experience.

Game developers may find valuable research results for improving the quality of their games through player satisfaction modelling and optimization techniques established within our task force. Interested developers may want to participate in the task force, and also, keep an eye out for research publications in this emerging field of PSM. So far there are promising results in small-scale games (both screen-based and real-world physical interaction-based games) that can be used as a starting point. For instance, work by Yannakakis and Hallam [1,2] in arcade prey/predator games; Togelius et al. [3] in racing games; Spronck et al. [4] in fighting games and so on.

Could research done by the task force actually improve a game company's financial bottom line?
We have indications of high interest from the game industry and it is my belief that pilot studies developed during basic research now may go commercial within the

next five years. I believe that building middleware capable of capturing player satisfaction in real-time will deliver products of higher commercial/marketing value and will automate specific game development processes like user testing.

The ways to achieve this is by bringing our results to the attention of the industry and provide evidence for the robustness and efficiency of our methodologies. However, in order to be more convincing about the potential of PSM, approaches should be first tested and evaluated in commercial-standard games.

If someone wanted to get started with this, where would your recommend that they turn? (books, first steps, etc)?

The PSM field is quite new; however, the increasing interest from academics and game developers has resulted to a significant number of research articles in the topic. Articles related to PSM can be found in the proceedings of the two workshops (in conjunction with SAB'06 and AIIDE'07) organized prior to the establishment of the task force. The IEEE computational intelligence and games (CIG) symposia and the AI for Interactive Digital Entertainment (AIIDE) Conference series include such articles, too. User and affective modeling related conferences cover some aspects of PSM.

I would highly recommend a visit to the IEEE-PSM website (http://game.itu.dk/PSM/) for further information on people, groups and articles related to PSM.

16.1 References

Yannakakis, G.N., & Hallam, J. (2007). Modeling and Augmenting Game Entertainment through Challenge and Curiosity. *International Journal on Artificial Intelligence Tools, vol. 16*(issue 6), 981–999.

Yannakakis, G.N., & Hallam, J. (2007). Towards Optimizing Entertainment in Computer Games. *Applied Artificial Intelligence, 21*, 933–971.

J. Togelius, R. De Nardi, and S. M. Lucas: Making racing fun through player modeling and track evolution, in Proceedings of the SAB Workshop on Adaptive Approaches to Optimizing Player Satisfaction, 2006, pp. 61–70.

P. Spronck, I. Sprinkhuizen-Kuyper, and E. Postma (2004), Difficulty Scaling of Game AI, GAME-ON 2004: 5th International Conference on Intelligent Games and Simulation, pp. 33–37. EUROSIS, Belgium.

SEVENTEEN (A)

Usability for Game Feel

Steve Swink is an independent game developer, author, and lecturer currently based in Tempe, Arizona. As a game designer and managing partner at Flashbang Studios, he's contributed to games such as Off-Road Velociraptor Safari, Splume, and the upcoming Jetpack Brontosaurus. Before joining Flashbang, he toiled in the retail game mines at Neversoft and the now-defunct Tremor Entertainment. His first book, entitled Game Feel: The Game Designer's Guide to Virtual Sensation, will be published by Elsevier/Morgan Kaufmann spring 2009. He also co-chairs the Independent Games Festival, is an IGDA Phoenix chapter coordinator, and teaches all game design classes at the Art Institute of Phoenix. Note to self: sleep every night, not just some.

Just so we're on the same page, I define game feel as the tactile, kinesthetic sensation of control in a videogame. In simple terms, it's when a videogame takes over the action-perception cycle you normally use to cope with and navigate your everyday physical environment. Instead of perceiving your hand moving to grab a coffee cup in front of you, you see Mario move in response to your inputs on the controller. You're not moving *your* hand, you're moving Mario. And you do not perceive the result of the resulting movement in your space, you perceive Mario's position in his space. It's a subtle transposition, where action flows from hands to controller and into the game transparently and the eyes, ears, and hands perceive the results, process them, and respond within a few milliseconds. If this happens uninterrupted, in what is more commonly known as a "correction cycle," then we have what I'd consider game feel. There are all sorts of other bits to it—creating clues about the nature of certain interactions using particle effects and screen shake, for example— but that's the core. Good game feel, then, is when the controls of a game feel intuitive, deep, and aesthetically pleasing. Like the difference between the feel of driving

a Porsche or a school bus with one flat tire, good game feel is subconscious, visceral and extremely important.

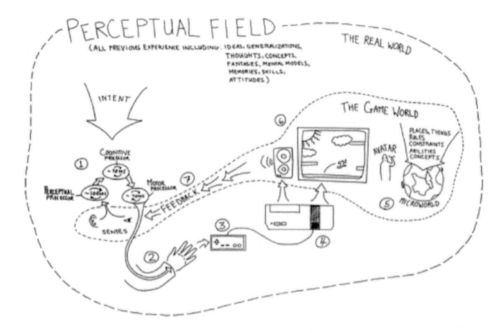

Game feel is particularly bound up with usability concerns because of the delicate interplay of learning, skill, and challenge. To cut to the chase, properly balancing and tuning a mechanic to feel good is one of the most difficult challenges a game designer will face. There will always be a learning curve for a new mechanic. Players will be frustrated at first. They understand this and tacitly agree to a certain amount of frustration on the promise that some enjoyable, engaging experience will result. Remember what it was like to learn to ride a bike or drive a car. When you finally got it, how did you feel? Was it worthwhile? The designer must make delineation, then, between what frustrations are the byproduct of the skill building process, and what is a usability concern. The problem lies primarily in the fact that players can learn any interface. The challenge is to create a mechanic worth learning. This is a moving target—the amount of "worth" will be a factor of how difficult it is to learn, of individual players, and of the other rewards provided for mastery. A very difficult mechanic may be worth learning if it's a game you play with your friends over and over again, or if there's an online leader board. Or it may be that you enjoy the theme and art of the game particularly, or the story which is doled out after the completion of challenges. Or you may just be the kind of player who enjoys mastering exceptionally challenging mechanics. I tend to fall into this category—I loved Gunvalkyrie, Ski Stunt Simulator, and Trials: Construction Yard (possibly the most difficult game ever to be worth playing.) Depending on your design

vision, extreme difficulty may be okay. As long as the reward for learning the skill seems commensurate to your intended player, you're all good.

What follows is one possible method for creating and testing a new mechanic, for creating good game feel.

17.1 The Gameplay Garden

It's been said that for each of his games, Shigeru Miyamoto creates a "gameplay garden" for experimenting with mechanics, objects, and game feel. As an approach, creating an experimental garden or playground in which to test a developing mechanic and game feel is an arresting notion. The trick is not to allow the problems of game feel to become intertwined with the problems of the design as a whole, or with usability concerns. One way to separate the pieces of game feel to make them a bit more manageable is as follows:

1. **Input**—How the player can express their intent to the system.

2. **Response**—How the system processes, modifies, and responds to player input in real time.

3. **Context**—How constraints give spatial meaning to motion.

4. **Polish**—The interactive impression of physicality created by the harmony of animation, sounds, and effects with input-driven motion.

5. **Metaphor**—The ingredient that lends emotional meaning to motion and provides familiarity to mitigate learning frustration.

6. **Rules**—Application and tweaking of arbitrary variables that give additional challenge and higher-level meaning to motion and control.

1. Input
Input is the player's organ of expression in the game world, the only way a player can speak to the game. This is an overlooked aspect of game feel: the tactile feel of the input device. Games played with a good-feeling controller feel better. The Xbox 360 controller feels good to hold; it's solid, has the proper weight, and is pleasingly smooth to the touch. By contrast, the PS3 controller has been lamented as being light and cheap feeling, like one of those third party knockoffs.

This difference in tactile feel of the input device has implications for the feel of a given game. When I prototype something—platformer, racing game, whatever—it will feel noticeably better if I hook up the inputs to my wired Xbox 360 controller than to simple keyboard inputs. You can't always control the input device your player is going to use to interface with your game so you should be aware of, and compensate for, how different input devices feel. One way to lean into a given input device is through natural mappings.

A natural mapping is a clear, intuitive relationship between possible actions and their effect on the system. Consider three possible configurations of burners and dials on a stove:

FIGURE

17.1

Configurations of burners on a stove.

Imagine trying to use each of them. Which one requires no thought to operate? Clearly, figure C is a natural mapping: the layout of the dials correspond clearly and obviously to the burners they activate. There is a clean, physical metaphor connecting the input device and the way it can alter the system. A good example from a modern game is *Geometry Wars* for Xbox 360.

Consider Geometry Wars relative to the Xbox360 controller. The way that the joystick is formed transposes almost exactly to the motion in Geometry Wars. It's almost one for one: the joystick sits in a circular plastic housing that constrains its motion in a circular way. Pushing the control stick against the edge of the plastic rim that contains it and rolling it back and forth creates little circles, which is almost exactly the analogous motion produced on screen by *Geometry Wars* in response to input. This is what Donald Norman would refer to as a "natural mapping." There's no explanation or instruction needed because the position and motion of the input device correlates exactly to the position and motion of the thing being controlled in the game. The controls of *Mario 64* also have this property; the rotation of the thumbstick correlates very closely to the rotation of Mario as he turns, twists, and abruptly changes direction.

Another way input device affects game feel is through the inherent sensitivity of the input device. Consider the difference between a button and a computer mouse. A typical button has two states, on or off. It can be in one of two positions. As an input device, it has very little sensitivity. By contrast, a typical computer mouse has complete freedom of movement along two axes. It is unbounded; you can move it

as far as the surface underneath allows, giving it a huge number of possible states. A mouse is an extremely sensitive input device.

So an input device can have an inherent amount of sensitivity, falling somewhere between a mouse (near-complete freedom in two axes) and a button (only two states, on or off.) This is what I call input sensitivity; a rough measure of the amount of expressiveness inherent in a particular input device.

The implication for game feel prototyping is to consider the sensitivity of your input device relative to how fluid and expressive you want your game to be. In most cases, this is a decision about complexity—as a general rule, additional sensitivity means greater complexity. This is not a value judgment per se; greater sensitivity has both benefits and drawbacks depending on the goals of the design and how the mechanic fits into that design. What's important to realize is the implications your choice of input device has for the sensitivity of the game. Of course, the input device is only half the picture. The other place to define sensitivity is in reaction: how does the game process—and respond to—the input it receives from the input device.

2. Response
Consider the games, Zuma and Strange Attractors.

In Zuma, there is a reduction in the inherent sensitivity of the mouse as an input device. Instead of freedom of movement in two axes, the object being controlled is stationary. The frog character rotates in place, always looking at the cursor, clamping the mouse's sensitivity down to something more manageable.

By contrast, Strange Attractors is a game that uses only one button as input. The position of your ship in space is always fluid, always changing very subtly, and you can manipulate it only by activating or deactivating your ship's gravity drive. Both Strange Attractors and Zuma have fairly sensitive, nuanced reactions to input. This is reaction sensitivity: sensitivity created by mapping user input to game reaction to produce more (or less) sensitivity in the overall system. It is in this space—between player and game—where the core of game feel is defined.

Consider just how simple the original Nintendo Entertainment System (NES) controller was relative to the expressive feel of Super Mario Brothers. The NES controller was just a collection of on/off buttons, but Mario had great sensitivity across time, across combinations of buttons, and across states. Across time, Mario sped up gradually from rest to his maximum speed, and slowed gradually back down again, his motion dampened to simulate friction and inertia in a crude way.

In addition, holding down the jump button longer meant a higher jump, another kind of sensitivity: across time. Holding down the jump and left directional pad buttons simultaneously resulted in a jump that flowed to the left, providing greater sensitivity by allowing combinations of buttons to have different meanings from the pressing of those buttons individually. Finally, Mario had different states. That is, pressing left while "on the ground" has a different meaning than pressing left while "in the air." These are contrived distinctions which are designed into the game but which lend greater sensitivity to the system as a whole so long as the player can correctly interpret when the state switch has occurred and respond accordingly.

The result of all these kinds of nuanced reactions to input was a highly fluid motion, especially as compared to a game such as Donkey Kong, in which there was no such sensitivity.

This comparison, between Super Mario Brothers and Donkey Kong, shows very clearly just how much more expressive and fluid Mario's controls are. The interesting thing to note is that Donkey Kong used a joystick, a much more sensitive input than the NES controller. No matter how simple the input, the reaction from a system can always be highly sensitive. No matter how sensitive the input, the reaction from a system can always be reduced or muted. Of course, there isn't some magic formula for the right amount of sensitivity in the system.

Look for happy accidents, though. Do you surprise yourself with what you can express or accomplish with your controls? Does the act of playing create something aesthetically pleasing? Do you find yourself wasting time noodling around instead of continuing to tweak and tune? Does it feel like you're building a meaningful skill? If the answer to these questions is yes, it's time to give this motion some spatial meaning.

3. Context

Returning to Mario 64, imagine Mario standing in a field of blank whiteness, with no objects around him. With nothing but a field of blankness, does it matter that Mario can do a long jump, a triple jump, or a wall kick? Context is the soil of your garden; it's necessary for the mechanic to grow and bloom.

If Mario has nothing to interact with, the fact that he has these acrobatic abilities is meaningless. Without a wall, there can be no wall kick. At the most pragmatic level, the placement of objects in the world is just another set of variables against which to balance movement speed, jump height, and all the other parameters that define motion. In game feel terms, constraints define sensation. If objects are packed in, spaced tightly relative to the avatar's motion, the game will feel clumsy and oppressive, causing anxiety and frustration. As objects get spaced further apart, the feel becomes increasingly trivialized, making tuning unimportant and numbing thoughtless joy into thoughtless boredom (most Massively Multiplayer Online games suffer from this phenomenon to some degree.)

For this reason, it's a good idea to build some kind of test environment as you create the system of variables you'll eventually tune into good game feel. This is the Magic Garden of game feel: if you can make it exceedingly pleasurable to interact with the game at this most basic level you've got a superb foundation for enjoyable gameplay.

So you should be putting in some kind of platforms, enemies, some kind of topology that will give the motion meaning. If Mario is running along with an endless field of blank whiteness beneath him, it will be very difficult to judge how high he should be able jump. So you need to start putting things in there to get a sense of what it will be like to traverse a populated level. In many cases, the goal is to find the standard unit from which the game's levels should be constructed. In a two-dimensional game, this could be the number of tiles high and wide for a good-feeling standard jump. In a racing game, this could be the width of the road and the angle of various curves (with an eye for how difficult they are to navigate successfully.)

My favorite approach is to use a wide array of primitives in various sizes. Just throw stuff in there; don't worry too much about the spacing. Tweak the spacing of the objects relative to the avatar and vice-versa until it all starts to feel really good, but then just throw in all kinds of objects of various sizes, types, shapes, and physical properties. Build a playground of interesting interactions. Put in big archways, round things, fat things, pointy things, anything you can think of. Get a bunch of shapes in there and study the way the spatial dynamics are interacting with the feel you're creating. Plan for happy accidents and stay loose and open-minded when testing. Take note of crescendos of enjoyment as you interact with the space and lean into them with tuning and additional test terrain.

Another thing to consider about adding spatial context is that constraint is the mother of skill and challenge. Think of a football field: there are these arbitrary constraints around the sides of the football field that limit it to a certain size. If those constraints weren't there, the game of football would have a very different skill set and would likely be less interesting to watch. If you could run as far as you want in one direction before bringing it back, where's the challenge? The skills of football are defined the constraints that bound it. If things are going well with a prototype, I find myself creating mini goals, trying to shoot through gaps or otherwise skillfully traverse the increasingly fleshed-out spatial topology.

4. **Polish**

At or around the same time you're building context, you're going to want to start putting in a bit of polish—but only what's essential to your prototype. Polish can include sprays or dustings of particles where things hit or interact, screen shake, view angle shifts, or the squash and stretch of objects colliding. The point is to convey the physical properties of objects through their motion and interaction. Any effect that enhances the impression that the game world has its own self consistent physics is fair game.

This is opportunity to take inspiration from the film, animation, and *gasp* the world around you. Look at the way things interact. If you hit a glass table with a hammer it will shatter, complete with noise, motion, and a spray of "particles." The more clues like that you can borrow to inform the player of the physical properties of the objects they're interacting with the better.

When prototyping, I like to list these cues out and sort them in order of importance to the physical impression that should be conveyed. As an example, consider the goal of making a game that feels squishy. This is a good place to start because to say that something is squishy implies visuals, sounds, tactile sensation. It provides a great benchmark: if something is squishy, it will deform in a certain way, like a water balloon or silly putty.

As these deformations happen, certain sounds accompany them; familiar squelching and schlucking noises which are hard for me to describe but easy to recall. It's the noise of walking through deep mud, or kneading wet dough with your hands. Separating out the various pieces of squishiness as a physical property yields something like this:

Motion—The thing must deform and bend when it comes into contact with other objects, especially relative to speed.

Tactile—You can easily deform, mold, or stretch the thing.

Visual—To aid the impression of squishiness, the thing could look moist like a slug, translucent with tiny bubbles like Jello, or amorphous like putty or clay.

Sound—Any movement or deformation of the object should be accompanied by squelching noises.

These comprise the physical clues that get assembled into your brain to create the notion of squishiness. Anything you can layer on top to fake these effects will increase and improve the impression of physicality and, hence, the feel. As polish is a notorious time sink, you want to limit the amount of time you spend creating effects to those that are crucial to demonstrate the impression of physicality you're going after.

Something squishy needs to deform and to sound squishy, but it probably doesn't need a full fluid or spring simulation. A simple squash and stretch deformation is probably enough to get the idea across.

So, yes, polish is time consuming but it's also vital. A little screen shake or spray of particles can make all the difference in the world to a game's feel.

5. Metaphor

Your choice of metaphor changes game feel dramatically. I like the following example: imagine Gran Turismo, Project Gotham, or whatever your favorite "simulation" style racing game happens to be. Now substitute for the car a giant, balding fat guy running as fast as he possibly can spraying sweat like a sprinkler in August. Without altering the structure of the game, the tuning of the game, or the function of the game, the feel of the game is substantially altered.

All you've done is swap out a 3D model of a car for a 3D model of a giant fat guy running and you've got Run Fatty Run instead of Gran Turismo. This will change the feel of the game because you have preconceived notions about the way a car should handle. Obviously.

You know how a car should feel and move and turn based on your experience driving a car and looking at cars. Oftentimes, people will play a game—horse-riding gameplay is my favorite example—and they'll say "this doesn't feel like a horse." And you'll ask them well, have you ever ridden a horse before? And they'll say "no, but this doesn't feel like a horse." People have these built-in, preconceived constructs, mental models about the way certain things move and, by extension, how it should feel to control them.

The implication for prototyping is this: you need to take a step back and decide how much of your metaphor to represent in the prototype to get an accurate read on the game feel you're building. Iconic is fine, but if it's going to be a car, it needs to read as a car. The trick is not to limit yourself to only everyday objects, but to look at how you can use preloaded conceptions to set up, and execute on, expectations for how a thing should feel and behave when controlled.

6. Rules

Rules are the final layer that goes into a game feel prototype. Basically, you're looking for longer-period objectives to give additional meaning to the sensation of control and mastery. If you've been noodling around with a mechanic for a couple hours, this shouldn't be too much trouble since you're probably already making up little goals for yourself. Race from point A to point B, scale this tall mountain, rescue five wayward puppies. These kinds of higher order goals define game feel at a different level: sustainability.

This is one of the most difficult things to do. You need to build in some longer period goals to find out whether or not this motion you've created has depth. This will necessarily be a bit of a rough test, and there's really not a good way to get an objective read on depth unless you watch a bunch of people play the game, but you can get a sense of whether or not your mechanic is deep.

That is, whether or not you can have long-period sustained interactions that are deeper than the surface pleasure of steering the guy around the most basic context and spacing you've created. This is things like get to the top of the hill, get from A to B, collect X number of coins, sort all these things into colored bins, perform a certain trick at a certain location, and so on. Just about any goal implies a set of rules for achieving that goal.

This sort of testing brings your fledgling game feel up against the hard hammer of game-creation reality. You're starting to try and create challenges that could become a sustainable game. This is a bit of a grey area, as it starts down the slippery slope of game design proper, but I would encourage you to consider creating these types of throwaway goals. Don't consider them a prototype of the complete structure of the game.

Just throw a bunch of goals in there—get around things, collect coins, get to a certain place—find the coolest interactions, the coolest parts of the level. If you've been playing around in your level, tweaking the mechanics and spacing the objects, you have a good sense of what's going to be fun about it. You've already developed a bunch of intrinsic, internalized goals: can I do a flip off this thing, can I get up there, can I do two flips before I land and so on. Just throw these in there and codify them.

Interestingly, there is a big difference between inventing goals for yourself and explicitly coding those goals into the game: completing a goal means satisfying the conditions of the impartial, third-party computer. It also means some kind of reward, no matter how meager. If you can't come up with a bunch of different goals that are enjoyably challenging, that's trouble. It might be time to abandon or significantly alter your mechanic.

17.2 Conclusion

At this point, you've proven whether or not your game is going to feel good at the most basic level.

With diligence and luck, you've got a game that feels great. Moment to moment, it just feels good to steer around and feel out the space. The spacing of objects is in perfect harmony with the tuning of your controls and you're quickly finding the places where the spatial context crosses over and constrains the motion, yielding the most interesting interactions. You feel yourself starting to build skills that might give rise to longer period interactions.

Finally, you started adding on some rules that test whether or not this mechanic will be sustainable and may give you some interesting directions to lean into when you start designing the system dynamics that are supposed to sustain the experience across an entire game. You now have the foundation for a great-feeling game.

As a final note, consider the aesthetic beauty possible with game feel. Create something beautiful at the intersection of player and game. Remember: the first, last, and most common thing a player will experience when playing your game is its feel.

CHAPTER

SEVENTEEN (B)

Further Thoughts from Steve Swink on Game Usability

(Editors' note: We asked Steve for a chapter on game feel, and he submitted that as well his musings about usability and games, more generally speaking. We include much of that rant here, because it is another interesting and valuable developer perspective on how to think about usability. Enjoy!)

17.3 Game Testing and Homework

If there's one thing I learned about videogame players while working on *Tony Hawk Underground*, it's that no one will ever read text if they have the ability to skip it. For this reason (among others), the success or failure of a videogame can come down to usability. The player must be able to engage with the core challenge of the game without reading instructions. They need to be able pick up the controls and go. I was asked to write a chapter on "usability testing for game feel." If you'll bear with me, I discovered that I have a bit to say on the subject of game testing in general, the efficacy of usability testing in specific, and, eventually, about how usability testing can help you make great-feeling games. First, I'll define game testing as I see it, broken into three primary types. Then, I want to address what I see as the fundamental difficulty individuals and teams face when testing their games, the problem of defining player experience, and provide one method for addressing that problem.

17.4 Three Types of Game Testing

In my experience, there are three fundamental types of testing crucial to creating a successful videogame. These are experiential testing, defect testing, and usability testing.

Experiential Testing

When I say experiential testing, I mean what most game designers mean when they say game testing. The goal is to get an objective read on the current state of the game as-is. If a fresh, uninitiated user were to play the game in its current form, what would the experience be? This is the most basic and fundamental form of game testing and addresses things like the balancing of systems, the tweaking of mechanics, the spacing and placement of level objects, flow and pacing, and other common game design issues.

In an experiential test, the designer sits down and watches players play the game, observing and taking notes on the results. The purpose of experiential testing is to compare the actual, live experience a player has with the game to an idealized vision of experience contained within the designer's mind from a purely artistic standpoint. Consciously or not, the designer takes the many subtle clues from the faces, posture, language, and mood of the players and intuits them into a generalized notion of how the game plays in its current incarnation. Players laugh and yell in triumph. They grind their teeth in frustration. Or they may be rapt, their entire conscious world focused into a narrow cone on the development and successful execution of strategy. At least, that's what the designer hopes for. Initially, the results are likely to be the most humbling and bitter pill for a designer to swallow: apathy. In game design, indifference is anathema. If the player is screaming and tearing their hair out in frustration, that can be tweaked. If they shrug and say "it's okay, I guess," it's the designer's turn for hair-pulling. So that's experiential game testing, and almost every game goes through some of it. There's just no other way to get a reasonable, objective read on the experience of the game. You as the designer have played it too much and understand it too well to objectively judge. You know how it's supposed to work and will subconsciously play it that way. Experiential testing reveals how it actually works.

Defect Testing

By defect testing I mean bug hunting. By "bug" I mean an unintended error in logic or syntax that prevents the software from behaving as intended. This includes crashes, which forcibly halt the game, and things like dead ends, which prevent the player from progressing further. At the end of every major software project, there is a period where all content and features are locked down and the team spends their time hunting down and fixing the inevitable bugs. It sucks, but it's reality:

every game has bugs. To find them, you have to explore every nook and cranny of the game, including bizarre cases such as leaving the game running all night in every possible state. Defect type of testing is rigorous, systematic, and intentionally excludes the concerns of experiential testing. It's not about experience; it's about building a solid piece of software. In other words, defect testing is no fun for anyone.

It's also worth noting that defect testing is carried out by paid professional testers. This is as far as it is possible to get from a fresh, objective test with an uninitiated player. These folks are (under) paid, overworked, and are literally handed a tasklist which tells them how specifically they are supposed to proceed through the game. Again, the purpose of this testing is simply to find and eliminate bugs by systematically trying every possible option or course of action.

Usability Testing

The third and final type of testing is usability testing, the type of testing this book is about. Usability testing straddles the line between experiential testing and defect testing. In a way, it's about debugging the experience. Will Wright once said that designing a videogame is half computer programming, half people programming. Usability testing is about finding and eliminating the flaws in the people programming. Imagine playing Tetris but being unable rotate to the block left and right. Is the game as engaging, challenging, or enjoyable? Hells no! Now, ask yourself this: is there any difference whatsoever between a game of Tetris where one cannot rotate and one where one cannot figure out *how* to rotate? Usability tests are intended to find and correct any such issues.

17.5 Why Do We Test?

The above definitions are predicated on the assumption that game testing is universally necessary for games as a medium. All games of all types everywhere must be tested, iterated on, and tweaked. Is this actually true? More importantly, why do we test videogames in the first place? It's a fair question. Why must games be tested? Let's take a step back and examine by example.

At Neversoft, we had testing sessions every week during most of production. But there was no clear concept of what a given test was intended to accomplish, no specific goals other than a sort of nebulous sense that we should use the tests to "make it awesome." For my part, I took detailed notes on every test I watched. I would take down specific notes such as "space benches wider" and "make Eric challenge goal easier." I still have a pile of seven or eight yellow legal pads with page after page of scrawled notes, each item crossed off as it was resolved. I used these notes as best I could to make my levels, goals, and systems as positive an experience as they could be for as many players as possible. By conventional

metrics, there was some success in all our testing and tweaking: the game sold over three million copies. But I could not escape the feeling that it was not as good a game as it could have been. Whether through lack of focus or the inevitable crush of time pressure that accompanies a one-year development cycle, I have always felt that we as designers could have done better. Specifically, the experience of playing the game could have been better if we had tested better. Not more, necessarily—testing once a week is fine—but testing *smarter*.

This thought led me to thinking about why we test games in the first place. The answer I arrived at is bound up in the frustratingly ephemeral nature of what we call "gameplay", that bizarre universe that is conjured improbably at the moment the game begins, living in the space between player and game. The insight is this: without a player, there is no game. This kind of seems like an obvious statement. But compare the active, multifaceted learning process of gameplay to the comparatively passive process of watching a film. There is mental engagement in a film, sure, and there can be critical discussion and analysis after the fact, but a film will still play back from start to finish if there's no one there to watch it. An unplayed game just sits there. The crucial point, I think, is that a videogame is fundamentally a system whose output is participatory human experience. A videogame is collaboration between player and designer intended to produce a particular experience. This is why testing is necessary in the first place. Filmmakers may screen their films and try to gauge the audience response. Based on this response, they may make some additional edits or reshoot a scene, but the vision of the film can be and is detached from the audience while it is in production. A director can look at a scene and say "yes, nailed it!" or "once more from the top, with feeling!" Would you release a completed commercial videogame on the hunch that it's an enjoyable, engaging experience? Would you build it to a near-complete state without ever having users test it afresh? Exactly.

The problem lies in the disconnect between a designer's intended experience and the actual experience of playing the game for a new user. Film has no active participation; you can guarantee that the frames will play back in the same order every time. It's possible that viewers will have wildly different experiences viewing it based on wildly varying interpretations, but probably not.[1]

In a participatory videogame, there is no such determinism. A player may move through the level exactly as the designer intended, or they may obsess over a plant in an obscure corner of the level for minutes at a time. They may succeed on the first try or they may fail one hundred times before beating a boss or song or stage. There are no guarantees about a player's behavior, only the signposts the designer has built into the game. As designers, we can't tell the players to take it from the top. We can only make small incremental improvements to bring the

[1]Perhaps this is why so many videogame designers, myself included, love David Lynch films. The high amount of ambiguity in every scene necessitates a high level of intellectual engagement.

player's actual reality in line with our desired experience. We can't be in every download. We can't pop up behind every player in every living room and wave a disapproving finger if they don't play the game the "correct" way. All we can do is modify your game's rules and structure so that most of our players will experience the game the way we intended it. This is, in a nutshell, the process of game design.

So we test because a game requires play. Play needs a player. In order to get an objective read on whether or not a game is providing players with the experience you as a designer intended, you have to see people play the game. Sounds simple enough. Just compare the desired experience to the experience of people playing. So what's the problem?

For starters, there's the Pandora's Box of definition. How do you codify the "ideal" experience you're testing against? Testing implies measurement, and to measure you need something to measure against. How do you explain experience? In terms of other art forms? In terms of everyday feelings and activities? By pointing, raving, and jabbering? Or what? Especially with finicky things like tuning game mechanics which have little or no real-world analogy, clarifying exactly the feel you want can be difficult in your own mind let alone when expressed to other members of a team. With no clearly defined experience to test against, it's easy to waste time when testing. You can fix the obvious stuff, make exploratory changes, and try to lean into the positive things that are happening, but it's difficult to adapt to large-scale problems in the overall design or to really drill down and strip away everything but the pure essence of the experience you're going for. Defining that experience is key, and is a key problem with game testing.

Another difficulty in effectively testing is what I would describe generally as "staleness." If you work on a project three months it's easy to lose all objectivity. Three months or three years; it's not a question of whether you as a designer will lose perspective, but when and how you deal with it. A well-run playtest with clear goals and fresh players is the best remedy I've seen. As I said, it takes a player to see a game. For a short while at the start of the design, that player can be you. You can be fresh enough, open-minded enough, and objective enough to tune your own system and get some kind of read on whether or not it feels good. For me this period lasts about a week. After a week of tweaking on the same mechanic or system, it starts to become extremely difficult to make a change and say definitively that it has had a positive or negative effect. Recognizing that this staleness is present and that it's an insidious danger whose primary solution is testing may take years of experience.

Finally, there is the problem of challenge versus obfuscation. It takes judgment and experience to figure out whether a problem is part of the challenge presented by the game or if it is outside of it and needs to be corrected in some way. In other words, can the user figure out what they're supposed to do? Can they master the controls or learn the interface well enough to engage with the challenge? Stated like that, it seems a clear division, an easy split between issues of usability and issues of game design. But, like everything else related to game design, it's never that simple.

Usability and game design are inextricably intertwined, and the relationship between them should be well explored and understood.

Of course, these problems are multiplied the longer a project goes on and the more people are working on it. The longer a project continues without a clear vision for its final experience, the greater the layering of testing and aimless tweaks that will pile on top of it. The longer the project continues, the easier it is to lose objectivity about balance and tuning, and the easier it is to lose sight of any dissonance between the intended experience and the actual experience. This in turn makes it difficult to discern whether a first time player is failing at the crucial skill of playing the game, or failing to understand it.

Hopefully, examining these issues in depth and with examples from my own work will help other designers in avoiding or mitigating them.

17.6 Defining Experience

Not to wax philosophical, but the only true experience we'll ever have is our own. We as humans have a unique capability for vicarious experience. We can experience what others have experienced in an indirect, imaginary way. This is not the same as actual experience, however. It must be conveyed in terms of description—metaphor, simile, gesture, explanation. In light of that, what does it mean to try to measure an experience? What we're actually measuring, as it turns out, are the artifacts of a given experience, the results. Since we can only ever experience something directly, we have to look at the clues available in order to discern what the experience a player is having playing our game is. It is possible to play one's own game, of course, but as was discussed earlier, it is virtually impossible to maintain objectivity over the entirely of a project. Our vocabulary for defining the intended experience of a game, then, comes in the clues we can glean from watching players before, after, and during testing.

First, there are the immediate social and physical clues: facial gestures, body language, and verbal comments. Shigeru Miyamoto puts it this way:

> "When I create a game, I try to envision the core element of fun in the game. To do that, I imagine one thing, the face of the player when he or she is playing the game. My personal view as a designer is that I want that reaction, that emotion to be positive. Glee, surprise, happiness, satisfaction. Certain obstacles may raise suspense, competition, frustration, but we insert these elements in order to produce a new sensation that you've never felt before. And I want that final emotion to be a positive one. That's what I have in mind when I create my games."

As human beings we've all had years and years of practice reading, understanding, and reacting to everyday social situations. You can watch a person's face, their

posture, and their body movements and read easily if they're deep in strategizing thought, deeply frustrated, or delightfully surprised and satisfied. This can tell you what experience specific moments in the game are conveying to the player and provide great signposts for modification. This is what most designers I know do; they watch the players test and try to emphasize the fun and minimize the boring (or excessively frustrating). A huge part of defining the intended experience of a game, then, should be to define exactly what the reaction of the player should be.

I think there's a possibility for oversimplification, though, in ending things there. There is a tendency in game design to oversimplify and ask "is the player having fun?" and call it day. Unfortunately, that word is both loaded and slippery in ways that make me uncomfortable using it as any kind of serious design discussion (let alone basing large-scale changes to a design on it). As one simple example, my dad loves to garden. He grows a lovely little crop of tomatoes, squash, and beans every year. He potters around and fusses over his garden, builds little planter boxes with spare wood from the garage, and relishes picking the fresh veggies each night and turning them into dinner. Is he having fun? By most definitions of fun I've read, the answer would be no. Is he enjoying himself and does gardening enrich his life? Does he find it engaging and worthwhile? Are there many benefits to him, both tangible and intangible, to gardening? Yes, of course. What I'm getting at is that the notion of fun is limiting in many ways, and it may blind us to some of the less obvious ways that people engage with games and find them enjoyable and enriching. He gardens because he loves it. He's not laughing, crying, or clenching his teeth in frustration, but I can see that gardening makes him happy and relaxed. In defining an experience we want to create, we should consider not only the signs that a player is experiencing triumph over adversity, frustration, or social gratification, but other, more subtle sorts of experiences. (For a great breakdown of different kinds of enjoyment, check out Nicole Lazzaro's Four Fun Keys model in chapter 20.)

My dad's gardening habits are also useful in that they illustrate the other important metric of experience: behavior. If he didn't enjoy gardening, he wouldn't do it. In the same way, there's often no better test of experience than in-game behavior. For example, in Tony Hawk's Pro Skater 4, it is possible to "skitch"—grab the back of a car and go along for the ride. Seems fun and interesting, right? But it's almost categorically ignored by players because it's not useful in the context of the game's other systems. Unlike, say, "grinding" ledges and rails which is one of the most crucial and fundamental mechanics in the game, skitching is totally ignorable. The player doesn't need to do it and has no in-built incentive other than "hey, cool, I can grab on to the car." In this case, the behavior of players (ignoring the skitch mechanic) was okay. Skitching was an Easter egg, a fun but ultimately unnecessary thing for advanced players to find and toy with briefly. When the skitching mechanic later became required, as it was in Tony Hawk's Underground, this behavior was no longer desirable.

As another example, think of games which feature high, climbable structures. In games like Super Mario 64, Aquaria, and Crackdown I often find myself looking

upwards and trying to reach the highest visible point. This is a simple, enjoyable goal for me to pursue and has given me a great amount of satisfaction in each game. I love the sensation of virtual vertigo and the feeling of calmness I get from being at the highest point in the level and surveying the surroundings. Without the challenge of jumping my way up there, the threat that I could misstep and fall, and the prominence of tall features in the landscape to attract my attention, I would not have this experience. And yet, I did not feel forced or coerced. Was this a designed experience? You bet your ass it was. And you can also be sure that it took some testing and a clear vision of the desired experience to get it right.

We can design for experiences like these. They don't have to spring full-formed from a complex and unpredictable interblending of different systems and mechanics as if by magic. Every designer I know intuitively translates ideas about mechanics and systems into player experiences in their head. All I'm proposing is that we should do a better job of pre-examining what we're looking for.

So in describing an experience in the detail needed to meaningfully test against, the following can be useful and should be thought out:

1. What should be the player's emotions and reactions at a given moment and what are the signs that the player is experiencing them? This includes facial expressions, body movement and posture, and verbal feedback.

2. What behaviors indicate that the player is engaged with the intended experience of the game? Do they chase the rabbit, use the skitching mechanic, or try to get to the highest point?

The best way I know of to get at the kinds of descriptive accounts of experience that are exceedingly useful for detailed testing is to break the game down into moments. We can think of these as specific moments of interactivity, if not moments in time. Even if we don't know when, we know that these things will happen at some point in time in the course of play. At least, we can test to make sure they do. If they don't happen, that's a usability issue. If they're happening but they're not conveying the proper experience, that's a game design issue. If we clearly define the experience moment by moment, minute by minute, hour by hour from the beginning experience to the end, we have something we can really test against. We don't have direct control over when things are going to happen in our games, but we do have access to the tools of people programming.

Here are some example segments of a detailed, written-out game experience, broken down by moments:[2]

[2]Note that these moments can be and are asynchronous. Even if we can't say for sure when, they're going to happen at some point in the course of play. So they can be tested for. Huzzah.

Off-Road Velociraptor Safari by Flashbang Studios

Initial Hook

The user arrives at the been website for the game via a link. They've either seen the promotional trailer or been referred by a friend or game news website. Hopefully, the player is intrigued by the ludicrous name of the game. Most likely, they watched Jurassic park as a kid (just like us) and now have an abiding and deep-seated love of dinosaurs. Off-Road Velociraptor Safari as a name and logo will bring in the kind of player who'll like our game: intelligent, skilled, and with a good sense of humor.

The game starts

At this point the player sees a flying Pteranodon and a "raptor fact" which is pulled randomly from a list of actual scientific raptor facts and made-up fun facts such as:

1. Raptor Fun Fact #53—Raptors live in a world where pants have no meaning.
2. Raptor Fun Fact #66—The Raptor word for love is "SCREEECH!"

This should continue to reinforce the irreverent tone and should get a chuckle. At this point, players will click to start the game:

Most players will have skipped the instructions, but the most basic controls are bound to the WASD or arrow keys on the keyboard. We assume that most players will be able to figure this out as it is as a commonly used convention in keyboard-controlled games played in a browser. Having figured this out, players will drive off from one of five possible starting points. If they start near some raptors, they'll drive towards the raptors. The raptors will be animated, colorful, and will stand out against the background. Based on the name of the game, the premise, and everything the player has seen on the website and in the game leading them to this moment, they'll assume that the goal of the game is to run down raptors.

Jeep Feel

The jeep should feel intuitive and satisfying to drive around. The player should not notice or be inhibited by the controls. There will be a slight learning curve to adjust to the specific feel of this mechanic and the spacing and layout of objects in the world. At the end of the first game, however, the player should be able to get the jeep to go where they want it to go 90% of the time and

should be focused on higher level goals and objectives such as hitting raptors or continuing combos. Simple steering should not be an impediment. Despite being controlled with simple on/off buttons, the driving should feel very expressive. The jeep should not flip over too easily, but it should be clear that rolling and crashing the jeep is possible (and encouraged through the damage and stunt systems.) It should have a sense of weight and presence, and feel to a player as though it is a large and heavy vehicle with responsive steering with which they can navigate the environment easily. Crunching tire sounds, engine revving, and crashing noises of various kinds further lend credibility to the impression of physicality. Slow motion camerawork at moments of impact or during long jumps further emphasize the physical nature of the interactions. Also, the world should feel expansive to the player and they should enjoy the simple pleasure of discovering new areas. "Ooh, waterfall!" and "hey, a ramp I can go up" are common exclamations. The player is actively seeking new places to go, and fleshing out their mental map of the world.

First raptor hit

At some point, the player will hit a raptor. The silly puff of feathers, the squealing noise, the satisfying thud, and the fact the raptor then goes into "ragdoll"

mode all give the player positive feedback. The interaction is extremely satisfying and has a sort of extreme sports bloopers appeal, but with virtual ragdoll raptors instead of some poor motorcyclist flying over hay bales, or a cowboy being gored by a bull. It's a victimless pleasure. The experience of hitting a raptor feels gratifying, interesting, and worthwhile in and of itself. The player should laugh and respond as the raptor is sent flying, looking around to see who else is watching. The ragdoll raptors will also hopefully have "over the shoulder" appeal. People walking by should stop and want to know more about this irreverent game in which you run over feathery ragdoll raptors that look like parrots in an off-road Jeep. In addition, the player gets score feedback. It becomes clear that this game is about score, and the player will hopefully now be attuned to ways to maximize their score. They haven't realized that there's a global high score list yet, probably. That will occur at the end of the first game.

Advanced skills

Through many playthroughs, the player begins to notice deeper skills in the game such as whipping the chain ball around and throwing it to hit a raptor and balancing the jeep on two wheels. These advanced techniques should provide a nice sense of depth and reward for those players who play the game obsessively for hours on end. These are also the skills needed to score large numbers of points and ascend the leader boards. This should make players, new and expert, feel as though the game is both easy to pick up and difficult to master, that it has a great deal of depth.

As you can see, much of the experience of Off-Road Velociraptor Safari is hooked into the web page/ browser experience and into the fact that there are global leader boards and the types of incentives that provides and the types of behaviors that result. We knew this going in and considered the design as a whole entity, including the web page wrapper, achievements, and trimmings (all of which were coded by the indefatigable Matthew Wegner in less than three days!) Even the press release about feathered velociraptors, promo videos, and t-shirts were part of it. It's all one experience, the experience of playing Off-Road Velociraptor Safari. Take it, raptors!

17.7 Usability and Game Design

Embedded in these detailed experiential definitions are two things: usability behaviors and experiential behaviors. Usability behaviors are things like this:

> *"The player understands that there is a boost button, that pressing it is essential to getting around quickly and doing huge stunts, and that it takes a certain amount of time to "reload"—it must be managed as a resource."*

This is what is known as a "got it/don't got it" behavior. It's binary. Either the player figured it out or not. In other words, you can test for this. A usability expert could use a list of got it behaviors like this to draft up a detailed test plan in preparation for running participants through usability tests in their lab. Each behavior would be distilled to a particular task, which the user would then be assigned and have to work through. The goal here is to make sure the player is able to engage with the game's challenge, that it is not obfuscated by a confusing interface. The challenge to this kind of testing is how to test for a behavior without invalidating your results. It's easy to give away what you're testing for or to otherwise lead the player into behaviors they would otherwise not have exhibited. For example, how do you test boost button usage without saying something like "use the boost button to get a huge stunt." You have to give participants a task can only be completed by using the boost. In the case of *Raptor Safari*, this could be something like "climb as high as you can" or "climb a steep hill." Alerting the player to the fact that there is a boost would denude the purpose of the test. That the player realizes there's a boost in the first place is part of what we're testing for. This is a classic usability test. It has nothing to do with whether the player thinks that using the boost is fun or annoying or whether they are generally getting the experience we as designers intended. It has everything to do with removing obstacles to engagement. If the player doesn't figure out that there is a boost button or how to use it, they will not be experiencing the game as intended.

By contrast, experiential behaviors test essence of the design. Experience is the payload; to make the game more usable is to ensure proper delivery. Doing a moment by moment breakdown like we did with Off-Road Velociraptor Safari opens the possibility of testing for the intended experience in the same way we test for usability issues. Watching a player play the game I can say definitively that they either enjoy hitting raptors or not, and how much. From total passivity (no reaction) through a snort to chuckle and on up to raucous laughter, I can tell how close the experience of hitting a raptor gets to our intended experience. If they check their scores after each game, or linger on the achievement page, I can tell that they understand how far the system extends. I can see if the player's left wanting more after each game. If they play again immediately, great success! As with testing for usability issues, the trick is to distill the intended experience down to got it/don't got it behaviors which can be measured. Unlike usability testing, however, there are shades and ranges. As with my above example of the raptor, the desired behavior is that a player thinks hitting raptors is absolutely hilarious and never gets tired of it but the possible outcomes fall on a range between apathy (worst) to laughter and a high level of ongoing enjoyment from hitting raptors (best).

I think that drafting a detailed test script and running a specific usability test is unnecessary, however. If you're properly organized, you can test for usability and game experience in one. As long as you put the work into preparation, you'll be ready when the data starts to fly and will have already determined possible problem areas, complete with what game experiences rely on what usability behaviors.

In the next section, I'll provide an example of one way to do this, by defining the important moments of experience and the types of experience to be tested for and correlating these with the usability behaviors that unlock them. First, though, an ugly example of what happens when tests are not properly prepared for or used to their fullest potential.

17.8 Clear the Bridge

In *Tony Hawk's Underground*, there is a particularly difficult goal on New Jersey, the first level. It is a goal that must be completed in order to progress, in order to reach the rest of the game. In the goal, the player must "skitch"—hold on to the back of a car while riding a skateboard a la Marty McFly—and build up speed as the car drives in a horseshoe pattern through half the level, eventually using the gathered momentum to jump hundreds of feet over a bridge which is blocked by a police barricade. The ridiculous premise notwithstanding, this is a very challenging goal to complete. In order to successfully clear the bridge, the player must keep the skitch meter balanced for the entire 20-second duration of the ride. The skitch meter periodically receives random impulses pushing it away from center; it's in constant danger of tipping off one direction or another, causing the goal to fail. To keep the meter balanced takes a particular skill and understanding of how to gently feather and tap the left and right buttons to pull the meter back towards the center without pulling it too far and tipping it off the other side. Maintaining this balance for 20 seconds requires a nontrivial amount of practice, but this is not the most difficult part.

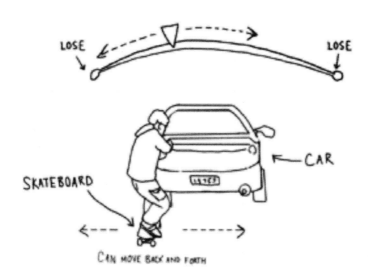

In addition, the position of the skater on the back of the car is important. While keeping the meter balanced, the player must press another button to adjust the skater slightly to the left. The skater needs to be a bit left of center of the car because after hanging to the car for this considerable length of time and keeping the skitch meter from failing, the player must release from the skitch within a very small window of time as the car nears the bridge and, having done so pull the fast-moving skater into proper alignment with a ramp in front of the bridge. If the skater has not been properly positioned, they'll have no chance of hitting the ramp.

This goal is difficult for me to complete consistently, and I've done it probably 100 times. It requires, among other things, multitasking, precise timing, knowledge about where to position the skater on the back of the car, and a nuanced understanding of how the meter balancing system works. As difficult as it is, however, the biggest problem for players in trying to complete this goal is their inability to understand exactly what they should be doing. There are instructions at the start, of course, but no one will ever read instructions if they have the ability skip them.

So here is the player, dumped on a skateboard moving slowly forwards towards the back of a stopped car. For most people, the normal reaction to this situation isn't to grab on to the back of the car and ride it around the block, building up speed to leap hundreds of feet over a bridge. Having skipped the instruction text (assuming that the player even knows what skitching is), the player has nothing to guide her. We included text at the top right telling the player exactly what button to press to start the skitch, but there is perhaps a two second window before the skater runs into the back of the car and is sent off in the other direction. Yowch!

What this problem illustrates is the relationship between game design and usability. They're crucially intertwined. With this goal, we inadvertently create a difficult puzzle for the player. Our intended experience, I think, was something like this:

> *The player gets an opportunity to use an underutilized mechanic, skitching, as part of a goal. The player gets a rush and a thrill from hanging on to the back of the car as it builds up a huge amount of speed. It's not a gimmie, of course; the player has to balance the meter for the duration of the ride, but that should be pretty easy for most players. The enjoyment comes from the speed and anticipation of the release. Seeing the bridge coming up quickly and now with a huge ramp in front of it, the player realizes that they should release the skitch. Releasing at just the right moment, they hit the ramp with tremendous speed and launch triumphantly over the bridge in a massive 200 foot jump. The goal should take two or three tries at most.*

Honestly, it wasn't all that well thought out from a game design perspective. For example, how does this skill relate to the rest of the game? Isn't this just a weird, esoteric goof goal that has no relationship to what you as the player have

learned and done up to this point? It has nothing to do with combos, scoring, and exploring the level, the skills the player has built up to this point. The Tony Hawk games have done a great job in the past of providing some weird/funny goals to mix it up a bit but now we've made this a required goal. You have to complete it in order to progress. Herm, that's not so good. At best it feels forced and the player says to themselves "um, ok... WTF LOL!" At worst, this is a game breaker. We're forcing the player to use skills that never get used in the normal sandbox gameplay and we're forcing them to apply them at an exceedingly high skill level. This goal is HARD. Ipso facto, this might be the point at which many players simply stop playing.

Another problem is in the necessarily repetitive nature of this goal. To figure out that you have to adjust the skater a bit to the left of the car in order to hit the ramp properly when you release takes knowledge and experience. In other words, we're pretty much guaranteeing that the player must fail at least once to complete this goal. There is a thirty second build up before you can try the release again, so we're essentially putting a 30 second tedium penalty on a goal that requires trial-and-error style play to figure out.

Finally, we just didn't think through what would happen if you missed the ramp or hit the jump at an off angle. Or, heh, if you plowed into the back of the car, which doesn't magically disappear just because you've released your skitch. So you miss and you hit something, thud. You lose all your speed instantly and get the goal fail noise and graphics. What an awful feeling! There is such a thing as entertaining failure—we could have had a missed jump still launch you somewhere interesting, or at least give you a huge air that could be turned into a trick or combo. Maybe the player could have gotten a stat bonus for this or some other, secondary goals could be hooked into it. Or, hell, it might have been funny just to watch the player crash spectacularly. As it is, this is a hugely punitive system.

In the end, the experience of this goal to an uninitiated player went something like this:

Player mashes buttons to skip text

Wah!? What's going on? Why is this car in my way! I just hit the back of that car! Now what do I do?

*Retries goal from the menu if they're aware of the menu retry. If not, they have to wait for the goal timer to end (30 seconds) and skate awkwardly back to the goal pedestrian to restart the goal *

Skips text

Um, what? Am I supposed to do something with the car?

Retry. Reads text or notices the message about which button to press for skitch.

Huh, ok, so I guess I'm riding on the back of this car now. Wait, what!? I fell off! Oh man, I have to balance this meter? Jeez!

Retry

Ok, ok, I got it, I've got it…I, CRAP! I fell off again!

Retry

Ok, I think I've got the hang of this.

Player nears bridge

What the hell? Am I supposed to…?

Player doesn't read or understand text that pops up telling him to release the skitch and fails to do anything. Car turns, player is released and just runs into barricade with an unsatisfying thud. Goal fail noise and graphics play. Player is livid.

GAH! THIS IS SO RETARDED!!!!1!

Retry until the player figures out that they must release the button and steer to hit the ramp

Oh my God I did it I…WHAT?!?!?

Player is reduced to nonsensical angry jabbering as he finally hits the ramp and is launched to the left of the bridge and into the river, failing the goal

WHAT. DO. YOU. WANT. FROM. ME?!?!

Retry

So I have to hit it just right…if I could just move the guy to the left…oh, ok, I can adjust the guy on the back of the car.

Retry three more times

FINALLY. God, I'm glad that's over. I don't even want to play this game anymore.

Excruciating, no? This is not a verbatim test log—we weren't doing anything that sophisticated—but it is cribbed from my notes and observations. Sadly, these were mostly observations after the fact, watching friends, family, and students play the game after its release. The goal stayed in as-is. Go play it, see what you think. It's one of the biggest halt points in the game, one of the places that lots of people get stuck and stop playing entirely. Besides the game design issues, a simple usability test would have told us that at every step of this goal, we'd inadvertently created a confusing, muddled mess for players to try and make sense of. Unfortunately, Tony Hawk is not a puzzle game. This example illustrates the crucial difference and constant clash between challenge and obfuscation.

17.9 Challenge vs. Obfuscation

What is the challenge of your game? If you can't clearly answer this question, you may not be ready to have players test it yet. If all your playtesting and all your changes are exploratory, you can easily get caught in a loop, tentatively observing, tweaking, and re-testing to try and find something that works. I play a lot of games and get the sense that this was the unfortunately aimless process behind them. The designers would have needed another two years of putzing around to figure out exactly what they were trying to design. They would have gotten there eventually, I think, but constraints of time and money forced the design to be abandoned. Joe Ybarra, one of the founders of Electronic Arts, once told me that any kid out of college can design a good game. The difference, he said, is time. A seasoned game designer will do it quickly and decisively, with a clear vision of the experience they're intending to create and vigorous iteration to reach that goal. I'm not sure I'd go that far—there's a reason we know the names Sid Meier, Will Wright, and Shigeru Miyamoto—but the point is well taken. To overcome this hurdle, we need to come to terms with the fact that challenge, usability, and game design are inextricably linked.

In hindsight, it seems simple to delineate between actual challenge and usability problems that obscure the challenge. In practice, it takes judgment and experience to figure out whether a problem is part of the challenge presented by the game or if it is outside of it. Most designers I've worked with have an innate sense that allows them, when watching a playtest, to make the distinction between a player failing to complete a challenge and a player failing to understand a challenge. But most designers, and I'm including myself here, don't do enough thinking beforehand about what the challenges we want our players to experience and how exactly they're supposed to work. For example, when playing the jetpack goals in the game Pilotwings 64, finding rings can be difficult. It takes trial and error to find them. Having found them, it takes skillful execution to get a gold medal score. The finding is part of the challenge, however. There's a sort of scavenger hunt feel to it. If there were a large arrow pointing to each ring, an important part of the challenge would be gone. In *Tony Hawk's Underground*, we ended up putting in a large goal arrow to guide the player from one checkpoint to the next.

The line dividing these two approaches is not at all clear and comes down to a judgment call by the designer. The question is, what is the actual challenge? Is it finding the thing in the first place or skillful navigation to collect it quickly? *De gustibus non est disputandum* (there is no accounting for taste.) In the case of *Pilotwings* it's a bit of both. In the case of the racing goals in *Tony Hawk* (very similar setup), it's about skillful execution. The point here is that there's no right answer. The challenges you use and how you implement them are your palette for painting an experience. Might as well argue over which color's better, blue or red. So where does this leave us? Again, I think it all comes down to clarity. If you're clear beforehand about the types of challenge you're presenting you can be clear about what is outside of the scope of those challenges, what's interfering with the player's ability to engage.

With that distinction made, let's pull it all together into a detailed test plan for actual use.

> I don't think there's any "correct" take on what the different types of chal-
> lenges are and how they can be used. That's part of the art of game design.
> One of my favorites is Chris Crawford's breakdown of different types of chal-
> lenge by areas of the brain they utilize (Chapter 4 in "Chris Crawford on Game
> Design".) I also like Scott Kim's Venn diagram of the various types of puzzles
> and the rich fruit yielded by their interblending (slides online at http://www.
> scottkim.com/thinkinggames/GDC03/index.html.)
>
> Also, many games riff on different kinds of challenges as part of their design.
> Some games that do a great job of exposing the nature of challenge and com-
> bining different kinds of challenge (and which are awesome games) include:
>
> • Wario Ware
>
> • Arcadia (http://www.gamelab.com/game/arcadia)
>
> • Brain Age
>
> • ROM CHECK FAIL (http://farbs.org/games.html)

17.10 Detailed Planning

What follows is a sample of a detailed test plan. It can be used to simultaneously test usability and game design, and is intended to show the relationships between them. The emphasis is on recording specific player behaviors at specific moments in the game according to pre-created definitions of the desired experience.

Again, the three things we want to define and track are:

Usability: What are the got it/don't got it behaviors? In order to play the game properly, what must the player first understand? For example, to play Super Mario Brothers properly, the player must understand that the A button makes Mario jump, that holding down the button longer will cause him to jump higher, and that Mario can still be steered left and right while in the air.

Experience: Define the important moments in the game. What is the desired expe-rience at each moment? What should the player be feeling, thinking, and expe-riencing at each moment? What are the specific behaviors and actions that will tell us what they are experiencing at a given moment, and how close is that to what we want? For example, in the game flOw, the experience of being bitten by another creature should not be jarring, frustrating, or pull the player out of state. Their creature is sent down one layer, but can immediately resume calmly swimming around and eating other creatures. If the player verbalizes, jumps, or shows other signs of frustration, this indicates that the transition is too jarring.

The ideal experience is uninterrupted calmness and serenity with mild challenge to keep the engagement level high.

Challenge: What are the intended challenges of the game? What types of challenge is the game about? This will keep clear the distinction between usability issues and game design issues. Is the game about quickly and decisively taking very specific tactical actions, like Bungie's Myth, or is about managing your own attention—figuring out what's important amidst a roiling sea of ever-changing unit movement and building upgrading as in Rise of Nations? Or maybe there should be no time pressure at all, as in Civilization 4, and each tiny decision should be deliberate and intended to further a greater over-arching strategic goal. Whatever the real challenge is, try to make sure it's clarified such that there is no ambiguity between usability and game design issues.

17.11 The Tetris Test

For the sake of brevity, I'm going to fill this out using Tetris, a simple game that most people have played at least once. See the end of the chapter for a blank version of this prep sheet or go to www.steveswink.com/usability/ for downloadable versions.

Usability

List the got it/don't got it behaviors. In order to experience the game properly, the player must understand:

1. Filling a line horizontally will clear it

2. If the blocks pile up to the ceiling the game ends

3. Blocks can be rotated (and actively rotating them to fit better is a key skill)

4. Blocks can be moved left and right (and actively moving them to fit better is a key skill)

5. The game speeds up as the player clears levels

6. A "Tetris" occurs when four lines are cleared at once

7. A Tetris can only be achieved with the long, thin block

Experience

What are the important moments in the game? For each, describe the "ideal" experience for the player.

1. Start game
 The empty playfield is blank and clean. This should provide a nice counterpoint to later in the game when the playfield becomes unordered and chaotic.

The player will want to keep things ordered. This is probably the only time in the game when everything will be perfectly ordered. No real behavior to track here, other than the player seeing the empty screen. The first block to drop down immediately draws attention; it is the only thing that moves.

2. Move and rotating the block left and right
 At first, moving the blocks left and right and rotating them has little effect. The player should feel a compulsion to keep the playfield aesthetically pleasing, though. A single block in the center of the screen is ugly. By about the fourth block, most players should have engaged with the core challenge of the game is to take these randomly generated shapes and quickly assemble them into perfectly interlocking solid forms, filling in the entire playfield. At first, the player might feel as though there's never enough time to choose exactly where they want the block to go, and that the game is very oppressive. Quickly, they become adept at putting the block just where they want. The player will probably cry foul if they continuously misplace blocks, such as "hey! That's not what I wanted you stupid game!" As long as they feel compelled to keep sorting the blocks, this is desirable.

3. Clear a line
 Clearing a line relieves the pressure slightly and provides the player a clear way to reverse the tide of ever-falling blocks. The player understands that their compulsion to sort and order is being rewarded in the form of cleared lines, which give them more space to maneuver and add to their score. This should feel good and is the primary reward that the player seeks in the game.

4. Complete a level
 After a few lines have been cleared, the player will graduate to the next level, at which point the game speeds up. This speed increase should return the player to a state of deep concentration as they have to now adjust the speed of their sorting to match. They may again start misplacing blocks. Every time the player clears a certain number of lines, the speed ratchets up. When the level changes, the music and color of the background also change, making each level feel different and making the transition distinct to the player. Eventually, a threshold will be hit where they simply cannot adjust their sorting to the speed of the game. Before then, though, it should feel like a gradual increase to which they are able to consistently adapt. It's sort of a frog in the frying pan scenario.

5. Complete a game (lose)
 Eventually, the player cannot sort quickly enough, the screen fills up, and the game ends. Depending on what level was reached, different reward events happen, in the form of rockets and fireworks. The larger the score, the bigger the rocket. It might take the player two games to realize this, but they should be champing at the bit to play again at this point.

6. High score

 The player should regard the score as a benchmark for their performance, and be interested in seeing how each game they play stacks up against all previous games. They want to see that they're improving, and quickly. Each time they beat their previous high score, they should feel a sense of triumph, and will probably yell and raise their hand in the air.

7. Score a Tetris

 After one or two games, players should quickly figure out that the best way to score a large amount of points is to go for a Tetris, clearing four lines at once. The player should also realize fairly quickly that this is a somewhat risky strategy—it relies on keeping one thin line of blocks open as you build, and it relies on getting lucky drop in the form of a long, thin block. The player should understand that this is a high risk, high reward strategy. If it causes them to lose, they should only blame themselves. This might be manifest by them saying "I got greedy there—damn!" or similar.

Challenge

What are the intended challenges of the game? What type of challenge is the game about?

The primary challenge is sorting irregular shapes into ordered patterns (horizontal lines) under ever-increasing time pressure. The skill is in quickly evaluating the play field relative to the currently falling piece and placing that piece such that it creates as few inaccessible holes as possible. Advanced players will plan ahead, constructing the playfield so later pieces may be fit more easily, especially long line pieces (clearing four lines simultaneously to create a Tetris.) Anything that interferes with the player being able to engage with this core challenge should be treated as a usability issue.

Assembling this into a shorthand Excel spreadsheet, I end up with this in next page top.

There are a few things going on here. First, you'll notice that I'm conflating usability concerns with intended experience. This is because there is a direct relationship between the two most of the time. By my earlier definition, a usability concern is something that interferes with a game design concern, preventing the player from properly engaging with it. So all I've done here is correlate desired experience with the usability concern that "unlocks" it. If the player doesn't understand that they can rotate the blocks left and right, they won't be able to order and sort them. Second, I've put in a numeric ranking 1-5 for each experience. This is to get a general sense of how close we're getting on this particular part of the experience. Again, this might be on a scale from total apathy to raucous laughter. What you're measuring is determined by the experience in the box above. If the player is supposed to feel overwhelmed, but the game ends abruptly and they're confused as to why, this might be a 1 or 2. We need to adjust the increment at which the speed builds up each level, perhaps, or further emphasize that when the playfield

is full the game is over. The idea is pinpoint the areas that need the most attention. Finally, I've left large blanks for note taking. This is the meat of any test, obviously. You're clear about what experiences you're going for and what it is required that the player get in order to engage with those experiences, but it's specific things that the player does and says that will really tell you how to proceed. I recommend the following note-taking format:

USE CAPITALS FOR OBSERVATIONAL NOTES
Use lowercase for quotes and comments from the participant
Keep notes short
Record bugs in bold

Actual notes would look something like this:

PLAYER DOESN'T REALIZE THEY CAN ROTATE RIGHT
I can't get this block how I want it!
USER PRESSING CORRECT BUTTON
Pressing button doesn't rotate to the right

This is what the sheet looks like when filled out with notes:

Test Plan - Tetris

Date & Build #: 4/19/2008 - Build 123
Tester(s): Johnny McTest (age 20)
Observer: Swink

Moment	"Got it" behavior	Notes	Experience	Notes
Start game	Press the correct button from the menu to start the game / Got it · Don't Got it	SLIGHT HESITATION ON MENU - MAKE START BUTTON GLOW	- Responds to visual appeal of gridfeel, colorful playfield - Responds to music, engagement heightened - Sees empty playfield then snaps focus on moving block / 1 2 3 4 **5**	SEEMS ENGAGED FROM THE START HUMS THEME MUSIC hmmm, blocks
Move the block left and right	Player understands that blocks should be moved into position using the directional pad / Got it · Don't Got it		- Tries to assemble random shapes into ordered, solid pattern - Upset if block is misplaced, calm and methodical otherwise - Feels compelled to keep sorting blocks / 1 2 3 **4** 5	IS SORTING BLOCKS Dammit, I keep messing up! ONLY A FEW BLOCKS MISPLACED LEARNING CURVE LOOKS GOOD FOR THIS USER
Rotate the block	Player understands that blocks can be rotated using the B button / Got it · **Don't Got it**		- Use rotation to adjust shapes' placement - Upset if block is rotated incorrectly, calm and methodical otherwise / 1 2 3 4 5	PLAYER DOESN'T REALIZE THEY CAN ROTATE RIGHT I can't get the how I want it USER PRESSING CORRECT BUTTON Bug: Pressing right doesn't trigger rotate
Clear a line	Player actively seeks to complete lines by filling them in with blocks / Got it · Don't Got it		Satisfied by the reward of clearing lines - Actively clears lines, shows relief when lines cleared - Relishes the after a few lines have been cleared - If lines are regularly cleared, player is in a relaxed state / 1 2 3 4 **5**	ZONED OUT - LOOKS GOOD
Complete a level	Player realizes level has changed / Got it · Don't Got it	Oooh, level up!	- Snaps back to renewed concentration because of the increased speed and difficulty - Rising interest of potential triumph and frustration close to the point of overwhelm / 1 2 3 **4** 5	Oh nice, this is fast! PLAYER STILL DEALING WITH BLOCKS EFFECTIVELY INCREASES FOCUS
Complete a game	If the blocks pile up to the ceiling, the game ends / Got it · **Don't Got it**	What the hell? Why did I lose?	- Overwhelm point reached, frustration occurs - Gradual tip-over into overwhelm should create a desire to play again - Rocket reward should mitigate frustration / 1 2 3 4 5	PLAYER HAD ONE TALL STACK OF BRICKS AND ACCIDENTALLY CAUGHT A FALLING BRICK ON IT, THE REST OF THE PLAYFIELD WAS VERY LOW
	Got it · Don't Got it		1 2 3 4 5	

Cool! What I've ended up with here is a couple clear places to focus my efforts. The problem with counter-clockwise rotation is a bug that will get fixed. We'll need to run another test to see if the player can figure it out once that's fixed. The other problem was with the challenge ramping up. The player died suddenly and didn't realize why. This is something of a usability issue in that the player misunderstood what was going on and it prevented him from getting the desired experience. The solution may be to add some kind of warning when blocks are getting close to the top, or may be a simple fluke that we can live with. Additional tests will be instructive here.

This is essentially represents what I would be otherwise tracking in my head were I taking the traditional Wild West approach to game testing. It may feel a little like homework, but codifying things this way has a few great benefits, among which are clarity, scope, and transparency. For me, clarity is the big one. I'm no Reiner Knizia, and I realize this. I can't create and playtest an entire game in my head in perfect detail. Writing this stuff down and thinking it through provides a clarity about what exactly is being built that seems refreshingly thorough compared to simply keeping it in one's head. These details may change as the game evolves and we discover that it appeals in different ways. But since our focus here was on

defining the experience—the actual output of the game in terms of the player and how they behave and how they feel about the game—what we have is more heading than task list. We can be flexible. Maybe when we watch a playtest of Tetris, the player doesn't feel compelled to sort the blocks and keep them as ordered as possible. That's a generalized, high-level problem to which there could be hundreds of different solutions. We could give a visual and aural reward when blocks are linked together, or punish the player by making holes in their structures glow in red. The point is, if we're clear about the *outcome*, we can keep trying things until something works. If we design only one possible solution to this problem and don't address the fact that the eventual output of the system is a particular experience, we're locking ourselves into an implementation that might not work. This is bad; it drastically reduces the possibility of success by treating the design as a "right answer" problem. In other words, you're looking for the one right answer to the problem instead of really exploring the potential design space. If instead you're clear on what the eventual outcome should be, and frame it as a high level experiential goal, you can brainstorm 20 different implementations. I guarantee that if you think of twenty different approaches to a well framed design problem, you'll find answers that are surprising and surprisingly good.

This clarity also allows me to address scope from an early point in development, which has ramifications for artists, designers, and programmers. Say the goal is to create a particular emotional connection between the player and a character in the game, something a lot of designers seem to be attempting just now. If we're clear on that point, we can be flexible about implementation. There are as many different approaches to this problem as there are games that try to do it. One solution is to try to make photorealistic characters with thousands of animations and to try to win the player over that way. Another approach is through a long, detailed story that brings out the character through narrative. But maybe we don't have the budget, time, or personnel to attempt these things. The strongest emotional connection I've seen between players and characters in a game exist in two games: The Sims and *X-Com: UFO Defense*. These games used clever systems design to give the characters meaning to the player, and featured characters with cartooned and generic faces. Well, herm, maybe this is the route we should go? It'll probably cost less. Again, if we're clear on our eventual output—that the player care deeply about particular characters—we can try anything to get there.

Defining by experience also has another great ancillary benefit: transparency. One of the most frustrating things for an artist or a programmer is to have to redo work when a designer decides that a particular system is simply not working or needs to be modified to change the player's experience. Luckily, this problem is easily solved. If you have a clear vision for what the experience of the game is intended to be and share it with the team up front, the changes will make sense. Be forthcoming. Say "look, this is what we're trying to do. I'm going to have you build this thing to test it out, but if doesn't work, we may have to try something else." And now we're finally back to the original topic I was intending to write about, usability and game feel.

(Editors' note: see previous chapter—17A)

CHAPTER EIGHTEEN

Interview about Prototyping and Usability with Jenova Chen

Jenova Chen is one of the first-generation video game design graduates from USC School of Cinematic Arts, creator behind the multi-award-winning student game *Cloud and flOw,* and co-founder of thatgamecompany, *(flOw PS3 & Flower)* Jenova Chen is dedicated to expanding the emotional spectrum of videogames and making them available for a much wider audience.

Have you utilized user testing and feedback in the design of your own projects?
FlOw was created as a master of fine arts thesis at the University of Southern California. Its user testing and feedback process was a little bit different from traditional game development.

flOw's user feedback collection process can be divided into three different phases:

1. Mentor and peer review

2. Friends and family testing

3. Beta testing

At the beginning of the project, while I was still consolidating thoughts and ideas for the design of the game, I shared my designs with my mentors and classmates who have a lot game design experience. Even though there was no game playable

yet, the bouncing of ideas between experienced designers was a great way to prevent potential flaws in the game. This kind of review allows you to test out the high levels of game design. And it continues through the entire project.

Once there were gameplay prototypes available, I had friends, classmates, and family members test them out. During this phase, because the prototypes are in a rather rough stage, certain guidance and help is needed to carry players through the game. And the testing is more focused on the core mechanics, whether the core gameplay mechanics work for the players or not.

Beta testing happened when the game was almost done, soon before release. I hosted the beta test for *flOw* on the Internet three weeks before the deadline. Having a large number of people playing the game will quickly provide you feedback. This feedback will help you further polish the game.

What have you learned from this kind of testing?
In fact, *flOw* is not the first thing I made for my dynamic difficulty adjustment thesis. Before *flOw* there was a quick prototype I made called *Traffic Light*. It used the same dynamic difficulty adjustment principle but implemented in a much rougher form. Players could control the difficulty of the game through a scroll bar on the side of the screen during play.

What I learned from playtesting *Traffic Light* is that having a difficulty control that is not part of the game will distract the player from engaging in the core gameplay. Therefore, as I moved on to the design of *flOw*, I tried to hide the control within the core gameplay. This embedded control is the key reason why *flOw* worked and *Traffic Light* didn't.

During the beta test of *flOw*, I discovered a lot of usability issues. By fixing these problems, the game became more accessible to the players. For example, players felt very frustrated when they couldn't find the red food to progress to the next level. I added a small ping signal at the border of the screen to indicate the general direction of the red food, to ease frustration.

What role do prototypes and prototype iteration play in getting feedback from players as you work?
The way we perfect a video game experience is very simple and similar to how we design many other human experiences.

Iteration is the core of refining an experience
Design -> Implementation -> User Testing - > ... Changes to the design based on user feedback. Then repeat the whole process beginning again with design.

However, implementing a feature usually takes a long time during video game production. If the designer can't iterate the design until weeks and months later, that particular feature's quality will suffer. A prototype is a quick alternative, so the designer can iterate the design without waiting for the real feature to be implemented. And that is why prototyping is especially useful during the early stage of game development.

How do you approach prototyping in general? Are there shifts in how this works when you investigate dynamic system adaptation as you did in flow?

Interestingly, the dynamic system I used to control the difficulty itself was a big unknown when I started the project. Therefore, I approached the game with multiple prototypes.

- **Visual prototype,** to test out the system limitations of how complicated the *flOw* creature could look, and how it moved. I realized that Flash 8 doesn't support transparent objects and solid objects very well. It informed us and influenced the line art look of the final game.

- **Control prototype,** to explore the potential ways players to control the *flOw* creature. I realized it was quite stressful to ask the player to constantly hold down the mouse button to move. Eventually, we let the creature be able to move even when player was not holding the mouse button.

- **Gameplay prototype,** a sandbox with creatures and food where I could mess around with different rules and mechanics. Unlike the scroll bar in the *Traffic Light* prototype, I ended up deciding to use a special food creature which is part of the gameplay to allow the player to switch levels and further change the game difficulty experience.

- **Sound prototype,** *flOw's* mesmerizing experience relied on a non-conventional sound and music interaction. However, I am not a musician, so prototypes for sound and music were made and sent to a real composer for feedback.

What recommendations do you have for developers who would like to use prototypes to get user feedback?

For Prototypes

You need to know when you should make a prototype. It is a good idea only when the feature you want to prototype is somewhat risky. Either you are not sure of a certain design and you really want to test it out, or you feel the implementation of a feature takes too long, and there are other design questions depending on the feature to answer.

When you make a prototype, make sure everybody on the team is aware of it. After all, the value of a prototype is to convince others whether certain design works. And make sure the way you make your prototype is quick and dirty. If you spend too much time perfecting a prototype on the bits and pieces, your goal fails. You want to test out an idea with the least amount of resource on it.

For Feedback

If you test your prototypes on your team members, make sure you communicate enough information to them before they start. They need to know things like why

you made the prototype and how you're going to use it. You need to guide them through the glitches and flaws in your prototype and help them to focus on the real issues your prototype is made to test.

If you are testing your prototype on real players, you need to pay extra attention to their reactions. Outside players are generally shy, and they don't react the same way under observation as they would at home. To get the best play test result, you should keep yourself away from the player's awareness. There are many ways you can do this. You can use a camera. You can hire or pretend to be an outsider rather than the maker of the game.

NINETEEN

Social Psychology and User Research

Katherine Isbister, prior to joining the IT University of Copenhagen Center for Computer Games faculty as an associate professor in 2008, was an associate professor at Rensselaer Polytechnic Institute in New York, where she was founder and director of the Games Research Laboratory. Dr. Isbister's current primary research interests include emotion and gesture in games, supple interactions, design of game characters, and games usability. Isbister's book—*Better Game Characters by Design: A Psychological Approach*—was nominated for a *Game Developer Magazine* Frontline Award in 2006. Isbister serves on the advisory board of the International Game Developers Association Games Education Special Interest Group, and is the vice chair of the Game Studies Special Interest Group of the International Communication Association.

19.1 Why Social Psychology?

Good game design involves not just understanding the limits of the technology from which games emerge, but also, a deep understanding of how players react given a particular set of design choices. Social psychology offers game developers a very useful framework for understanding (and discussing) the effects that game design choices can have on players. The language of social psychology helps to put words upon effects that great designers are able to achieve, and thus helps those new to the field learn about and make good choices about what to do.

The focus of social psychologists is in understanding how individuals react and interact in social situations, with an emphasis on finding general patterns that hold true across groups of people. And where such generalization is not possible, understanding how people differ along well-defined lines of difference, such as age or

gender or nationality. Understanding how players will react in social situations is helpful in two broad categories of design thinking for games—crafting interactions with characters, and designing to support interaction between multiple players. I'll touch on both of these larger areas in this chapter.

The work practice of social psychologists is to come up with hypotheses about how people work, and then to test and confirm their hypotheses with rigorous studies. So a game designer who makes use of relatively well-established theories and results in social psychology can benefit from the fact that these principles have been tested out and validated.

Of course, the field of social psychology is huge, and can't be thoroughly explored in one chapter. I'll focus on introducing some of the effects that I'm familiar with and have found most useful to game developers, with recommendations for how to fold these into your user research and play testing.

19.2 Some Helpful Social Psychological Findings

19.2.1 First Impressions

Social psychologists have conducted a great deal of research on what happens in the first few moments that two people meet. It turns out that human beings form quick, and surprisingly enduring, assessments of others within just a minute or two. Interestingly these impressions can be surprisingly accurate when compared to impressions formed from a longer amount of time with someone. For example, one study examined impressions of teachers' skills, and found that people who saw only a 30-second video of a teacher *without sound* made ratings of that teacher's skill that had a .76 correlation with their end of semester rankings from students (Ambady and Rosenthal, 1993). However, first impressions can also have the unfortunate effect of distorting ongoing interactions. If a first encounter with someone was especially negative, then our impression of that person may continue to be negative, despite several positive interactions afterward.

This recognized bias toward forming quick and enduring impressions of other people has led to a whole self-presentation industry. Specialists coach businessmen and women, and even defendants in trials, in how to dress and behave in order to create positive first impressions.

All this is very relevant to game design and usability, in terms of the thoughtful crafting of game characters—both player characters and non-player characters (NPCs). Players will be using the same strategies for making judgments about game characters that they use in making judgments about other people. This might sound hard to believe, but it has been demonstrated in a series of studies by Stanford researchers, which substitute a computer for a person in classic social psychological studies (see Reeves and Nass, 1996). These studies have consistently found that people unconsciously use social rules and processes such as politeness, flattery, and judgments based on body language and the like, in their interactions with computers.

Therefore, game developers can make conscious choices about what qualities they would like to come across in a player's first impression of his/her avatar, and of NPCs in the game, and then can use psychological findings to help guide the design choices that are made. User research can confirm whether or not the avatar or NPC is "reading" as it should for players. Researchers can even find and use the same measures that are used in social psychological studies to figure out whether the game characters are hitting the mark.

There are many facets to first impressions; what follows here is a targeted subset that may be especially useful in game character design.

Attractiveness

There is a reason that the cosmetics and beauty industry is so large. Social psychological research has demonstrated that people who are thought to be attractive are perceived to have other positive qualities that do not rationally follow—what is termed a "halo effect." For example, they are also perceived to be more intelligent and capable, may be given preferential treatment in work situations, and are awarded bigger settlements in experiments that simulate jury trials. Making a character attractive (by the standards of your game's target audience, that is) can create powerful positive attributions from players right from the start.

Maturity (the "babyface" effect)

The shape and features of a person's face can have a powerful impact on first impressions, due to a phenomenon psychologists call the "babyface" effect. Babies have round faces, small brows, chins, and noses, and large eyes. When an adult has these features, people tend to react to that person as they would to a child—they see that person as more warm and trustworthy, but perhaps also less reliable and independent. A person with more mature features (longer face, large nose, prominent brow, strong chin, smaller eyes) will be seen as more independent and not in need of nurturing. There are many game characters that make use of babyface features. While it was once true, when pixel count was limited, that this was the only way to make a character's features legible, it's no longer true. This author believes one reason for the babyfaces lingering is that players find these characters trustworthy and likeable, due to the babyface effect. However, a designer wanting to create a strong, mature impression of a character probably does not want to use this feature set.

Dominance and friendliness

Practically speaking, human beings are trying to glean useful information for the future when forming first impressions. Two of the most important questions each seeks to answer about the other are:

- Is this person friendly toward me?
- How powerful is this person?

The answers to these two questions shape the strategies a person will take in inter-acting with the other. Will this person become an ally? Is the person a potential threat? Where do they fit in the social hierarchy in relation to me? What sorts of relationships are possible and desirable between us? Because social encounters unfold so quickly, people are very adept at reading cues of friendliness and power in others in just a few moments. As a game designer, you can make strategic use of these cues to telegraph to the player what a character's social position and relationship to the player's charac-ter are. Social psychologists have made in-depth studies of the various cues of domi-nance and friendliness, and these can be used as guidelines for developing character appearance and behavior (for a detailed taxonomy of these cues, see Isbister, 2006).

Power of the situation

One thing that has complicated the rigorous study of forming first impressions is how powerful the situation and surrounding circumstances are, in shaping how one person perceives another. The same behavior from someone that is encountered in one setting, may have a very different meaning to it when seen in a different setting. For example, acting very outgoing and exuberant comes across very differ-ently at a New Year's Eve party versus at a funeral. This is because human beings intuitively grasp how powerfully circumstance shapes everyone's behavior, and we modulate our impressions of one another to take situation into account. However, we are also to some degree insensitive to this difference. That is to say, if a person meets another in a very happy context, where that person is happy because of the situation at hand, there will still be a tendency to attribute greater general happiness to that person, as a result of forming a first impression of them in a happy circum-stance. It's another sort of halo effect.

Game designers can take advantage of the power of situation, because game designers are able to control both the character and the situation. A designer can heighten the first impression of a character's qualities, either by contrasting them with the situation at hand, or by using the situation to emphasize and add to the impression s/he wants to make of a character.

Marks of belonging

Another very practical set of judgments that people are making when forging a first impression, are ideas about what sorts of group memberships a person has—what cultural and subcultural groups does this new person belong to? This includes social class, political stance, and many other factors. Getting a read of group memberships helps establish potential common ground, or potentially troublesome conflicts.

People literally "wear" these cultural and subcultural memberships, encoded in the choices they've made about how they dress, how they move, their style of speak-ing and the language they use. Game designers can use these group memberships to develop a plan not just for how a character will dress, but also, for how the character will move and speak, and how s/he will behave toward others depending upon their

own group markers. Showing these nuanced reactions among characters is a very powerful way to create heightened believability and engagement for players.

Mood management

Another very helpful category of social psychological findings for game designers is results concerning the mechanics of emotions. There are two specific results that I've found to be very useful in understanding why certain design choices work well to create player emotions:

Emotional contagion

This result was initially put forward by social psychologists, and since then, neuropsychologists have found complementary information that backs up what was observed in the laboratory. Essentially, it is the case that human beings are highly susceptible to feeling the feelings of others. When a person talks with another person who expresses a feeling, s/he subconsciously and subtly mimics the expression of those feelings, and also internally begins to feel those feelings as well. Evolutionary biologists have suggested that this is part of how the powerful social bonds among people (and other primates) are formed. Neuropsychologists have found that there is physiological support for these observations—they've found what have been termed "mirror neurons," which fire in the brains of primates when they observe others taking an action such as expressing an emotion. These neurons fire as if the primate itself were taking this same action.

What all this means for game designers, is that you have a very powerful psychological mechanism at your disposal. In particular, designers can use the expression of emotions in both the player character and in NPCs in a game to powerfully influence the feelings of the player him/herself. For example, if the player sees his/her avatar gleefully celebrating a victory, this can heighten his/her own feelings about that victory. Conversely, if the player sees his/her avatar calmly navigating obstacles despite the player's own nervousness, it can help to steady that player's nerves. Emotional contagion is also a very useful principle to consider in the design of social games. If the designer wants to evoke a certain mood in the group of players, s/he can use the actions and reactions of their on-screen avatars to encourage and exaggerate to move people toward this mood state.

Physical feedback loop

This result is complementary to the emotional contagion research, and may be a part of how that effect occurs. Basically, the idea is that a person gets part of his/her information about how s/he is feeling, by noticing what his/her body is signaling. In other words, if I notice that I'm acting as if I'm happy in how I move or with a smile on my face, I may decide that I'm happy. Social psychologists have isolated this effect with some clever experiments to rule out actual happiness or sadness. For example, Strack, Martin and Stepper (1988) had people try out an interface that

they had to use by holding a penlike device in their mouth. Half of the participants were told they should purse their lips around the device as they used it, which happened to activate their frown muscles. The other half were told they should clench their teeth with lips parted, which happened to activate their smile muscles. The latter group reported a more positive impression of the device!

Game designers can use this physical feedback loop particularly in the case of input devices that allow for physical movement, such as the Sony EyeToy or the Nintendo Wiimote. Getting players to move as if they feel certain ways can then lead them to attribute these feelings to themselves as they play—for example, I'm smiling and gesturing as if I'm happy so I must be happy.

19.2.2 *How to Use these Findings in Design and Evaluation*

Now that you have a few of these patterns in mind, how can you use them to improve the player experience of your game? Here are three suggestions that can go a long way:

1. Use these principles to make explicit design choices that you can test against. Where possible, include established social psychological metrics that you can use to confirm whether you've achieved what you hoped.

 For example, when you sketch out concepts for your main characters, discuss how they relate to the player in terms of dominance and friendliness, and what cues you'll use to convey this. When crafting the player character visuals, consider whether you'll use the baby face effect, and if so, make note of the classic features that evoke this effect. If you want a player to feel specific emotions at certain moments in gameplay, consider using characters to generate this emotion through emotional contagion.

2. Provide design specifications to all who work on game development, as well as those who will conduct any usability and play tests.

 Social and emotional impressions come from a wide range of very subtle cues, which unfold moment-to-moment. It's essential that everyone who will shape the player's experience of your game understands the effects you are aiming for, otherwise you may end up sending mixed signals to the player. For example, inconsistent emotional signals from a person's face, body, and tone of voice can be interpreted by an observer to mean that the person is lying. So both animators and voice actors need to have a strong vision for the emotional signals you want a character to send. And programmers who will handle the feel of a player-character need to know target emotional effects in players so that they can contribute to this through responsiveness of that character. If all team members understand that you value certain social and emotional impressions, they will find ways to achieve these effects through subtle, in-the-moment development decisions that may never have occurred to your design team in pre-production.

 Testers will likely have a full sheet of issues and target effects they are looking at, and may not notice issues with the social and emotional impressions your game is making unless they know to look for them. Passing along and explicitly

valuing these qualities in your testing results will help ensure that they catch any problems as they emerge.

3. Make decisions and tradeoffs throughout production based upon these criteria.

 Inevitably in the course of production, many features of a game end up cut due to time and budget limitations. If your team has decided it values certain social and emotional impressions on players, then it's important to weigh these in decisions that get made about cuts. There may be ways to preserve these impressions with creative reworkings of key moments or qualities in the game, but this will only happen if the team is keeping an eye on these effects and making sure they are preserved when things get scaled down.

19.3 How to Find More Useful Patterns?

Perhaps you would like to learn more about social psychological research findings, to see if there are more results that are of practical value for you in your particular design challenges. There are a few tactics I would recommend:

- *Have someone on your team read a couple basic textbooks, or attend an introductory course.* I've included some textbooks in the resources section of this chapter, which highlight certain areas. You can also find a list of introductory social psychology textbooks here: http://www.socialpsychology.org/texts.htm#intro. Many community colleges have courses, and there are online distance courses available as well.

- *Hire someone on your team who has a background in social psychology.* Many people in the usability field have psychology training—you might find that your user testing lead can also help the design team to come up with some valuable design principles based on sound research about human social and emotional tendencies.

- *Work with an outside expert.* It might be worthwhile to bring in someone with a strong background in social psychology and an interest in applying this knowledge to design challenges, to consult directly with your team. For example, if you are venturing into new genre or input device territory, and can't rely on prior successes or design intuition to keep you on the right path. You can find such experts by looking for people with research training and credentials who also write and speak in the game design community. Such individuals will be more likely to be able to quickly translate results into practical and actionable guidelines for your group.

19.4 References

Ambady, N., & Rosenthal, R. (1993). Half a minute: Predicting teacher evaluations from thin slices of nonverbal behavior and physical attractiveness. *Journal of Personality and Social Psychology, 64*(3), 431–441.

Isbister, K. (2006). *Better game characters by design: A psychological approach.* San Francisco, CA: Morgan Kaufmann.

Reeves, B., & Nass, C. (1996). *The media equation: How people treat computers, television, and new media like real people and places*. Cambridge: Cambridge University Press.

Strack, F.L., Martin, L., & Stepper, S. (1988). Inhibiting and facilitating conditions of the human smile: A nonobtrusive test of the facial feedback hypothesis. *Journal of Personality and Social Psychology, 54*, 768–777.

19.5 Resources

Fiske, S.T., & Taylor, S.E. (1991). *Social Cognition*. New York: McGraw-Hill, Inc.

A thorough overview of cognitive approaches to understanding social behavior—topics like the use of social categories and schemas, how we form impressions and inferences about one another and what attracts our attention, how we form attitudes about thing and each other, and much more. Great material for building interesting in-depth characters that feel realistic to players in terms of their assumptions and problem-solving strategies in interaction. Also great for understanding how to set up multi-player dynamics and situations, and casts of playable avatars.

Goffman, E. (1967). *Interaction ritual: Essays on face-to-face behavior*. New York: Pantheon Books.

A classic text that analyzes interpersonal interaction in unexpected and very useful ways for design thinking. Goffman introduces notions of what drives the dynamics of interaction such as the idea of "saving face."

Gudykunst, B., & Mody, B. (2002). *Handbook of international and intercultural communication*., 2nd ed.Thousand Oaks, CA: Sage Publications.

Includes valuable research findings on emotion and culture, and other topics that become very relevant when designing games that appeal across cultures.

Knapp, M.L., & Hall, J.A. (2002). *Nonverbal communication in human interaction*. Australia: Wadsworth Thomson Learning.

Another excellent overview textbook that covers all the fundamental research in how nonverbal communication works. Very helpful for designing characters that have realistic and engaging nonverbal behaviors.

Oatley, K., Keltner, D., & Jenkins, J.M. (2006). *Understanding emotions*. Madden, MA: Blackwell Publishing.

A recent and comprehensive introductory text that covers the basics about emotion—from cues that you can see in people's bodies, to the physiology of emotion, to cultural and social factors. A great place to begin if you are looking for more information about how emotion works and how to use it in your designs.

Zebrowitz, L.A. (1997). *Reading faces: Window to the soul?* Boulder, CO: Westview Press.

A great overview of some of the main psychological effects associated with faces, including attractiveness and babyface findings.

TWENTY

The Four Fun Keys

Nicole Lazzaro, founder and president of XEODesign, Inc., is an award-winning designer and an expert on emotion and games. Clients include Sony, EA, Ubisoft, Sega, PlayFirst, The Cartoon Network, LeapFrog, Mattel, Monolith, Xfire, D.I.C.E, The Learning Company, Broderbund, Roxio, and Maxis. She has a degree in psychology from Stanford University where she also studied filmmaking and computer programming. A frequent speaker at industry events, she consults extensively on games and why people play them.

20.1 Forget Usability! What Makes Games Fun?

Why do we play games? Play experiences are not work experiences. Games are not used to achieve particular tasks; they are played for pure fun. What players like about games and what makes computer games so engaging falls outside traditional usability goals of increasing efficiency and effectiveness and of providing the satisfaction of a job well-done. Now of course some aspects of games must be usable, but usability is not the only way to improve the quality of a game.

Games are self-motivating activities and, as such, inspire a dedication to learning new features that productivity application designers can only dream about. Indeed, aspects of game design can even make business software more self-motivating.

Games entertain by daring the user to change the course of events. Gamers do pursue goals, but what they value most is the experience that the game creates. Instead of task completion, time-on-task, and error prevention the true measure of a player's experience is how much the game affects his or her internal sensations, thoughts, and feelings.

People play games not for the graphics, the license to kill, or even the genre. Rather, we play games for the chance to compete, to explore a new experience, to feel specific emotions, and to spend time with friends. These, then, are XEODesign's

four keys to unlocking emotions in games:

1. Hard Fun: challenge and mastery

2. Easy Fun: inspiring imagination, exploration, and role play

3. Serious Fun: changing a player's internal state or doing real work

4. People Fun: social interaction

FIGURE
20.1

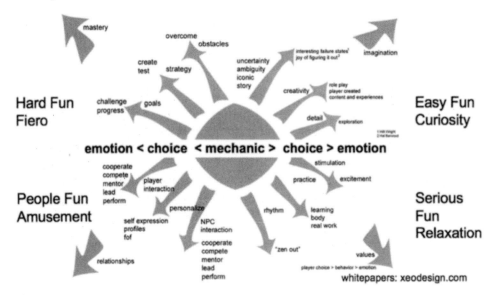

The Four Fun Keys.

To create a model of how games create emotion XEODesign conducted independent research of players playing best-selling games. By watching the emotions in player's faces we identified four different types of fun each with its own set of mechanics and emotions. For each mechanic the game offers the player choices and feedback that creates different emotions in the player. The relationship between the mechanics and emotions of a game give it its unique player experience profile (PX Profile). The playstyles most enjoyed by players offer different PX Profiles. What we found is that players preferred three out of four different types of fun and that best selling games offered three out of the four. Players likewise would rotate between different types of fun during play.

There are over thirty emotions that come from gameplay. Game designers design the mechanics that create the emotions in players. Games that offer choices in these four quadrants provide more emotions and increase the enjoyment of the game for more people.

Different emotions come from the mechanics of different playstyles. By presenting a goal and breaking it into small achievable steps, games create emotions from Hard Fun, where the frustration of the attempt is compensated by the feelings of accomplishment

and mastery from overcoming obstacles. Outside of goals, games provide novel opportunities for interaction, exploration, and imagination, which create Easy Fun. Games that use emotions in play to motivate real-world benefits to help players change how they think, feel, and behave or to accomplish real work create Serious Fun. Finally, games that invite friends along get an interpersonal emotional boost from People Fun (Lazzaro, 2004b). The Four Fun Keys are a collection of related game interactions (game mechanics) that deliver what players like most about games. Each offers a key to "unlock" unique emotions such as frustration, curiosity, relaxation, excitement, and amusement. Best-selling games provide features that support at least three of these Four Fun Keys to create a wider emotional response in the player. To keep things fresh during a single-play session, gamers move between the four different play styles (Lazzaro, 2004b). Developing each key focuses and rewards the player with emotion from a self-motivating experience that deepens the game's player-experience profile. Designers of products and productivity software can also use these Four Fun Keys to increase emotional engagement for applications outside of games.

Only some of the emotions from playing basketball in the real world come from the Hard Fun of making baskets. Close examination reveals that all Four Fun Keys are part of this popular sport. Dribbling the ball or doing tricks like a Harlem Globetrotter offers Easy Fun from novelty and role-play. Intentionally blowing away frustration and getting a workout creates Serious Fun. Competition and teamwork make the game even more emotional from People Fun. All four types of fun make basketball's player experience more enjoyable. None of these require story or character. Through examination of how each type of fun creates emotions, designers and researchers can create better and more emotional player experiences.

20.2 Emotion and Engagement in Player Experiences

The goal of testing is to improve quality. However, there is more to software quality than ease of use. There is a lot more going on for games. Without usability no one can play a game, make it too usable and it's no fun. That's the difference between user experience design (UX) and player experience design (PX). Games create emotions from experiences that usability and traditional market research cannot measure. Other methods can and designers who can assess a player's emotional responses early in the development cycle can innovate with much less risk. Over the years of testing games and interactive entertainment experiences we developed and modified usability practices to address new areas of human experience not covered by usability.

20.2.1 *Player Experiences Are Not User Experiences*

As the practice of improving the quality of interactive experiences matures we find that there are many differences between the goals and user expectations of productivity software and games. If there are two separate factors then we should

see games that are highly usable, but are no fun. In XEODesign's lab we often see games that do just that. To differentiate the two we use the term user experience (UX) and player experience (PX) defined as follows:

- UX: is the experience of use, how easily and well suited to the task, what the person expects to accomplish.
- PX: is the experience of play. How well the game supports and provides the type of fun players want to have. Players cannot just push a button once and feel like they won.

Put even more simply for UX we look at what prevents the ability to play and for PX we look for what prevents players from having fun. To test games the first step is to divide the features into two buckets, then apply different techniques to measure and improve the quality of each. Comparing the goals of user and player experiences reveals they are used for different purposes and that they strive for different values.

UX Usability Goals: Productivity	PX Game Goals: Entertainment
task completion	entertainment
eliminate errors	fun to beat obstacles
external reward	intrinsic reward
outcome-based rewards	process is its own reward
intuitive	new things to learn
reduce workload	increase workload
assumes technology needs to be humanized	assumes humans need to be challenged

(Lazzaro & Keeker, 2004) Revised

User experiences and player experiences are like 2 wheels on a bicycle. One connects to the drive chain to make the bike go (UX), the other wheel steers and creates the fun (PX). The practice of improving software has only identified a few spokes on that rear wheel: heuristic evaluation, usability testing, time on task, reduce error rates, satisfaction surveys, certain ethnography such as contextual inquiry. All of these improve interface design and the quality of the user experience. None of these usability related practices address specific emotions. If anything, current UX methods target a single emotion, frustration, in order to reduce it; and they track "satisfaction" without a precise definition. Taken to an extreme a system that is 100 percent usable will have few errors and require little effort, however this risks boring workers by making a task too routine. It also does nothing to increase a worker's sense of accomplishment from mastering a complex task or a job well-done. Usability alone is not enough to improve all aspects of interactive experiences humans enjoy at work or at play.

20.2.2 Emotions Are the Key to Great Experiences

Emotions play an important role in games and give them their engagement. Emotions that match the game mechanic help players concentrate more and

mechanics that offer players emotions they enjoy give players a reason to play. Games are self-motivating activities. Emotion plays a big role in this. Emotions focus attention, make decisions, improve performance, create enjoyment, and reward learning (Lazzaro, 2007). Researchers are only beginning to understand the important role that emotions play in decision making. In fact people without emotional systems cannot make choices (Damasio, 1994). Because games are about making interesting choices, studying the emotional reactions of player serves a critical role in improving the quality of player experiences (PX.) Without emotion, or too much of the wrong kind, gameplay feels flat and uninspired. Players know what to do. The game is usable. They know how to play, but they don't know how to have fun.

TABLE **20.1** Emotion During Play Helps Gamers

1. Enjoy: Creates entertainment from strong shifts in internal sensations

2. Focus: Directs effort and attention
3. Decide: Aids decision-making
4. Perform: Supports different approaches to action and execution

5. Learn: Provides motivation for learning, aids in memory and rewards progress

(Lazzaro, 2007)

20.2.3 *Emotion's role in Choice/Games*

To create more emotion from games the relationship between specific emotions must be understood and planned from the beginning. In games player choices must capture attention and motivate further interaction. Targeting specific emotions related to a type of fun at the start of the project allows the designer to understand how emotions relate to each other and design new types of fun. Next breaking the type of fun into specific mechanics, allows the designer to craft emotion with specific choices and feedback. Finally the designer can tune the game by adjusting how the mechanics work together.

Comparing Engagement Models Reveals Similarities and Open Issues

Before beginning our independent study on emotion and games we did a survey of literature about creating engaging products and entertainment experiences. Comparing these models show striking similarities as well as open issues based on our experiences testing and designing games. Of the dozens of emotions that we saw regularly during play, we could not find a model that accounted for more than a handful of them. Plus outside of psychology most literature on creating book, theater, and film experiences focused on creating emotions in a passive audience through empathy rather than the role emotion played through active participation.

These frameworks lay out several basic requirements for entertainment products, however none addressed designing for specific emotions. Paul Ekman's work treats

emotions in detail, but like most emotion research, focuses on negative problematic emotions rather than enjoyable ones. Ekman also focuses on real-life emotions rather than how emotions come from entertainment. Tiger, Jordan, and Norman describe the importance of emotion in product design but focus on general positive or negative emotion, but not how to measure or increase specific emotions such as curiosity or amusement. There is likewise very little discussion about the role specific emotions play in making different types of decision or how one emotion builds into the next.

TABLE **20.2** Comparison of Models for Creating Emotion and Engagement

XEODesign Four Fun Keys	Hard Fun Fiero Challenge Game, Goal	Easy Fun Curiosity Novelty, Fantasy Game, Open = Ended	Serious Fun Relaxation Real World Purpose Life, Open = Ended	People Fun Amusement Social Life, Goal
Bartle's Original 4 Player Types, (1996, 2003a, 2003b)	Achiever Player Killer	Explorer		Socializer Player Killer
Boorstin (1990)		Voyeuristic Eye Visceral Eye		Vicarious Eye
Csikszentmihalyi (1990)	Enjoyment, flow	Pleasure, microflow		
Ekman (2003)		Auto appraisal, memory of emotion, imagination, reflective appraisal		Empathy w/another, violation of social norm, talking about emotion, making facial expression of emotion
Hassenzahl et al. (2000)	Ergonomic quality	Hedonic quality		
Kim (2000)				Community
La Blanc et al. (2004)	Mechanics, Dynamics Aesthetics	Aesthetics		
Malone (1981)	Challenge	Curiosity Fantasy		
Norman (2004)	Behavioral		Reflective Visceral	Reflective
Piaget (1962)	Formal games with rules	Sensory-motor play Pretend play		

(Continued)

TABLE **20.2** (Continued)

XEODesign Four Fun Keys	Hard Fun Fiero Challenge Game, Goal	Easy Fun Curiosity Novelty, Fantasy Game, Open = Ended	Serious Fun Relaxation Real World Purpose Life, Open = Ended	People Fun Amusement Social Life, Goal
Tiger (1992) Jordan (2000)		Physio-pleasure Psycho-pleasure	Ideo-pleasure	Socio-pleasure
Wright et al. (2003)	Spatial-temporal thread	Compositional thread Sensual thread Emotional thread		
Common Drama and Theater Constructs	Character Motivation, Plot points, Objectives 3-act structure	Setting, Plot, Story, Character, Suspension of disbelief	Catharsis, Music, Set and costume design	Character Dialogue Acting

(Lazzaro, 2007)

1.1.1

To help make better games, researchers and designers need tools to measure and adjust the emotional engagement coming from play. Reviewing the literature we found very little on how experiences create emotions, let alone how games create emotions. The three most relevant and detailed models were Csikszentmihaliyi's Flow and Bartle's four player types, and Norman and Boorstin's three sources of engagement (Norman, 2004, Boorstin, 1990). However, none of these mapped out the wide range of emotions we saw when people played their favorite games. None of them broke out different factors for creating engagement.

Csikszentmihaliyi's Flow models one aspect of how games create engagement (Csikszentmihalyi 1990). The flow model offers two parameters for designers to adjust and three emotional states: boredom, anxiety, and "flow" which is more of a state of engagement than an emotion. In testing games we often measured how players responded to other parameters than the game's balance of skill and difficulty. During great gameplay we knew that players responded to: reward cycles, the feeling of winning, pacing, emotions from competition and cooperation. To get great gameplay designers had to make a lot of adjustments, not only in difficulty.

Our experience testing players showed there were several types of player behavior not predicted by Csikszentmihalyi's model for Flow. The experience of being in a flow state is an important part of many ways that games create engagement not just the actions that are challenging. Players also experienced other emotions such as curiosity in addition to frustration. The most engaging designs that came through our lab often started with challenge but players preferred games that offered more than balancing difficulty with skill. Examining the relationship between players'

favorite emotions and how they play we saw that people played for other experiences as well. Players clearly responded to factors outside the Flow model.

Similarly, we saw that players enjoyed games in more ways than Bartle's four player types (or his revised model). There were likewise more forms of creating engagement than in Norman and Boorstin's models. Players enjoyed more than whether an emotion was positive and negative or was arousing or relaxing. In short game designers needed a model for creating emotion from gameplay and researchers needed a way of collecting data from players to inform the designers.

Given the lack of research on this subject we decided to use a simplified version of Paul Ekman's Facial Action Coding System (Ekman, 2003) to identify what emotions came from what players liked most about games. Watching the emotions on players' faces that would lead us to understand how they relate to the types of choices that players liked the most. We would hack the "what's fun" problem from the player's perspective.

In designing the studies to look at how games create emotions we kept two things in mind. First to design emotions game developers needed a way to measure specific emotions. Second, the emotions to measure were ones that relate to what players like the most about games.

20.3 Hard Fun

1.1.2

"Games are a series of interesting choices."

Sid Meiers

Hard Fun is the opportunity for challenge and mastery. Hard Fun is also what most people think of when they talk about game design. Players play to overcome obstacles and score points. In short people play games not because they are easy, but because they are hard. It requires balance of difficulty with player skills. Many familiar game design techniques such as levels, boss monsters, and power ups evolved to maximize the Hard Fun.

In testing, games lacking Hard Fun often have goals that are too difficult, too easy, or uninspiring. A common flaw in the Hard Fun of games is only increasing the challenge by giving players more monsters and less time. This is one way to make the game harder, but ignores a big source of pleasure for gamers; which is the creation of new strategy.

20.3.1 *Hard Fun Emotions*

"I always know how my husband feels about a game. If he screams 'I hate it! I hate it! I hate it!' then I know two things: a) he'll finish it, and b) he'll buy version two. If he doesn't say these things, he'll put it down after a couple of hours."

Wife of a Hard-Core PC Gamer

Hard Fun comes from a careful balance of three emotions. The most important emotion has no word in English, so at XEODesign we borrow an Italian word, fiero (like the car) which means personal triumph over adversity (Ekman, 2003). For example fiero is the feeling you get from winning the Grand Prix or beating the boss monster. Players experience fiero often scream "Yes!" and punch an arm up over head, jump their characters, or do a victory dance. If the feeling is especially strong players even jump up out of their chairs.

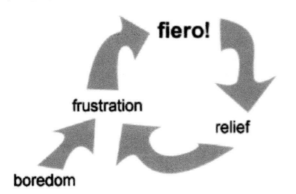

Hard Fun: The opportunity for challenge and mastery

FIGURE
20.2

During play gamers often start bored, then become frustrated, experience fiero and then feel relief.

Looking for fiero during player testing is a good way to assess the Hard Fun in a game.

PX Spiral: Hard Fun Creates Fiero.

Players cannot push a button and feel fiero, they must feel frustrated first.

In Hard Fun players cycle between three emotions: fiero, frustration, and relief. We call the way players cycle between emotions a PX Spiral. During play gamers often start bored (a top reason to play a game), then become frustrated as they work to solve the challenge. When they solve the challenge they feel fiero causing a huge state change in the body where they go from feeling very negative to feeling very good. As the feelings of fiero fade the player feels relief. Then the player encounters a new challenge and the cycle repeats.

Because game design requires balancing a number of choices and parameters, it is helpful to first focus on the Hard Fun of the game and creating fiero. Fiero is the strongest and most satisfying emotion coming from Hard Fun mechanics and for many players fiero is their favorite emotion. Fiero also offers a special paradox to researchers and designers: usability requires removing frustrating features, where as mechanics that produce fiero demand adding them. In game testing separating good frustration from bad frustration is a requirement during observations aimed at improving Hard Fun. Make a game too usable and it is no fun at all.

20.4 Hard Fun Mechanics

Game designers cannot design player emotions directly; instead they design the rules that offer players the choices and the feedback that creates the emotions. The choices and feedback that the game offers the player are called game mechanics and based on our research these mechanics are different for each type of fun. In

this way each type of fun focuses on different types of choices with different kinds of feedback and therefore creates different emotions. To create the emotions in the PX Spiral for Hard Fun the game requires different mechanics than those found in other types of fun.

The emotions for Hard Fun come from the choices and feedback relative to a goal with at least one major obstacle. We call how the mechanics create the emotions a PX Profile. It is possible to target these emotions and increase the Hard Fun of a game by adding mechanics such as the extra bonus coins in *Zuma* or seating customers by color in *Diner Dash*. Creating a PX profile helps explore the relationship between choices, feedback, and player emotions.

The emotions for Hard Fun come from the player using the controls to make choices, develop strategies, overcome obstacles, and achieve the goal. Typical Hard Fun mechanics include short term and long term goals, obstacles, levels, boss monsters, and power ups. All of these vary the pace of the game, affect the challenge ramp, and enhance player feelings of accomplishment. Player testing of Hard Fun examines what kind of response these mechanics create in players.

TABLE **20.3** Hard Fun PX Profile

Choice and Feedback	Emotion
goals	fiero
challenge	frustration
obstacles	boredom
strategy	
power ups	
puzzles	
score	
levels	
monsters	

Hard Fun mechanics are the ones most at odds with traditional measures of usability. Here is where usability recommendations can do the most damage to gameplay. Usability advice to widen and lower a basketball hoop will reduce error rates however, it also makes the game less fun. Pushing one button to buy a car upgrade improves the game, pushing another button to win the Grand Prix does not feel like winning.

20.5 How Hard Fun Mechanics Work Together to Create Mastery

There are many ways to measure and increase the Hard Fun of a game. Mechanics that enhance the challenge and progress towards goals, suggest multiple strategies, and otherwise increase the opportunities to overcome obstacles will help. The designer increases Hard Fun emotions by balancing these aspects to create opportunities for mastery and create more Fiero.

Hard Fun: Mastery creates Fiero. Player choice rewards effort.

FIGURE
20.3

How to increase emotions from choice related to a goal.

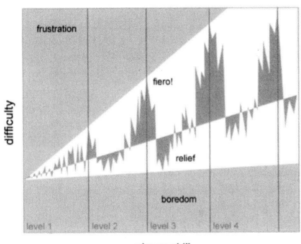

Hard Fun offers the player more emotions than the boredom and frustration (anxiety) predicted by Csikszentmihalyi's model of flow.

Hard Fun PX Model.

How to increase emotions related to goal.

Designing how Hard Fun mechanics work together as a system is as important as having the right ones. To get players "into the zone" Hard Fun offers players the perfect balance of player skill with game difficulty. If the game is too easy the player quits because they are bored. If the game is too hard players quit because they are too frustrated. Over time as the player improves, the game must also increase in difficulty to keep the player in this zone. Games increase variety by offering secondary objectives, extra points, or expert scores to offer more ways to win. Having mechanics that suggest multiple strategies also increases engagement as players try out different ways to play.

Hard Fun builds on the observations of Csikszentmihalyi's model of Flow in several ways (Csikszentmihalyi, 1990). First of all players enjoy games where the difficulty varies rather than progresses in a straight line. The level of challenge had to wiggle and the overall angle had to match player preferences. It can be relatively flat for meditative games like Bejeweled on un-timed mode, and quite steep for a first person shooter like *Halo*. The game also must present some degree of challenge to start. The placement of levels and power ups relative to the game's more difficult challenges (boss monsters and puzzles) affects enjoyment as well.

The most important difference between Hard Fun and Csikszentmihalyi's Flow is that players clearly enjoyed other emotions such as fiero and relief, in addition to boredom and frustration (anxiety). For example for fiero to occur players had to become so frustrated that they were about ready to quit. To get fiero, the player must succeed just when they are on the verge of quitting. When they achieve at that point they experience a huge phase shift in the body from feeling very bad to feeling very good. Being close to the edge of quitting enhances the positive elative feelings of fiero. This meant the player has to wiggle within the zone often touching both edges. Players' favorite games have them alternate between Hard Fun and Easy Fun (definition coming up) to prevent becoming too frustrated or to motivate the next round of challenges. We saw players alternating between challenge and exploration. Games that were more successful provided rewarding experiences for both.

20.6 Easy Fun

"In real life, if a cop pulled me over I'd stop and hand over my driver's license. Here I can run away and see what happens."

Xavier playing GTA Vice City

Easy Fun is the bubble wrap of game design. Best selling games offer interactions outside the main challenge to inspire player imagination and capture their attention in between challenges. Novelty inspires player curiosity to fill their attention and motivate different kinds of play. In Easy Fun these opportunities for fantasy, exploration, and role play increase immersion into the game world outside of the main goal and offer a refreshing alternative to the emotions from Hard Fun.

For Easy Fun novelty inspires player curiosity similar to the role challenge has in Hard Fun. Because of this Easy Fun lacks the structure of Hard Fun. Instead players play for the sheer enjoyment of the interaction. Like Improv theater, games such as Grand Theft Auto (GTA) make offers to the player. To get from point A to point B in a mission the game offers the player a car, in fact any car they want and then other things such as parking meters, plate glass windows, and freeway exit ramps. It is up to the player to accept these offers and see what happens.

Easy Fun plays an important role in the life cycle of a play session. Players often self regulate their emotions when the challenge becomes too hard by switching from Hard Fun to Easy Fun such as goofing off inside the game, off track play, or exploring what Will Wright calls "interesting failure states."

Games without enough Easy Fun may be highly usable and have appropriate challenge ramp, but players will play less if they don't want to see what is on the next level, they don't enjoy the theme, or if the controls feel arbitrary or too realistic. Accelerometer games such as XEODesign's accelerometer game *Tilt* on the iPhone or *Wii Sports* on the Wii creates part of their appeal from the controls themselves. The difference between using the real object and the virtual one increases engagement. Without enough Easy Fun players are more likely to become frustrated with pursuing the game's main goal. Oftentimes players find the theme unappealing or the story uninspiring. They don't see the point and don't care about the outcome. If the game is only about the Hard Fun players loose interest.

20.6.1 *Easy Fun Emotions*

For Easy Fun we look for curiosity in the player, examining what activities they engage in outside the main challenge for the game. Similar to the emotion of frustration in Hard Fun, curiosity focuses player's attention this time with a positive emotion. As players fool around curiosity leads to surprise then wonder which is a big emotion in humans. And wonder (rather than fiero) rewards their actions. Like fiero, the feeling of wonder is a big emotion, plus it focuses player attention. Wonder is a feeling such as the first time someone sees *Trinity* do her slow motion round house kick in the movie *The Matrix*, or in *Close Encounters of the Third Kind* when the mother ship UFO rises up over the desert. The feeling of wonder rivets attention on something that appears impossible or at least highly improbable without being so unlikely that the player feels disbelief.

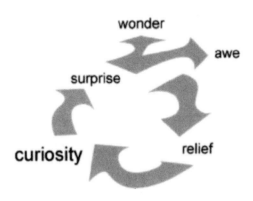

PX Spiral: Easy Fun Creates Curiosity.

Easy Fun: Inspires experimentation, role play, and fooling around.

During play something inspires curiosity that leads to surprise then wonder and awe. Relief completes the cycle and the player either explores further or encounters a new goal and starts Hard Fun.

Tracking player curiosity is a good way to identify opportunities for Easy Fun.

FIGURE
20.4

Curiosity is an emotion with a strong intellectual component. Once the mystery is solved curiosity disappears instantly. That's one of the reason movies are less

compelling if someone "spoils the plot" by telling you the ending. If the outcome is known the only curiosity left is how the characters get there.

20.7 Easy Fun Mechanics

Easy Fun inspires player curiosity through mechanics that suggest novel forms of interaction. They inspire players to ask, "What happens if I put my Sims in the pool and pull out all the ladders?" or "What if I drive in the race track backwards?" Easy Fun mechanics offer players choices and feedback that create an interesting fantasy. Like affordances in interface design Easy Fun mechanics invite the player to try something out and see what happens. Easy Fun mechanics often suggest uncertainty or employ ambiguity (lack of detail) so that players take action to figure it out. For example, *The Sims* use an ambiguous cartoon language. To have more fun the player must interpret what they are saying. Other games such as *Myst* and *World of Warcraft* (WOW) provide a lot of detail to encourage exploration and paying attention to small details. Evoking iconic situations and characters such as a battle between trolls and humans rallies players to action inspired by emotions drawn from other entertainment experiences.

TABLE **20.4** Easy Fun PX Profile

Choice and Feedback	Emotion
role play	curiosity
explore	surprise
experiment	wonder
fool around	awe
just have fun with the controls	
iconic situations	
explore	
experiment	
ambiguity	
detail	
fantasy	
uniqueness	

Identify a game's Easy Fun by looking at how these kinds of choices and feedback create the emotions of curiosity, surprise, and wonder.

20.8 How Easy Fun Mechanics Work Together to Inspire Imagination

Easy Fun mechanics such as role play, ambiguity, creativity, and story work together to inspire player imagination. The use of detail and iconic situations gives players something to start with. An appropriate level of uncertainty and ambiguity encourages

players to explore what Will Wright calls interesting failure states or what Hal Barwood calls the pure joy of figuring it out.

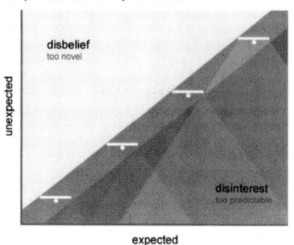

Easy Fun: Imagination creates curiosity

How to increase emotion from choice relative to imagination.

FIGURE
20.5

Easy Fun: choices novelty fills attention

Increase Easy Fun emotions by balancing these aspects to engage the player's imagination and create more curiosity.

Easy Fun PX Model.

20.8.1 *Novelty and familiarity*

Like Hard Fun choices that create Easy Fun must balance to maintain equilibrium between the two emotions. Instead of frustration and boredom, Easy Fun mechanics balance novelty and familiarity to keep the player engaged between disbelief and

disinterest. If the game becomes too predictable the player leaves because they are bored, if it becomes too novel then they quit because it does not make sense. To borrow a phrase from literature the game balances novelty and boredom to create a suspension of disbelief. If something is too predictable players leave because they are bored, if it is too improbable players slip into disbelief. A 100 percent novel experience where nothing is recognizable would be confusing like a gun that shoots flowers. A 100 percent familiar experience is too much like real life. Games strive to balance between these.

20.9 Serious Fun

"Playing helps me blow off frustration at my boss."

A Hard-Core Halo Player

Serious Fun* is where players play with a purpose to create something of value outside of the game itself such as to relax after a hard day at work. Players aim to change how they think, feel, behave, or to accomplish real work. Players often select games based on how they feel before, during, and after play. Serious Fun requires engaging the player viscerally and mentally. Players use the fun of games to motivate the development of other skills or to change how they feel inside. For Serious Fun we look for what players are doing to relax, create excitement, learn, or do real work through play. They play with a purpose or use games as therapy.

Serious Fun focuses on the emotions created at the intersection of the game and the player in the real world. Where as Hard Fun and Easy Fun both create emotions about events inside the game world. In Serious Fun players feel differently about how the game changes their real life. Although like Easy Fun, Serious Fun offers engagement without challenge; Serious Fun is different than Easy Fun in that it creates engagement directly from visceral sensory stimulation and thoughts about the game rather than through the imagination and curiosity of Easy Fun. People play the game because the game gives them something they value and reflects their values. These additional outcomes and reasons to play creates emotions as well. Most importantly Serious Fun uses different mechanics to create different emotions than other kinds of fun.

Serious Fun creates emotions about benefits from playing a game such as playing *Dance Dance Revolution* to loose weight or *Brain Age* to get smarter, or playing *Halo* to blow off frustration at their boss. The emotions from play reward practice. Some games create a real work product such as the *ESP Game* developed at Carnegie Mellon University, where people play a guessing game to make the otherwise boring task of providing text labels for images on the Internet more exciting

*Note: At first we called this type of fun Altered States because it was clear that players played to change how they felt (Lazzaro, 2004a, Lazzaro, 2004b). The visceral sensations from the game's graphics, audio, and rhythm clearly created enjoyment. As we continued our analysis we then found that those who played word and card games or ones that did real work wanted a mental workout and often created a real world skill or work product. Therefore, we renamed this playstyle Serious Fun.

(von Ahn, 2004). That players accomplish a real world task increases their enjoyment. Simulation games can also teach complex ideas such as city management (Sim City) or leadership (running a guild in World of Warcraft (WOW)) (Gee, 2003). Such simulation games give players the ability to make choices and get real-time feedback—an experience that reading from a textbook cannot.

Games low on Serious Fun feel like a waste of time. The enjoyment quickly fades as the game does not make a lasting impact on how the player feels, or it creates a less desirable mental state such as watching too much TV. While all games to a certain extent are "time wasters" especially among adults, players believe they provide value whether it is stress release or a quick break. Without visceral or mental stimulation from Serious Fun the game often is not engaging enough to change how they are thinking and feeling.

A common flaw in games is that players may find it challenging (Hard Fun) and are curious about the theme (Easy Fun) but the game fails to establish a rhythm, or provide enough visceral stimuli to draw them in, or does not let them express their interests, morals, or values. For example the pacing of interaction for the game may be too chaotic for players to find a pattern. In this way Serious Fun can influence the enjoyment of other kinds of fun. The basic sequence of moves may require too much thinking for players to complete a strategy (Hard Fun). If the game does not engage them to relax, get excited, or enough mental stimulation then it fails to provide them an experience they value. Players often enjoy learning something they don't know, even if it is as simple as where chocolate comes from, as in the game *Chocolatier*.

20.10 Serious Fun Emotions

"I felt better about playing [crosswords] because it's good for me. If someone would tell me Tetris was good for me I'd feel better about playing that."

Ellen, on doing crosswords to keep her mentally sharp and delay the onset of Alzheimer's disease.

Because they play to change how they think and feel, players can experience a number of emotions from Serious Fun. Most common is to play to relax or to get excited. These different states of arousal are on different ends of a continuum. The visceral pleasure of the senses may become so strong that the player becomes enchanted, like finding the perfect sea shell on a beach or becoming mesmerized by a surrealistic vista in *Halo* or *Myst*, or coming to a compelling realization about the player's own character. Thoughts about playing the game create emotions as well. Players enjoy getting their daily workout, preventing Alzheimer's, or learning something new.

Interestingly, the same game can produce different player responses. It is important how they play. Those who play intense demanding games can feel more frustrated or force themselves to calm down to pay attention to complex stimuli with a zen-like focus. Casual game players often choose to turn on timed mode depending on whether they want to feel excited or relaxed.

FIGURE
20.6

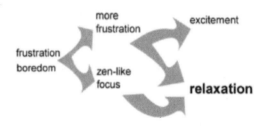

Serious Fun: a ticket to relaxation and enjoying otherwise boring tasks.

During play players start bored and seek to relax or get excited.

Looking for how much a game relaxes or excites a player is one way to measure Serious Fun. Be also on the lookout for how gameplay creates other things that players value such as learning a new skill or a mental workout.

PX Spiral: Serious Fun Creates Relaxation.

20.11 Serious Fun Mechanics

Serious Fun mechanics create emotion by offering stimulating visceral engagement that relieves boredom and makes repetitive tasks more engaging. Players enjoy how the bright graphics, catchy music, and rhythmic interaction change how they feel. Some really enjoy a certain mood whether it is the thrilling crossfire of *Counter Strike* or the flurry of customers during a lunch rush in *Diner Dash*. Feedback that counts the calories they have burned in *Dance Dance Revolution* or how long it took to reach age 30 in *Brain Age* makes the doing something good for themselves more fun. Learning activities such as a vocabulary game or points earned from a stress reduction biofeedback such as the *Stresseraser* boost self-esteem and create pleasure from acquiring new skills. In addition, what players play whether it is *Super Smash*

TABLE **20.5** Serious Fun PX Profile

Choice and Feedback	Emotion	Value
rhythm	Visceral	relax
repetition (practice)	relax	excite
collection	excite	kill time
completion	learn	relieve boredom
bright visuals		loose weight
music	Self	get smart
learning	learning	practice
simulation	esteem boost	create real work
meditation	express values	product
work out		develop skill
study	Real work	
take away	pleasure from	
	do real work	

Bros, *Gears of War*, or *Animal Crossing* expresses a player's identity and their sense of values to themselves and to others.

20.12 How Serious Fun Mechanics Work Together to Express and Create Value

There are many ways to measure and increase Serious Fun. Serious Fun creates engagement through the raw stimulative attention grabbing power of a game's graphics, audio, and ideas. Measuring mechanics such as rhythm, collection, and learning during testing is one way to track the game's perceptual and mental engagement and offers opportunities to increase Serious Fun.

Serious Fun: Players value how a game makes them feel and helps them change themselves

FIGURE
20.7

Serious Fun PX Model.

20.12.1 *Visceral Engagement*

The emotions from Serious Fun require offering experiences in a way that creates relaxation or excitement and something of value for the player. To create relaxation and excitement the pacing of choices and feedback is very important to motivate play. Some games such as *Halo* create excitement with a lot of stimulation and unpredictability while other games like *Bejeweled* offer a more meditative PX Profile through slower paced highly predictable stimulation. That said, the fast pace of playing Bejeweled on timed mode excites many players. Therefore the temporal design of stimuli, choices, and feedback creates a desirable rhythm and engagement.

Many Serious Fun mechanics have a strong visceral component. Pleasure from the visual and audio stimulation increases desire to continue. Matching and gathering mechanics such as Bejeweled have a very primal sense of enjoyment. Collecting Achievement badges in *Pogo* or completing a set of *Pokemon* cards is rewarding. Whether it is the collecting dream jewels in *Dream Chronicles* or a gold star for an expert score in *Diner Dash*, designing game objects that look valuable or pleasing to hold enhances the feeling of collecting them. *Bejeweled* would create a very different experience if instead of matching rubies, diamonds, and emeralds the player matched dog droppings and dirty broken glass.

Serious Fun: Purposeful play changes self and real world

FIGURE
20.8

Serious Fun: PX Model.

20.12.2 *Cognitive Identity and utility*

Serious Fun mechanics also operate on a more cognitive level. How players react to ideas in the game and how they feel about playing are both important sources of emotions. Players can express their identity through the games they play whether it is *Madden NFL* or *RockBand*. Offering players a concrete take away such as learning new defense plays or a better singing voice adds to the fun. All games involve learning. If nothing else, players learn how to play better. Serious Fun offers the opportunity to learn something beyond the game. The Serious Fun of the game gives the brain a workout and gives players something to think about outside of the game. Serious Fun mechanics that exaggerate the player's sense of progress encourage repeat play.

20.13 People Fun

"People are addictive, not the game."

Bob, a sports game player

People Fun offers players the excuse to hang out with friends. People Fun is also the source of more emotions than all the other types of fun combined. Players play to spend time with their friends, many play games they don't like, or play even though

they don't like playing games. Games often serve as icebreakers, topics of conversation, something to get the party started, or structure the conversation. Some players enjoy talking about a game more than actually playing it.

The emotions from People Fun can also come from in game characters as well as other players. Part of the success of *Diner Dash* is the tight integration of the game mechanic with balancing the emotional states of numerous NPCs (non player characters)(Lazzaro, 2005). Please enough customers as a waiter and the player wins. Not all games need People Fun, however, games that lack people fun such as Bejeweled have to be a lot stronger in the other areas to create the same level of emotional engagement.

Games without enough People Fun offer limited interaction between players and game characters. As a result players do not care about the plight of a game character. Without People Fun the game fails to spark competitive urges or cooperation between players towards a shared goal. These games can be MMOs whose NPCs feel like quest vending machines rather than reacting to choices players make. In multiplayer games each player's actions can feel isolated lacking the opportunity to interact with other players.

An easy way to reduce People Fun is to provide a highly organized experience that is too immersive for social interaction. Such games offer one way to play and provide too much structure, limit customization, restrict house rules, offer ridged communication channels, and too much stimuli. Sometimes the only reason the other player is there is to provide more competition (where Hard Fun and People Fun overlap) and in doing so these games miss out on opportunities for other emotions between players.

20.13.1 *People Fun Emotions*

"Since we lost half our guild to Star Wars Galaxies it's not as fun."

—A Hard-Core Gamer Playing Dark Age of Camelot

People Fun comes from social interaction around the game. The game focuses, structures, and suggests new types of interaction between players. People playing in the same room express more emotions than people playing the same game in different rooms. People playing together express a wider variety or emotions, more intense emotions, and more frequent emotions than those playing on their own. Many human emotions such as amusement also require two people whether they are real people or NPC's. These emotions from interacting with friends offer an opportunity not available in passive forms of entertainment such as movies.

The most visible emotion from People Fun is amusement, where players laugh with and at each other. Amusement is the most common emotion expressed between two friends playing together. Schadenfreude, the feeling of pleasure at a rival's misfortune, is often seen during competitive play. The emotion most prized by players is the feeling of social bonding such as how one feels after laughing hard with friends. This emotion has no good word in English, but it feels good to players, and strengthens bonds between friends.

The experience of playing games together deepens social bonds. Players will laugh at each other, themselves, and tell jokes. They develop secret languages and pass social tokens that create rich emotional bonding between players (Lazzaro, 2008). Playing together generates positive emotions, feelings of trust, companionship even in highly violent games. It is this emotion of feeling closer to one's friends that players most enjoy from People Fun. It is the intense feeling of closeness and companionship after laughing with a friend. Again there is no word in English for it.

FIGURE
20.9

People Fun: the excuse to hang out with friends.

Social interaction through the game creates amusement and results in social bonding.

Wherever there is a lot of amusement between players social bonding and People Fun cannot be far behind.

PX Spiral: People Fun Creates Amusement.

In People Fun players interact and cycle between many emotions. These cycles of emotions offer what players like about hanging out with friends and increase social bonding.

20.13.2 *People Fun Mechanics*

The emotions from People Fun come from many types of social interaction. Games cannot make people friends directly, but they can offer the opportunity to spend time together. Players like to test their skills with others and enjoy the feeling of camaraderie while accomplishing a joint challenge. People playing together in the same room often add content, change rules, and compete to outwit each other with witty commentary. For online play, open channels of communication allow players greater freedom to personalize their game experience such as sharing secrets and niche interests, teasing each other, and telling inside jokes (Lazzaro, 2008). During gaming players chat about common passions and get to know each other. It is these kinds of social interactions that also increase the bonds between people. Offering choices and feedback that require people to interact increases the amount of People Fun.

These emotions between people and types of choices are huge drivers in Massively Multiplayer Online games (MMOs) as well as social media (collaborative websites such as Wikipedia, Flickr, and YouTube). These applications allow people to interact with each other and create group experiences instead of one person editing a single document. The emotions from creating something that millions will take part in are a strong motivator for action (Lazzaro, 2008).

People Fun is often more emotional with other players, but it does not require other people. NPC's and even animals, such as *Nintendogs*, can provide the "other"

with which to play. In *Diner Dash* the game mechanic requires players to balance the emotions of the NPC's. In *Diner Dash Home Town Hero* players can do this and play with and against other players.

TABLE **20.6** People Fun PX Profile

Choice	Emotion
cooperate	amusement
compete	social bonding
communicate	schadenfreude
mentor	naches
lead	envy
perform	love
spectacle	gratitude
characters	generosity
personalize	elevation
open expression	inspire
jokes	excite
house rules	ridicule
secret meanings	embarrass
Pets	
endorsements	
chat	

People Fun mechanics have the ability to greatly widen a game's PX. If we look at what choices create the emotions seen between players the PX Profile includes game mechanics such as cooperation, competition, and the opportunity to perform and to personalize. These choices create emotions such as schadenfreude (taking delight in the misery of others), naches (a Yiddish word for the sense of pleasure and pride when someone you help succeeds), and amusement between players. Adding a single mechanic such as a tradable health pack to a game creates three emotions: generosity when a player gives it, gratitude when a player receives it, and elevation when someone witnesses the human kindness in the exchange. Later on in the game the emotions switch places depending on who's in what role in the interaction.

20.13.3 *How People Fun Mechanics Work Together to Create Relationships*

There are many ways to measure and increase the People Fun of a game. Players connect, interact, and express their identity and themselves. To allow players to enjoy each other's company the game provides just enough structure for social interaction but not so much structure that players focus more on the game than on their friends. Knowing that a person is playing against another person often increases their efforts to express their personality as well as those to compete. Games that

provide opportunities for people to express themselves or create their own special way to play enhances the emotions that players feel. Increase People Fun emotions by balancing these aspects to increase the amount of player interaction and increase amusement and social bonding.

FIGURE
20.10

People Fun: Playing with friends creates amusement and social bonding

How to increase emotion from choices involving social interaction.

The ability to connect and make friends, send messages, and customize actions helps develop relationships and deepen interaction.

People Fun: choices with others increase emotions and social bonds

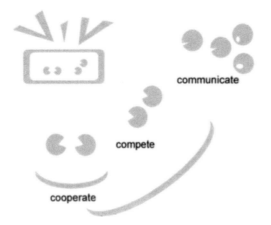

Players use games to start and structure social interaction.

Players experience more emotions, wider variety of emotions when played in the same room.

Offering more lines of interaction, more opportunities for players to interact with each other increases the opportunities for People Fun.

People Fun PX Model.

Cooperative and competitive gameplay increase the opportunities for People Fun. In *Top Spin Tennis* players feel one way playing across the net and another interacting with their tennis partner on the same side of the court. For example each car in *Mario Kart* has two seats, one player drives and the other throws stuff. Players cooperate to win and compete against others. This also allows junior players to learn

how to play from the back seat and eventually drive their own cars creating naches for their mentors.

We found other interesting results in a study we ran people playing multiplayer games and using social media (Lazzaro, 2008). The opportunity for emotions came across three channels: how the service allowed players to connect and make new friends, the messages that were passed between them, and the actions they could take. The shape of these channels, how they worked, affected how and what type of engagement they created between players. By offering different features the services created different emotions.

People Fun is the difference between eating a cheese sandwich and eating fondue with friends. The additional lines of interaction structure social actions to create more emotions whether it is helping someone with a long string of cheese or fighting over the piece that fell off someone's fork.

20.14 A Few Suggestions for Applying the Four Fun Keys

20.14.1 *Improving PX Player Experience for Games*

Tuning emotions with the 4 Fun Keys can improve the PX of a game at any part of the process. Here are a few pointers to get you started. At concept, personas for

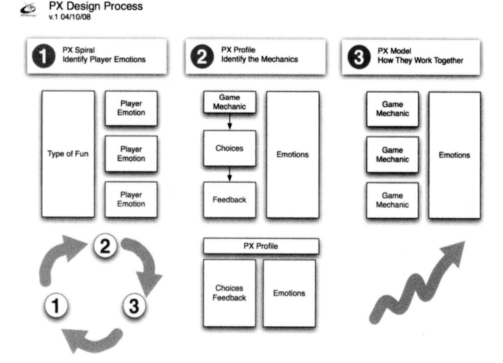

FIGURE 20.11

each type of fun can be used to focus design discussion of how to support particular playstyles. Balancing the game between personas will widen the base of appeal by increasing the opportunities for emotion and providing more ways to enjoy the game.

Player Experiences and emotions need to be designed and measured from the beginning of the project, not just tacked on at the end. Starting with a playstyle such as Hard Fun, identify the desired player emotions. Then choose the mechanics (the choices and feedback) that create these types of emotions. Finally, tune the mechanics by looking at how these choices and feedback work together as a system to create the intended player response.

Towards the end of the process, testing a playable build with players against opportunities for fun from each of the four Fun Keys offers a way to fine tune the emotions from gameplay. Analyzing player behavior and responses to the game's Hard Fun, Easy Fun, Serious Fun, and People Fun can identify weaknesses in game design as well as expose opportunities for deeper engagement beyond what is possible with pure usability methods.

20.15 References

Ahn, L. von, & Dabbish, L. (2004). Labeling images with a computer game. Proceedings Association for Computing Machinery (ACM) Special Interest Group on Computer-Human Interaction Conference (CHI), 319–326. Vienna, Austria. Publisher: ACM Press New York, NY, USA.

Bartle, R. 1996(a). Hearts, clubs, diamonds, spades: Players who suit MUDs. MUSE Ltd, Colchester, Essex., UK. Retrieved December 29, 2005, from http://www.brandeis.edu/pubs/jove/HTML/v1/bartle.html

Bartle, R. (2003a). A self of sense. Retrieved December 29, 2005, from http://www.mud.co.uk/richard/selfware.htm

Bartle, R. (2003b). *Designing virtual worlds. New Riders Games.* Berkeley, CA: Peach Pit Press.

Boorstin, J. (1990). *Making movies work.* Beverly Hills, CA: Silman-James Press.

Csikszentmihalyi, M. (1990). *Flow: The psychology of optimal experience.* New York: Harper & Row Publishers Inc.

Damasio, A. (1994). *Descartes' error: Emotion, reason, and the human brain.* New York: Quill Penguin Putnam.

Ekman, P. (2003). *Emotions revealed.* New York: Times Books Henry Hold and Company, LLC.

Gee, J. (2003). *What video games have to teach us about learning and literacy.* New York: Palgrave Macmillan.

Hassenzahl, M., Platz, A., Burmester, M., & Lehner K. (2000). Hedonic and ergonomic quality aspects determine a software's appeal. Proceedings Association for Computing Machinery (ACM) Special Interest Group on Computer-Human Interaction Conference (CHI), 201–208, The Hauge, The Netherlands.

Jordan, P.W. (2000). *Designing pleasurable products: An introduction to the new human factors.* London: Taylor & Francis.

Kim, A.J. (2000). *Community building on the Web.* Berkeley, CA: Peach Pit Press.

Lazzaro, N., & Keeker, K. (2004). "What's My Method?" A game show on games. (pp. 1093–1094) Proceedings Association for Computing Machinery (ACM) Special Interest Group on Computer-Human Interaction Conference (CHI), Vienna, Austria.

Lazzaro, N. (2004a, Winter). Why we play games. (pp. 6–8) User Experience Magazine, 8.

Lazzaro, N. (2004b). Why we play games: Four keys to more emotion in player experiences. Proceedings of the Game Developers Conference, San Jose, California, USA. Retrieved December 28, 2005, from www.xeodesign.com/whyweplaygames.html

Lazzaro, N. (2005). Diner dash and the people factor. Retrieved March 2, 2005, from www.xeodesign.com/whyweplaygames.html

Lazzaro, N. (2007). Editors Jako, J. & Sears, A. Why We Play: Affect and the Fun of Games: Designing Emotions for Games, Entertainment Interfaces and Interactive Products The Human-Computer Interaction Handbook: Fundamentals, Evolving Technologies and Emerging Applications, (pp 679–700) Lawrence Erlbaum Associates, Inc., Mahwah, NJ.

Lazzaro, N. (2008). Halo vs. Facebook: Emotions that Drive Play. Proceedings of the Game Developers Conference, San Jose, California, USA. Retrieved April 13, 2008 from www.xeodesign.com/whyweplaygames.html

LeBlanc, M., Hunicke, R., Zubek, R. (2004). MDA: A formal approach to game design and game research. Retrieved March 2, 2005, from http://www.cs.northwestern.edu/~hunicke/pubs/MDA.pdf

Malone, T. (1981). Heuristics for designing enjoyable user interfaces: Lessons from computer games. Proceedings Association for Computing Machinery (ACM) Special Interest Group on Computer-Human Interaction Conference (CHI), (pp. 63–68).

Norman, D.A. (2004). *Emotional design: Why we love (or hate) everyday things*. New York: Basic Books.

Piaget, J. (1962). *Play, dreams, and imitation in childhood*. New York: Norton.

Tiger, L. (1992). *The pursuit of pleasure*. (pp. 52–60). Boston: Little, Brown & Company.

Wright, P., McCarthy, J., & Meekison, L. (2003). Making sense of experience. In M.A. Blythe, K. Overbeeke, A.F. Monk, & P.C. Wright (Eds), *Funology: From usability to enjoyment* (pp. 43–53), Dordrecht, The Netherlands: Kluwer Academic Publishers. 00020

For more articles on emotion and game research, see http://www.xeodesign.com/whyweplaygames

All trademarks are the property of their respective holders.

PUTTING IT ALL TOGETHER AND WHERE THINGS ARE GOING

CHAPTER TWENTY-ONE

Matrix of Issues and Tools

This chapter offers two different approaches to selecting among the methods described in the book. The first is a list of the development phases, with techniques that may be of use in each. If you are in the midst of a project right now, you may find this outline helpful in determining what might be of use to you. You can follow chapter references to learn more about the techniques in the list.

The second is a table that compares the various methods described in the book, in terms of resources and expertise required, with pointers to chapters that outline these methods in more detail.

Finally, we've included a list of common complaints or concerns about usability, and some answers you can use to help people in your team warm up to these methods.

I. Development stages and user research techniques to use

Before a project even begins:
Management buy-in. A first step in successful user research is getting everyone on board for what you are doing, and setting good processes up for including the results of research in your development process. (Chapter 2).
Researching how other developers use user research. You may want to read the interviews and writings by game developers about how they use these techniques, to get ideas and inspirations (Chapter 3; Chapter 4; Chapters 11, 15, and 17).
Instrumenting your game. If you know you want to collect metrics and use these to influence design, you will want to build this into your process from the very beginning (Chapters 9 and 15).
Consider setting up company standards for usability (Chapter 8) that all teams can re-use.

2. Concept phase:
As you make decisions about your core audience and the genre and platform of your game, you may find some of the advice in Section 3 helpful. You can also

seek out heuristics relevant to your particular genre and collect heuristics from your team based on their prior knowledge (Chapter 6).

As you start to shape your design, you may want to set fun types to aim for (Chapter 20) and make note of social psychological effects you know you'll want to use and test (Chapter 19).

3. Pre-production:
You may want to use expert evaluation within your team during this phase, to make sure you stay on track with user experience goals (Chapter 7).

Two game designers have written about how they use prototyping and testing to keep their games on-track personally—you may want to read these chapters if you haven't already (Chapters 17 and 18).

4. Production phase:
In this phase, traditional usability methods as adapted to games are particularly helpful. The chapter from Microsoft has an excellent overview (Chapter 4) and Chapter 5 offers advice on using think-aloud user testing.

If you have the time and resources, you might find it useful to try out physiological measures that can confirm emotional responses to your games (Chapters 13 and 14).

5. Post-production phase:
If your game will require post-launch updates and patches, you'll want to keep doing some usability and playtesting as needed (overviews in Section II). Collecting metrics on play once a game is released is also a great way to tune future releases and games in the same genre (see Chapter 15 for a brief discussion of this strategy).

Methods comparison chart

Method	Time/expense/ equipment	Expertise needed	Suggestions for use	For more information
Traditional usability	Enough participants for statistical significance, enough facilitators to run that many participants, a prototype or version of the game, space to run the test, recording equipment (optional)	Usability and statistical analysis expertise	To pinpoint usability issues in crucial areas of your game worth the resource investment.	See Chapter 4.

(Continued)

Method	Time/expense/ equipment	Expertise needed	Suggestions for use	For more information
Think aloud recorded play sessions	3–5 sessions each iteration. Each session: 1 representative user, 1 facilitator, recording equipment, prototype or version of the game, time to review the tape from the session and then make and present a report	Facilitator needs expertise. Observer needs no expertise. Participant needs expertise that will match target users.	Use once you have a prototype or an early version to test—a relatively inexpensive way to get some valuable feedback early.	See Chapter 5.
Heuristics with experts	Time: select heuristics, review game, make a report, present report, make changes to game. Resources: 2 or 3 experts, something to review (sketches of screens in a scenario are enough).	Usability and game design expertise.	If you can find and afford experts, this is preferred. Use early, as soon as you can sketch up a scenario, to identify mistakes to avoid in prototyping.	See Chapters 6 and 7.
Heuristics with non-experts	Same resources as with experts, but with 4 or 5 non-experts.	Moderate expertise needed in selecting heuristics.	If you can't find and afford experts, this is a good alternative. Use early, as soon as you can sketch up a scenario.	See Chapter 6.
Design Standards	Time from opinion leaders who will meet as a committee, time to design the standards, time to design and teach a class on the standards, time from all designers to take the class on the standards, time and attention on enforcement of the standards.	Design expertise. Management expertise. One or two usability experts.	These have to be established before the game is made. Use these if your studio makes lots of games, especially if you do lots of the same type of games.	See Chapter 8.

(Continued)

Method	Time/expense/ equipment	Expertise needed	Suggestions for use	For more information
Instrumentation and metrics	A prototype or version of the game to test, many representative participants, and time and resources to develop and run an automated testing setup.	Considerable for design of the automatic facilitation.	When you have the resources and time, can pinpoint user issues in a broader swath of game play, and show aggregate patterns.	See Chapter 15. Also Chapter 9.
Physiological measures	Measurement equipment cost, equipment calibration time, data interpretation software and time, resources and time for running whatever is being measured.	Equipment use expertise, data interpretation expertise.	When you have the resources and time, can provide additional helpful information about player emotions and engagement during gameplay.	See Chapters 13 and 14.

Some typical complaints about usability and user research, with responses you can use.

Complaints	Responses
But the game is supposed to be hard!	But there's such a thing as being too difficult. Players will hate your game on a deep personal level if it makes them feel stupid. Also, there's a difference between the challenge that you intended and an unintended challenge that makes a game unplayable.
Players will learn to use it!	Usability addresses learnability. They may need to learn, but your game has to help.
Why can't I just test it with myself? I'm a player, right?	You're not a **typical** player. Compared to the typical player, you have much more game experience and much more knowledge about your game.
I already know what our players will like and do!	No, you don't. Even usability professionals frequently get surprised by some of the problems real users have. You won't really know your players until you see some representative players interact with your game.

(Continued)

Complaints	Responses
It's too expensive!	Can you afford to make a game that people won't buy because they heard it's unplayable? Can you afford the returns and customer service calls when players get totally stuck? The return on investment (ROI) of usability is typically huge. And there are 'discount' techniques, such as using heuristics that can help to keep the costs manageable.
It takes too much time!	The process is integrated into the design process, so it doesn't take too much extra time. Doing testing early can save time later in development, correcting issues before they are too embedded to change. As several of the authors in this book point out, an unplayable game is a time-consuming problem that you don't want to have …

TWENTY-TWO

Interview with Don Norman, Principal in the Nielsen-Norman Group, and Professor, Northwestern University

Interviewer: Katherine Isbister

Don Norman is co-director of the joint MBA/Engineering program at Northwestern University that emphasizes design and operations, cofounder of the Nielsen Norman Group, and former vice president at Apple Computer. He serves on numerous advisory boards. He has received honorary degrees from the University of Padova (Italy) and the Technical University of Delft (Netherlands), and the Benjamin Franklin Medal in Computer & Cognitive

Science from the Franklin Institute. He is well known for his books *The Design of Everyday Things* and *Emotional Design*. His latest book, *The Design of Future Things*, discusses the role that automation plays in such everyday places as the home, and automobile. He lives at www.jnd.org.

Don, you are a renowned expert in productivity-software user research and traditional usability testing. I'm wondering what thoughts you have about how these methods are currently applied in game production, as well as how you think they could be applied.

Productivity software? I think you must have me confused with someone else. Traditional usability testing? I'm against it. I've spent a fair amount of time talking to game designers and visiting a number of different sites in the United States and Europe and Japan.

I reject it in general anyway. Usability testing is a frill done afterwards to make sure you make no errors.

What I advocate in design, in general, is iterative design. Where you do a quick mock-up and a quick test and then come back and iterate. You improve and retest, and then improve and retest.

In the game arena, if you look at what Microsoft does in its game division, for example, I would not call this usability testing. They'll watch people play a game at an intermediate phase of development in order to discover the parts that work well and that work badly. This allows them to enhance the game and improve the overall experience. It is *not* about usability: it is about experience. There are places where people got into trouble, and they had to do something about it.

Mind you, getting in trouble in a game is not necessarily bad. It's often part of the fun of the game. So what Microsoft has done very nicely is try to look at what is happening and see where people get into trouble for incidental reasons, the sorts of trouble the game designer is not interested in. They'll fix that.

Games are very different than normal applications. You must always be pushing the skill level. You must always be playing at the limit of your abilities. In fact, there are games that are too easy. You may want to change that.

What you really want to do is observe the people and whether they are enjoying the process. It's not usability, it's appropriateness. That's why I advocate emotions and total experience. Not that usability crap.

What about the argument, and I'm sure you've heard this in a lot of your consulting work, and it's especially acute in the game development industry, that there simply isn't time and money to do user testing?

I agree with the arguments: product development is always behind schedule and over budget. Any company that is proud of its user testing is a company in trouble. Instead, you need game designers and experience designers working together to make the best possible experience. You want to engage the player. Doing this right will save money and time. In fact, it does far better than just *saving* money: it *makes* money by increasing sales.

But studying people, observing players, and doing quick tests need not take much time, nor need it be expensive. If you have a small team of people always testing, they could be looking and making observations while you're doing today's game that will be applied to tomorrow's game. That means that when you're ready to do tomorrow's game, you have a team of people who already can offer you advice.

And the team can be very small, even as small as one. So it doesn't have to be a large team. But finding errors and finding problems early on is a great time *saver* and money saver. That's why it's always a good call to be continually evaluating what you're doing.

Any thoughts on the future of games and where user research fits in?
I think the most exciting developments are that we are finally breaking away from the traditional high-intensity, high-graphics dominated games and exploring a variety of experience, including music, the arts, virtual experiences, social interaction, and physical activities. Three cheers to Nintendo's Wii for showing the way! Some of the stuff I have experienced in today's research labs will be in the homes in ten years: really exciting, mind-blowing experiences.

The power comes from imaginative, creative new situations and experiences, enhanced by inexpensive sensors that let people move around, jump, run, twist and turn. Add new actuators that can exert force and movement, tactile sensations (these are all called "haptics"), coupled with surround sound and visual displays that take an entire wall or even, as in some cases, all eight walls and the possibilities are endless.

New sensors allow you to tell just where the person is looking. How they're standing, where they're facing. If there are several people, then how they're interacting.

I also see a huge potential with games in the educational field. Games are wonderful learning opportunities. To play a game with skill requires a tremendous amount of study and practice and learning. What an opportunity to transform this from the artificial world to games to the real world! How much that might be valuable for us in the real world!

I think the real opportunities are with non-traditional game players, and so we need to go out and study them. For example, why do so many people *not* play games? I suspect that they could actually be interested in the correct type of game. So we have to look at them and try to understand what is it they would do if it were available. There is a field that we call ethnographic observation which is used heavily in product design and that's what we need to do. We need to invest time watching more non-gamers to understand what will appeal to them.

TWENTY-THREE

"Gamenics" and its Potential—Interview with Akihiro Saitō*, Professor, Ritsumeikan University, College of Image Arts and Sciences; Director, Bmat Japan

Interviewer: Kenji Ono, game journalist, IGDA, Japan

*The contents of this article are based solely in the following interview and do not represent the official opinions of the companies mentioned herein.

Akihiro Saitō is a professor at Ritsumeikan University, College of Image Arts and Sciences, and a director at Bmat Japan. He involved in animation design since middle school, and worked for both Suntory Limited and LaForet as a CM director while attending Tama Art University. He also involved in the development of several game from the dawn of the Nintendo Entertainment System (NES). He established his own game studio, DICE CO.Ltd., in 1991. At first, he started working as a game designer for Nintendo, and has since developed game software for several other companies. He became a professor at Ritumeikan University in 2005. In addition to his research and lectures that advocate "gamenics theory", he continues to make advances in the development of sensibility reasoning AI technology for the information age.

- Involved in animation design since middle school, and worked for both Suntory Limited and LaForet as a CM director while attending Tama Art University.

- Involved in the development of several games from the dawn of the Nintendo Entertainment System (NES). Established his own game studio, DICE Co. Ltd., in 1991. First started working as a game designer for Nintendo, and has since developed game software for several other companies.

- He became a professor at Ritsumeikan University in 2005. In addition to his research and lectures that advocate "gamenics theory," he continues to make advances in the development of sensibility reasoning AI technology for the information age.

There are two mottos for Japanese videogame development: "young and old alike, anyone can start playing a game without reading the instruction manual" and "players will continue to improve their skills while they are absorbed in a game." This phenomenon is particular to videogames and is often lacking in other home electronics or Internet services.

Especially well-designed videogame user interfaces (UI) made this possible. Players will not get absorbed in a game just because it is a game. Instead, it is the massive amount of know-how built into a game that enables players to become "totally absorbed" during a gaming session. The reason both the Nintendo DS and Wii are such explosive hits is due not only to their innovative input devices, but also the know-how represented primarily by their user interfaces that allows players to get absorbed in a game.

The know-how that goes into the development of videogame user interfaces is potentially applicable to a wide variety of commercial fields. Professor Akihiro Saitō of Ritsumeikan University, a former game designer, has codified this practice as "gamenics," and is currently applying the principles of his theory to the development of actual products. I recently asked Professor Saitō about gamenics and its potential.

23.1 What is "gamenics"?

Thank you for agreeing to this interview. I hope you don't mind if I start out by asking you to explain briefly what "gamenics" is.
Gamenics is the massive body of know-how related to the user interfaces that were first created for the Japanese videogame market by Nintendo. It's a portmanteau combing the word "game" with the "nics" of "electronics" and "mechanics," and is meant to be a word for the "scientific" study of videogames.

To what extent has gamenics theory penetrated the Japanese game market?
Gamenics isn't actually a word in common use yet, but you can see game development based on its principles at a lot of companies. Nintendo is respected for this more than any other company, because I codified the word based on the know-how I learned while developing games for their systems.

I have a Toshiba Digital High-Vision TV and an HD DVD recorder at home, and they are both hooked up with HDMI cable. But the remote controls are difficult to use, and they have a lot of functions that I don't know how to use. I've read the instruction manual for them a number of times, but I can't make any sense of the directions. I'm actually quite an electronics nerd, and can figure out how to work just about anything. But the UIs for these controls are not well thought-out, and most digital home electronics are falling into the same ruts because of the "functions" war between competing companies.

This is unacceptable for videogames. Most people start playing a new game without even reading the instruction book. They get sucked into the world of a game and ultimately finish it after passing a number of challenges. This doesn't happen just because they are playing a game, but rather because a game designer has incorporated all sorts of workings into it. Gamenics is the engineering that makes it possible for anyone "to use a product without reading the manual" and "internalize every function without even know it."

How are gamenics and game design different?
Game design is a method for coming up with new ways to have fun playing a game. But regardless of how good these methods are, in order for players to understand why a game is fun you have to get them to play it. This is especially true for games being designed right now, which are larger and more complicated than previous generations of games. That's why it's so important to come up with a way to communicate to a player those things that make a game interesting. Thus, it's necessary to refine game UIs. A player will have to struggle before they can finally enjoy a game if the UI is amateurish. Game design makes a game interesting, and gamenics is what communicates this to the player.

So game design and gamenics are different fields?
That's right. Let me put it another way. Videogames are fundamentally based on a cyclical shift between "stress" and "pleasure." Players experience stress due to

a wide array of impediments, and they experience pleasure when they overcome them. That's the basic repetitive structure of games. Game design lays down the rules for this cyclical structure, and must not make a player feel stress outside of this cycle.

If a player feels stress before they even start playing a game because the game's operability is no good or they don't know what they are supposed to do, then the player won't be able to endure the stress the game designer has built into the game. That's why gamers are better served if they are not aware of the controller, which should exist in their hands as much as possible like air. Gamenics is the science devoted to making this sort of thing possible.

Could you give a specific example?
Well, I don't think that the Nintendo DS and Wii would have been the big hits that they are without gamenics. The touch panel for the DS interface is also used for ATMs and train ticket dispensers in Japan, but you can tell how much better the quality of its operability is at a glance. The Wii Remote is appreciated by a large number of people, young and old alike. There are various elements of gamenics theory built into these products.

See Figure in Next Page.

In the sense that information is displayed and managed with touch screen sensors, the DS is similar to ATMs and ticket dispensers, but continual operation of an ATM would be a real pain. Once a player is sucked into a game without their knowing it, they can continue playing for a long time.

A new input device is not enough to keep a player playing a game. Players might be interested at first, but they will get bored very soon.

UIs are generally those "operational procedures" found in device and screen designs, but gamenics sounds like it's applicable to a broader industrial field.
That's right. Just being able to play a game right away is not enough. A player must be able to play a game for long periods of time. The president of Nintendo, Satoru Iwata, often says that their ideal game is "broad in scope, and deeply structured," which is emblematic of gamenics theory. High-quality game design is not enough. Good UI design rooted in gamenics theory is also necessary.

23.2 Gamenics and Professor Saitō's Career

Before I ask you for an outline of gamenics theory, I'd like to talk a little bit about your career. To start, have you always been a game creator?
No. I first got involved in the entertainment and multimedia industries with *anime*. I belonged to *anime* groups when I was a kid, and sometime during middle school I started working part time as an animator. I was pretty good at drawing. In the

Nintendo DS(upper) and Wii(lower). When I analyze the success factor of two game consoles, I understand that not only the change of the input device but also the know-how based on gamenics was important.

mid-1970s the anime industry was still in its infancy and somewhat open. That seems so unimaginable now.

What are some of the major projects you worked on?
A variety of projects, actually. I worked on the animation for the television show *Future Boy Conan* and the art and animation for the feature-length film *Lupin the Third: The Castle of Cagliostro*, both of which were directed by Hayao Miyazaki. From *anime* I moved on to animated commercial film production and started doing direction work for Suntory and Meiji Seika when I was in college.

When did you get involved with games?
Also when I was in college. In 1985 I started working part time as an artist and game designer for a game studio called HAL Laboratory. I worked there with Satoru Iwata, the president and CEO of Nintendo, who was a programmer at the time. We worked on a number of NES games together. I also did some part-time work as an editor for ASCII Corporation. And I was involved with the publication of the PC magazine *Roguin* (Login) from its inception and *Famikon Tsūshin* (Famicom Journal) in 1986.

Why did you move from commercial film production to game production?
Primarily because of Mr. Iwata. When we were working together he was always so upbeat and good at praising others, which is a major reason why Iwata later became the president of Nintendo. Second, the fields of *anime* and CF visual production have a long history, and as a result there is something like an apprentice system already in place. Film making methodology is already established, and it isn't an environment in which younger artists can make unique projects. However, the videogame industry was very open when the NES was the major console, which is characteristic of media still in an early stage.

You established your own game studio in 1991, right?
That's right. I set up a game studio called Dice in 1991 with Iwata's help. I initially worked on the development of Super NES and Game Boy games meant for overseas markets. Some of the major projects I worked on include the fishing game Itoi Shigesato no Bass Tsuri No. 1, Definitive Edition for the Nintendo 64 and SimCity 64 (Nintendo) for the 64DD. Other than games for Nintendo, I was also involved with the development of the Game Boy Advanced edition of Sega Rally (Sega Corporation) and Gunparade Orchestra (SCE) for the PS2. I was the producer and director for these projects.

Why did you decide to do academic work focusing on gamenics theory rather than continue with game development?
I actually didn't initially enter the videogame industry because I liked playing and making games. I started making games because of Iwata's influence and the appeal of the open-minded environment associated with games. That's why I became

aware of the limits of being a game creator relatively early into my career. Games like *Mario Kart* and *Super Smash Bros.* that enjoy worldwide success could never have been made by me, because I cannot fathom what makes them so interesting to others. I'm very different from other game creators in this way.

Actually, the games that I made received very high marks from Super Mario Club. *Itoi Shigesato no Bass Tsuri No. 1, Definitive Edition,* for example, once received the highest class game rating from Super Mario Club. But it didn't break any records in terms of sales.

Super Mario Club is the organization that conducts debugging tests and quality assurance for Nintendo, right?
That's right. I don't know how they handle things overseas, but at Nintendo Japan a game used to be evaluated extensively at Super Mario Club during the final stages of development by letting numerous testers play the game from the perspective of a broad demographic. If a game didn't receive above a certain score, it wasn't sold as a Nintendo game. Some of the things they took into special consideration when assigning their evaluations were: "Can anyone play the game without reading the manual?" and "Can anyone get absorbed in the game for long periods of time while they are playing?" They subjected games to very rigorous tests, and then sent them back with all sorts of comments. It was also possible to have the review checked by a third party if desired.

Those last two standards are the same as the objectives of gamenics.
True. Again, I'm not sure how they develop games in Europe and the United States, but UIs for Japanese games have been made comparatively well for quite some time now. One reason for this is that Nintendo's principles for making games with a player's intentions in mind gradually spread to third parties through Super Mario Club. Like I said before, gamenics theory is based on my organized understandings of the know-how I acquired when I developed games for Nintendo.

So even though my games were especially well made in terms of gamenics, they weren't hits, perhaps because the game design ingenuity was insufficient. It was at about that time when I began to see myself as someone who develops gamenics products and services rather than as a game creator, which is why I broke off from Nintendo. Then again, if I had stayed at Nintendo, I might have had a chance to work on touch generation DS games and *Wii Fit*.

Are you glad that you left the gaming industry?
I am. Another reason is because game design theory is more established now and the open environment of the game industry isn't the same as back in the day of the NES, because organizational power for PS3 and Xbox 360 game development is so important now. I'd rather challenge myself by coming up with new forms of media like we did when the NES dominated the industry by developing products and doing research based on gamenics theory. That's why I went from game development to academics.

23.3 The Two Objectives and Four Principles of Gamenics

I think this is a good place for you to give an outline of gamenics theory.
OK. Gamenics theory has two objectives: *intuitive operability* and *gradual learning curve*. In both cases this means that users can "intuitively and instinctively know how to operate something without reading a manual," and "gradually and naturally learn to understand complicated contents without becoming stressed."

These two elements were especially important to NES, since it was originally designed for kids, right?
Exactly. And gamenics also has four principles, each of which are further subdivided.
The Four Principles of Gamenics:

1. Intuitive user interface (emphasizing ease of use)
2. Operability that does not require a manual (designed so that users are not confused about what they can do)
3. Engaging choreography, gradual learning curve (devices that promote enthusiasm)
4. Beyond gaming (links things to reality so they seem real)

(*Editors' note: It may be helpful to readers to think of the gamenics principles as a class of heuristics for good game user interface design. For more information about heuristics, see Chapter IIC.*)

Would you mind briefly explaining each of these principles?
Sure. And I'll use actual games as examples so that they're easier to understand.
The first principle is basically about making things "easy to use." Remember *Space Invaders* (Taito Corporation)? That game was designed so well that people intuitively knew how to play it. On the *Space Invaders* game machine there was a joystick that moved left and right and was outfitted with a single button. The object of the game was to destroy all the "invaders" descending from the top of the screen by operating the "gun battery" at the bottom of the screen. When the game starts the invaders shoot bullets as they edge their way down toward the bottom of the screen. Do you remember how to play the game?

Move the gun battery left and right with the joystick and attack the invaders by shooting missiles with the button, right?
That's right. A player knew how to play the game by just looking at the screen and control panel. It was this relationship between the screen and the controller that made *Space Invaders* such a skillfully created game. And it's important to remember that this was an arcade game. No one would have kept playing the game if they inserted a coin only to die without figuring out how to play. This is a good example of the first principle, "intuitive UI." The same point could be made for the world's first videogame, *Pong!*

The second principle is "operability that does not require a manual." In short, these are mechanics that "ensure users will not be confused about what they can do." You could say that this is about workings that allow a user to understand intuitively not only what is on the screen, but also the game rules and systems built into what is displayed. Remember how *Super Mario Bros.* (Nintendo) starts?

©1985 Nintendo
Super Mario Bros. (1985, Nintendo). The first sequence of Super Mario functions as the main tutorial.

Sure. A couple of goombas start walking toward Mario from the right side of the screen, which you have to avoid, and Mario hits a block from below to get the Super Mushroom and other power-ups.
Right. This opening scene is a very well made tutorial for the entire Super Mario Bros. game. The game's basic actions are summarized in the following three actions, all of which can be experienced in this scene:

1. Move toward the right through the levels to reach the goal within a certain time limit while evading the enemy characters,

2. Mario jumps when the A button is pushed,

3. Gain items by smashing blocks (Mario will get bigger or gain stronger attacks when obtained).

The fact that these fundamental actions can be learned while playing the game for just 30 to 60 seconds is one of the strong points of *Super Mario Bros.*, and is a good example of the second principle.

The third principle has two elements, "engaging choreography" and "gradual learning curve," right?
Yes. The two are interrelated and difficult to separate. By "engaging choreography" I mean the attempt to hold a player's attention by using choreographed animations and sound effects in timely manner and devices to get players to feel a sense of accomplishment when they collect items and level up. By "learning curve" I mean techniques that encourage a player to push on until they achieve their goal by gradually raising the difficulty level or having them discover new things on their own.

So in other words, engaging choreography would lead to boredom and "learning curve" would feel too much like school if one were utilized without the other?
Right. But when the two are used together, players will get engrossed in a game. Take *Dragon Warrior 1* (Square Enix Co., Ltd.), for example. It's not known very well overseas, but it was a huge hit in Japan and has influenced a number of other RPGs.

Dragon Warrior 1 moves forward by alternating between "exploration" and "battles." This cycle corresponds with "engaging choreography." Battles are exciting, but they are flat on their own. Likewise, exploration is intellectually stimulating, but it's boring if that's all there is. By alternating between the two, however, game play becomes well modulated and doesn't easily lead to boredom. But with *Dragon Warrior 1*, the accents and changes are directed so as to have very fine modulations by altering the screen structure and music tempo for the battle and exploration modes.

Is it important to combine animation, background music, and special effects carefully?
Exactly. When playing an RPG, for example, the player has to open and close the same windows thousands and thousands of times. So it is imperative that the animation and sounds for these actions are choreographed so as to be swift and rhythmical, thereby reducing operational stress. That way it's possible to design a UI that is fun to use just by pushing buttons.

A good example for explaining "learning curve" is spell names. In *Dragon Warrior 1* the healing spells, for example, are structured so that weakest spell is called "hoimi,"

the intermediate spell "behoimi," and the strongest spell "behoma." As a result a player can infer a spell's effect by the name alone when their character acquires it.

The learning curve is also very well designed for the objectives of this game. As soon as a player starts *Dragon Warrior 1*, for example, the final objective, the "Dragonlord's castle," is displayed on the screen. But the Dragonlord's castle is protected by a channel of water and you can't get there until your character travels around the world. So as soon as you start the game, the end goal, the "main objective of the game, is clear.

Also, in order to overcome the Dragonlord, a player's character must bring down lower-level enemies, level up, gather money and get well equipped. These are the "minor objectives" of the game. And there are secret underground passages, powerful items, and various puzzles and devices placed throughout the world. These are "intermediate objectives." Among all of these, the "major" and "minor" objectives are necessary for completing the game, while the "intermediate objectives" are those that the player can choose on their own. It is for these reasons that a player will feel as if they're always moving toward a self-imposed objective as they progress through the game.

So, a player is directed to achieve the goal without knowing it?
Right. And it's especially important that the game isn't too pushy, because a player will get bored if they feel they are being forced along. That's why it's possible to get a player completely absorbed in a game without boring them by carefully placing a sequence of minor, intermediate, and major objectives throughout the game.

So far we've been talking about the first three principles. The first and second principles are "ease to use" and "users not getting confused about what they can do." The third principle is about "getting a user absorbed." It's possible to get a user "engrossed" by utilizing all three of these in tandem.

Is the fourth principle, "beyond games," different from these three?
Yes. The fourth principle denotes the relationship between games and the real world. This relationship works in two directions: "bringing the entertainment value of a videogame into the real world" and "magnifying the real world in a game's universe."

The former is about applying in-game experience to the real world. For example, with *Brain Age* a player can make the age of their brain younger as they play or lower their BMI by playing *Wii Fit*. Similarly, *Speak! DS Cooking Navigator*, which is not scheduled for release overseas yet, shows players how to make actual recipes. The "incentive," in this case, is the dish itself and seeing the whole family enjoy eating it.

In contrast, the latter can be exemplified by a number of games that are based on things in reality, such as sports and simulation games. *Pro Yakyū Family Stadium* (Namco Bandai Games, Inc.) is a good example of this.

© 2007 NBGI

Pro Yakyū Family Stadium (1986, Namco Bandai Games, Inc.) exaggerated the elements of real professional baseball well and succeeded in evoking a quality of realism more than previous baseball games (image shows Pro Baseball Netsu Stadium 2007 (PS2) in "Family Stadium" mode).

That was one of the best-known games sold for the NES in Japan, right?
Yes. The rules of the game are based on those of real baseball. However, the graphics and movements were simplified due to the limitations of the NES. The greatest difference is with the game length. Rather than take more than three hours like a real baseball game, a session of *Pro Yakyū Family Stadium* ends in about 20 to 30 minutes. No one got bored with the game and it went on to become a big hit, because it condenses and enhances the appeal of real baseball. The same can be said for soccer and golf games that are well made.

Just making them look real doesn't mean they will have wide appeal.
Exactly. Players don't want videogames that will feel as real as reality. The important point is to choreograph an "extra-real" experience by abstracting and enhancing reality well.

23.4 Enhancing Button Reliability

I understand that the fourth principle can be broken down even further. Could you talk about this a little?
Sure. At present there are about sixty subcategories, and I am still coming up with more. For example, "screen design" categories are different for a "directional pad"

and a "mouse" because suitable conditions change depending on the device. I based this on my own experiences making games, so it is nothing more than a hypothesis at this point, but I plan to move on to experimental studies soon.

Could you describe some of the more important articles?
Sure. I can talk a little about "button reliability," a subcategory of the second principle.

Games are very complicated now, and it's possible to do all sorts of actions with a game. Because there's a limit to how many buttons a controller can have, however, it's necessary to assign functions and actions to specific buttons so that players can intuitively operate the controller. So "button reliability" is about the degree to which players internalize the relationship between the buttons and certain actions.

If buttons have a high reliability, it is easy for players to infer what will happen if they push a button and to try various other functions. And when a player gets confused, they can easily go back. Conversely, if the button reliability is low, players will easily be confused about operations and will gradually lose interest in trying to figure out all the functions. So in order to raise a player's desire to operate something, it's extremely important to maintain a high level of button reliability.

Could you explain how this is done?
It's important to make button operations consistent between game modes and deployment. At the most fundamental level, the A button should always be the "select" button and the B button the "cancel" button. The A button should always operate basic character actions, open windows, select, and navigate hierarchical menus, and the B button should always be for supplemental actions, closing windows, cancelling, and returning to hierarchical menus.

Like how the A button is for jumping and the B button is for dashing and shooting fireballs in Super Mario Bros?

See Figure in Next Page.

Right. And operational conventions such as navigating menus with the directional keypad, selecting with the A button, and cancelling with the B button came into use for the first time with Dragon Warrior 1. This became the de-facto standard in Japan as games got more complicated, and for the first time players could start playing games right away without getting confused about the operations.

And this has remained the case even as the number of controller buttons increases. It's especially important that the B button remain the cancel button. In Japan the ○ button on the PlayStation is always for "select" and the × button is always for "cancel." It's the opposite overseas, but their functions are fixed as well. This is normal for videogames, but surprisingly there are a lot of commercial electronics that don't do this.

Like mobile phones and DVD recorders?
Those two are representative of household electronics with low button reliability for sure. Like game controllers, space is limited on mobile phones, and it's difficult to

In Super Mario, pressing the A button performs the main action, and pressing the B button performs the assistant action. This allows us to perform complicated actions such as swimming (top), or jumping (bottom) intuitively.

increase the number of buttons for other functions. That's why hierarchical menus are utilized, but there are still too many different buttons for "cancel" depending on the mode. There are too many buttons on DVD recorder remotes and the button for canceling is not fixed, so they are impossible to operate without looking at them like you can with game controllers.

The iPod, on the other hand, is an example of good operability. The design of the iPod controller is very similar to the NES. The basic operation of the current iPod is that you can move up and down through a menu with the touch wheel, the right button (fast forward) opens hierarchical menus, the left button (rewind) backs out of hierarchical menus, and the down button (play/pause) plays music. The hierarchical menu screen design and button functions are exactly the same as the methodology for the NES. The sensation of operating the touch wheel as it emits pleasant sound effects is similar to the pleasure associated with using a game console, and is enough to make the user feel happy.

The combination of the touch wheel and the hierarchical menu of the iPod is very similar to the screen operation with the cross button and A, B buttons of the NES (Nintendo Entertainment System).

Ah, that's an interesting analogy.
I think it was inevitable that the controls used to navigate thousands of music files stored on a hard drive would develop into something similar to the "choose

with directional pad, select with the A button, and cancel with the B button" method.

How would you analyze the iPhone and iTouch UIs using gamenics theory?
The iPhone isn't for sale in Japan, but I have an iTouch and love it. It has photos and movies of my kids, and I can take them with me wherever I go. In terms of the first principle, "intuitive UI," it's excellent. And the device and software are integrated very well. I showed my iTouch to my mother-in-law once, and I was so surprised when she started browsing through the albums loaded on it without any explanations about how to use it. And she's seventy-eight years old! It employs animation and is fun to play with.

Using the touch screen of the iPhone is very comfortable. It is because the device and software are integrated very well just as in a videogame.

Meaning that it adopts of the third principle "engaging choreography."
That's right. But operation simplicity is suddenly lost and a product becomes difficult to use, if you have to go deep in a hierarchical menu to try a complicated operation. In terms of gamenics theory, the product would be "broad in scope, but shallow in use."

Another example would be Sony's XMB (Cross Media Bar), which is very well thought out. It was designed for home electronics by applying the accumulated UI

technology originally designed for PlayStation game development and is now used for notebook computers, DVD recorders, and Digital High-Vision TVs. Of course, it's also used for the PS3. That's why it's easy to link a DVD recorder to a PSP and transfer recorded programs from one device to the other. I think people who are accustomed to how the PlayStation operates can just look at the screen and know what to do.

The UI technology of the Play Station is converted into the XMB (Cross Media Bar) of the Sony product (picture shows Aplicast on Sony's High-Vision TV Bravia).

Multitasking has also become very common. Due to our "multi-gadget" life-styles, whereby people use multiple digital gadgets in combination, it's necessary that basic operations be the same. I think that's why the XMB occupies such a favorable position. Apple, in the same way I think, want the iPhone or iTouch to be able to control the information of all digital components.

Any other interesting examples of products that utilize or extend gamenics?
There is a monitor that was developed by Nissan called the multifunction meter, which is loaded on their new GT-R and adopts the essence of games. Polyphony Digital, which is the famous development studio that makes the *Gran Turismo* game series, was in charge of the planning and design and developed the monitor in collaboration with Nissan Motor Company.

Polyphony Digital (developers of Gran Turismo) developed the multi-function meter of the new model GT-R jointly with Nissan.

Is game technology reflected in the same way as with the XMB?
Yes. Until now, speedometers and engine meters could only display information based on occasional readings, but the multifunction meter monitor can display information based on time series readings. It can show g-forces when the car turns, speeds up, and brakes using a time-based line graph display. Compared to the standard way of producing information, this is an example of how the fun of driving can be increased by adding a time axis to the equation. Products that apply gamenics don't require efficient operation, but they increase pleasure and bring new meaning to current products by adding a new axis.

And that new "axis" sometimes has an "entertainment" value to it?
That's right. It might be an axis associated with "joy," or it might be quantitative like "time," which I have already mentioned. The point is to know how to integrate a "new axis" when producing a gamenics product. For example, there was once an idea to add a sensitivity axis to car navigation systems. There were navigators on sale that used voice input technology to analyze the content and tone of a driver's speech, determine how they are feeling, and suggest a course. Unfortunately, the product wasn't successful, but it was a start.

A mobile phone that gradually adds functions beginning with the easiest ones the more a user uses it might be a good idea. Like games, it could display the parameters for mastering its use, and would need a "hide command" function as well. People who want to use all of the functions from the start should be able to turn this function on and off in the menu. All of this is normal for games, of course.

It's been said that one of the reasons it's difficult for the gaming industry to collaborate with other fields is that the cultures are so different. Taking this into consideration, what would be required in order to actually develop a gamenics product?
The main cultural differences between game and home electronics development is that one builds things by trial and error while the other does so according to certain specifications. It's often said that home electronics engineers have to build things according to certain specifications, and to make an enhancement they have to start with the specifications. That's its culture. It would be impossible to make a gamenics product in this way for budgetary reasons. It's necessary to understand this difference.

And it's important to develop a good balance between hardware and software for a gamenics product. The Nintendo game console is a good example of this. One might say that software exercises some control over the development of hardware. So it's important to have a systems integration programmer who can understand gamenics sense.

Is that difficult for game programmers?
Not if the programmer is interested in gamenics products. But since the final product is not a game, the programmer won't be satisfied if they just want to make games. That's why I think it would be more effective to have systems programmers work on gamenics products. Also, since today's systems programmers were raised

playing games, they won't react negatively to gamenics and they will understand how it works perceptually.

23.5 Current Projects

What sort of projects are you working on now? What sort of research are you doing as a professor in the College of Image Arts and sciences at Ritsumeikan University?
I published two books last year, *Nintendō DS ga ureru riyū: gēmunikusu de intāfēsu ga kawaru* [Why the Nintendo DS Sells: How Gamenics changes the Interface (Shūwa System) and *Gēmunikusu riron to wa nani ka* [What is Game-nics Theory] (Gentosha), and with those books I was able to present an overview of gamenics theory. But everything is theory at this point, and I don't have the data to back up my ideas yet. My goal this year is to move on to empirical testing. I am scheduled to work on this with Masayuki Uemura, who came to Ritsumeikan as a professor after retiring from Nintendo, where he led the development of the NES and Super NES systems.

I'll also be doing gamenics related research beginning this spring with Professor Kōhei Komago of Kansai University of International Studies. Professor Komago specializes in behavioral studies, and works on the relationship between blinking and psychological states. We are scheduled to conduct psychological studies of UIs based on gamenics using his research.

Other than that, there are also plans to create basic criteria called the gamenics method in collaboration with major advertisement agencies. Ritsumeikan authorizes the extent to which gamenics methods are reflected in products such as mobile phones. The details haven't been settled yet, but I hope this is going to be a standard for good UIs.

The Possibilities of Gamenics
Lastly I was hoping you could say a few things about the possibilities of gamenics.
I've used this example a number of times, but I'll start with the field of digital home electronics. Although the functionality of current digital home electronics like DVD recorders and flat-screen televisions is increasing, the operability is perfunctory and most people cannot use them very well. On the other hand, we cannot compete with emerging countries from a cost perspective by making a product with simple functions. That's why companies try to discriminate products based on appearance or by increasing brand awareness, but that's not a real solution. Products should be made with gamenics UIs so that they are easy to use by anyone, young and old alike, and can include a large number of functions.

Mobile phones are a typical example of products that have multiple functions. In addition to the communication functions, Japanese mobile phones also include an Internet browser, camera, television reception, virtual money economic function, play music, and increasing function more as an information handset.
That's true. For those who have one, the monitor on their mobile phone is the "gateway to the world." Mobile phone monitors must have a display that is as exciting

as that of a game, but they don't. Makers are mistakenly focusing on multifunction-ality instead of whether or not a phone is "exciting to operate." It should be more like what Iwata and Miyamoto at Nintendo often say: "the user is king." I want other companies to learn this from Nintendo.

We're entering an era when every house will have a home server, and people will use a network with multiple digital home electronics. With a television hooked to the internet, you can search for resort information and send maps to the car navi-gator before heading out. But if each operation system is not integrated at this time, things won't work together smoothly. The operation network of home electronics must be integrated into a single system for gamenics theory to be applicable.

The field of medicine is also adopting game technology. It is well known that the home version of Konami's dancing game *Dance Dance Revolution* is being used at West Virginia State University to prevent obesity in children. The Wii Fit is a huge hit in Japan, and it will be an even bigger hit once it's released overseas. There is plenty of potential for health products that utilize gamenics theory.

23.6 Japanese Culture and Gamenics

Gamenics theory harbors all sorts of possibilities. And the fact that it was created in Japan makes it is unique, too. What made this possible?
Videogames were invented in the United States and later imported to Japan, where they have developed into an independent form. Japanese games are gradually being exported overseas now. But lately European and American developers are getting very good, and the share of Japanese games in the global market is shrinking. Do you know what game reversed the position of the Japanese gaming market in rela-tion to the United States?

Space Invaders (Taito), right? It wasn't just a huge hit in Japan, though. It was later reworked for the Atari 2600 and went on to be a greatly influential game.
That's true. What's so special about this game is that it was the first Japanese arcade game with a platform loaded with a CPU. As a result, it was different from other games that were designed with TTL circuits, and it was easy to fine tune the game by improving the programming. It came at a time when more attention was being paid to software rather than hardware and it was possible to do things from trial and error, which is when Japanese game design became so cutting edge.

I mentioned this at the beginning of the interview, but the essence of what makes a game interesting is a cyclical fluctuation between stress and pleasure. In order to do this, we need to deal with human mentality and have a fine sensibility. But that's not all. In order for pleasure to be conveyed to a player appropriately, a UI must be thought out in detail. And in order to be realized on a system with low powered hardware like the NES, it is necessary to place more emphasis on software develop-ment. By predicting player psychology, it's possible to hide help information and to make button operation more fun, add choreographed animations and special effects.

It's for that very reason that the NES was such a huge hit all over the world, right?
Exactly. A basic way to think about gamenics theory is that it's about making software so that players will be able to predict what they are supposed to do without feeling any stress about performing the action. This idea is closely related to traditional Japanese hospitality that is evident in the tea and flower arranging arts. In Japan, the birthplace of this hospitality culture is Kyoto. Nintendo was born in Kyoto, and the company takes great pride in this culture. I think that's why Nintendo was able to make the NES the way it is.

On the other hand, there are a lot of games made in Europe and the United States that have great user interfaces. Games like Gears of War *and* God of War *have enjoyed high reviews from Japanese game developers. I feel like they have analyzed the good points of Japanese game UIs and applied them well to their own games.*
That's because gamenics know-how, which was developed in Japan, has started to spread throughout the world. *Super Mario Bros.* and *Pokémon* are major world hits, meaning that user interfaces based on gamenics theory have spread throughout the world.

© 1985 Nintendo
The know-how of Gamenics from Japan spreads throughout the world as Japanese videogames evolve.

Gamenics theory will expand products and services in the global market as it is applied to more fields outside of the gaming industry, and what's important will

be revealed in the process. The gaming era will continue to influence global consumption for years to come. The key for game development know-how to transcend nation and culture is for game developers to do what they think is fun. This shows that the application of gamenics to more fields outside of videogames is important for the development of products and services in the world market. The gaming generation will dominate global consumption for years to come, and I am sure that game developers would be very happy if game development know-how turns out to be the key to transcending nation and culture

Thank you very much.

Index

CELEBRATE AMERICA

IN POETRY AND ART

"WE ARE NOT AFRAID..."

KENNETH JOSEPHSON

We are not afraid to entrust
the American people with
unpleasant facts, foreign
ideas, alien philosophies, and
competitive values. For a nation
that is afraid to let its people
judge the truth and falsehood in
an open market is a nation that
is afraid of its people.
— **John F. Kennedy**

CELEBRATE AMERICA
IN POETRY AND ART
EDITED BY NORA PANZER

PAINTINGS, SCULPTURE, DRAWINGS, PHOTOGRAPHS, AND OTHER WORKS OF ART
FROM THE NATIONAL MUSEUM OF AMERICAN ART,
SMITHSONIAN INSTITUTION

PUBLISHED IN ASSOCIATION WITH THE
NATIONAL MUSEUM OF AMERICAN ART, SMITHSONIAN INSTITUTION

HYPERION PAPERBACKS FOR CHILDREN

NEW YORK

FOR DAVID, JOANNE, JAMIE, AND CAROLYN

ACKNOWLEDGMENTS

I wish to thank Elizabeth Broun, director of the National Museum of American Art, and Steve Dietz, chief of publications, for their encouragement of this project; Melissa Hirsch, museum editor, Debbie Thomas and Claudine Tambuaco, museum editorial assistants, for helping to bring this book to fruition; and the museum's curatorial and education staffs, along with those docents and interns, all of whom have given generously of their time.

<div align="right">—N.P.</div>

Smithsonian
National Museum of American Art

© 1994 by the Smithsonian Institution
First Hyperion Paperback Edition 1999
The individual copyright holders for the illustrations and text are listed on pages 93-94, which constitute an extension of this copyright notice. All possible care has been taken to trace the ownership of every selection included and to make full acknowledgment.

1 3 5 7 9 10 8 6 4 2
Library of Congress Cataloging-in-Publication Data
Celebrate America: in poetry and art/edited by Nora Panzer-1st ed.
p. cm.
"Published in association with the National Museum of American Art, Smithsonian Institution"
Includes index
Summary: A collection of American poetry that celebrates 200 years of American life and history as illustrated by fine art from the collection of the National Museum of American Art.
ISBN: 1-56282-664-4 (trade)-ISBN 1-56282-665-4 (lib. bdg.)-ISBN 0-7868-1360-1 (pbk.) 1. America-Juvenile poetry. 2. Children's poetry, American. 3. United States-Juvenile poetry. 4. America in art-Juvenile literature. 5. United States in art-Juvenile literature. [1. United States-Poetry. 2. American Poetry-Collections. 3. United States in art.] I. Panzer, Nora. II. National Museum of American Art (U.S.)
PS595.A43C431994
811.008'03273-dc20 93-32336

The National Museum of American Art, The Smithsonian Institution, is dedicated to the preservation, exhibition, and study of the visual arts in America. Its publications program includes the scholarly journal *American Art*. The museum also has extensive research resources: the databases of the inventories of American Painting and Sculpture, several image archives, and a variety of fellowships for scholars. The Renwick Gallery, one of the nation's premier craft museums, is part of the NMAA. For more information or a catalog of publications, write: Office of Publications, National Museum of American Art, Smithsonian Institution, Washington, D.C. 20560.

CONTENTS

SUN

ARTHUR DOVE

PREFACE

By paying visual and poetic tribute to the shared experience of the American people, past and present, this book celebrates America. Today, when our country is more ethnically diverse than at any other time in history, there is a great need for us to be aware of America's unique cultural heritage.

It is fitting, then, that we turn to our nation's poets and visual artists to chronicle the events, rites, and rituals we share as Americans. The works of art and poetry in this book were chosen to represent both genders as well as a range of ethnic groups, social and economic classes, regional styles, and historical periods. The paintings, prints, photographs, and folk art do not merely illustrate the poems, nor do the words of the poems merely explain the pictures. Together they form a kind of synergy, creating a complementary way of expressing, with joy or sorrow, longing or despair, sensuality or reason, humor or anger, the dynamic rhythms of American life.

Walt Whitman, one of the greatest poets to celebrate America, holds a special significance for the National Museum of American Art. During the Civil War the building that now houses the museum was used as a makeshift hospital, and it was here that Whitman came to tend the wounded and to read his poetry in the evenings. More

than a century ago he wrote words that eloquently express the intention of this book and have inspired me to marry poetry and art in a collection: "The Americans of all nations at any time upon the earth," he said, "have probably the fullest poetical nature. These United States are essentially the greatest poem."

Just as Whitman's poetry revels in all of America, Tato Laviera's lighthearted "AmeRícan," written in 1981, celebrates the pride of newly arrived Puerto Ricans and their part in the creation of yet another national identity in the barrios of bustling New York City. Laviera writes, "[W]e gave birth to a new generation, / AmeRícan salutes all folklores, / european, indian, black, spanish, / and anything else compatible."

Yet our greatest poetry can also critique as well as celebrate. It can give voice to protest or praise what has been ignored or denied. Langston Hughes lifts his voice in "I, Too" to speak about the racism and neglected promise of the American dream for African Americans. Gloria Anzaldúa, in "To live in the Borderlands means you," recounts how as a Mexican American you live *sin fronteras,* or "without borders." You carry all five races of your Mexican-American heritage on your back and are not grounded in any one. Mark Van Doren's prophetic poem "I Went Among the Mean Streets" recalls images of fear and violence, the "thieves of joy" that haunt America's cities.

Our visual artists, too, provide us with provocative insights into our society. Their treasured views of American faces and places document the appearance of our people and interpret our changing land from colonial times to the present. Helen Lundeberg's powerful image of pioneers facing west, William H. Johnson's brightly colored scenes of Harlem in the 1930s, and Norman Chamberlain's depiction of a corn dance in a Taos pueblo are just a small sample of what awaits you as you browse through this book.

The book is divided into five sections to allow us to see how poets and artists are often inspired by common experiences. There are many ways of looking at the same world and many ways of expressing intimate, personal reactions to it. The sections focus on America's natural landscapes, the lineages of its people, the building of its cities and towns, its history of struggle and protest, and the many tempos of its everyday life.

I am very grateful to have had the expert advice of Ethelbert Miller, Indran Amirthanayagam, Heid Erdrich, and Virgil Suárez. They each provided invaluable assistance in researching and selecting poetry for this book. By offering a broad sampling of the country's poetry and art, I hope to unite all readers in a shared understanding of our nation—to celebrate America.

—NORA PANZER

Chief, Office of Educational Programs
National Museum of American Art

7

AMONG THE SIERRA NEVADA MOUNTAINS, CALIFORNIA

ALBERT BIERSTADT

A
PLACE
OF
EAGLES

from
AMERICA THE BEAUTIFUL

KATHARINE LEE BATES

O beautiful for spacious skies,
 For amber waves of grain,
For purple mountain majesties
 Above the fruited plain!
 America! America!
 God shed His grace on thee
And crown thy good with brotherhood
 From sea to shining sea!

MIST IN KANAB CANYON, UTAH

THOMAS MORAN

LEGACY

MAURICE KENNY

my face is grass
 color of April rain;
arms, legs are the limbs
 of birch, cedar;
my thoughts are winds
 which blow;
pictures in my mind
 are the climb uphill
 to dream in the sun;
 hawk feathers, and quills
 of porcupine running
 the edge of the stream
 which reflects stories
 of my many mornings
 and the dark faces of night
 mingled with victories
 of dawn and tomorrow;
corn of the fields and squash . . .
 the daughters of my mother
 who collect honey
 and all the fruits;
meadow and sky are the end of my day
 the stretch of my night
 yet the birth of my dust;
my wind is the breath of a fawn
 the cry of the cub
 the trot of the wolf
 whose print covers
 the tracks of my feet;
my word, my word,
 loaned

legacy, the obligation I hand
 to the blood of my flesh
 the sinew of the loins
to hold to the sun
and the moon
which direct the river
 that carries my song
 and the beat of the drum
to the fires of the village
 which endures.

RIVER BLUFFS, 1320 MILES ABOVE ST. LOUIS

GEORGE CATLIN

THE FAREWELL

BERNARD PERLIN

IN HARDWOOD GROVES

ROBERT FROST

The same leaves over and over again!
They fall from giving shade above
To make one texture of faded brown
And fit the earth like a leather glove.

Before the leaves can mount again
To fill the trees with another shade,
They must go down past things coming up.
They must go down into the dark decayed.

They *must* be pierced by flowers and put
Beneath the feet of dancing flowers.
However it is in some other world
I know that this is the way in ours.

NIAGARA

CARL SANDBURG

The tumblers of the rapids go white, go green,
go changing over the gray, the brown, the rocks.
The fight of the water, the stones,
the fight makes a foam laughter
before the last look over the long slide
down the spread of a sheen in the straight fall.
 Then the growl, the chutter,
 down under the boom and the muffle,
 the hoo hoi deep,
 the hoo hoi down,
 this is Niagara.

NIAGARA

GEORGE INNESS

MONUMENT VALLEY, NATIONAL MONUMENT, ARIZONA

LEN JENSHEL

THE MONOLITHS

N. SCOTT MOMADAY

The wind lay upon me.
The monoliths were there
in the long light, standing
cleanly apart from time.

FAIRY RING #2, FENT'S PRAIRIE

TERRY EVANS

from
A DAKOTA WHEAT-FIELD

HAMLIN GARLAND

Like liquid gold the wheat-field lies,
　A marvel of yellow and russet and green,
That ripples and runs, that floats and flies,
　With the subtle shadows, the change,
　　　the sheen,
　　That play in the golden hair of a girl, —
　　A ripple of amber — a flare
　Of light sweeping after — a curl
In the hollows like swirling feet
　Of fairy waltzers, the colors run
　To the western sun
Through the deeps of
　　　the ripening wheat.

TO MAKE
A PRAIRIE

EMILY DICKINSON

To make a prairie it takes a clover
　　and one bee,
One clover, and a bee.
And revery.
The revery alone will do,
If bees are few.

WHEAT

THOMAS HART BENTON

AT SEA

JEAN TOOMER

Once I saw large waves
Crested with white-caps;
A driving wind
Transformed the caps
Into scudding spray—
"Swift souls," I addressed them—
They turned towards me
Startled
Sea-descending faces;
But I, not they,
Felt the pang of transience.

HIGH CLIFF, COAST OF MAINE

WINSLOW HOMER

DRUMBEAT

CAROL SNOW

Listen.
There! Do you not hear them?
Come away from your overcrowded city
To a place of eagles
And then perhaps you will hear.
Be still this once;
Hold the yammering
of your jackhammer tongue.
Take your stainless steel hands
From the ears of your heart

And listen.
Or have you forgotten how?
They are there yet
Through these hundred centuries
And all your metal thunder
Has not silenced them.
The wind is messenger,
Heed the whispering spirit.
Now. . . . the drums still talk,
From the grizzly bear hills,
Across the antelope plains,
In the veins of your blood:
The heartbeat
Of the Mother Earth.

FALL IN THE FOOTHILLS

W. HERBERT DUNTON

WILD WEST

EMIL ARMIN

THE ROAD TO TRES PIEDRAS

LEO ROMERO

what a lone lonely
road
stretching out
ever winding away
with spreading fields
around it
with the vastness of an outdoor
sky around it
lonely lone road
away away
to a needle's point
on a remote horizon

A CLIFF DWELLER'S
CEREMONY, COLORADO

WILLIAM HENRY HOLMES

REMEMBER THE SKY YOU WERE BORN UNDER

EMPTY KETTLE

LOUIS (LITTLE COON) OLIVER

I do not waste what is wild
I only take what my cup
 can hold.
When the black kettle gapes
 empty
and children eat roasted acorns
 only,
it is time to rise-up early
 take no drink—eat no food
 sing the song of the hunter.
I see the Buck—I chant

I chant the deer chant:
 "He-hebah-Ah-kay-kee-no!"
My arrow, no woman has ever touched,
 finds its mark.
I open the way for the blood to pour
 back to Mother Earth
 the debt I owe.
My soul rises—rapturous
 and I sing a different song,
 I sing,
 I sing.

BUFFALO DANCE, LEADER AND HUNTER

OQWA PI

LINEAGE

MARGARET WALKER

My grandmothers were strong.
They followed plows and bent to toil.
They moved through fields sowing seed.
They touched earth and grain grew.
They were full of sturdiness and singing.
My grandmothers were strong.

My grandmothers are full of memories
Smelling of soap and onions and wet clay
With veins rolling roughly over quick hands
They have many clean words to say.
My grandmothers were strong.
Why am I not as they?

PIONEERS OF THE WEST (detail)

HELEN LUNDEBERG

DREAMS NO. 2

JACOB LAWRENCE

DREAM VARIATION

LANGSTON HUGHES

To fling my arms wide
In some place of the sun,
To whirl and to dance
Till the white day is done.
Then rest at cool evening
Beneath a tall tree
While night comes on gently,
 Dark like me—
That is my dream!

To fling my arms wide
In the face of the sun,
Dance! whirl! whirl!
Till the quick day is done.
Rest at pale evening. . . .
A tall, slim tree. . . .
Night coming tenderly
 Black like me.

THE NEW COLOSSUS

EMMA LAZARUS

Not like the brazen giant of Greek fame,
With conquering limbs astride from land to land;
Here at our sea-washed sunset gates shall stand
A mighty woman with a torch, whose flame
Is the imprisoned lightning, and her name
Mother of Exiles. From her beacon-hand
Glows world-wide welcome; her mild eyes command
The air-bridged harbor that twin-cities frame.
"Keep, ancient lands, your storied pomp!" cries she
With silent lips. "Give me your tired, your poor,
Your huddled masses yearning to breathe free,
The wretched refuse of your teeming shore.
Send these, the homeless, tempest-tossed to me—
I lift my lamp beside the golden door!"

MISS LIBERTY CELEBRATION

MALCAH ZELDIS

WATER LILY (detail)

JOHN LA FARGE

I ASK MY MOTHER TO SING

LI-YOUNG LEE

She begins, and my grandmother joins her.
Mother and daughter sing like young girls.
If my father were alive, he would play
his accordion and sway like a boat.

I've never been in Peking, or the Summer Palace,
nor stood on the great Stone Boat to watch
the rain begin on Kuen Ming Lake, the picnickers
running away in the grass.

But I love to hear it sung;
how the waterlilies fill with rain until
they overturn, spilling water into water,
then rock back, and fill with more.

Both women have begun to cry.
But neither stops her song.

from
AmeRícan

TATO LAVIERA

we gave birth to a new generation,
AmeRícan, broader than lost gold
never touched, hidden inside the
puerto rican mountains.

we gave birth to a new generation,
AmeRícan, it includes everything
imaginable you-name-it-we-got-it
society.

we gave birth to a new generation,
AmeRícan salutes all folklores,
european, indian, black, spanish,
and anything else compatible:

AmeRícan, singing to composer pedro flores' palm
trees high up in the universal sky!

AmeRícan, sweet soft spanish danzas gypsies
moving lyrics la española cascabelling
presence always singing at our side!

AmeRícan, beating jíbaro modern troubadours
crying guitars romantic continental
bolero love songs!

AmeRícan, across forth and across back
back across and forth back
forth across and back and forth
our trips are walking bridges!

it all dissolved into itself, the attempt
was truly made, the attempt was truly
absorbed, digested, we spit out
the poison, we spit out the malice,
we stand, affirmative in action,
to reproduce a broader answer to the
marginality that gobbled us up abruptly!

AmeRícan, walking plena-rhythms in new york,
strutting beautifully alert, alive,
many turning eyes wondering,
admiring!

AmeRícan, defining myself my own way any way many
ways Am e Rícan, with the big R and the
accent on the í!

GIRL AT SPRINKLER

JOSEPH RODRIGUEZ

DAY OF THE REFUGIOS

ALBERTO RÍOS

In Mexico and Latin America,
celebrating one's Saint's day
instead of one's birthday is
common.

(detail, Bien Venida y Vaya con Dios)

I was born in Nogales, Arizona,
On the border between
Mexico and the United States.

The places in between places
They are like little countries
Themselves, with their own holidays

Taken a little from everywhere.
My Fourth of July is from childhood,
Childhood itself a kind of country, too.

It's a place that's far from me now,
A place I'd like to visit again.
The Fourth of July always takes me there.

In that childhood place and border place
The Fourth of July, like everything else,
It meant more than just one thing.

In the United States the Fourth of July
It was the United States.
In Mexico it was the *día de los Refugios*,

The saint's day of people named Refugio.
I come from a family of people with names,
Real names, not-afraid names, with colors

Like the fireworks: Refugio,
Margarito, Matilde, Alvaro, Consuelo,
Humberto, Olga, Celina, Gilberto.

Names that take a moment to say,
Names you have to practice.
These were the names of saints, serious ones,

And it was right to take a moment with them.
I guess that's what my family thought.
The connection to saints was strong:

My grandmother's name — here it comes —
Her name was Refugio,
And my great-grandmother's name was Refugio,

And my mother-in-law's name now,
It's another Refugio, Refugios everywhere,
Refugios and shrimp cocktails and sodas.

Fourth of July was a birthday party
For all the women in my family
Going way back, a party

For everything Mexico, where they came from,
For the other words and the green
Tinted glasses my great-grandmother wore.

These women were me,
What I was before me,
So that birthday fireworks in the evening,

All for them,
This seemed right.
In that way the fireworks were for me, too.

Still, we were in the United States now,
And the Fourth of July,
Well, it was the Fourth of July.

But just what that meant,
In this border place and time,
It was a matter of opinion in my family.

**BIEN VENIDA
Y VAYA
CON DIOS**

MARIA ALQUILAR

REMEMBER

JOY HARJO

Remember the sky that you were born under,
know each of the star's stories.
Remember the moon, know who she is. I met her
in a bar once in Iowa City.
Remember the sun's birth at dawn, that is the
strongest point of time. Remember sundown
and the giving away to night.
Remember your birth, how your mother struggled
to give you form and breath. You are evidence of
her life, and her mother's, and hers.
Remember your father. He is your life, also.
Remember the earth whose skin you are:
red earth, black earth, yellow earth, white earth
brown earth, we are earth.
Remember the plants, trees, animal life who all have their
tribes, their families, their histories, too. Talk to them,
listen to them. They are alive poems.
Remember the wind. Remember her voice. She knows the
origin of this universe. I heard her singing Kiowa war
dance songs at the corner of Fourth and Central once.
Remember that you are all people and that all people
are you.
Remember that you are this universe and that this
universe is you.
Remember that all is in motion, is growing, is you.
Remember that language comes from this.
Remember the dance that language is, that life is.
Remember.

FAN QUILT, MT. CARMEL

RESIDENTS OF BOURBON COUNTY, KENTUCKY

TRAIN IN COAL TOWN

JACK SAVITSKY

A GREAT PULSE BEATING

WESTERN WAGONS

ROSEMARY AND STEPHEN VINCENT BENÉT

They went with axe and rifle, when the trail was still to blaze,
They went with wife and children, in the prairie-schooner days,
With banjo and with frying pan—Susanna, don't you cry!
For I'm off to California to get rich out there or die!

We've broken land and cleared it, but we're tired of where we
 are.
They say that wild Nebraska is a better place by far.
There's gold in far Wyoming, there's black earth in Ioway,
So pack up the kids and blankets, for we're moving out today!

The cowards never started and the weak died on the road,
And all across the continent, the endless campfires glowed.
We'd taken land and settled—but a traveler passed by—
And we're going West tomorrow—Lordy, never ask us why!

We're going West tomorrow, where the promises can't fail.
O'er the hills in legions, boys, and crowd the dusty trail!
We shall starve and freeze and suffer. We shall die, and tame the
 lands.
But we're going West tomorrow, with our fortune in our hands.

WESTWARD THE COURSE OF EMPIRE TAKES ITS WAY

EMANUEL GOTTLIEB LEUTZE

FRONT PORCH

LESLIE NELSON JENNINGS

People who live in cities never know
 The creak of hickory rockers and the hum
Of talk about what happened years ago.
 Just sitting on the sunny side of some
Old house can bring us closer to events
 Than counting seconds, though the world says not.
If looking backward doesn't make good sense
 Tomorrow, then, may be as well forgot.

Those who planned farmsteads hereabouts took time
 Enough to square a beam and see it placed
A man of sixty wasn't past his prime
 And nothing worth a penny went to waste.
We can remember many things with pride,
Who built front porches neighbourly and wide.

INDEPENDENCE (SQUIRE JACK PORTER)

FRANK BLACKWELL MAYER

39

from
VAQUERO

JOAQUIN MILLER

His broad-brimm'd hat push'd back with careless air,
The proud vaquero sits his steed as free
As winds that toss his black abundant hair.
No rover ever swept a lawless sea
With such a haught and heedless air as he
Who scorns the path, and bounds with swift disdain
Away, a peon born, yet born to be
A splendid king; behold him ride, and reign.

VAQUERO

LUIS ALFONSO JIMÉNEZ, JR.

ASSEMBLY LINE

ADRIEN STOUTENBERG

Henry had something on his mind
beyond the folderol of birds,
or horses waltzing in a field,
or loafing trees. Henry inclined
toward something practical and square,
and built it black and built it cheap
with wheels to last an average trip
(and, for emergencies, a spare).
Henry had hit on something new
to fill up dinner pails and time
and occupy men's noisy hands
and start a factory or two.

History was bunk, Henry averred
and turned a crank and set a spark,
honked at the corn and shimmied out
headlong across a neighing world;
plowed frogs and leaves and eagles under,
corrected mountains, fixed the dark,
followed a rainbow, found instead
the freeway's hot and surly thunder—
and at the end a twitching flare
like a red bush. History is junk.
Beneath, the earth is six feet deep;
the grass is optional and spare.

THE DRILLER

HAROLD LEHMAN

SONG OF THE BUILDERS

JESSIE WILMORE MURTON

O beams of steel are slim and black
And danger lurks on the skyward track,
But men are many, and men are bold,
And what is risk, when the stake is gold?
 So riveters ring,
 And hot bolts fly,
 And strong men toil,
 And sweat . . . and die . . .
But the city's towers grow straight and high!
O beams of steel are black and slim,
But the wills of men are stubborn and grim,
They reach forever to clutch the sun,
And what is life, if the goal be won?
 So riveters ring,
 And hot bolts fly,
 And strong men toil,
 And sweat . . . and die . . .
But the city's towers grow straight and high!

BUILDING

GWENDOLYN BROOKS

When I see a brave building
straining high, and higher,
hard and bright and sassy in the seasons,
I think of the hands that put that strength together.

The little soft hands. Hands coming away from cold
to take a challenge and to mold this definition.

Amazingly, men and women
worked with design and judgment, steel and glass,
to enact this announcement.
Here it stands.

Who can construct such miracle can enact
any consolidation, any fusion.
All little people opening out of themselves,

forging the human spirit that can outwit
big Building boasting in the cityworld.

NEW YORK SKYLINE

ABRAHAM WALKOWITZ

MIDWEST TOWN

RUTH DE LONG PETERSON

Farther east it wouldn't be on the map—
 Too small—but here it rates a dot and a name.
In Europe it would wear a castle cap
 Or have a cathedral rising like a flame.

But here it stands where the section roadways meet.
 Its houses dignified with trees and lawn;
The stores hold tete-a-tete across Main Street;
 The red brick school, a church—the town is gone.

America is not all traffic lights,
 And beehive homes and shops and factories;
No, there are wide green days and starry nights,
 And a great pulse beating strong in towns like these.

IOWA FARMER

MARGARET WALKER

I talked to a farmer one day in Iowa.
We looked out far over acres of wheat.
He spoke with pride and yet not boastfully;
he had no need to fumble for his words.
He knew his land and there was love for home
within the soft serene eyes of his son.
His ugly house was clean against the storm;
there was no hunger deep within the heart
nor burning riveted within the bone,
but here they ate a satisfying bread.
Yet in the Middle West where wheat was plentiful;
where grain grew golden under sunny skies
and cattle fattened through the summer heat
I could remember more familiar sights.

EVENING ON THE FARM

ORR C. FISHER

CITY TRAFFIC

EVE MERRIAM

Green as a seedling the one lane shines,
Red ripened blooms for the opposite lines;
Emerald shoot,
Vermilion fruit.

Now amber, now champagne, now honey: go slow:
Shift, settle, then gather and sow.

SLUSHING

RED GROOMS

POMONA

CARLOS CORTEZ

Like a morning ghost
The snow-capped
Gabrieles
Loom above
The palm trees and
Cottages and motels
And smog
Of the car-culture
Streets
Ever reminding
That eternity
Is NOW!

**UNTITLED,
FROM THE LOS ANGELES
DOCUMENTARY PROJECT**

DOUGLAS HILL

LIFT EVERY VOICE

SINGING HEAD

ELIZABETH CATLETT

PREAMBLE TO THE CONSTITUTION OF THE UNITED STATES

We, the people of the United States, in order to form a more perfect union, establish justice, insure domestic tranquillity, provide for the common defence, promote the general welfare, and secure the blessings of liberty to ourselves and our posterity, do ordain and establish this Constitution for the United States of America.

PREAMBLE

MIKE WILKINS

THE CONTINENTALS

FRANK BLACKWELL MAYER

OUR FATHERS FOUGHT FOR LIBERTY

JAMES RUSSELL LOWELL

Our fathers fought for liberty,
They struggled long and well,
History of their deeds can tell—
But did they leave us free?

Are we free to speak our thought,
To be happy and be poor,
Free to enter Heaven's door,
To live and labor as we ought?

Are we then made free at last
From the fear of what men say.
Free to reverence today,
Free from the slavery of the past?

Our fathers fought for liberty,
They struggled long and well,
History of their deeds can tell—
But *ourselves* must set us free.

WASHINGTON'S HEAD-QUARTERS 178

At Newburgh, on the Hudson.

CONCORD HYMN

RALPH WALDO EMERSON

By the rude bridge that arched the flood,
 Their flag to April's breeze unfurled,
Here once the embattled farmers stood,
 And fired the shot heard round the world.

The foe long since in silence slept;
 Alike the conqueror silent sleeps;
And Time the ruined bridge has swept
 Down the dark stream which seaward creeps.

On the green bank, by this soft stream,
 We set today a votive stone;
That memory may their deed redeem,
 When, like our sires, our sons are gone.

Spirit, that made those spirits dare
 To die, and leave their children free,
Bid Time and Nature gently spare
 The shaft we raise to them and thee.

WASHINGTON'S HEADQUARTERS AT NEWBURGH ON THE HUDSON IN 1780

UNKNOWN ARTIST

LIFT EVERY VOICE AND SING

JAMES WELDON JOHNSON

Lift every voice and sing
Till earth and heaven ring,
Ring with the harmonies of liberty.
Let our rejoicing rise
High as the list'ning skies;
Let it resound loud as the rolling sea.
Sing a song full of the faith that the dark
	past has taught us;
Sing a song full of the hope that the present
	has brought us;
Facing the rising sun
Of our new day begun,
Let us march on, till victory is won.

Stony the road we trod,
Bitter the chast'ning rod,
Felt in the days when hope unborn had died;
Yet, with a steady beat,
Have not our weary feet
Come to the place for which our parents
	sighed?
We have come over a way that with tears
	has been watered;
We have come, treading our path through
	the blood of the slaughtered,
Out from the gloomy past,
Till now we stand at last
Where the white gleam of our bright star is cast.

God of our weary years,
God of our silent tears,
Thou who hast brought us thus far on the way;
Thou who hast by thy might
Led us into the light:
Keep us forever in the path, we pray.
Lest our feet stray from the places, our God,
	where we met thee;
Lest, our hearts drunk with the wine
	of the world, we forget thee;
Shadowed beneath thy hand,
May we forever stand.
True to our God, true to our native land.

CHURCH, SPROTT, ALABAMA (detail)

BILL CHRISTENBERRY, JR.

A POEM FOR MYSELF
(OR BLUES FOR A MISSISSIPPI BLACK BOY)

ETHERIDGE KNIGHT

I was born in Mississippi;
I walked barefooted thru the mud.
Born black in Mississippi,
Walked barefooted thru the mud.
But, when I reached the age of twelve
I left that place for good.
Said my daddy chopped cotton
and he drank his liquor straight.
When I left that Sunday morning
He was leaning on the barnyard gate.
Left her standing in the yard
With the sun shining in her eyes.
And I headed North
As straight as the Wild Goose Flies,
I been to Detroit & Chicago
Been to New York city too.
I been to Detroit & Chicago
Been to New York city too.
Said I done strolled all those funky avenues
I'm still the same old black boy
 with the same old blues.
Going back to Mississippi
This time to stay for good
Going back to Mississippi
This time to stay for good—
Gonna be free in Mississippi
Or dead in the Mississippi mud.

SELF-PORTRAIT

MALVIN GRAY JOHNSON

I HEAR AMERICA SINGING

WALT WHITMAN

I hear America singing, the varied carols I hear:
Those of mechanics—each one singing his, as it should be,
 blithe and strong;
The carpenter singing his, as he measures his plank or beam,
The mason singing his, as he makes ready for work, or
 leaves off work;
The boatman singing what belongs to him in his boat—the
 deckhand singing on the steamboat deck;
The shoemaker singing as he sits on his bench—the hatter
 singing as he stands;
The wood cutter's song—the ploughboy's on his way in the
 morning, or at noon intermission, or at sundown;
The delicious singing of the mother—or of the young wife
 at work—or of the girl sewing or washing—
Each singing what belongs to him or her and to none else;
The day what belongs to the day—at night, the party of
 young fellows, robust, friendly,
Singing, with open mouths, their strong melodious songs.

CONSTRUCTION OF THE DAM

WILLIAM GROPPER

I, TOO

LANGSTON HUGHES

I, too, sing America.

I am the darker brother.
They send me to eat in the kitchen
When company comes,
But I laugh,
And eat well,
And grow strong.

Tomorrow,
I'll sit at the table
When company comes.
Nobody'll dare
Say to me,
"Eat in the kitchen,"
Then.

Besides,
They'll see how beautiful I am
And be ashamed—

I, too, am America.

SONNET TO NEGRO SOLDIERS

JOSEPH SEAMAN COTTER, JR.

They shall go down unto Life's Borderland,
 Walk unafraid within that Living Hell,
 Nor heed the driving rain of shot and shell
That round them falls; but with uplifted hand
Be one with mighty hosts, an armed band
 Against man's wrong to man—for such full well
 They know. And from their trembling lips shall swell
A song of hope the world can understand.
All this to them shall be a glorious sign,
 A glimmer of that resurrection morn
When age-long faith, crowned with a grace benign,
 Shall rise and from their brows cast down the thorn
Of prejudice. E'en though through blood it be,
There breaks this day their dawn of liberty.

UNDER FIRE

WILLIAM H. JOHNSON

IN RESPONSE TO EXECUTIVE ORDER 9066
ALL AMERICANS OF JAPANESE DESCENT MUST REPORT TO RELOCATION CENTERS

DWIGHT OKITA

Dear Sirs:
Of course I'll come. I've packed my galoshes
and three packets of tomato seeds. Denise calls them
love apples. My father says where we're going
they won't grow.

I am a fourteen-year-old girl with bad spelling
and a messy room. If it helps any, I will tell you
I have always felt funny using chopsticks
and my favorite food is hot dogs.
My best friend is a white girl named Denise—
we look at boys together. She sat in front of me
all through grade school because of our names:
O'Connor, Ozawa. I know the back of Denise's head
 very well.

I tell her she's going bald. She tells me I copy on tests.
We are best friends.

I saw Denise today in Geography class.
She was sitting on the other side of the room.
"You're trying to start a war," she said, "giving secrets
away to the Enemy, Why can't you keep your big
mouth shut?"

I didn't know what to say.
I gave her a packet of tomato seeds
and asked her to plant them for me, told her
when the first tomato ripened
she'd miss me.

DIARY, DECEMBER 12, 194
(detail)

ROGER SHIMOMURA

CITY CROWD STUDY— A STREET EVENT

ROBERT BIRMELIN

I WENT AMONG THE MEAN STREETS

MARK VAN DOREN

I went among the mean streets
Of such a city
As should have moved my wrath;
But it was pity.

I did not count the sad eyes,
They were so many.
I listened for the singing;
There was not any.

O thieves of joy, O thoughtless
Who blink at this,
Beware. There will be judgment,
With witnesses.

"BEST GENERAL VIEW" OF RIO GRANDE RIVER LOOKING WEST AT PUMP CANYON

PETER GOIN

TO LIVE IN THE BORDERLANDS MEANS YOU

GLORIA ANZALDÚA

[To live in the Borderlands means you]
are neither *hispana india negra española*
ni gabacha, eres mestiza, mulata, half-breed
caught in the crossfire between camps
while carrying all five races on your back
not knowing which side to turn to, run from;

To live in the Borderlands means knowing
 that the *india* in you,
 betrayed for 500 years,
 is no longer speaking to you,
 that *mexicanas* call you *rajetas,*
 that denying the Anglo inside you
 is as bad as having denied
 the Indian or Black;

Cuando vives en la frontera
 people walk through you, the wind
 steals your voice,
 you're a *burra, buey,* scapegoat,
 forerunner of a new race,
 half and half—both woman and man,
 neither—
 a new gender;

To live in the Borderlands means to
 put *chile* in the borscht,
 eat whole wheat *tortillas,*
 speak Tex-Mex with a Brooklyn accent;
 be stopped by *la migra* at the border checkpoints;

Living in the Borderlands means you fight hard to
 resist the gold elixir beckoning from the bottle,
 the pull of the gun barrel,
 the rope crushing the hollow of your throat;

In the Borderlands
 you are the battleground
 where enemies are kin to each other;
 you are at home, a stranger,
 the border disputes have been settled
 the volley of shots have shattered the truce
 you are wounded, lost in action
 dead, fighting back;

To live in the Borderlands means
 the mill with the razor white teeth wants
 to shred off
 your olive-red skin, crush out the kernel,
 your heart
 pound you pinch you roll you out
 smelling like white bread but dead;

To survive the Borderlands
 you must live *sin fronteras*
 be a crossroads.

gabacha—a Chicano term for a white woman
rajetas—literally, "split," that is, having betrayed your word
burra—donkey
buey—oxen
sin fronteras—without borders

**"CIVILIZATION IS
A METHOD OF LIVING,
AN ATTITUDE OF EQUAL
RESPECT FOR ALL MEN."
—JANE ADDAMS, 1933**

GEORGE GIUSTI

from
ON THE PULSE OF MORNING

MAYA ANGELOU

Women, children, men,
Take it into the palms of your hands,
Mold it into the shape of your most
Private need. Sculpt it into
The image of your most public self.
Lift up your hearts
Each new hour holds new chances
For a new beginning.
Do not be wedded forever
To fear, yoked eternally
To brutishness.

The horizon leans forward,
Offering you space
To place new steps of change
Here, on the pulse of this fine day
You may have the courage
To look up and out and upon me,
The Rock, the River, the Tree, your country.
No less to Midas than the mendicant.
No less to you now than the mastodon then.

Here on the pulse of this new day
You may have the grace to look up and out
And into your sister's eyes,
And into your brother's face,
Your country,
And say simply
Very simply
With hope —
Good morning.

TIMELESS IS THE WHEEL

FARM SCENE (detail)

J. C. HUNTINGTON

anyone lived in a pretty how town

e. e. cummings

anyone lived in a pretty how town
(with up so floating many bells down)
spring summer autumn winter
he sang his didn't he danced his did.

Women and men (both little and small)
cared for anyone not at all
they sowed their isn't they reaped their same
sun moon stars rain

children guessed (but only a few
and down they forgot as up they grew
autumn winter spring summer)
that noone loved him more by more

when by now and tree by leaf
she laughed his joy she cried his grief
bird by snow and stir by still
anyone's any was all to her

someones married their everyones
laughed their cryings and did their dance
(sleep wake hope and then) they
said their nevers they slept their dream

stars rain sun moon
(and only the snow can begin to explain
how children are apt to forget to remember
with up so floating many bells down)

one day anyone died i guess
(and noone stooped to kiss his face)
busy folk buried them side by side
little by little and was by was

all by all and deep by deep
and more by more they dream their sleep
noone and anyone earth by april
wish by spirit and if by yes.

Women and men (both dong and ding)
summer autumn winter spring
reaped their sowing and went their came
sun moon stars rain

FAMILY REUNION

ROGER MEDEARIS

RAISING MY HAND

ANTLER

One of the first things we learn in school is
 if we know the answer to a question
We must raise our hand and be called on
 before we can speak.
How strange it seemed to me then,
 raising my hand to be called on,
How at first I just blurted out,
 but that was not permitted.

How often I knew the answer
And the teacher (knowing I knew)
Called on others I knew (and she knew)
 had it wrong!
How I'd stretch my arm
 as if it would break free
 and shoot through the roof
 like a rocket!

How I'd wave and groan and sigh,
Even hold up my aching arm
 with my other hand
Begging to be called on,
Please, *me*, I know the answer!
Almost leaping from my seat
 hoping to hear my name.

Twenty-nine now, alone in the wilds,
Seated on some rocky outcrop
 under all the stars,
I find myself raising my hand
 as I did in first grade
Mimicking the excitement
 and expectancy felt then,
No one calls on me
 but the wind.

SCHOOL'S OUT (detail)

ALLAN ROHAN CRITE

THE WHEEL

WENDELL BERRY

For Robert Penn Warren

At the first strokes of the fiddle bow
the dancers rise from their seats.
The dance begins to shape itself
in the crowd, as couples join,
and couples join couples, their movement
together lightening their feet.
They move in the ancient circle
of the dance. The dance and the song
call each other into being. Soon
they are one — rapt in a single
rapture, so that even the night
has its clarity, and time
is the wheel that brings it round.
In this rapture the dead return.
Sorrow is gone from them.
They are light. They step
into the steps of the living
and turn with them in the dance
in the sweet enclosure
of the song, and timeless
is the wheel that brings it round.

COWBOY DANCE/
FIESTA DE VAQUEROS

JENNE MAGAFAN

A LAZY DAY

PAUL LAURENCE DUNBAR

The trees bend down along the stream,
 Where anchored swings my tiny boat.
The day is one to drowse and dream
 And list the thrush's throttling note.
When music from his bosom bleeds
Among the river's rustling reeds.

No ripple stirs the placid pool,
 When my adventurous line is cast,
A truce to sport, while clear and cool,
 The mirrored clouds slide softly past.
The sky gives back a blue divine,
And all the world's wide wealth is mine.

A pickerel leaps, a bow of light,
The minnows shine from side to side.
The first faint breeze comes up the tide—
I pause with half uplifted oar,
While night drifts down to claim the shore.

**DOWN THE RIVER
(THE YOUNG FISHERMAN)** (detail)

THOMAS HART BENTON

SANTO DOMINGO CORN DANCE
SANTO DOMINGO PUEBLO, NEW MEXICO

R. P. DICKEY

Each beat of the drum's a round drop of rain,
the stamping of the dancers' feet is rain,
their heartbeats and breathing resound as rain,
the fringes on the men's moccasins are rain,
their feathers are iridescent sheets of rain,
the toes of the barefooted females are rain,
the women's hair runs thick with black streams of rain,
the billions of motes of dust underfoot are rain,
the chunks of turquoise a lighter shade of rain
than each needle in hundreds of evergreen sprigs,
the links and clasps and rings of silver are rain,
the ghostly Koshares' antic movements are rain,
even the billions of beams from the sun become rain,
and then the actual rain, onto the earth,
for the corn, O always the actual rain,
there it comes, then it comes, and it comes.

CORN DANCE, TAOS PUEBLO

NORMAN CHAMBERLAIN

KNOXVILLE, TENNESSEE

NIKKI GIOVANNI

I always like summer
best
you can eat fresh corn
from daddy's garden
and okra
and greens
and cabbage
and lots of
barbecue
and buttermilk
and homemade ice-cream
at the church picnic
and listen to
gospel music
outside
at the church
homecoming
and go to the mountains with
your grandmother
and go barefooted
and be warm
all the time
not only when you go to bed
and sleep

COMIDA/ FOOD

VICTOR M. VALLE

Uno se come
la luna en la tortilla
Comes frijol
y comes tierra
Comes chile
y comes sol y fuego
Bebes agua
y bebes cielo

One eats
the moon in a tortilla
Eat frijoles
and you eat the earth
Eat chile
and you eat sun and fire
Drink water
and you drink sky

COCINA JAITECA

LARRY YÁÑEZ

CHELOUS AND HERCULES (detail)

THOMAS HART BENTON

CONEY

VIRGINIA SCHONBORG

There's hot corn
And franks.
There's the boardwalk
With lots of games,
With chances
To win or lose.
There's the sun.
Underneath the boardwalk
It's cool,
And the sand is salty.

The beach is
Like a fruitstand of people,
Big and little,
Red and white,
Brown and yellow.
There's the sea
With high green waves.
And after,
There's hot corn
And franks.

SCENES OF AMERICAN LIFE (BEACH)

GERTRUDE GOODRICH

JUKE BOX LOVE SONG

LANGSTON HUGHES

I could take the Harlem night
and wrap around you,
Take the neon lights and make a crown,
Take the Lenox Avenue buses,
Taxis, subways,
And for your love song tone their rumble down.

Take Harlem's heartbeat,
Make a drumbeat,
Put it on a record, let it whirl,
And while we listen to it play,
Dance with you till day—
Dance with you, my sweet brown Harlem girl.

ANALYSIS OF BASEBALL

MAY SWENSON

It's about
the ball,
the bat,
and the mitt.
Ball hits
bat, or it
hits mitt.
Bat doesn't
hit ball, bat
meets it.
Ball bounces
off bat, flies
air, or thuds
ground (dud)
or it
fits mitt.

Bat waits
for ball
to mate.
Ball hates
to take bat's
bait. Ball
flirts, bat's
late, don't
keep the date.
Ball goes in
(thwack) to mitt,
and goes out
(thwack) back
to mitt.

Ball fits
mitt, but
not all
the time.
Sometimes
ball gets hit
(pow) when bat
meets it,
and sails
to a place
where mitt
has to quit
in disgrace.
That's about
the bases
loaded,
about 40,000
fans exploded.

It's about
the ball,
the bat,
the mitt,
the bases
and the fans.
It's done
on a diamond,
and for fun.
It's about
home, and it's
about run.

BASEBALL AT NIGHT

MORRIS KANTOR

IN THE BEGINNING WAS THE

LILLIAN MORRISON

In the beginning was the

Kickoff.
The ball flew
looping down true
into the end zone
where it was snagged,
neatly hugged
by a swivel-hipped back
who ran up the field
and was smeared.

The game has begun.
The game has been won.
The game goes on.
Long live the game.
Gather and lock
tackle and block
move, move,
around the arena
and always the beautiful
trajectories.

OHIO STATE UNIVERSITY STADIUM

WILLIAM HAWKINS

SPARKLERS ON THE FOURTH

HANANIAH HARARI

THE PINTA, THE NINA AND THE SANTA MARIA; AND MANY OTHER CARGOES OF LIGHT

JOHN TAGLIABUE

America
I
carry
you
around
with
me
the
way
Buddha
carried
a
grain
of sand
the
way
Columbus
carried
a
compass
the way
Whitman
carried

a
poem
growing
expanding
like
a
galaxy
the
way
a
firefly
carries
a
galaxy
the
way
Faulkner
carries
eloquence

the
way
eloquence
carries
hope,
faith,
and
the
4th
of
July.

BIOGRAPHICAL NOTES

The following are brief biographical notes about the writers and artists whose work appears in this book. Every effort has been made to achieve accuracy, but in some cases, sources offered conflicting information about such matters as date or place of birth. In other cases, it was impossible to locate any information at all.

WRITERS

ANGELOU, MAYA (1928–) Born in Missouri. Written work includes her five-volume autobiography. At various times she has been a poet, dancer, actress, scriptwriter, director, producer, editor, and social activist. She wrote "On the Pulse of Morning" to read at the inauguration of President Bill Clinton.

ANTLER (1946–) Born in Wisconsin. A Native-American writer who has received many honors, including the Walt Whitman Award and the Wittner Bynner Prize given to "an outstanding young poet."

ANZALDÚA, GLORIA (1942–) Born in Texas. Raised in the borderlands, she is a *mestiza*, a combination of Mexican, Indian, and Anglo. Her essays, poetry, and prose are concerned with crossing the physical border between the southwestern United States and Mexico and examine psychological and spiritual borders as well. Her writings use a combination of English, Castilian Spanish, northern Mexican dialect, Tex-Mex, and Nahuatl, a Native-American dialect.

BATES, KATHARINE LEE (1859–1929) Born in Massachusetts. Author and educator who wrote "America the Beautiful" for a volume of poetry published in 1911. It later was set to music.

BENÉT, ROSEMARY (1898–1962) Born in Illinois. With her husband, Stephen, co-wrote *A Book of Americans*, which included poetic sketches of memorable figures of American history such as Johnny Appleseed, Clara Barton, and Abraham Lincoln.

BENÉT, STEPHEN VINCENT (1898–1943) Born in Pennsylvania. The author of more than sixty works, including poetry, fiction, and radio plays. Co-wrote *A Book of Americans* with his wife, Rosemary.

BERRY, WENDELL (1934–) Born in Kentucky. Writes poems, stories, magazine articles, and wry essays on farming and nature in his native state. Has won numerous awards for his poetry, including Guggenheim and Rockefeller fellowships.

BROOKS, GWENDOLYN (1917–) Born in Kansas. Began writing at the age of seven and was later encouraged by both Langston Hughes and James Weldon Johnson. Awarded the Pulitzer Prize for poetry in 1950.

CORTEZ, CARLOS (1923–) Born in Wisconsin. Role as a member of the labor union Industrial Workers of the World (IWW) has greatly influenced his writing. A poet and activist who is also well known for his powerful woodcuts and cartoons.

COTTER, JOSEPH SEAMAN, JR. (1895–1919) Born in Kentucky. Son of the well-known poet Joseph Seaman Cotter, Sr., the younger had to leave college in his second year because he contracted tuberculosis. In 1918 he published his only volume of poetry, *The Band of Gideon*.

CUMMINGS, EDWARD ESTLIN (e. e.) (1894–1962) Born in Massachusetts. Acclaimed poet of lyric energy, imagination, and verve whose work epitomized the irreverent humor and slapdash rhythms of the Jazz Age.

DICKEY, ROBERT PRESTON (R. P.) (1936–85) Born in Missouri. His ironic, self-mocking, and rebellious writings conveyed a primary theme of confronting life honestly and without pretense.

DICKINSON, EMILY (1830–86) Born in Massachusetts. Lived a secluded life. Did not write with the intent to publish, yet she is one of the most renowned poets of the English language.

DUNBAR, PAUL LAURENCE (1872–1906) Born of former slaves in Ohio. The first African-American poet to gain a national reputation in the United States. His poetry is written both in black dialect and in conventional English. Also wrote novels and short stories.

EMERSON, RALPH WALDO (1803–82) Born in Massachusetts. Poet, essayist, and philosopher whose belief in both the unlimited potential of the individual and in freedom of the spirit has been an inspiration for generations of readers.

FROST, ROBERT (1874–1963) Born in California. Author of more than thirty volumes of poetry and the recipient of many honors. He is one of America's most popular and widely read poets. Won the Pulitzer Prize in 1924, 1931, 1937, and 1943.

GARLAND, HAMLIN (1860–1940) Born in Wisconsin. Early exposure to the poverty and drudgery of farm life directed much of his writing, in which he sought to shatter the sentimental myths about rural America. Won the Pulitzer Prize for fiction in 1921.

GIOVANNI, NIKKI (1943–) Born in Tennessee. Came to national attention as a revolutionary poet of the 1960s. Later founded her own company to publish literature that speaks directly to African Americans and celebrates positive features of African-American life.

HARJO, JOY (1951–) Born in Oklahoma. A member of the Creek tribe and author of three volumes of poetry. Poetry editor for *High Plains Literary Review*.

HUGHES, LANGSTON (1902–67) Born in Missouri. An acclaimed poet, song lyricist, librettist, newspaper columnist, and playwright who not only overcame racial prejudice but also actively encouraged other African-American writers. Edited six anthologies of African-American literature.

JENNINGS, LESLIE NELSON (1890–1972) Born in Massachusetts. Primarily self-educated, a prominent writer and editor of poetry books and frequent contributor to the *New Yorker.*

JOHNSON, JAMES WELDON (1871–1938) Born in Florida. Played a vital role in the early civil rights movement of the twentieth century as poet, teacher, critic, diplomat, and NAACP official. Most often remembered as the lyricist for "Lift Every Voice and Sing," a poem referred to by many as the African-American national anthem.

KENNY, MAURICE (1929–) Born in New York. Tribal affiliation is Mohawk. His writings are characterized by their historical and spiritual depth and are shaped by the rhythms of Mohawk life and speech. His poetry book *Blackrobe* was nominated for the Pulitzer Prize in 1982.

KNIGHT, ETHERIDGE (1931–91) Born in Mississippi. Sentenced in 1960 to serve twenty years in Indiana State Prison for armed robbery. Later said, "I died in 1960 from a prison sentence and poetry brought me back to life." His books of poetry, including *Poems from Prison* (1968), have been widely read.

LAVIERA, TATO (1950–) Born in Puerto Rico. Poet, playwright, and composer whose first book, *La Carreta Made a U-Turn* (1979), is one of the most popular books of poetry by an Hispanic-American author.

LAZARUS, EMMA (1849–87) Born in New York. Poet, essayist, and champion of oppressed Jewry, best known for her sonnet "The New Colossus" (1883), inscribed on the Statue of Liberty in New York harbor.

LEE, LI-YOUNG (1957–) Born in Indonesia. Immigrated to the United States at age seven by way of Hong Kong, Macao, and Japan. His poems convey a fascination with the inarticulate—experiences that one can't talk about or express. Awarded Guggenheim and National Endowment for the Arts fellowships.

LOWELL, JAMES RUSSELL (1819–91) Born in Massachusetts. Poet, critic, editor, teacher, and diplomat, Lowell was among the most popular American writers of the nineteenth century.

MERRIAM, EVE (1916–92) Born in Pennsylvania. Poet, playwright, and lyricist who wrote more than fifty works for adults and children. Her writing ranged in theme from lighthearted verse to realistic poems on inner-city poverty.

MILLER, JOAQUIN (1837–1913) Born in Indiana. Pseudonym for Cincinnatus Hiner Miller, a lawyer who rose to fame not in America but in England, where he became a spokesman for the American West. Especially noted for his attempts to write poetry in the American vernacular.

MOMADAY, N. SCOTT (1934–) Born in Oklahoma. A member of the Kiowa tribe. Awarded the 1969 Pulitzer Prize for his novel *House Made of Dawn.*

MORRISON, LILLIAN (1917–) Born in New Jersey. For many years worked as a librarian for young people at the New York Public Library. Author of seventeen books for children, including four anthologies of sports poems.

MURTON, JESSIE WILMORE (n.d.) Born in Kentucky. Little is known about this author who published nearly one thousand poems in magazines, journals, and newspapers from the 1930s to the 1960s.

OKITA, DWIGHT (1958–) Born in Illinois. Poet and playwright, a third-generation Japanese American who wrote *Crossing with the Light,* his first book of poetry, in 1982.

OLIVER, LOUIS (LITTLE COON) (1904–91) Born in Oklahoma. Member of the Creek tribe, his ancestry is traced to the Indian clans who lived along the Chattahoochee River in Alabama. His poetry honors and maintains reverence for the natural world.

PETERSON, RUTH DE LONG (1916–) Born in Iowa. Has lived within a few miles of New London, Iowa, all her life. Work celebrates the gentle hills and prairies of the American Midwest. Served for twenty years as editor of *Lyrical Iowa,* the Iowa Poetry Association's annual, and currently is a journalist for two local newspapers.

RÍOS, ALBERTO (1952–) Born in Arizona. First book of poetry, *Whispering to Fool the Wind* (1982), chosen as winner of the 1981 Walt Whitman Award of the Academy of American Poets.

ROMERO, LEO (1950–) Born in New Mexico. Author of five volumes of poetry and owner of a small bookstore in New Mexico. Awarded Pushcart Prize from the Pushcart Press in 1982.

SANDBURG, CARL (1878–1967) Born in Illinois. Wrote poetry about the industrial cities and pastoral countryside of the American Midwest. His poems often contained a passionate concern for the common man. Famous for both his poetry and his six-volume biography of fellow Illinoisan Abraham Lincoln.

SCHONBORG, VIRGINIA (1913–91) Born in Rhode Island. Author of well-known children's books such as *The Salt Marsh* and *The Subway Singer.* Wrote frequently about urban children.

SNOW, CAROL (1950–) Born in New York. A native of the Allegheny Indian reservation in New York State. Her tribal affiliation is Seneca. A zoologist, Snow artfully depicts wildlife in her poetry and drawings.

STOUTENBERG, ADRIEN (1916–82) Born in Minnesota. Author of more than thirty books for children, her poems have also appeared in such distinguished journals as the *New Yorker*, the *Nation*, *Poetry*, and the *Yale Review*.

SWENSON, MAY (1919–89) Born in Utah. Self-taught poet whose vibrant poems of delicate humor earned her the Bollingen Poetry Award in 1981, Rockefeller and Guggenheim fellowships, and a grant from the National Endowment for the Arts.

TAGLIABUE, JOHN (1923–) Born in Italy. A U.S. citizen, he travels extensively, teaching in universities around the world. His thoughtful poems and essays include reflections on his experiences in France, England, Italy, Greece, Mexico, and Guatemala.

TOOMER, JEAN (1894–1967) Born in Washington, D.C. One of the major writers of the Harlem Renaissance. Although widely published as a poet, best known for his avant-garde novel, *Cane*, a celebration of blackness.

VALLE, VICTOR M. (1950–) Born in California. A poet, translator, editor, activist, and *Los Angeles Times* investigative reporter. "Poetry is a tool," he once wrote, "because it helps you take things apart."

VAN DOREN, MARK (1894–1972) Born in Illinois. Published more than sixty-five books, including twelve volumes of poetry. His writing records everyday events and the lessons to be learned from them.

WALKER, MARGARET (1915–) Born in Alabama. Took up writing at the age of eleven. In 1942 won the Yale Series of Younger Poets Award for *For My People*, becoming one of the youngest African-American writers to publish a volume of poetry, as well as the first African-American woman to win a prestigious national prize.

WHITMAN, WALT (1819–92) Born in New York. His *Leaves of Grass*, published in 1855 and revised frequently thereafter, brought attention to his vision of equality, national purpose, and brotherhood. His book revolutionized the techniques and subject matter of American poetry.

ARTISTS

ALQUILAR, MARIA (1935–) Born in New York. The daughter of a Russian Jewish mother and Spanish father. Her altarpieces seek to explore the mythic heritage of many cultures and expose their common threads.

ARMIN, EMIL (1883–1971) Born in Romania. Immigrated to the United States at age twenty-two. Painter known for his use of vibrant color and brushwork.

BENTON, THOMAS HART (1889–1975) Born into a famous Missouri family of politicians. His work captures the American Midwest—its people, life, and culture.

BIERSTADT, ALBERT (1830–1902) Born in Germany. Immigrated to the United States as a child. Paintings show an idealistic view of the American wilderness.

BIRMELIN, ROBERT (1933–) Born in New Jersey. Painter known for his New York crowd scenes that convey a sense of panic and urgency.

CATLETT, ELIZABETH (1919–) Born in Washington, D.C. Sculptor whose primary theme is the African-American woman, portrayed with strength, physicality, and grandeur. Known for her masklike facial sculptures that incorporate both African and Mexican features.

CATLIN, GEORGE (1796–1872) Born in Pennsylvania. Created more than two thousand paintings, drawings, and sketches of North American Indians, which are some of the earliest depictions of Native Americans and their customs by an outside artist.

CHAMBERLAIN, NORMAN (1887–1961) Born in Michigan. Muralist whose work was inspired by his visits to Taos, New Mexico, in the 1920s and 1930s.

CHRISTENBERRY, WILLIAM, JR. (1936–) Born in Alabama. An artist of national acclaim, equally known for his photographs of the South and his disturbing sculptural pieces.

CRITE, ALLAN ROHAN (1910–) Born in New Jersey. Best known for his religious illustrations; also an observer of urban African-American life in Boston during the 1930s and 1940s.

DOVE, ARTHUR G. (1880–1946) Born in New York. A pioneering abstract painter known for expressing natural forms, sounds, and musical motifs in his paintings.

DUNTON, W. HERBERT (1878–1936) Born in Maine. A painter who specialized in wildlife scenes, cowboys, and other themes of the American West.

EVANS, TERRY (1944–) Born in Missouri. Photographer of the Kansas landscape and an activist in the conservation movement.

FISHER, ORR C. (1885–n.d.) Born in Iowa. Muralist commissioned to create *Evening on the Farm* for the Forest City, Iowa, post office. His art explores the role of the farmer in local history and the nature of rural life.

GOIN, PETER (1951–) Born in Wisconsin. Well known for his photographic surveys of contemporary landscapes and a series of photographs entitled *Nuclear Landscapes,* which depict nature after nuclear explosions.

GOODRICH, GERTRUDE (1914–) Born in New York. Muralist whose art appears in federal buildings across the United States. Her work examines everyday aspects of American life.

GROOMS, RED (1937–) Born in Tennessee. Renowned artist whose lifelong fascination with the circus has filled his work with colorful, energetic figures that convey a simple sense of fun.

GROPPER, WILLIAM (1897–1977) Born in New York. Best known as a social realist and as a radical cartoonist for numerous popular magazines.

HARARI, HANANIAH (1912–) Born in New York. Has led a double life as both an abstract painter whose work has been exhibited in museums and as a commercial artist who has designed print advertisements and magazine covers.

HAWKINS, WILLIAM (1895–1990) Raised in Kentucky. Folk artist who learned to draw by copying illustrations from horse-auction announcements and calendar pictures.

HILL, DOUGLAS (1950–) Born in England. Immigrated to the United States to study photography at UCLA and the California Institute of the Arts. Photographer whose search for insight into the Southern California experience has led him to document its commonplace and often overlooked sites.

HOLMES, WILLIAM H. (1846–1933) Born in Ohio. Studied geology and archaeology in the West for fifteen years; his interest in art was primarily for illustrating his research. Later served as curator at the Smithsonian Institution, the Field Colombian Museum, and the National Gallery.

HOMER, WINSLOW (1836–1910) Born in Massachusetts. A landmark painter of the nineteenth century who often painted the ocean, streams, and rivers to capture the elemental forces of nature. During the Civil War, Homer traveled the front as a correspondent for *Harper's Weekly,* sketching scenes of the daily lives of soldiers.

HUNTINGTON, J. C. (n.d.) Lived in Sunbury, Pennsylvania. Little is known about this retired railroad worker who used his daughter as the model for the children in his folk-art paintings.

INNESS, GEORGE (1825–94) Born in New York. Landscapist whose varied styles ranged from the romantic landscapes of his youth to a more personal vision of nature expressed in the frenzied strokes and rich tones of his later years.

JENSHEL, LEN (1949–) Born in New York. Has won many awards for his photographs of American landscapes—from southwestern deserts to the palatial mansions of the East Coast. Recipient of National Endowment for the Arts and Guggenheim fellowships.

JIMÉNEZ, LUIS, JR. (1940–) Born in Texas. Creates monumental public sculptures that both celebrate and question mythic icons of his Hispanic heritage.

JOHNSON, MALVIN GRAY (1896–1934) Born in North Carolina. One of the first African-American artists to develop themes of cubism in his work.

JOHNSON, WILLIAM H. (1901–70) Born in South Carolina. Trained in a highly academic tradition, but over time his work evolved to include bright, pure colors and a deliberately "primitive" style that expressed the spirit of the African-American experience.

JOSEPHSON, KENNETH BRADLEY (1932–) Born in Michigan. Internationally known photographer and assemblage artist whose works are often commentaries on picture making because they contain images within images and force the viewer to think about what is real and what the artist has created.

KANTOR, MORRIS (1896–1974) Born in Russia. Immigrated to the United States at the age of ten. From the semi-abstract works of his early career to his later depictions of the natural world, Kantor was a vital force in American art as both an artist and as a mentor to Robert Rauschenberg and John Hultberg.

LAFARGE, JOHN (1835–1910) Born in New York. Traveled the world in search of the exotic. His artistic interests were varied—watercolors, murals, and stained glass.

LAWRENCE, JACOB (1917–) Born in New Jersey. Preeminent African-American painter and a distinguished educator whose work has wide appeal because of its colorful, abstract style and the universal nature of its subject matter.

LEHMAN, HAROLD (1913–) Born in New York. Muralist and painter whose work has been exhibited in prestigious New York museums and whose murals appeared in Riker's Island prison and a Pennsylvania post office.

LEUTZE, EMANUEL GOTTLIEB (1816–68) Born in Germany. Immigrated to the United States as a child and settled in Philadelphia, Pennsylvania. Largely known for his historical and portrait painting.

LUNDEBERG, HELEN (1908–) Born in Illinois. The artist frequently uses images of herself as an element in her art; work most often conveys a peaceful waiting, a mystical calm.

MAGAFAN, JENNE (1915–52) Born in Illinois. Primarily a muralist, the artist achieved national recognition in a brief career.

MAYER, FRANK BLACKWELL (1827–99) Born in Maryland. Known for his large collection of life studies of Native Americans and as a painter of colonial subjects.

MEDEARIS, ROGER (1920–) Born in Missouri. A map draftsman for the Naval Department during World War II. His fine draftsmanship influenced all his later works in the detail and meticulous realism of his style.

MORAN, THOMAS (1837–1926) Born in Lancashire, England. Immigrated to the United States in 1844. As an artist for the U.S. Geological Survey, he was inspired by his many expeditions to the West. A master at portraying the illusion of height, his paintings often include a perch or a precipice looking down a chasm or waterfall.

OQWA PI (Abel Sanchez) (ca. 1899–1971) A Native American from San Ildefonso Pueblo. He recognized painting as one of his talents early and pursued it, developing a style distinguished by a variety of geometric designs and bright colors.

PERLIN, BERNARD (1918–) Born in Virginia. After high school moved to New York City to study art. During World War II, he traveled the world as a newspaper sketch artist.

PYLE, ARNOLD (n.d.) Resident of Iowa. Painter who worked largely in watercolor throughout his career. Little is known about this artist who was part of the Works Progress Administration during the Great Depression in the early 1930s.

RESIDENTS OF BOURBON COUNTY, KENTUCKY (n.d.) A quilt, designed and created by residents of Paris, Kentucky, in 1893, bears the 110 names of the people who worked on it; features the fan, a common Victorian pattern, as a design element; and is a collage of hand-sewn scraps formally arranged.

RODRIGUEZ, JOSEPH (1951–) Born in New York. Photographer who captures people in the context of their culture and locale. Subjects have included the Kurdish people of southeastern Turkey, street children in Mozambique, Africa, and the everyday life of people who live in Spanish Harlem, New York.

SAVITSKY, JACK (1910–91) Born in Pennsylvania. Well known for his bright and colorful depictions of life in and around the hard-coal regions of Lansford, Pennsylvania. He drew with a variety of materials and painted in oils on all kinds of surfaces.

SHIMOMURA, ROGER (1939–) Born in Washington. Painter of Japanese descent who has been a diligent arts educator most of his life.

WALKOWITZ, ABRAHAM (1880–1965) Born in Russia. Immigrated to the United States in 1889. Avant-garde painter who experimented with different styles and subjects, incorporating realism and social issues into his work.

WILKINS, MIKE (n.d.) Born in North Carolina. Best known as a conceptual artist who celebrated the bicentennial of the U.S. Constitution by requesting personalized license plates from all fifty states to form its preamble.

YÁÑEZ, LARRY (1949–) Born in Arizona. A multi-talented artist and musician who is best known for his use of Chicano cultural symbols. The painting included in this book was also featured on the cover of an album by his band, Jackalope.

ZELDIS, MALCAH (1931–) Born in Michigan. A self-taught artist who did not begin painting until her late thirties. Famous for her folk-art paintings that reflect both urban and Jewish traditions.

LIST OF ILLUSTRATIONS

POETRY ACKNOWLEDGMENTS

Page 11: "Legacy" by Maurice Kenny from *Between Two Rivers: Selected Poems 1956–1984*, reprinted by permission of White Pine Press. **Page 13:** "In Hardwood Groves" from *The Poetry of Robert Frost*, edited by Edward Connery Lathem. Copyright 1934, © 1969 by Henry Holt and Company, Inc., Copyright © 1962 by Robert Frost. Reprinted by permission of Henry Holt and Company, Inc. **Page 14:** "Niagara" from *The People, Yes* by Carl Sandburg, copyright 1936 by Harcourt Brace & Company and renewed 1964 by Carl Sandburg, reprinted by permission of Harcourt Brace & Company. **Page 15:** "The Monoliths" by N. Scott Momaday from *The Gourd Dancer*, reprinted by permission of the author. **Page 20:** "Drumbeat" by Carol Snow, © Carol Snow—Seneca Indian Heritage. **Page 21:** "The Road to Tres Piedras" by Leo Romero, first published in *New Mexico* magazine, reprinted by permission of Leo Romero and *New Mexico* magazine. **Page 24:** "Empty Kettle" by Louis (Little Coon) Oliver, reprinted by permission of the estate of the author and the Greenfield Review Literary Center. **Page 25:** "Lineage" by Margaret Walker Alexander from *This Is My Century: New and Collected Poems*. Copyright 1989 by Margaret Walker Alexander. Published by the University of Georgia Press (Athens, Georgia). **Page 26:** "Dream Variation" by Langston Hughes from *Selected Poems* by Langston Hughes, copyright 1926 by Alfred A. Knopf, Inc. and renewed 1954 by Langston Hughes. Reprinted by permission of the publisher. **Page 28:** Li-Young Lee. "I Ask My Mother to Sing," copyright © 1986 by Li-Young Lee. Reprinted from *Rose* by Li-Young Lee, with permission of BOA Editions, Ltd., 92 Park Ave., Brockport, NY 14420. **Page 29:** "AmeRícan" by Tato Laviera is reprinted with permission from the publisher of "AmeRícan" (Houston: Arte Publico Press—University of Houston, 1985). **Pages 30–31:** "Day of the Refugios" by Alberto Ríos, © 1993 by Alberto Ríos. Reprinted by permission of the author. **Page 33:** "Remember" by Joy Harjo from the book *She Had Some Horses* by Joy Harjo. Copyright © 1983 by Joy Harjo. Used by permission of the publisher, Thunder's Mouth Press. **Page 36:** "Western Wagons" by Rosemary & Stephen Vincent Benét from: *A Book of Americans* by Rosemary & Stephen Vincent Benét. Copyright 1933 by Rosemary & Stephen Vincent Benét. Renewed © 1965 by Thomas C. Benét, Stephanie Mahin. Reprinted by permission of Brandt & Brandt Literary Agents, Inc. **Page 41:** "Assembly Line" by Adrien Stoutenberg, reprinted by permission of Curtis Brown, Ltd. Copyright © 1964 by Adrien Stoutenberg; copyright © 1992 renewed by Laura Nelson Baker. **Page 43:** "Building" by Gwendolyn Brooks from *The Near-Johannesburg Boy*, 1987. © 1991 by Gwendolyn Brooks (reissued by Third World Press, Chicago). **Page 44:** "Midwest Town" by Ruth De Long Peterson. Reprinted with permission from the *Saturday Evening Post* © 1954. **Page 45:** "Iowa Farmer" by Margaret Walker Alexander from *This Is My Century: New and Collected Poems*—University of Georgia Press (Athens, Georgia), 1989. **Page 47:** "City Traffic" by Eve Merriam from *It Doesn't Always Have to Rhyme* by Eve Merriam. Copyright © 1964 by Eve Merriam. © renewed 1992 by Eve Merriam. Reprinted by permission of Marian Reiner. **Page 48:** "Pomona" by Carlos Cortez, reprinted by permission of Carlos Cortez, courtesy MARCH/Abrazo Press. **Page 56:** "Lift Every Voice and Sing"—James Weldon Johnson, J. Rosamond Johnson. Used by permission of Edward B. Marks Music Company. **Page 57:** "Song for Myself" is reprinted from *The Essential Etheridge Knight*, by Etheridge Knight, by permission of the University of Pittsburgh Press. © 1986 by Etheridge Knight. **Page 59:** "I, Too" by Langston Hughes from *Selected Poems* by Langston Hughes, copyright 1926 by Alfred A. Knopf, Inc. and renewed 1954 by Langston Hughes. Reprinted by permission of the publisher. **Page 62:** "In Response to Executive Order 9066" copyright © 1983 by Dwight Okita, from *Crossing with the Light* by Dwight Okita (Tia Chucha Press, Chicago, 1992). **Page 63:** "I Went Among the Mean Streets" from *100 Poems* by Mark Van Doren. Copyright © 1967 by Mark Van Doren. Reprinted by permission of Hill & Wang, a division of Farrar, Straus & Giroux, Inc. **Page 65:** "To live in the Borderlands means you" by Gloria Anzaldúa from *Borderlands/La Frontera: The New Mestiza* © 1987 by Gloria Anzaldúa. Reprinted with permission from Aunt Lute Books, (415) 558-8116. **Page 67:** From "On the Pulse of Morning" by Maya Angelou. Copyright © 1993 by Maya Angelou. Reprinted by permission of Random House, Inc. **Page 70:** "anyone lived in a pretty how town" is reprinted from *Complete Poems, 1904–1962*, by E. E. Cummings. Edited by George J. Firmage, by permission of Liveright Publishing Corporation. Copyright © 1923, 1925, 1926, 1931, 1935, 1938, 1939, 1940, 1944, 1945, 1946, 1947, 1948, 1949, 1950, 1951, 1952, 1953, 1954, 1955, 1956, 1957, 1958, 1959, 1960, 1961, 1962 by E. E. Cummings. Copyright © 1961, 1963, 1966, 1967, 1968 by Marion Morehouse Cummings. Copyright © 1972, 1973, 1974, 1975, 1976, 1977, 1978, 1979, 1980, 1981, 1982, 1983, 1984, 1985, 1986, 1987, 1988, 1989, 1990, 1991 by the Trustees for the E. E. Cummings Trust. **Page 73:** "Raising My Hand" copyright 1986 by Antler: reprinted from *An Ear to the Ground: An Anthology of Contemporary American Poetry* with permission by the University of Georgia Press. **Page 74:** "The Wheel" from *The Wheel* by Wendell Berry. Copyright © 1982 by Wendell Berry. Reprinted by permission of North Point Press, a division of Farrar, Straus & Giroux, Inc. **Page 78:** "Knoxville, Tennessee" from *Black Feeling, Black Talk, Black Judgment* by Nikki Giovanni. Copyright © 1968, 1970 by Nikki Giovanni. Reprinted by permission of William Morrow & Company, Inc. **Page 79:** "Comida/Food" by Victor Valle from *Fiesta in Aztlan*. Reprinted by permission of the Capra Press. **Page 80:** "Coney" from *Subway Swinger* by Virginia Schonborg. Copyright © 1970 by Virginia Schonborg. Reprinted by permission of Morrow Junior Books, a division of William Morrow & Company, Inc. **Page 81:** "Juke Box Love Song" by Langston Hughes from *Selected Poems* by Langston Hughes. Reprinted by permission of Harold Ober Associates Incorporated. Copyright 1951 by Langston Hughes. Copyright renewed 1979 by George Houston Bass. **Page 82:** "Analysis of Baseball" by May Swenson © 1971. Used with permission of the Literary Estate of May Swenson. **Page 85:** "In the beginning was the" by Lillian Morrison from *Sprints & Distances* by Lillian Morrison. Copyright © 1965 by Lillian Morrison. Reprinted by permission of Marian Reiner for the author. **Page 87:** "The Pinta, the Nina and the Santa Maria; and Many Other Cargoes of Light" by John Tagliabue from *A Japanese Journal* by John Tagliabue. Reprinted from *Prairie Schooner* by permission of the University of Nebraska Press. Copyright © 1963 University of Nebraska Press.

POETRY ACKNOWLEDGMENTS (PAPERBACK EDITION)

Page 26: "Dream Variation" by Langston Hughes from *Collected Poems* by Langston Hughes. Copyright © 1994 by the Estate of Langston Hughes. Reprinted by permission of Alfred A. Knopf. Inc. **Page 43:** "Building" by Gwendolyn Brooks from *The Near-Johannesburg Boy*, published by Third World Press. Copyright © 1991 by Gwendolyn Brooks. **Page 59:** "I, Too" by Langston Hughes from *Collected Poems* by Langston Hughes. Copyright © 1994 by the Estate of Langston Hughes. Reprinted by permission of Alfred A. Knopf. Inc.